Updated for CC 2018

**A PLAIN ENGLISH GUIDE TO THE
COMPLEXITIES OF PHOTOSHOP**

Speaking Photoshop CC

David Bate

Bate Publishing Milwaukee

Speaking Photoshop CC • David Bate

Bate Publishing

18745 Ridgewood Lane
Brookfield, Wisconsin 53045
DBate@SpeakingPhotoshop.com

Editors

Rick Bate
Mary Bath
Bill Elliott
Robert Manak

Contributors

Phyllis Bankier
Rick Bate
Bill Elliott
David Espurvoa
Caron Gray
Mélanie Lévesque
Shari Kastner
Billy Knight
Mitch Potrykus
Melissa Staude

Cover Photo

The cover photo was taken in Ireland by Rick Bate. I added two filters to the left and right portions of the image to highlight Photoshop's editing capabilities. The section on the left features Photoshop's Oil Paint filter, and the section on the right features the Patchwork filter. The center section is unfiltered.

© 2018 by David Bate

Copyright for individual images used in this book are retained by the original creator. All other images used in this book, for which copyright is not specifically indicated, belong to David Bate.

Notice of Rights

All rights reserved. No part of this book may be reproduced or transmitted in any form without the prior written permission of the publisher. To obtain permission for reprints and excerpts, contact *DBate@SpeakingPhotoshop.com*.

Notice of Liability

While every precaution has been taken in the preparation of this book, the author assumes no responsibility for errors or omissions, or for damages resulting from the use of the information contained herein.

Trademarks

Adobe, Photoshop, Bridge, InDesign, Illustrator and Acrobat are registered trademarks of Adobe Systems, Incorporated.

ISBN: 978-0-9882405-2-0 Printed in U.S.A.

TABLE OF CONTENTS

1. An Overview of Bridge & Photoshop — 2
Use Adobe Bridge to Open and Manage Photoshop files 4
 Accessing Bridge through Photoshop . 5
 The Bridge Workspace. 6
 Browsing through Files . 9
 Managing files in Bridge .10
 Understanding Metadata .20
 Opening Files from Bridge .23
The Photoshop Workspace. .24
Navigating Around an Image .28

2. Resizing, Cropping & Transforming — 32
Uncovering the Mysteries of Image Size. .34
Canvas Size. .41
The Crop Tool .46
Transforming. .51

3. Creating Selections — 58
The Selection Tools .60
 Marquee Selection Tools .60
 The Lasso Tools .67
 The Quick Selection Tool .71
 The Magic Wand Tool .73
 Color Range .77

4. Levels, Curves, Shadows/Highlights — 84
Auto Exposure Adjustments .86
 Making your job easy .86
 Making your job not so easy .88
The Levels Command .89
Adjustment Layers .94
 Nondestructive Editing .94
 Adjusting Part of an Image .98
Curves .101
Shadows/Highlights .106

5. A Color Balancing Act — 110

- How is Color Created? .. 112
 - The Additive Color System .. 112
 - The Subtractive Color System 112
 - The Color Wheel .. 113
 - Finding the Color Wheel in Photoshop 115
 - Gamut! We Have a Problem 119
- Balancing Color ... 122
 - Making an initial color analysis 122
 - Color Balance Adjustment Layer 124
 - Manual Levels Adjustments 125
 - Gray Point Eyedropper .. 126
 - Correcting Color with Curves 128

6. Retouching — 132

- An Overview of the Retouching Tools 134
 - Gradient Tool ... 134
 - The Brush Tool .. 138
 - Red Eye Tool .. 142
 - Clone Stamp Tool .. 143
 - Healing Brush Tool .. 147
 - Spot Healing Brush ... 148
 - Patch Tool .. 149
 - Which Tool is the best Cloner/Healer/Patcher? 149
 - Blur, Sharpen and Smudge Tools 150
 - Dodge, Burn and Sponge Tools 150
 - Brightening Teeth with Hue/Saturation 151

7. Layers & Layer Effects — 154

- Background Layer versus Regular Layer 156
 - Basic Layer Construction .. 156
 - Background Layer Attributes 158
 - Regular Layer Attributes .. 160
 - Converting between Background and Regular Layers 160
- Blending Modes, Opacity and Fill 161
- Locking and Linking Layers ... 162
- Layer Effects and Layer Styles 163
- Organizing and Moving Layers .. 173
- Layer Masks .. 176
- Clipping Masks ... 179

8. Smart Objects, Filters & Vanishing Point — 182

- Smart Objects .. 184
 - Smart Objects and Raster Images 184
 - Smart Objects and Vector Images 187
 - Editing Smart Objects 188
 - Using Smart Filters 191
- Working with Filters ... 192
 - An Overview of Filters 192
 - The Sharpen Filters 194
 - The Displace Filter 198
 - The Clouds Filter .. 200
 - Vanishing Point .. 201

9. Distort, Warp & Content Aware — 210

- Liquify .. 212
- Puppet Warp .. 219
- Content Aware Scale .. 224
- Content Aware Move ... 228

10. Camera Raw, Photomerge & HDR — 232

- Camera Raw .. 234
 - An Overview of Camera Raw 234
 - Adjusting White Balance 236
 - Synchronize Settings with Other Photos 238
 - Exiting Camera Raw 239
 - Tone Controls ... 240
 - Clarity, Vibrance and Saturation 244
 - Other Adjustment Tabs 246
 - Adjusting Part of an Image 249
 - Cropping and Straightening 253
 - Transform Tool .. 254
 - Spot Removal Tool .. 255
 - Other Tools ... 256
 - Using Camera Raw as a Filter 257
- Creating Panoramas with Photomerge 258
- Merge to HDR Pro .. 260

11. Extracting Images—A Hairy Proposition — 264

- Manual Masking Techniques for Hair 266
- Splitting Hairs with Select and Mask 275

TABLE OF CONTENTS

12. Photoshop's Vector Capabilities — 286

- Vector versus Raster Art .. 288
 - Vector Tools ... 289
 - Shape, Path or Pixels .. 290
- Vector Shapes ... 290
- Paths and the Pen Tool .. 295
 - Creating Paths ... 295
 - Putting Paths to Use ... 299
- Setting Type .. 303
 - Point Type ... 303
 - Paragraph Type ... 304
 - Type Options ... 304
 - Type on a Path ... 306
- Putting it all Together ... 307
 - Compose the Main Graphic ... 308
 - Add a Gradient Background .. 312
 - Create a Map of Africa ... 313
 - Set the Type ... 314

13. Output for Print & Web — 318

- Printouts .. 320
- Preparing Images for Offset Printing 325
 - CMYK Images ... 325
 - Duotones .. 328
 - Spot Color Images ... 331
- Saving Images for the Web .. 336
 - Understanding Web File Formats 337
 - Optimizing Line Art ... 338
 - Optimizing Photos ... 341

Index — 344

About Speaking Photoshop

Learning to master an intricate and involved software program like Photoshop is akin to learning a foreign language. Having taught German and Photoshop for many years, I see a lot of similarity between the challenges faced by the foreign language student and the Photoshop student. The program can do virtually anything you need it to do—but do you know how to tell it what you want?

Yes, if you learn how to *speak Photoshop*.

This book will help you do just that. It provides a comprehensive look at Photoshop's most practical and powerful tools for image editing. It's not a recipe book that shows you how to create pretty projects by applying specific settings that don't apply elsewhere. Rather *Speaking Photoshop* stresses the concepts behind the magic. It explains why editing techniques work in certain situations and why they don't in others. Armed with this knowledge, you will be able to trouble-shoot your way through future challenges. Photoshop can do almost anything related to image editing. It's your responsibility to understand and implement the proper tools for the job, then *speak Photoshop* to communicate your vision to the software program.

Speaking Photoshop Workbook

For high school, college or university courses, the supplemental *Speaking Photoshop CC Workbook* helps round out your curriculum with real world projects and questions designed to solidify the skills introduced in each chapter. But you don't have to be a student to benefit from the *Speaking Photoshop CC Workbook*. The extra practice it provides is helpful to anyone wanting to master the complexities of Photoshop. Order ISBN: 978-0-9882405-3-7.

Chapter Files

All of the files used in the book and workbook are available for download at *www.SpeakingPhotoshop.com*. They are intended for use with *Speaking Photoshop* or *Speaking Photoshop Workbook* only. Please do not use the files for other purposes or distribute them in any way. Copyrights remain with the author or the original photographers or artists.

About the Author

Dave and Kris Bate with Toby, Callie and Tyke.

David Bate began his professional career as a Music and German teacher, switched to the field of advertising, where he owned and operated his own ad agency for over 20 years, then returned to the teaching profession as a Graphic Design instructor at Waukesha County Technical College. An early adopter of desktop publishing technology, he has used Photoshop since Version 2.0 and has had the advantage of growing up and evolving with the software as it became more powerful and versatile. Photoshop has always been a passion of his, and he is an *Adobe Certified Expert* in Photoshop.

Acknowledgments

Writing a book is not a one-person proposition. I depended on many colleagues, friends and family members to help me along the way, and I'm extremely appreciative of their support.

It all started with Terry Rydberg, a fellow WCTC instructor and author of the excellent textbook, *Exploring InDesign*. She was the one who convinced me to take on this project. Without her support and advice, I would never have considered writing a book.

Along the way, I received encouragement and support from my Photoshop students. Many of the image files used throughout this book were captured by former students of mine. I'm proud of what they have accomplished.

My editors, Rick Bate, Mary Bath, Bill Elliott and Robert Manak, spent countless hours pouring over the text and exercises. Their invaluable advice has made this a better book than it would have been without their dedication and insight.

Finally, my poor wife Kris deserves a debt of gratitude. She unselfishly assumed extra household responsibilities and refrained from interrupting me, as I hid in *Speaking Photoshop* hibernation. I felt like emailing her a picture now and then, so she would remember who I was.

Overview of Topics

Chapter 1—An Overview of Bridge & Photoshop
Covers how to find, organize and open image files through Adobe Bridge. Introduces the Photoshop Workspace and familiarizes the reader with the basic menu commands, tools and panels.

Chapter 2—Resizing, Cropping & Transforming
Addresses the differences between image size and canvas size and explains the importance of resolution to image quality. Also covers how to rotate, skew, distort or warp an image.

Chapter 3—Creating Selections
Provides a comprehensive look at the various methods of selecting part of an image for further editing. Discusses the differences of aliasing and anti-aliasing and the effects of feathering.

Chapter 4—Levels, Curves, Shadows/Highlights
Covers Photoshop's major tools for correcting poorly exposed images. Explains the mechanics of histograms, how the various luminosity commands work and why they improve detail in an image.

Chapter 5—Color Balancing Act
Explains the theory of color and how it comes to life through Photoshop. Readers will learn what to look for when color correcting images and what methods to use to improve color.

Chapter 6—Retouching
Discusses how to complete valuable retouching tasks, such as creating gradient backgrounds, using specialized brush tips, cloning, healing, removing red eye and brightening teeth.

Chapter 7—Layers & Layer Effects
Explores the power of layers. Covers layer blending modes, opacity, fill, layer effects, layer masks, clipping masks, and alignment and distribution.

Chapter 8—Smart Objects, Filters & Vanishing Point
Covers the advantages of using Smart Objects and explores the unlimited possibilities of using Photoshop filters, including Vanishing Point.

Chapter 9—Distort, Warp & Content Aware
Introduces the diverse distorting capabilities of Liquify and Puppet Warp. Also covers Content Aware Fill, Content Aware Scale and Content Aware Move.

Chapter 10—Camera Raw, Photomerge & HDR
Explains the powerful features of Camera Raw for adjusting white balance, correcting exposure and more. Also demonstrates how to merge multiple photos into a seamless panorama with Photomerge and how to create a high dynamic range photo from multiple exposures using Merge to HDR Pro.

Chapter 11—Extracting Images–A Hairy Proposition
Covers manual masking techniques and the powers of Select and Mask to extract images that contain hair. Includes compositing tips on placing an image into a background with a different white balance or exposure.

Chapter 12—Photoshop's Vector Capabilities
Covers Photoshop's abilities to create vector paths, shapes, strokes and type. Includes tips on how to create paths and edit on-the-fly using the Pen tool.

Chapter 13—Output for Print & Web
Explains how to prepare your image for output to print or the Web. Includes tips on printing to desktop printers, preparing images for four-color or spot-color offset printing, and saving optimized images for the Web.

Images have a unique power to impart that which is beyond words.

▸ *William Shirley*
British Politician, 1694–1771

1

◂ *An Overview of Bridge & Photoshop* ▸

Dave Bate

Topics

- ▶ Browse for and open files using Bridge.
- ▶ Assign labels and ratings to images.
- ▶ Create and apply custom keywords.
- ▶ Display selected images through sorting and filtering.
- ▶ Conduct multi-criteria searches for metadata.
- ▶ Create a Photoshop workspace tailored to your needs.
- ▶ Change your image view using the Zoom, Hand and Rotate Tools.

Preview

Whether you are an aspiring graphic artist, a serious photographer, a webmaster, or a printing professional, chances are that you will have to keep track of thousands of photographs and other images throughout the years. That can be a daunting task for sure! But it won't be nearly as difficult if you take advantage of the wonderful file management capabilities of Adobe Bridge. More than just a program that gives you a nice preview of a file before you open it, Bridge also lets you manage files by adding labels, ratings and keywords—all for the sake of making it easier to locate that elusive photo when you need it.

Another way to improve your efficiency is to create a custom workspace in Photoshop. Photoshop lets you place, size and group panels where you want them, then save your arrangement by creating a new workspace.

Take time now to learn how to manage your image files and customize your Photoshop workspace. You'll save yourself tons of time in the future.

Use Adobe Bridge to Open and Manage Photoshop files

Photoshop's capabilities to enhance and enrich photographs is truly legendary. In fact, its use in the world of image enhancement has become so commonplace, that people frequently use the word Photoshop as a verb to describe anything perceived as incredible or awesome in a photo.

"Does that model really look that good? Naw, she had to be Photoshopped!"

So where is the best place to start in our quest to learn this comprehensive and awe-inspiring program? Strange as it may seem, nine times out of ten, the best place to start working with Photoshop documents is not even within the Photoshop application itself. Rather, it's with a companion software program called Adobe Bridge. That's the application you should turn to when you want to open a Photoshop file. Sure, there's a File>Open command within Photoshop just as you would expect, but its capabilities pale in comparison with the capabilities of Adobe Bridge.

Bridge had its origin as a file-menu command in an earlier version of Photoshop, and it was called the *Browser*. Its initial purpose was to make life easier by giving you a much better preview of images than the typical File>Open dialog box. Based on its early success, Adobe decided to promote the Browser to a standalone application and expand its capabilities to work with other applications in the Adobe Creative Suite, such as InDesign and Illustrator. Thus was born a very useful application for previewing and organizing files of all types.

In a nutshell, Bridge lets you preview files and sort through them using techniques reminiscent of a good database program. You can add labels, ratings, keywords and important metadata, all for the purpose of making it easier to find that wonderful photo you knew you took three years ago. Or was it four years ago? Doesn't matter, Bridge will find it for you quickly and easily as long as you follow a few simple "housekeeping" procedures along the way. Through Bridge, you can also create PDF contact sheets or slide shows of your favorite images. We'll delve into those capabilities in a later chapter.

Accessing Bridge through Photoshop

As mentioned, Bridge is a standalone application and, as such, it can be opened like any other standalone application. On the Mac, you can find it in the Applications folder, and on the PC you can open it through the Start menu. Yet the most convenient way to launch Bridge is through the application that you intend to edit your file with, in our case Photoshop. Let's take a look at some Photoshop images using Bridge and see what we can do with them.

▶ *Launch Photoshop.* On the Mac, double-click the Adobe Photoshop CC program icon (in the Adobe Photoshop folder in the Applications folder). On the PC, choose Adobe Photoshop CC using the Start Menu.

▶ *Open Bridge from Photoshop.* When Photoshop opens, choose File>Browse in Bridge from the Main menu, or, better yet, type the keyboard shortcut that you see to the right of the menu command: Option+Command+O (Mac) or Alt+Control+O (PC). You will immediately be whisked away to Bridge. Then, when you open an image file in Bridge, you will automatically be returned to Photoshop to work on it.

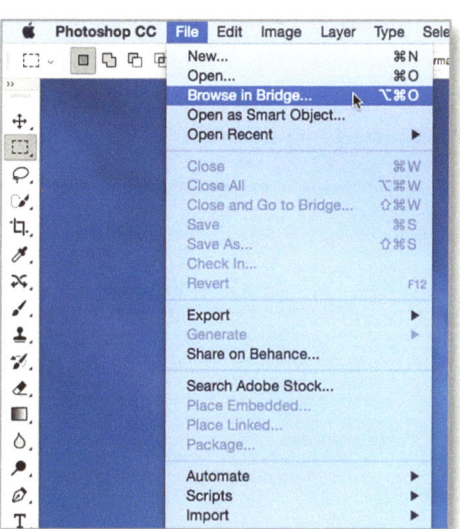

Speaking Photoshop…

Real Photoshoppers use keyboard shortcuts!

I find it helpful to try to make sense of keyboard shortcuts—it makes remembering them that much easier. The keyboard shortcut for opening a file in Bridge is a case in point. *Command+O* (Mac) and *Control+O* (PC) are the standard keyboard shortcuts for opening files in virtually any application, and opening files is one of the things that Bridge does so well. But Bridge gives you more options, or alternatives, than the standard Open dialog box—hence the keyboard shortcuts of *Option+Command+O* (Mac) and *Alt+Control+O* (PC).

The Bridge Workspace

The Bridge workspace bears a striking resemblance to other Adobe applications. That's no accident. Adobe strives to give all of its programs a similar look. That way, when you learn something in one program, you can often apply it in another. Typical to all Adobe applications, you have a Main menu across the top. Immediately below that, also running from left to right across your screen, you have the Application bar, then the Path bar.

The main work area is broken into three sets of panels: one large Content panel in the middle, flanked by various other panels along the left and right sides. Most of your work is accomplished using a panel—it's far more efficient than using the Main menu. I like to think of them as little *Control Centrals* which specialize in completing specific tasks. Let's take a closer look at the Bridge workspace.

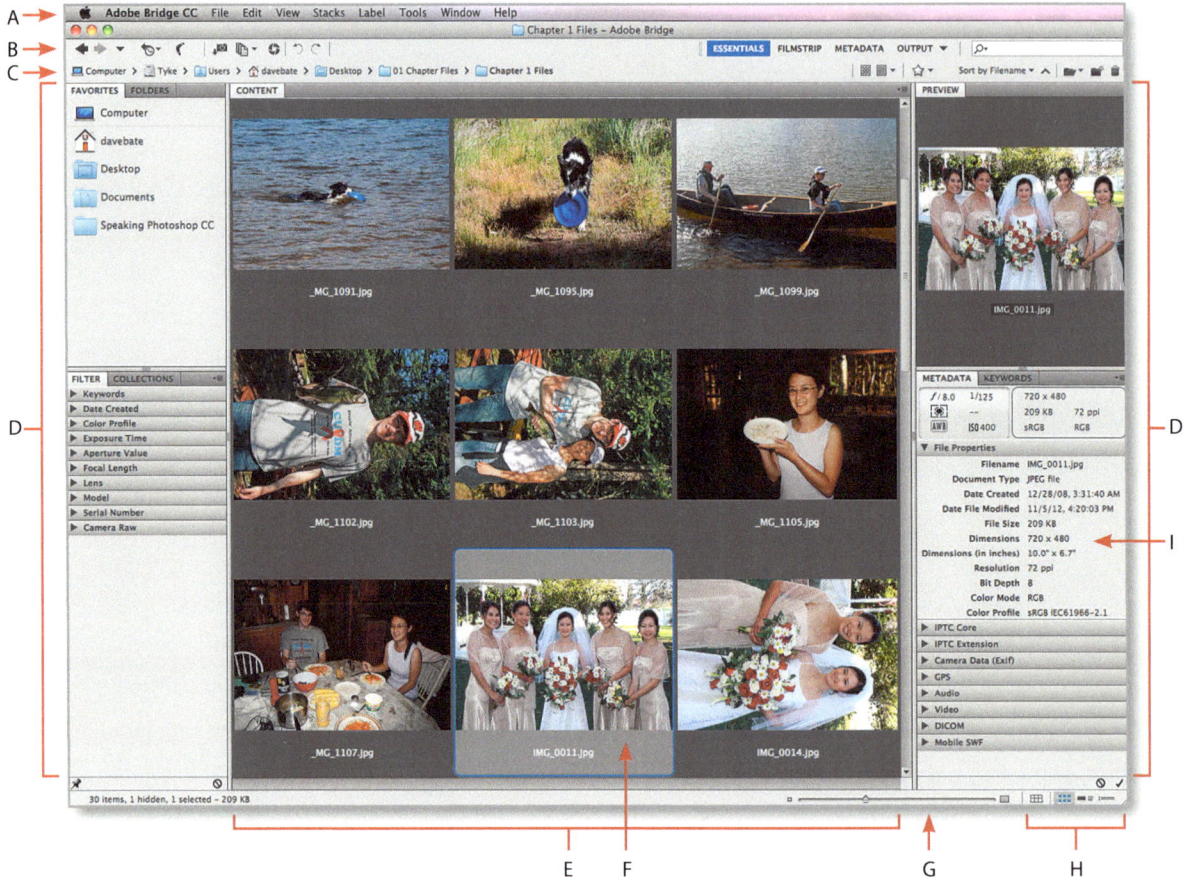

A. Main menu
B. Application bar
C. Path bar
D. Panels
E. Content panel
F. Selected image
G. Thumbnail slider
H. View buttons
I. Metadata for selected image

▶ *Main menu.*

Bridge's Main menu functions just as it does in virtually all other software applications. It is the place to look if you want to do something, but you're not sure how, or even if, your program can do that certain something. Commands are grouped logically to help you in your search. But there are usually faster ways to access the Main menu commands, and as you become more accomplished with the software, you should rely less and less on the Main menu. Take just a brief moment to click on the menu headings and familiarize yourself with the array of commands that are available.

▶ *Application bar.*

Directly below the Main menu is the Application bar which contains commonly used commands, some of which interact with other programs. Mouse over them and read the corresponding Tool Tips that pop up. Notice, too, that the icons are broken up into groups by vertical lines.

The first group is all about navigation. The two arrows on the left function like arrows in a browser, letting you retrace your viewing steps. The next two icons help you browse through files on your computer, and the boomerang returns you to the application that sent you to Bridge.

The next group of three icons lets you get photos from an attached camera, review selected images, rename files, view file information, or open a file in Camera Raw.

The third group contains two icons that are pretty self-explanatory. They let you rotate image thumbnails counter-clockwise or clockwise.

The right hand side of the Application bar gives you an easy way to select a different workspace or perform a search for a file.

▶ *Path bar.*

The strip below the Application bar is called the Path bar. It shows you your current location on your computer's hard drive and also contains some useful commands for working with files, such as filtering and sorting. If you don't see a Path bar on your screen, you can make it visible by choosing Window>Path Bar under the Main menu. If it has a check mark by its name, the Path bar should be visible on your screen.

▶ *Panels.* The major workspace area is broken down into three vertical columns, each containing one or more panels. The middle column is the Content panel, where you see and select the files you want to work on, and the left and right columns contain various panels that enable you to do specific tasks. Panels have tabs reminiscent of file folders and, if you want, you can drag the panels by their tabs and place them anywhere you want on the screen to create your own custom workspace.

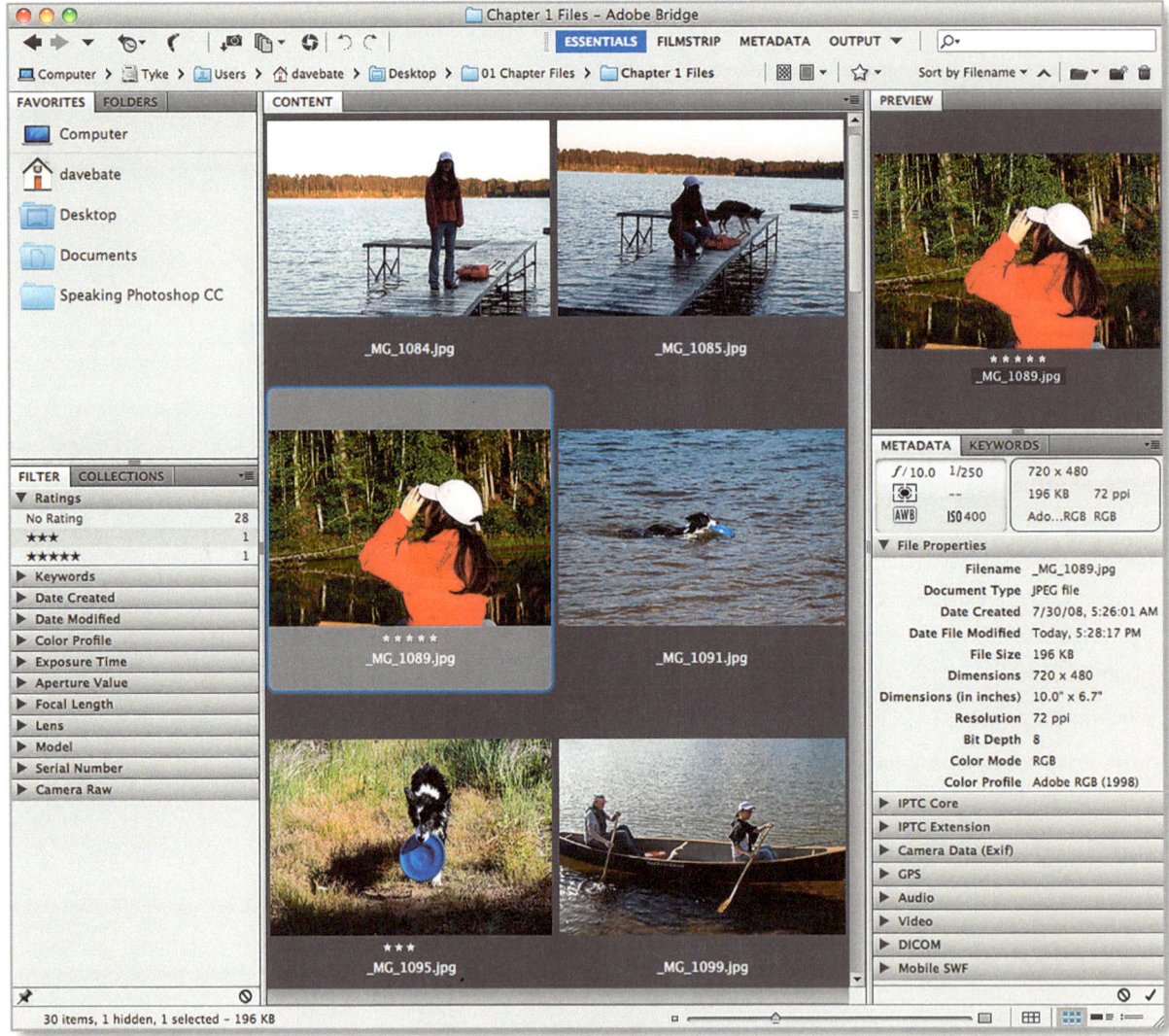

Left Hand Panels

Favorites and Folders panels let you browse for images.

Filter and Collections panels let you display only certain images.

Content Panel

Content panel displays folders and files as you navigate through your hard drive.

Click an image to select it; double-click the image to open it in the application that created it.

Right Hand Panels

Preview panel displays selected images.

Metadata panel displays pertinent data associated with an image.

Keywords panel lets you create and assign keywords to images.

Browsing through Files

▶ *Find the Chapter 1 files.* The top two control panels on the left side let you navigate through your hard drive and connected devices. The Favorites panel gives you quick access to files or folders that you use frequently. The Folders panel lets you navigate through any internal and external devices that are connected to your computer in typical Macintosh or Windows fashion.

Activate the Folders panel by clicking on its tab, then click on the Desktop icon to reveal the contents of the Desktop inside the large Content panel. There you should find the Speaking Photoshop CC folder that you downloaded from the internet, providing of course that you chose to download it to the Desktop. If not, use the Folders panel to navigate to the area where you placed the Speaking Photoshop CC folder. Now activate the Favorites panel by clicking on its tab and drag the Speaking Photoshop CC folder from the Content panel into the Favorites panel. Repeat this procedure with any other folder

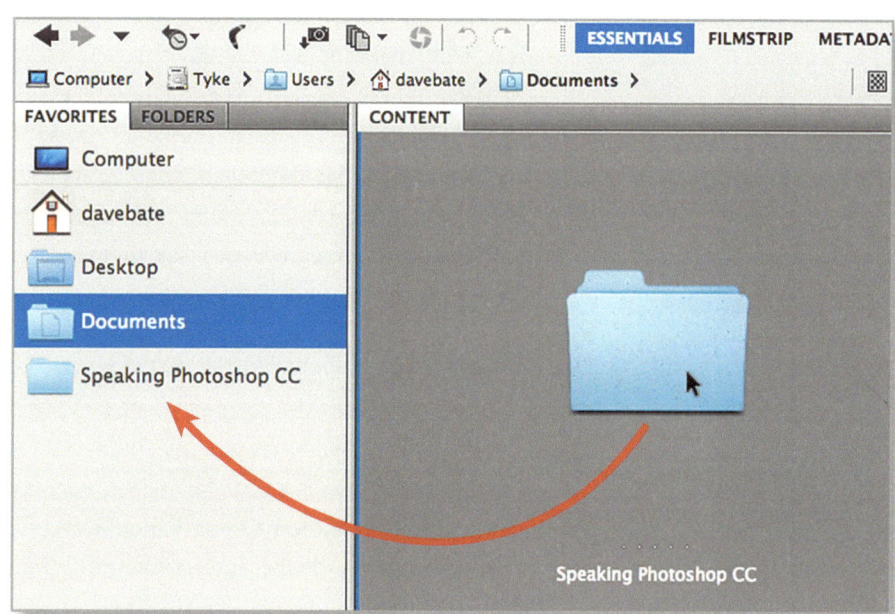

that you use frequently, and it will save you the trouble of navigating through your hard drive using the Folders panel. To remove a folder or file from your Favorites panel, simply highlight it and choose File>Remove from Favorites in the Main menu. You can also remove it using the contextual menu by Control+Clicking (Mac) or Right+Clicking (PC) on the folder.

With the Speaking Photoshop CC folder selected in the Favorites panel, you should see the Chapters folder in the Content panel. Double-click it to open it, then double-click the Chapter 1 folder to view the images inside. The wedding photos, provided courtesy of Mills Photo & Video Studios, were taken at my son's wedding in Las Vegas. The others are from a vacation in northern Wisconsin.

Managing files in Bridge

▶ *Resize the image thumbnails.*

The file name appears beneath each image—handy if you know the name of the file you want to work on—but the image thumbnails are a bit too small to see easily. We can fix that. Find the slider at the bottom right of the Bridge window and drag it towards the right to make the thumbnails grow; slide it to the left to make them shrink. Alternatively, you can click on the icons to the left and right of the slider to make thumbnails shrink or grow in increments. Better yet, use the keyboard shortcuts Command+Plus (Mac) / Control+Plus (PC) to enlarge the thumbnails, or Command+Minus (Mac) / Control+Minus (PC) to reduce them. Play around with the thumbnail sizes to get comfortable with the various methods, then size them as large as possible, but not so large that you can't see all of them in the Content panel without scrolling.

▶ *Rotate image thumbnails.* The next step in making the thumbnails user friendly is to rotate the images that are on their sides. Click on _MG_1102.JPG to highlight it, then locate and click the ⟲ icon in the Path bar to rotate it counterclockwise. As you might expect, there are also keyboard shortcuts that accomplish the same thing. Command+[(Mac) or Control+[(PC) rotates counterclockwise, and Command+] (Mac) or Control+] (PC) rotates clockwise.

Select _MG_1102.JPG, then type *Command*+[(Mac) or *Control*+[(PC) to rotate it counterclockwise.

▶ *Use multiple selections to streamline your work.* There are other thumbnails we want to rotate, but instead of doing them individually, we can rotate them in one operation by making a multiple selection first. Bridge lets us make two types of multiple selections: sequential and non-sequential.

To make a sequential selection, Click on the first file that you want to select, then Shift+Click on the last file you want to select. All files between your first and last images are automatically added to the selection, giving you a range of images.

To make a non-sequential selection, simply Click on the first image, then Command+Click (Mac) or Control+Click (PC) on each additional file that you want to select. If you select an image by mistake, just Command+Click (Mac) or Control+Click (PC) on it again to deselect it. That's the method that makes the most sense in our case, since the files that need to be rotated are not all in a bunch. Go ahead and select all of the images that are on their side and rotate them using the keyboard shortcut Command+[(Mac) or Control+[(PC). Get used to using keyboard shortcuts whenever possible, because that's the fastest, most efficient way to work.

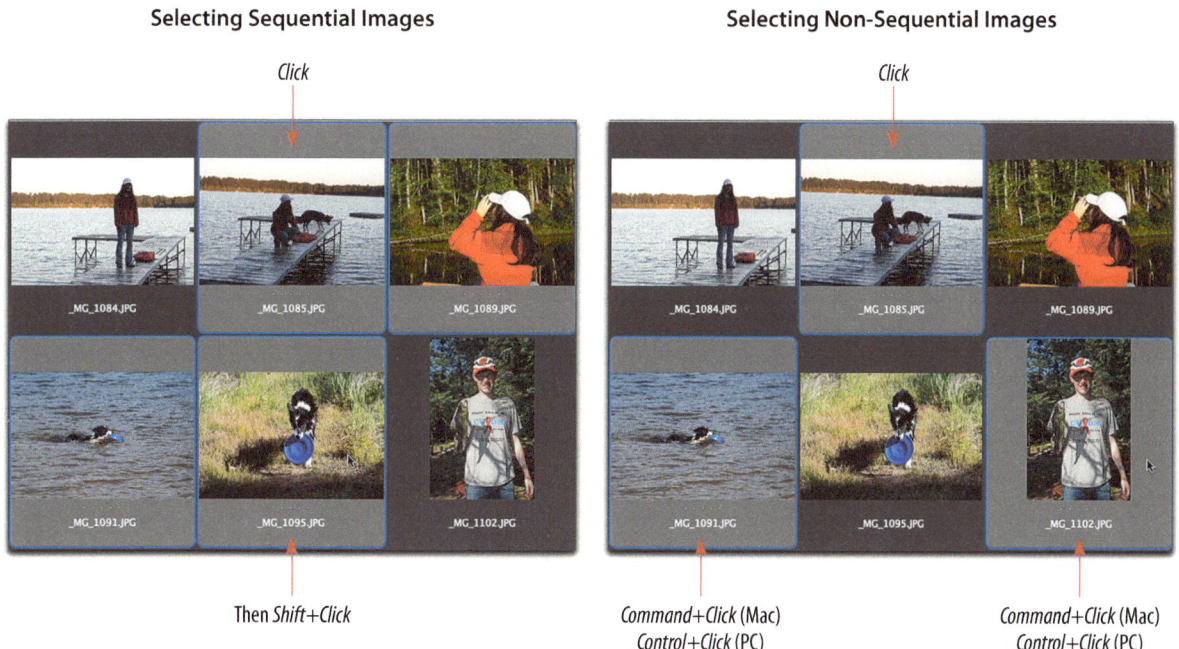

12 ◀ An Overview of Bridge & Photoshop ▶

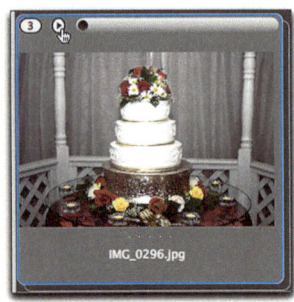

The thumbnail above shows a collapsed stack containing three images. A play button and slider appear when you mouse over the area above the thumbnail, allowing you to play a slide show that displays the images contained in the stack.

▶ *Group photos together in stacks.* Notice the three photos of the cake, which differ from one another in exposure only. Even if we had tremendously fond memories of that cake, we don't really need to see the same image three times in a row. That's where stacks come in handy. A stack lets you place multiple images on top of one another to conserve viewing space without discarding any of the images. They don't have to be identical images, as they are in this case. You can create a stack for any grouping that makes sense to you.

To create the stack, select all three image thumbnails, then use Command+G (Mac) or Control+G (PC)—think *group*—to consolidate them all into one thumbnail. The number 3 at the top left of the thumbnail lets you know how many files are included in the stack. Click the number, and the stack will expand, revealing its contents. Click it again and the stack will collapse.

Mouse over the area immediately to the right of the number and two new icons appear: a right-pointing triangle and a slider button. Click the triangle and you'll see a quick slide show of the images within the stack. The slider button moves to reveal the progress of the slide show as the images advance. You can also drag the slider button with your mouse to move forward or backward through the slide show.

Unfortunately our best photo, the middle exposure, is hidden when the stack is closed, but we can fix that. Open the stack by clicking on the 3, then select only the middle image by clicking it once. When it's selected, drag it to the left of the first image to promote it to "favored status." Click on the 3 again to collapse the stack and verify that the middle image is shown. A collapsed stack always shows the first image in the stack.

To disable a stack, select it and type Shift+Command+G (Mac) or Shift+Control+G (PC). You can also remove individual images from a stack by dragging them out of the stack.

By the way, all of the things we have done with stacks could have been accomplished using a command from the Stacks menu, but as I mentioned earlier, the Main menu is not the most efficient way to work.

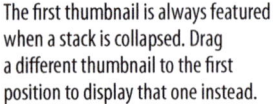

Click the number to expand or collapse the stack.

The first thumbnail is always featured when a stack is collapsed. Drag a different thumbnail to the first position to display that one instead.

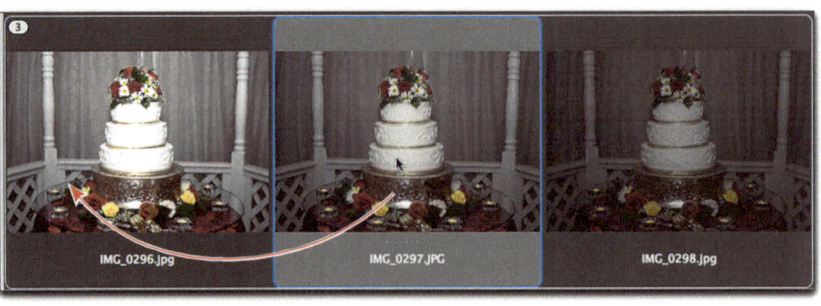

▶ *Use labels to define broad categories.* There are many ways to organize your files, and using labels is an effective way to separate images into broad categories. Click on the Label menu in the Main menu, and you'll find five possible labels named *Select, Second, Approved, Review* and *To Do*. These names are merely suggestions from Adobe as to how labels might be used. Chances are you'll want to rename them to fit your own situation. To do that, type Command+K (Mac) / Control+K (PC) or choose Adobe Bridge CC>Preferences (Mac) or Edit>Preferences (PC) from the Main menu. When the Preferences dialog box opens, click on the Labels category in the list along the left side, then type in new names in the text fields to the right.

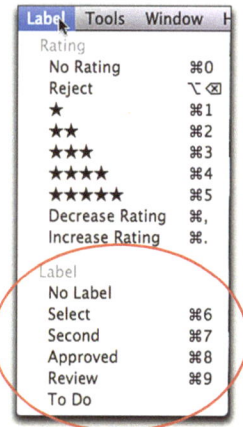

Labels let you divide your images into five categories.

We'll use the labels to help us separate our wedding photos into three categories: the bride's family, the groom's family and both families. Rename the red label Bride, the yellow label Groom and the green label Bride and Groom, then click OK.

Back in the Content panel, select all of the photos that correspond to the bride's family (Asians) and type Command+6 (Mac) or Control+6 (PC) to apply the Bride label. Next, choose all of the photos of the groom's family (Caucasians) and type Command+7 (Mac) or Control+7 (PC) to assign the Groom label to them. For photos that apply to both families, such as large group shots or the cake, assign the Bride and Groom label by typing Command+8 (Mac) or Control+8 (PC). To remove a label, choose Label>No Label from the Main menu.

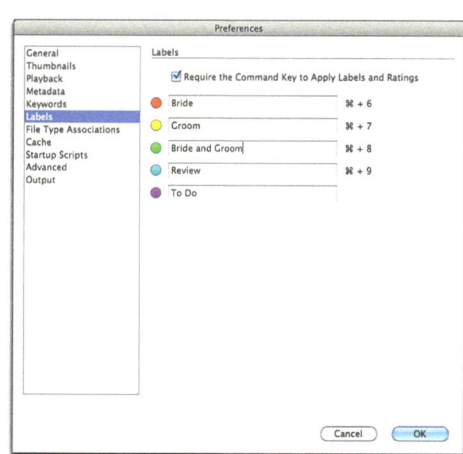

Labels can be renamed in the Preferences dialog box.

You now have a nice overall visual as to which photos belong with which family just by looking at the label colors, but there's more we can do.

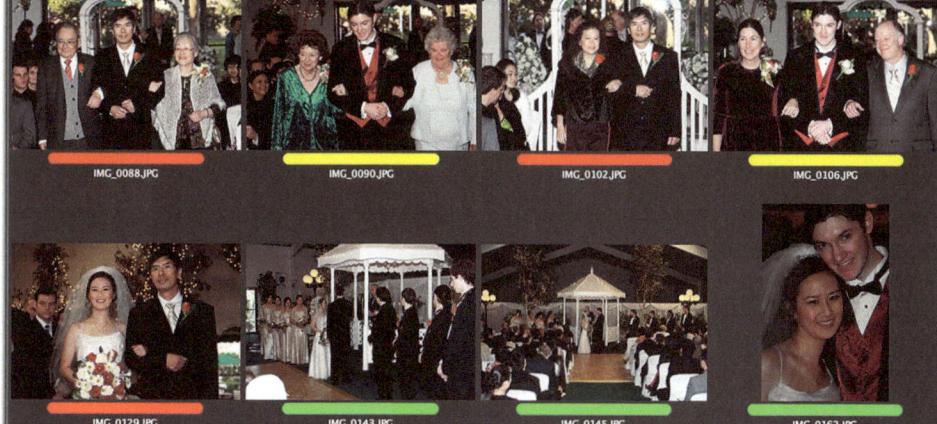

Labels give you a quick visual reference as to which group an image is associated with.

14 ◀ An Overview of Bridge & Photoshop ▶

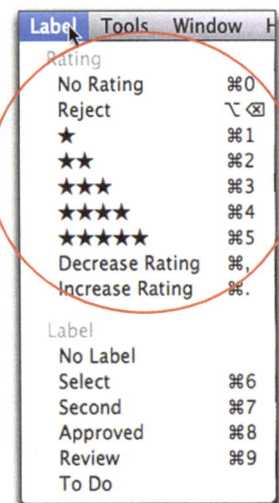

Ratings can be found under the Label menu, but use the logical keyboard shortcuts instead.

▶ *Prioritize your favorite images with ratings.* Ratings let you identify your favorite and least favorite images using a scale of 1 to 5 stars. You can do this using the Label menu in the same way that we just applied labels, but there are two easier ways to apply a rating. The first is by using the keyboard shortcuts Command+1 through Command+5 (Mac) or Control+1 through Control+5 (PC), where 1 is a one-star rating and 5 is a five-star rating. Another easy way is to select an image or images, then simply click on one of the five dots that appear directly beneath the thumbnail. If you can't see any dots when an image is selected, you need to enlarge your thumbnails. To remove a rating, simply click to the left of the dots or type Command+0 (Mac) or Control+0 (PC).

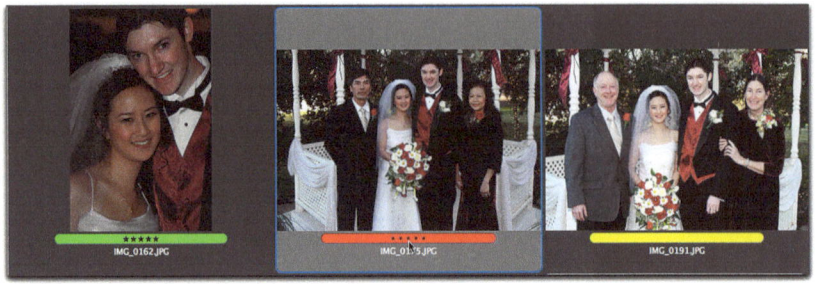

The image on the left has a rating of five stars.
The center image will get a three-star rating if the middle dot is clicked.
The image on the right has no visible dots because it's not selected.

Click to reverse the sort order.

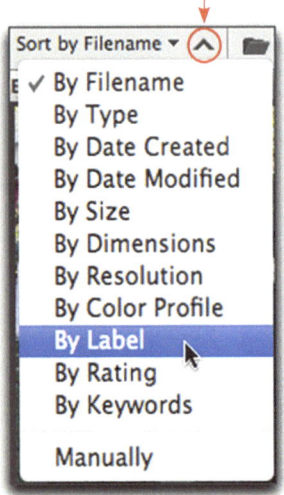

Eleven categories plus a manual sort option let you arrange you images in a logical order.

▶ *Sort the images by label and rating.* Bridge lets you sort images based on eleven different criteria, labels and ratings among them. You can also create one custom Manual sort by dragging files into the order you want to view them. In the Path bar, click on the phrase that begins with the word Sort, and a pop-up menu appears revealing the sort categories. You can also access the sort categories using the View>Sort menu. However you decide to do it, choose Sort by Label and Bridge instantly rearranges the images based on their label color. If you would like to see them arranged in the opposite order, click the icon immediately to the right of the Sort by Label icon in the Path bar to toggle between ascending and descending order. You can also choose View>Sort>Ascending Order to remove (or add) the check mark.

Take a moment to sort by ratings and other alternatives to get a feel for the different ways you can organize your files. As you do, notice how the cake images within your stack remain in the same order relative to one another, regardless of which sort order you choose.

▶ *Create keywords for more detailed identification.* Keywords are the best way to keep tabs on your images. Unlike labels, which only give you five choices, keywords give you unlimited control, because you can create as many keywords as you like. Here's how to do it.

Click on the Keywords panel along the right side. You'll notice that Adobe has already created three major keywords—Events, People and Places—as well as various sub keywords under each of the main keyword categories. These are just examples of how keywords could be arranged. We'll be able to make good use of the keyword "Wedding" in our case, but normally you'll want to create your own assortment of keywords.

Let's create keywords for the bride, Daisy, and the groom, Craig, and place them as sub keywords under the main keyword, People. First, click the word People (not the check box to the left of the word). Then click the New Sub Keyword icon at the bottom of the panel and type *Daisy* in the text field that appears. Then reselect the People keyword and add another sub keyword for *Craig*.

We need just one more keyword to make our scenario complete. All of the non-wedding photos were taken on a vacation in Northern Wisconsin. Add a new sub keyword named *Up North* under the Places keyword.

▶ *Link keywords to the appropriate images.* Once keywords have been created, assigning them to individual images is a simple, two step process: first select the image, then click the check box to the left of the keyword to link it to that image.

Let's start out by assigning the keywords Up North and Wedding. Sort the photos in ascending order by Date Created to place all of the Up North images in front of the wedding photos. Then select all of the Up North photos with a click on the first image and a shift-click on the last image and click the check box to the left of the keyword Up North. Follow the same procedure to assign the keyword Wedding to all of the wedding photos. Finally go through and assign the keywords Craig and Daisy as appropriate. Notice that one image can have multiple keywords associated with it.

We could sort the images by keyword just as we did earlier by label and rating, but a more practical alternative is to use Bridge's filtering capabilities.

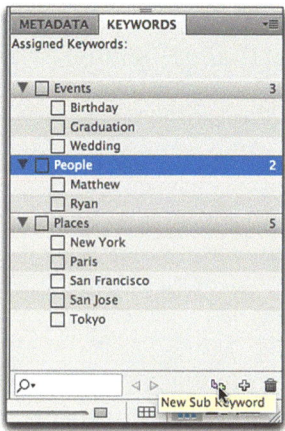

Click the New Sub Keyword icon to add a new sub keyword under the main keyword People.

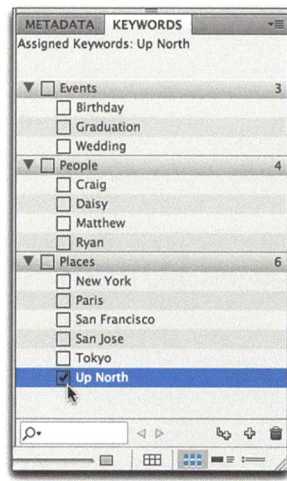

Add the keywords Craig, Daisy and Up North. Then assign them to the appropriate images by selecting the images and clicking the check box to the left of the keyword.

Speaking Photoshop...

Anatomy of a Panel

Panels throughout the Adobe Suite are set up in similar fashion, and you'll see features similar to the ones in the Keywords panel in many other panels. The icon to the top right of the Keywords panel—the one with the downward pointing triangle next to the parallel horizontal lines—is called a flyout menu. Click it and a dropdown menu appears, letting you access a number of commands that apply to the panel's specific function.

Another typical characteristic of panels are the icons that appear across the bottom. These particular icons let you search for specific keywords, create new keywords and sub keywords, or delete keywords you no longer want. You can also find those commands in the flyout menu, but the icons give you a quicker way to accomplish the same thing.

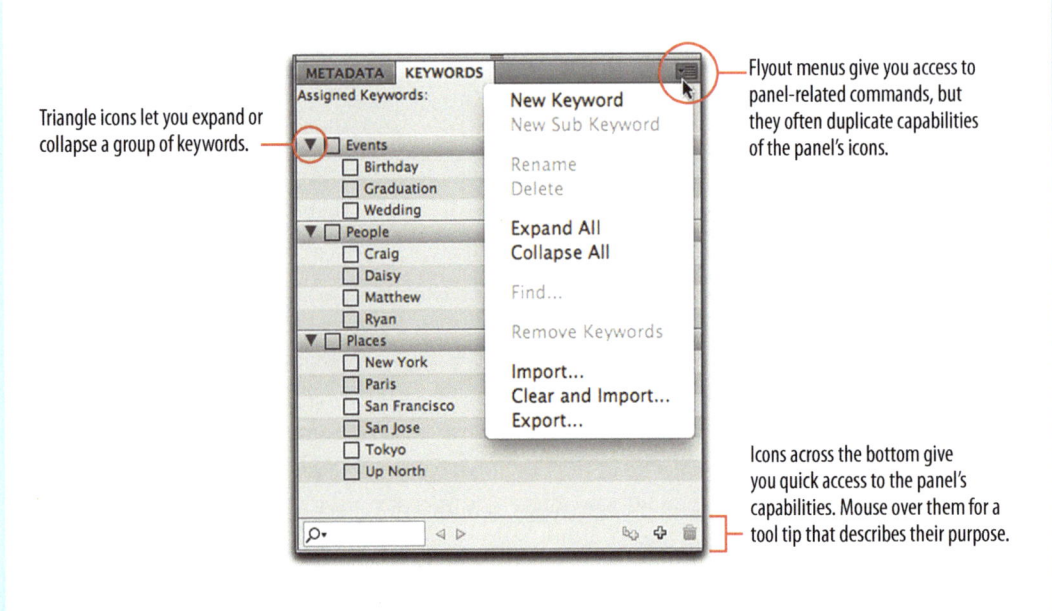

◀ Chapter 1 ▶ 17

▶ *Isolate images using filters.* Click on the Filter panel located beneath the Favorites and Folders panels to activate it. There you'll see a variety of criteria that Bridge can use to filter, or isolate, files. Click the little triangle on the Keywords section to open it up, and you will see the keywords that we just assigned to our images. Click on Craig to display only images that have the keyword Craig assigned to it, then click on Up North to see all of the photos with Craig, plus all of the photos that were taken up North, not all of which have Craig in them.

You can narrow that selection further by opening the Ratings category and clicking on the 5-star rating to display only your favorite images from the Craig and Up North groups. In fact, you could narrow the search by choosing any of the different criteria that are available, including Date Created, Orientation, Exposure Time, and so on. Whenever you choose values from *different* criteria groups, your choice becomes more specific, like an AND statement in database applications. Whenever you choose multiple values from the *same* criteria group, for example 3-, 4- and 5-star rating values, then your selection grows, like an OR statement for databases.

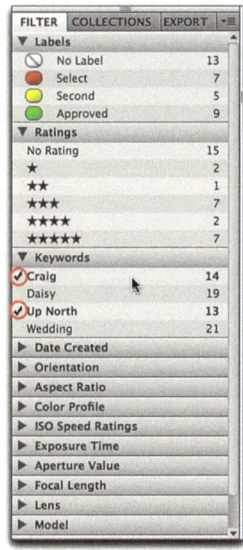

All values associated with your images are automatically added to the Filter panel. The check marks to the left of Craig and Up North mean that those images are currently displayed in the Content panel below.

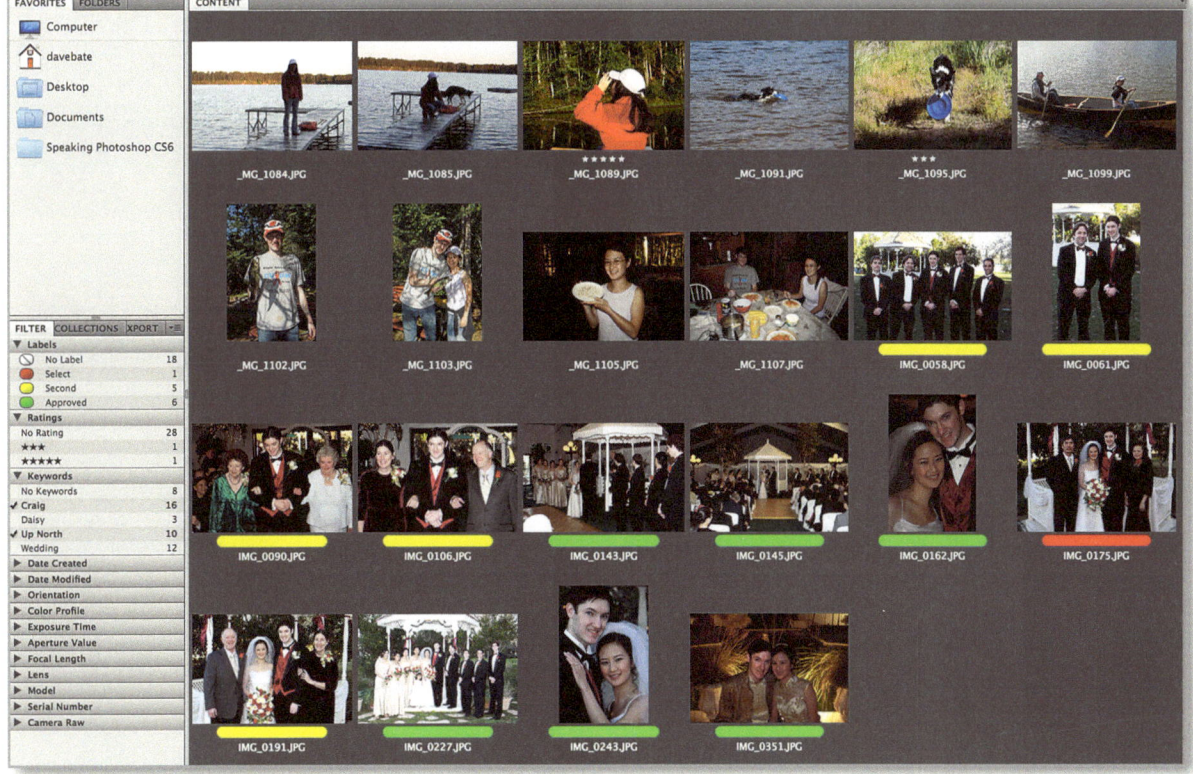

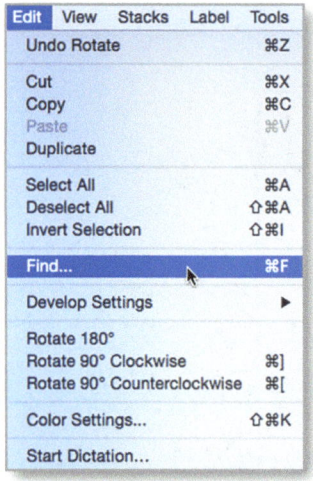

Use the *Edit>Find* command for more sophisticated searches.

▶ *Use the Find command to narrow your search further.* As you click additional values within one criteria group, such as Keywords, the images displayed grow in number. If, for example, you clicked the keywords Craig and Daisy, you would see every possible photo with one or both of them. But what if you wanted to restrict the display to photos where Craig and Daisy were together? For that, you would turn to the more sophisticated find command.

Choose Edit>Find from the main menu or type Command+F (Mac) or Control+F (PC). The dialog box that appears is broken down into three sections: Source, Criteria and Results. Check to make sure that the pop-up menu in the Source section displays the folder containing our photos. If not, select it from one of the pop-up choices or choose Browse at the end of the list.

Next specify the criteria for your search. Choose Keywords from the first pop-up menu, contains from the second, and type Craig in the text field. Click the plus sign to the right of the text field to add a new criterion and set it to Keywords contains Daisy.

The Results section lets us specify how our criteria interact. "If any criteria are met" would give us the same result that we got when we clicked Craig and Daisy in the Filter panel. In other words, we would see any photo with Craig and/or Daisy. Select If all criteria are met to give us just the photos where Craig and Daisy are together.

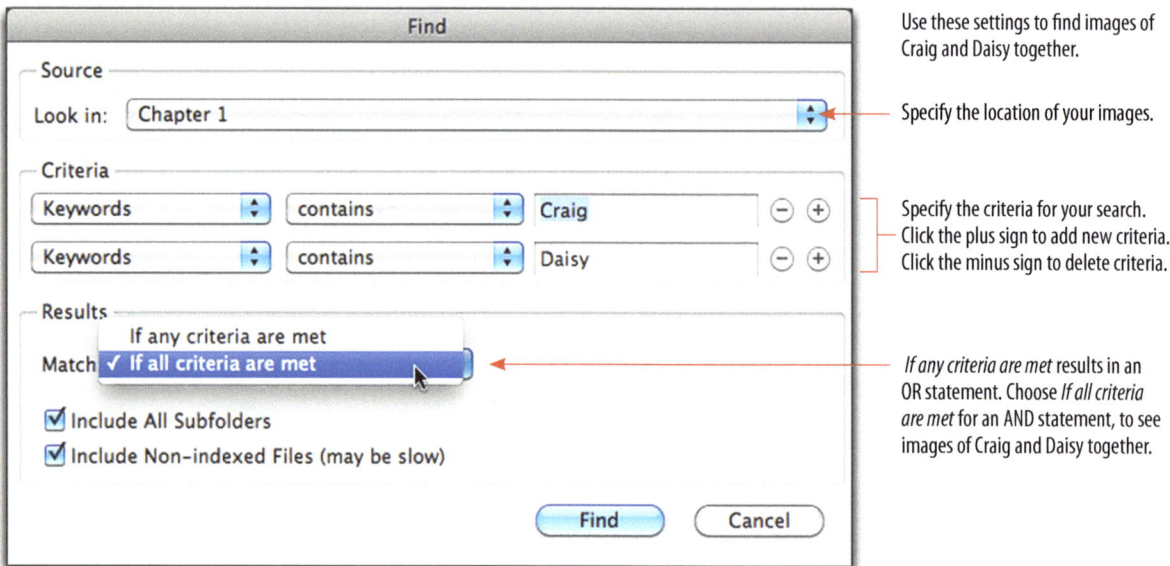

Use these settings to find images of Craig and Daisy together.

Specify the location of your images.

Specify the criteria for your search. Click the plus sign to add new criteria. Click the minus sign to delete criteria.

If any criteria are met results in an OR statement. Choose *If all criteria are met* for an AND statement, to see images of Craig and Daisy together.

◀ Chapter 1 ▶ 19

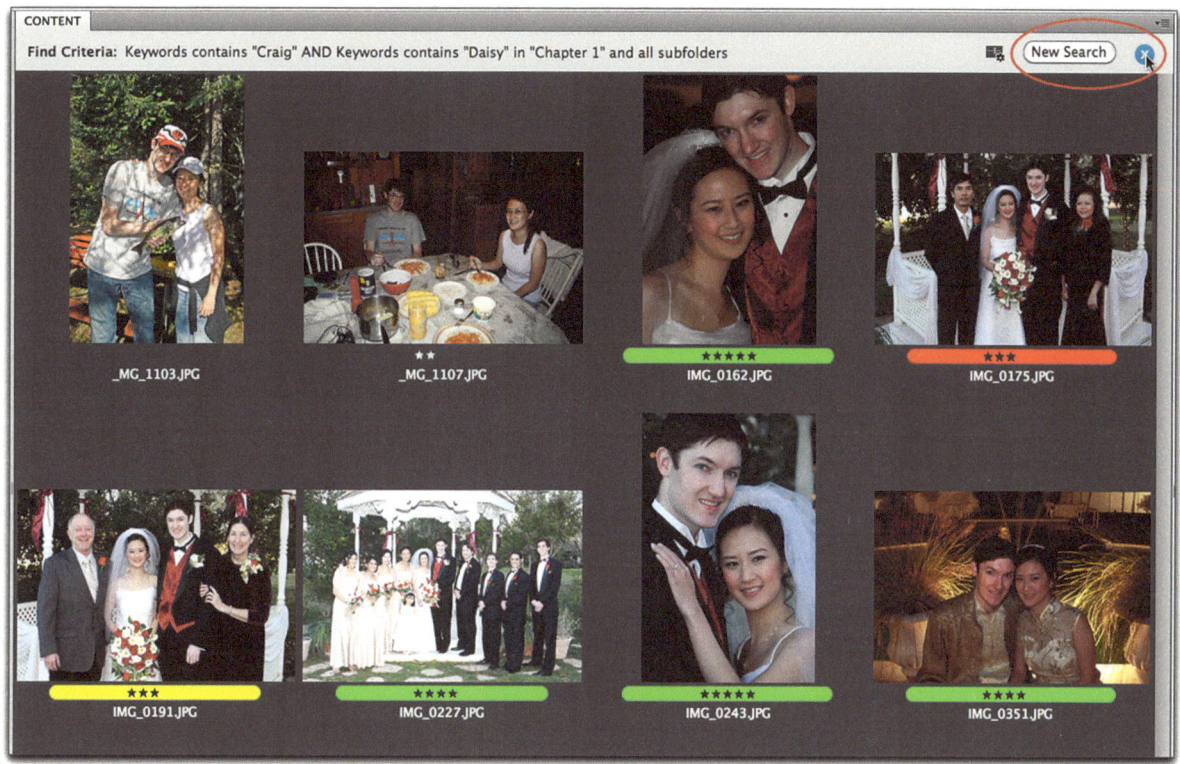

▶ *Cancel a search or create a new search.* To refine your search, click the New Search button on the top right of the Content panel and you will be returned to the search dialog box. To cancel a search, click the X.

▶ *Use the Application bar search field for quick searches.*

Perhaps you noticed the search field to the right of the Application bar. To use it, simply type a word or phrase and hit return or enter. It's convenient and fast, but your search will be restricted to file names and keywords exclusively, using an OR statement match.

Understanding Metadata

It's amazing, almost spooky, how much Bridge knows! It can tell you what digital camera you used to take that photo. Not only that, it can tell you the shutter speed and aperture your camera was set at, whether or not the flash fired, and much more. All of these "secrets" are recorded by your camera as metadata, and Bridge can access that information.

▶ *Examine the Metadata categories.* Click on any image to select it, then click on the Metadata panel to activate it. At the top of the panel are two placards that list pertinent information captured by your camera. The first one displays camera settings, including aperture, shutter speed, metering mode, exposure compensation value, white balance setting and ISO speed. The dashes for exposure compensation shown below indicate that no compensation value was set. The second placard lists image properties: width and height in pixels, file size in megabytes, resolution, color profile and color mode.

Beneath the placards is an assortment of metadata categories. A brief overview of what they contain follows.

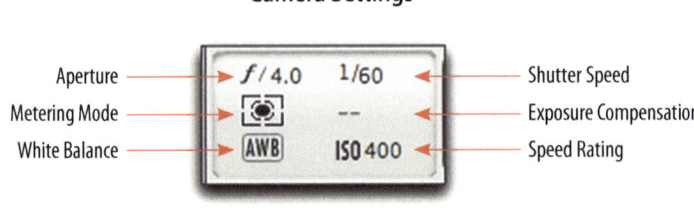

◀ Chapter 1 ▶

File Properties. Includes useful information about your image, including the date it was created and modified, as well as some other important information.

IPTC Core and IPTC Extension. Created by the International Press Telecommunications Council to help photographers and journalists keep track of their images. Click on a value, such as Creator, and Bridge lets you enter your own personalized information. We have actually already done this without even opening up the IPTC panel. Scroll down and you'll see the keywords you assigned earlier in this chapter. We could have entered them here, too. Just wouldn't have been as convenient.

Camera Data (Exif). Gives you specific information about the camera and lens, as well as the settings used to take the photograph. EXIF stands for Exchangeable Image File.

GPS. Displays coordinates of the photograph when recorded by cameras that support this feature.

Audio and Video. These categories allow you to add file information specific to those industries.

DICOM. Used for medical applications.

File Properties Panel

IPTC Panels

▶ *Change Metadata preferences.* No single person needs all the metadata that Bridge offers! If you would like to tone down the number of metadata categories listed in your Metadata panel, choose Preferences from the Metadata flyout menu. In the dialog box that appears, click the check boxes to hide or reveal the values that you would like displayed. Values that are checked appear in the panel.

Metadata preferences can be accessed through the Metadata flyout menu or the main menu.

Check the values that you want displayed in your Metadata panel. Uncheck the ones you don't.

Opening Files from Bridge

Oh, yes. I told you that Bridge was the best way to open files, and we've done just about everything else but! So let's say that you finally found that wonderful image in Bridge, thanks to a keyword search, and now you want to work on it in Photoshop. Opening files couldn't be any easier. Just double-click a thumbnail and you'll find yourself in Photoshop with the file open.

There are a couple of other open options in the main menu. You could specify an application other than Photoshop by using the File>Open With command. You could hunt for files you recently worked on by using the File>Open Recent command. Or you could choose to open a Raw, JPEG or TIFF file in Camera Raw by choosing File>Open in Camera Raw.

▶ *Open an image in Photoshop.* Type 243 in the search field on the right side of the Application bar to find IMG_0243.JPG, a head and shoulders shot of Craig and Daisy, then double-click the thumbnail to open it in Photoshop.

The File menu gives you several options for opening an image above and beyond the standard *Open* command. Shown here are several other applications that could open your file using *Open With*.

24 ◀ An Overview of Bridge & Photoshop ▶

The Photoshop Workspace

When the photo of Daisy and Craig opens, take a moment to look at how Photoshop's workspace is organized. Front and center is the Image window displaying your image. It's surrounded by the Main menu and Options bar above, the Tools panel to the left, and various panels to the right and across the bottom. Let's take a closer look at the various workspace components and see how they interact.

◀ Chapter 1 ▶ 25

▶ *Tools panel.* The Tools panel contains an impressive assortment of Tools common to the graphics trades. Mouse over a tool, and a tool tip appears, revealing its name and displaying a quick video. Most of the tools have a tiny triangle in the bottom right-hand corner. Click and hold one of those tools and a pop-up menu appears, revealing related tools beneath it. Drag through the pop-up menu to select your tool of choice, or Option+Click / Alt+Click the tool icon to cycle through the entire group.

▶ *Options bar.*

The purpose of the Options bar is to let you fine-tune a tool for the specific task at hand. For example, when you select the Type Tool (as shown here), the Options bar lets you set the font, style and size, as well as other attributes. The contents of the Options bar change to reflect the tool currently in use.

▶ *Panels.* A panel distinguishes itself from a bar in that a panel can be moved and a bar cannot. As in Bridge, panels function as little control centrals specializing in specific tasks. Much of your Photoshop work will be accomplished using panels.

At the very top of a panel is a gray bar called a title bar, and below that is a tab containing the panel's name. Beneath the tab is the content area of the panel, and at the bottom of most panels are icons that perform panel related tasks.

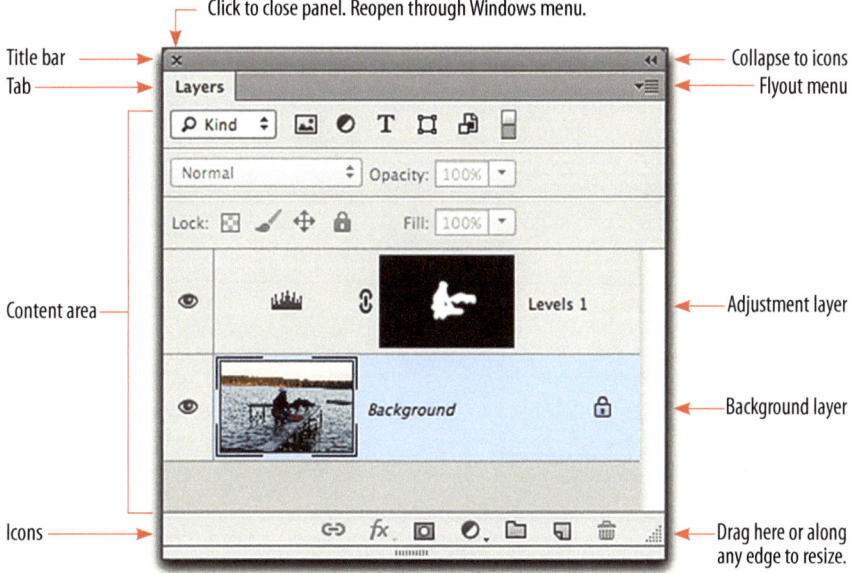

Layers Panel, Expanded View

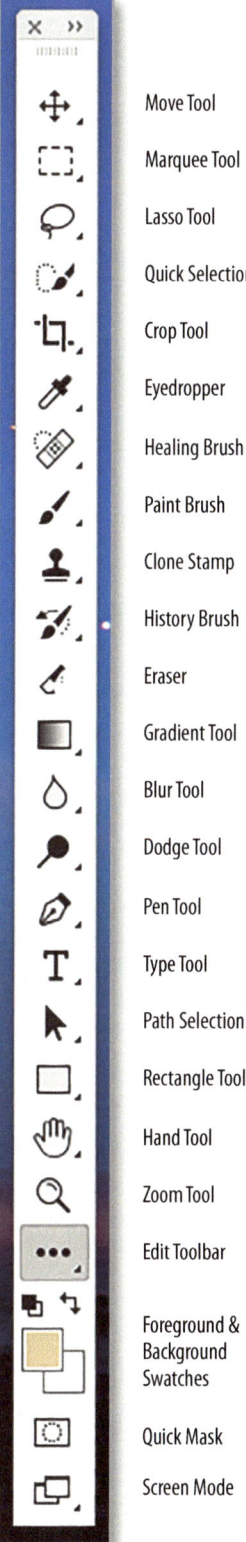

Tools Panel

Collapsed Panel, Icon and Name

Drag edge to collapse further.

Collapsed Panel, Icon Only

All panels can be dragged by their title bars or tabs and placed anywhere on screen. They can also be resized by placing the cursor along an edge or at the bottom right corner and dragging when the double arrow appears.

Panels can be expanded (with content showing) or collapsed (content hidden). To collapse a panel, click the double arrow in the top right corner of the title bar (or double-click anywhere in the title bar). You can adjust a collapsed panel's width to show just an icon, or the panel's name with the icon.

If you don't need a panel, click the X on the top left of the title bar to close it. If you want to reopen it, click Window in the main menu and select it. Visible panels have a check mark beside them in the menu.

▸ *Panel groups.* If you drag one panel and drop it onto another, you form a panel group. A panel group shares one title bar, letting you move, collapse or expand the panels as one. To remove a panel from a group, simply drag it out by its tab.

▸ *Panel docks.* Individual panels and panel groups can be merged into a "super group" called a panel dock. Groups and docks are similar in that they can be moved as one by dragging a title bar. The main difference is that a group contains panels that are stacked on top of each other, which means that you can only see one panel at a time. Panel docks, on the other hand, can grow vertically or horizontally and display multiple panels simultaneously.

To create a panel dock, drag a panel or panel group to the top, bottom or sides of another panel or panel group. Focus on the arrow tip of your cursor as you do this, not on the panels themselves. When the arrow tip touches an edge, a thick blue line appears, indicating a successful dock. To disassemble a panel dock, drag individual panels out by their tabs.

Panel Group

This group consists of the Layers, Channels and Paths panels. Click on a tab to bring a specific panel to the foreground.

Panel Dock

Drag a panel or panel group to the edge of another panel or panel group to create a dock. Release the mouse when you see the blue line.

▶ *Save your own custom workspace.* You'll find that certain project types require a specific selection of Photoshop panels. Close the panels you don't need, then drag the panels you use most often into a convenient location and resize, group and/or dock them in a way that makes sense to you. Then choose Window>Workspace>New Workspace… from the main menu. When the New Workspace dialog box appears, name your custom workspace and select whether or not you want to include keyboard shortcuts, menu or toolbar settings. I highly encourage you to spend time crafting a workspace tailored to your needs. It will save you tons of time throughout the years. Otherwise you'll find yourself wasting a lot of time searching for panels that are hidden somewhere on screen.

▶ *Resetting workspaces.* Photoshop can remember two versions of a workspace: the original as it was saved and the most recently modified version. To see how this works, choose Window>Workspace>Photography, then drag a few panels into a new location. When you have completed that, choose Window>Workspace>Painting then switch right back to the Photography workspace. The panels remain right where you placed them. To get back to the original Photography workspace, choose Window>Workspace>Reset Photography.

Use the New Workspace command to create your own custom workspace. Type a name and specify your capture options in the ensuing dialog box.

Use the Reset command to revert your workspace to its original settings.

Navigating Around an Image

There are three tools towards the bottom of the Tools panel that help you navigate through your image—the Hand Tool, the Rotate View Tool and the Zoom Tool. Actually you really shouldn't use any of them because they can all be replaced with quicker keyboard shortcuts. These tools *do not* change your image in any way. They just change your view of the image on screen. Practice the following image navigation techniques on the Craig and Daisy photo until you feel comfortable with them.

> ▸ *Zoom Tool.* Select the Zoom Tool by clicking on its icon or type Z, then do one of the following.
>
> - Click or Click & Hold in the image window to enlarge your view.
> - Option+Click or Option+Click & Hold (Mac) / Alt+Click or Alt+Click & Hold (PC) to reduce your view.
> - Drag Right to enlarge or Drag Left to reduce. The Scrubby Zoom option must be checked in the Options bar for this to work.
> - Uncheck Scrubby Zoom, then Drag a Marquee around an area to enlarge.

Rather than click on the tool icons themselves, you should really use a keyboard shortcut instead. Hold Command+Space (Mac) or Control+Space (PC) to temporarily access the Zoom Tool, then proceed with any of the actions above. When you release your shortcut keys, you return to the tool that you were using before. This is a very important keyboard shortcut to know, because it is the only way to access the Zoom Tool during certain operations, such as scaling, rotating or from within many dialog boxes.

You can also press and hold the Z key to access the Zoom Tool temporarily, but that method doesn't work from within dialog boxes or while scaling, etc.

The Scrubby Zoom option enables the Drag Right and Drag Left function. Uncheck it if you want to drag a marquee around the area to be enlarged.

▶ *Hand Tool.* The Hand Tool is the easiest way to reposition an image that is too large to fit on screen. Access it by holding the spacebar or by clicking on its icon or typing H. Then place your cursor on the image and drag to move it.

If you press and hold the H key then Click and Hold with your mouse, you can access the handy Bird's Eye View function. The image zooms out to fit on screen and a zoom marquee appears. Drag the marquee to a different location and release the mouse to return to your original magnification.

Drag the Bird's Eye View marquee to select a targeted segment of your image. When the mouse is released, the area inside the marquee enlarges to fill the screen. (Areas of this photo have been darkened for clarification purposes only.)

▶ *Rotate View Tool.* The Rotate View Tool can be accessed by clicking on its icon (which is under the Hand Tool) or by holding the R key. When the Rotate cursor appears, simply Drag to rotate your view or Shift+Drag to rotate in 15° increments. Press Escape when you want to return to normal view. It's important to note that the Rotate View Tool does not really rotate your image. It just changes your on-screen view. Use the Image>Image Rotation command if you truly want to rotate your image.

Rotate View lets you change your on-screen view without actually rotating the image.

Speaking Photoshop...

Changing Interface Appearance

Perhaps you've noticed that the images in the book look brighter than what you see on screen. The default appearance of Bridge and Photoshop looks a little bleak to me and it's difficult to read the reverse type. Fortunately Adobe lets you change that in the Preferences settings. Type *Command+K* (Mac) or *Control+K* (PC) to access the Preferences dialog box, then click on the Interface category. To the right you will find Appearance settings which let you choose a color theme or tweak individual attributes. I find that the color theme on the far right is the most attractive and legible, but experiment with the settings and choose the one that most appeals to you.

The Bridge Appearance settings (left) and Photoshop Appearance settings (below) let you adjust the brightness of your workspace.

Final Thoughts

Sometimes your biggest challenge hits you head on when you begin to work on a project. You have a few simple corrections to make—you've done it a million times—but you can't locate the darn photo. In the world of obscure digital photography file names, in a diverse business environment where coworkers each have their own naming conventions, at a time when society bombards us with a surplus of information, it's really nice to have a program like Bridge to help us keep things straight.

More than a simple way to view images, Bridge also serves as a database, letting you assign labels, ratings and keywords, then retrieve files quickly by sorting or filtering. You can even search for important metadata recorded by your camera. So go ahead and work on that project. Get it done! Because if you have been keeping up with your file management using Bridge, you'll be able to find that darn photo quickly and efficiently.

Another key to working efficiently is to use keyboard shortcuts and make good use of the options Photoshop gives you in creating a customized workspace. Drag panels where you need them, place them in logical groups or docks, hide the ones you don't need, and save your own custom workspace. That way you won't spend precious time looking for a panel when you could be editing your image.

◂ *Resizing, Cropping & Transforming* ▸

2

Caron Gray

Topics

- Differentiate among image size, canvas size and resolution.
- Determine the proper resolution for offset printing, desktop printing and the web.
- Know when to apply resampling to an image.
- Use Canvas Size to add a border or crop an image.
- Crop and straighten an image using the Crop tool.
- Scale, rotate, skew, warp and adjust perspective using Transform commands.

Preview

Size matters when it comes to Photoshop documents. But what is the best size for your image and how is size actually defined? Is it possible to have a file that is too large or too small? What are the ramifications of having a file that is not the proper size? And if the image size is not what you need, which methods can you use to adjust it? All these questions and more will be answered in Chapter 2, *Resizing, Cropping and Transforming*.

Uncovering the Mysteries of Image Size

When we talk about image size, what do we mean? Is it the size of the image as viewed on screen? Is it the size of the image when printed on paper? Is it the file size in megabytes? Is it the total number of pixels? Is it the resolution as measured in pixels per inch?

Yes.

No wonder everybody seems to be confused about this topic. There are a lot of angles to keep straight. Unfortunately I can't give you a "one size fits all" answer, so let's take a closer look at these components and discover how and where they are important, and how and where they are not.

▸ *Image construction.* Launch Bridge and find the photo titled *Fox.jpg* and double-click it to open it in Photoshop. What you have before you is a cute picture (taken by Caron Gray, a former WCTC student of mine) of a fox standing in the grass, right? Well, not exactly.

At a normal magnification you can't tell that the photo of this fox is really a series of individual pixels.

Access the Zoom tool by holding Command+Space (Mac) or Control+Space (PC) and dragging to the right until you reach the maximum magnification. If your drag didn't work, it's because you have to check the Scrubby Zoom option in the Zoom tool's Options bar. You can verify your magnification in one of two places: in the Status bar at the bottom left, or in the Title bar at the top.

Now you see what a Photoshop document truly contains—a grid work of tiny squares called pixels, short for picture elements. It's only when you zoom out that these pixels create the illusion of a fox standing in the grass. Take a look at the individual pixels—each one contains a single color. Pixels can never be split up to contain more than one color.

Images that are composed of pixels are called raster images, and Photoshop is the king of raster images. Images created using Adobe Illustrator, on the other hand, are vector-based—defined by mathematical formulas, not individual pixels. In actuality, Photoshop has limited vector capabilities and Illustrator has limited raster abilities, but those are not the programs' strengths.

Photoshop's grid work of pixels is easy to see at 3200% magnification.

▶ *Image Size dialog box.* Return your fox picture to a more reasonable magnification by typing Command+0 (Mac) or Control+0 (PC) to "fit on screen." Then proceed to the Image Size dialog box by choosing Image>Image Size from the Main menu, or, better yet, typing Option+Command+I (Mac) or Alt+Control+I (PC).

The Image Size dialog box lets you: 1) Change the actual image size by altering the number of pixels and/or 2) Change the printout size by changing the resolution. For now, make sure that Resample is checked.

A. Preview Window
The preview window lets you monitor image quality. You can change its size by dragging the lower right-hand corner to resize the dialog box.

B. Actual Size
The *Image Size* in megabytes and *Dimensions* in pixels represent the true size of the image. The more pixels Photoshop has to remember, the larger the file size.

C. Output Size
Fit To, *Width*, *Height* and *Resolution* let you resize your image to various monitor or printout dimensions. The printout size is determined by dividing the number of pixels by the resolution.

D. Resample
When checked, *Resample* gives Photoshop permission to change the total number of pixels in the image. If unchecked, only the printout size can be changed.

▶ Actual Size—Image Size and Dimensions

The first two settings in the Image Size dialog box, *Image Size* and *Dimensions*, are the only two that truly affect the size of the image itself. By default, *Dimensions* are displayed in pixels, and with good reason. Pixels are the one and only unit of measure that has a direct effect on the actual image size. The more pixels Photoshop has to remember, the bigger the file size. If you change the number of pixels, you *always* change the file size. That's not true with other units of measure.

Click the down arrow and you can view your image in percent, inches, centimeters, millimeters, points or picas. These parameters are useful if you want to know how large the image would be if printed on paper.

Image size dimensions can be viewed in various parameters.

▶ Output Size—Fit To, Width, Height and Resolution

This next section lets you change the initial image size to fit typical monitor or paper sizes. Click the Fit To popup menu and cycle through the various presets. Do you see how the settings change throughout the dialog box? Choose Original Size to restore values to their original settings.

If one of the *Fit To* presets doesn't meet your needs, just type a number directly into any one of the three text fields. Try changing the Width, Height and Resolution values and watch what happens. If you make your image larger, the total number of pixels grows, and so does the file size. If you make it smaller, the number of pixels and file size both shrink.

The Fit To popup menu resizes your image to fit on popular monitor or paper sizes.

For now, let's say you want your image to be exactly 600 pixels wide for a web page you're working on. Select Pixels for the Width popup menu and type 600 into the text field. Immediately Photoshop creates a 600 x 400 pixel image that has shrunk in size to 703.1K, down from the original 22.8M. Click OK to accept that change, and watch how much smaller your image becomes as you exit the dialog box.

Now let's take a closer look at the role of *Resolution*. Undo the image size change by typing Command+Z on the Mac or Control+Z on the PC, then return to the Image Size dialog box.

Reducing the number of pixels results in a smaller Image Size.

The *Resolution* field deals strictly with printout sizes. Select Inches in the Width popup menu, and you'll notice that our image is currently 48" wide. What does that have to do with *Resolution*?

When you invoke the print command, Photoshop sends all of the image's pixels to the printer. The printer then asks how closely it should space those pixels, and Photoshop responds with the *Resolution* value. In our case, when the 3456 pixel width is divided by the 72 pixels/inch resolution, it results in a printout that is 48 inches wide. If we wanted to change the printout size, we could do one of two things:

 1) Change the total number of pixels that the printer has to print, or

 2) Change the spacing of the pixels (resolution).

The method we choose is determined by the *Resample* check box.

▶ *Resample*

Uncheck Resample and notice how the Image Size dialog box changes. The down arrow for the *Dimensions* setting is no longer accessible, and you can no longer select *Pixels* in the *Width* or *Height* settings. Why is this?

Resample, when checked, gives Photoshop permission to add or delete pixels as you change your image size settings. As mentioned earlier, changing the total number of pixels is the one and only way to change an image's *Actual Size*. The popup menu to the right of *Resample* lets you choose the interpolation method that Photoshop uses as it adds or deletes pixels. I recommend the *Automatic* setting, which lets Photoshop choose the best method for the circumstances.

When Resample is unchecked, pixels cannot be changed.

But when *Resample* is unchecked, Photoshop is not allowed to change the number of pixels, which means that the *Actual Size* also remains unchanged. Nevertheless we still *can* change the printout size, and we can do that by altering the resolution value that tells the printer how closely to space the pixels. Other than this one piece of computer code, our Photoshop file remains untouched. Let's try it.

With Resample unchecked, change Resolution to 300 pixels/inch—the value used most often for professional quality printing—and the printout shrinks to 11.52 x 7.68 inches. The number of pixels hasn't changed at all, but they're spaced closer together on paper for sharper print detail. Click OK and your screen view of the fox also remains unchanged.

Changing the resolution from 72 to 300 ppi reduces the printout width from 48 to 11.52 inches.

Speaking Photoshop…

What is the best resolution?

Resolution really only affects how closely pixels are spaced when they are printed on paper. That spacing, of course, is what determines the final print size, but it also has an effect on the quality of the printout. If your pixels are too spread out, the image becomes blurry and pixelated. If they are too close, you are adding unnecessary file size without improving the image. So what is that perfect value, the one that gives you all the quality you can use without bloating the file size? It all depends on the equipment and paper you are using.

Professional Quality Print

If you are preparing a color or grayscale image bound for professional offset printing, the resolution value that we use most often is 300 ppi. It's large enough to accommodate most situations, yet not too large to be unwieldy. Nevertheless, there is an accepted formula that lets you determine the exact resolution you need, but you have to know what paper stock you are using first. Just as a Photoshop image is made from a raster of tiny pixels, a four-color offset printed piece is made from a pattern of tiny cyan, magenta, yellow and black dots. The spacing of those dots is determined by the line screen value, and it's measured in lines per inch, or lpi.

Ink droplets sit politely on top of a good coated paper stock, and you can place those dots close to one another for sharp detail. Ink droplets on uncoated newspaper stock, on the other hand, absorb and spread out into the porous texture. If the dots are too close together, they run into one another and you get a muddy effect. Typical line screen values for coated paper are 133, 150 or 200 lpi. Newspaper stock requires coarser line screens of 85 to 100 lpi. Now the formula…

 Image Resolution (ppi) = 1½ to 2 x Line Screen (lpi)

If our image was destined to be printed on newspaper stock using 100 lpi, then our Photoshop resolution should be 1½ to 2 times that value, or 150 to 200 ppi. Using that same formula, you can see that a 300 ppi image is sufficient for print jobs run at 150 to 200 lpi. When in doubt, go with a higher resolution. Yes, your file size might be a little bigger than necessary, but it's better to err on the side of quality.

Black-on-white line art, such as a logo, is a completely different animal. For those images, use an image resolution of 1200 ppi in Bitmap mode to maintain crisp, unpixelated edges.

Desktop Printers

Laser printers and inkjet printers don't need as much detail as professional offset printing equipment. A resolution of 200 ppi is all you need.

Web Images

Accepted internet resolution is just 72 ppi, a value that harkens back to the density of pixels used in early computer monitors. In reality, browsers don't pay attention to Photoshop image resolution settings anyway—that's just for printouts. Instead, a web image is always mapped on a one-to-one basis of one image pixel to one monitor pixel. In Photoshop if you choose *View>100% (Command+1 on the Mac or Control+1 on the PC)*, you will see your image at the size it will appear on the web.

▶ *Scale Styles.*

Click the gear icon at the top right of the dialog box to reveal the *Scale Styles* option. When checked, special effects, such as a drop shadow, resize along with the image. Leave it checked to retain a natural appearance.

▶ *Constrain Proportions.*

Constrain Proportions keeps width and height values in proportion as you resize. Click and break the link between Width and Height only of you want to distort your image as you resize it.

▶ *Accept your new image size—or not.*

Cancel becomes Reset when you hold Option (Mac) or Alt (PC).

After you are done changing your image size settings, you can do one of three things:

- Press Return (Mac), Enter (PC), or click OK to apply the changes.
- Click Cancel to abort the changes and exit the dialog box.
- Hold Option (Mac) or Alt (PC) and click Cancel, which changes to Reset, to remain in the dialog box but restore all settings to their original values. You can also accomplish the same thing by choosing Original Size from the Fit To popup menu.

For now Option+Click (Mac) or Alt+Click (PC) on Reset to restore the values back to their original settings, because that will set us up for the next exercise.

▸ *Resize an image for use in InDesign.* Let's say we wanted to resize our fox to 6 inches wide and import it into Adobe InDesign for a brochure we're working on. We plan on printing it professionally, so we need a resolution of 300 ppi.

- Make sure that Resample is not checked, and type 300 in the Resolution field. We haven't changed the number of pixels in our image—we are just ensuring that we have good print detail on paper. The new width shrinks from 48 inches to 11.52 inches, better but still too large. We'll need to get rid of some pixels.

- Check Resample to grant Photoshop permission to physically remove pixels. Then change the Width to 6 inches. Dimensions should now show a width of 1800 pixels, because that's how many pixels it takes to print a 6 inch wide image at 300 pixels per inch. When you change one value, Photoshop calculates all of the other values accordingly.

- Press Return (Mac) or Enter (PC) to accept the changes and exit the dialog box.

Your image will now import into InDesign at 6 inches wide. It's smaller on screen because it has fewer pixels than before. Also it's just 6.18 megabytes, down from its original size of 22.8 megabytes. Granted, you could have left the fox large and scaled it down in InDesign, but then your would have been processing a 22.8 megabyte file, when you can realistically use only 6.18 megabytes of that data.

Step 1: Set the Resolution
• Uncheck Resample to change the resolution without changing the total pixels.
• Enter a resolution of 300 ppi to meet professional quality printing standards.

Step 2: Resize the Image
• Check Resample to allow Photoshop to change the number of pixels.
• Type your desired width. Photoshop changes all other values accordingly.

Canvas Size

Canvas size and image size are sometimes confused, but think of it this way. Using our previous photo as an example, image size refers to the actual size of the fox. Canvas size refers to the size of the paper, or canvas, that the fox is displayed on.

▶ *Access the Canvas Size dialog box.* Go to Bridge—Option+Command+O (Mac) or Alt+Control+O (PC)—and open *Grand Tetons.jpg* by double-clicking its thumbnail. Once again we have a beautiful Caron Gray photo, this one taken of, naturally, the Grand Tetons.

Caron Gray

Choose Image>Canvas Size from the Main menu, or type Option+Command+C (Mac) or Alt+Control+C (PC) to open the Canvas Size dialog box. There you will see two major categories: current size, which cannot be edited, and new size, which can.

Canvas Size lets you change the width and height of the "canvas" that your image is sitting on without changing the actual size of the image itself.

▶ *Add a border using Canvas Size.* Let's say we wanted to expand our canvas to include a one inch border around the entire image. Type 12 in the Width field and choose Inches from the popup menu. That gives us a new width that is two inches larger than the original, or one inch on each side.

As easy as it was to add 10 + 2, we could have let Photoshop do the math for us instead. Click the Relative check box and notice how the width value changes from 12 to 2 inches. Relative lets you specify how much you want to *change* the canvas instead of figuring out its final dimensions. Type 2 in the Height field to add an inch to the top and an inch to the bottom.

The Anchor proxy immediately below the width and height fields lets you determine where the extra canvas is going to be placed relative to the image. The image itself is represented by the circle in the middle. The arrows represent the directions that the canvas will expand. Click on the various cells and observe how the circle and arrows adjust, but then click back on the center cell, because we want our image to be centered inside the border.

With Relative unchecked, the width and height refer to the overall dimensions. With Relative checked, the width and height refer to the change in dimensions.

The final step is to select a canvas extension color from the popup menu. If you don't like one of the predefined colors, you can specify a custom color by choosing Other from the popup menu or by clicking the tiny color swatch. Click OK when you are finished to apply your settings and exit the Canvas Size dialog box. The landscape should now be framed with a one inch border using the color that you chose.

◀ Chapter 2 ▶ 43

The Grand Tetons photo now has a one-inch black matte around it, thanks to the Canvas Size dialog box.

▶ *Add more canvas to the bottom.* What we have looks very nice, but let's add a line of type below the photo to let people know that it was taken at the Grand Tetons. Go to the Canvas Size dialog box, make sure that Relative is checked, enter .5 inches in the Height field, and click the top center cell of the Anchor proxy. Use the same canvas extension color that you did before, then click OK. That gives us some breathing room for the type.

▸ *Add a caption to the matte.*

Click the Type tool or type T. In the Options bar, choose a font, a size, center alignment and a color for your type. I chose Apple Chancery, 36 point, and yellow, but select whatever appeals to you.

Now click once in the center of the border region below the photo and when the blinking cursor appears, type The Grand Tetons. If you want to change one of the type options, simply drag your cursor over the letters to select them, then choose a different option from the Options bar. Finally, select the Move tool and drag your type to its final location.

By adding extra canvas just to the bottom, we were able to make room for our headline.

▶ *Reduce the canvas size.*

Open *Foxes Playing.jpg*, yet another creation of Caron Gray. Type Option+Command+C (Mac) or Alt+Control+C (PC) to access the Canvas Size dialog box and, with Relative checked, enter –3 inches in the width field and –1 inch in the height field. Negative values reduce the canvas size and positive values increase it when Relative is checked. Select the top center proxy cell to anchor the image to the top, click OK, then Proceed to dismiss the clipping warning that follows. Although the Canvas Size dialog box can be used to crop an image, it's usually easier to use the Crop tool. We'll talk about that next.

The Crop Tool

Using the Canvas Size dialog box to crop an image has its limitations. It works great if you know that you want to trim off a given amount on one or more sides, but the Crop tool lets you do much more and in a more intuitive fashion.

▶ *Crop an image with unconstrained flexibility.* Reopen *Foxes Playing.jpg* if you closed it. If not, type Command+Z (Mac) or Control+Z (PC) to undo your canvas size crop. Type C or click the Crop tool to activate it.

Place your cursor over the image somewhere to the top left of the foxes and drag diagonally towards the bottom right. When you release your mouse, you will see a bounding box with four tiny squares in the corners called corner handles. Drag any one of those corner handles or any edge to adjust your bounding box further. Place your cursor inside the box and drag to relocate the entire crop area.

Drag a corner handle or edge to resize the crop bounding box.

There are four different ways to drag a corner handle.

- Drag to form a bounding box of any proportion.
- Shift+Drag to maintain your width-to-height aspect ratio.
- Option+Drag (Mac) or Alt+Drag (PC) to adjust all edges symmetrically from the center out.
- Shift+Option+Drag (Mac) or Shift+Alt+Drag (PC) to maintain your aspect ratio *and* adjust edges from the center out.

As soon as you initiate a crop, you enter *crop mode*, and you won't be allowed to proceed with other edits until you make a decision as to whether or not you want to apply the crop. You have three options:

- Click the Check Mark icon in the Options bar, or, better yet, press Return or Enter to accept the crop.
- Click the Slashed Circle in the Options bar or press Escape to abort the crop and exit crop mode.
- Click the Rotating Arrow in the Options bar to reset the bounding box to the image's outer edges and remain in crop mode.

Experiment with these cropping techniques until you feel comfortable with them, then choose a nice tight cropping of the two foxes and hit Return or Enter to accept the crop.

Reset, Abort and Accept crop options

▶ *Crop an image constrained to a specific proportion.* Revert the foxes image back to its original state. Choose Window>History to display the History panel and click the image thumbnail at the top to revert the photo to the way it was when you first opened it. Make sure the Crop tool is still selected.

Let's say you wanted to prepare this photo for an 8" x 10" enlargement. The first option in the Options bar lets you do just that. Click the popup menu, currently titled *Ratio*, to reveal a number of popular print sizes. Choose 4 : 5 (8 : 10) and a bounding box appears, ready to be adjusted. Drag or Option/Alt+Drag a corner handle to zero in on the portion of the image that you want to keep. Hit Return or Enter, and the cropped image is now proportionally correct for an 8" x 10" or 4" x 5" print.

Click the image thumbnail layer to revert a file to its original state.

Notice that 4 and 5 now appear in the Options bar just to the right of the popup menu. You can manually enter any values you want into those text fields. If it's a proportion that you use repeatedly, choose New Crop Preset to add it as a choice in the popup menu. The double arrow icon between the two text fields lets you swap width and height values, changing from landscape to portrait and back again.

Click the double arrows to toggle between portrait and landscape.

Choose a predefined crop proportion. *New Crop Preset* lets you save your own custom crop settings.

Choose *W x H x Resolution* to access functions from the Image Size dialog box.

▶ *Resize your image as you crop.*

If you want, you can access portions of the Image Size dialog box as you crop your image. Choose W x H x Resolution from the popup menu in the Options bar, then do one of the following:

1) Enter values into the Width and Height fields only, leaving Resolution blank. When you accept the crop, your image will be sized as specified, and your resolution will change to accommodate the new size. It's as if we had gone to the Image Size dialog box and resized the image with Resample unchecked. Pixels will be spread out or squeezed during the printing process to achieve the printout size but the pixels themselves remain unchanged.

Leave the Resolution field blank to prevent Photoshop from resampling pixels.

2) Enter values into all three fields—Width, Height and Resolution. When you complete the crop, your image will be that exact size and resolution. In this case, Photoshop will add or delete pixels to make the change happen. It's as if we had the Resample option checked in the Image Size dialog box.

Filling in dimension and resolution values will result in resampling.

Clear erases any values you have in the Options bar.

▶ *Clear settings.*

If you want your Crop tool to operate in an unconstrained fashion again, click Clear to delete values from the Width, Height and Resolution fields.

▶ *Straighten an image with the Crop tool.*

Go to Bridge and open *Sunset.jpg*—a photo of me rowing on Lake Michigan with my brother-in-law and son. Pretty nice, but it has one flaw that needs to be corrected. The horizon line is tilting downward. The Crop tool lets us fix that in seconds.

Click the Straighten icon in the Options bar, place your cursor over the image, then drag a line right along the horizon. A bounding box forms parallel to the line you drew, and the image will rotate accordingly when you hit Return or Enter. The straighten option works with any horizontal or vertical reference that you can identify in an image. You can also rotate images by placing your cursor outside the bounding box and dragging with your mouse.

Drag along a horizontal or vertical reference line to crop and straighten a photo.

▶ *Other Crop tool options.*

Overlay Options, the first icon, lets you choose from various overlays meant to assist you in your cropping decisions. Cycle through them and pick the one that you find most helpful. In addition you can choose *Auto Overlay* (only displays the overlay while you are resizing a bounding box), *Always Show Overlay*, or *Never Show Overlay*.

Additional Crop Options, the gear icon, offers the following:

- *Use Classic Mode.* An older version of the Crop Tool.
- *Show Cropped Area.* Lets you see outside the bounding box.
- *Auto Center Preview.* Keeps the bounding box centered.
- *Enable Crop Shield.* Hides the area to be cropped with a color of your choice.

Delete Cropped Pixels determines whether or not the area outside the bounding box is deleted or just hidden beyond the boundaries of the image in a *big layer*. With the latter scenario, you could slide the layer with the Move tool to access the pixels outside of the visible image area.

Content Aware is useful if you use the Crop tool to rotate an image or make it larger. It automatically fills in any missing pieces along the edge.

Overlay Options
Choose from various overlay options to help you crop precisely.

Additional Crop Options
Specify if your bounding box is centered and pick the color of the shield surrounding the bounding box.

Transforming

There are many ways you can transform an image or part of an image. You can scale it, rotate it, skew it, distort it, change its perspective, warp it or flip it. These commands are all available as separate options under the Edit>Transform menu, but they can also be done using the Edit>Free Transform command, as long as you know a few keyboard shortcuts.

▶ *Transforming images.* Go to Bridge and open *Wine Glass.psd*, a photo taken by Phyllis Bankier, a former WCTC student of mine. Locate your Layers panel, probably on the bottom right of your screen. If you don't see it, choose Window>Layers to make it visible. This photo is a layered image file consisting of a Background and a layer named Glass 1. Transform commands cannot alter the Background, but they can alter a layer such as our Glass 1. If you want to perform a transformation on the Background, you either have to convert it to a normal layer by double-clicking it, or you have to make a selection and transform just that selected area.

A selected layer is highlighted.

Click Glass 1 in the Layers panel—we want the layer to be highlighted, indicating that it is selected. Then choose Edit>Transform>Scale to bring up the transform bounding box. Does it look familiar? It should. It operates much like the bounding box for the Crop tool, and the corner handles function in the same way:

- Drag to scale in any proportion.
- Shift+Drag to maintain your width-to-height aspect ratio (the best choice unless you want to distort your image).
- Option+Drag (Mac) or Alt+Drag (PC) to scale from the center out.
- Shift+Option+Drag (Mac) or Shift+Alt+Drag (PC) to maintain your aspect ratio *and* scale from the center.

The bounding box for the transform commands works very similarly to the bounding box for the Crop tool, except you are scaling or reshaping the selected image instead of defining a crop area.

▶ *Accepting or aborting the transformation.*

The similarity to the Crop tool doesn't end with the bounding box. You can't perform other edits until you hit Return or Enter to accept the transformation or Escape to abort it. However, you *can* access multiple transform commands in one operation. For example, you can choose Edit>Transform>Scale, then Edit>Transform>Rotate, then Edit>Transform>Skew and so on—all before you hit Return to complete the transformation.

Go ahead and give the transform commands a spin. Try dragging all of the handles with and without Option and Shift, try dragging inside the bounding box, and try dragging outside of the bounding box. It won't take long before you get the feel of it. Try completing numerical transformations, too, by typing values in the Options bar.

The Transform commands can be performed one after another without leaving transform mode. Always do multiple transformations in one operation if possible. Not only does it give you more flexibility while performing the edits, it also helps preserve the quality of the image because pixels are only resampled once.

Transform Options Bar

Reference Pt. | Vertical Position | Vertical Scale | Horizontal Skew | Interpolation Method | Cancel

Horizontal Position | Horizontal Scale | Rotation | Vertical Skew | Warp Mode | Commit

▶ *Using the Free Transform command.*

Scale, rotate, skew, distort, perspective and warp can all be accomplished using the Free Transform command. Here's how.

Type Command+T (Mac) or Control+T (PC) to enter transform mode, then choose from the following to activate a transform function.

- Scale—Use the exact same methods that were discussed earlier using Edit>Transform>Scale.
- Rotate—Place the cursor outside of the bounding box and Drag or Shift+Drag. Choose a Reference Point in the Options bar or Option+Click (Mac) / Alt+Click (PC) a specific spot in the image to set your own custom rotation point.
- Skew—Command+Drag (Mac) or Control+Drag (PC) a side handle vertically or horizontally. Add the Option or Alt key to skew symmetrically.
- Distort—Command+Drag (Mac) or Control+Drag (PC) a corner handle.
- Perspective—Shift+Option+Command+Drag (Mac) or Shift+Alt+Control+Drag a corner handle.
- Warp—Click Warp icon in Options bar. Drag directional handles.

You can even switch back and forth between the menu transform functions and Free transform if you like.

Rotate
Drag outside bounding box.

Skew
Command+Drag (Mac) or Control+Drag (PC) a side handle.

Perspective
Shift+Opt+Cmd+Drag (Mac) or Shift+Alt+Control+Drag (PC) a corner handle.

Distort
Command+Drag (Mac) or Control+Drag (PC) a corner handle.

Warp
Click on Warp icon. Drag one or more handles.

The final Layers panel has one layer for each glass.

▶ *Use Transform Again to repeat your last transformation.*

Go to the History panel and click the thumbnail at the top to return to the original Wine Glass photo. We're going to create a group of three wine glasses in large, medium and small sizes.

Make sure that the Glass 1 layer is selected. Then type V, or click the Move tool, and drag the glass over to the left side. From the Layers panel flyout menu, choose Duplicate Layer and name it Glass 2. Make sure that the Glass 2 layer is now selected, then Shift+Drag the glass towards the center with the Move tool. The shift key keeps Glass 2 from moving up or down.

Type Command+T (Mac) or Control+T (PC) to enter free transform mode, then Shift+Drag the top right corner handle to scale the glass down. Press Return/Enter to accept the scale. That's our medium size glass.

Now duplicate the Glass 2 layer, name it Glass 3 and Shift+Drag it to the right with the Move tool, so you can see all three glasses. Finally choose Edit>Transform>Again to reapply the exact same scale that you did to glass 2.

The smallest glass was created by using Transform Again on a duplicate layer of the midsize glass.

▶ *Correcting keystoning using distort.*

Phyllis Bankier

Go to Bridge and open *Pena Palace.jpg*. This beautiful photo, taken by Phyllis Bankier while in Portugal, exhibits an exaggerated perspective called keystoning. It's a common problem with wide angle lenses, but fortunately it's fairly easy to correct using distort.

Double-click the Background in the Layers panel to turn it into a regular layer. Name it if you want, or leave its name as Layer 0. Type Command+T (Mac) or Control+T (PC) to enter Free Transformation mode. Although the transform bounding box is there, it's difficult to work with because it's so close to the edge. Enlarge the content window by dragging the resize box (not the transform corner handle) on the bottom right corner to reveal gray pasteboard around the image. That exposes the bounding box and also gives us a little room to work with.

It's often advantageous to enlarge your window when working with a bounding box.

Hold Command (Mac) or Control (PC) and drag the top left corner point to the left. Add the Shift key to keep from wandering up or down as you drag. Notice how the verticals become more realistic looking. But there's an undesirable side effect, too—the buildings soon look a little too fat. Counteract that by Command or Control dragging the bottom left corner handle to the right. Continue tweaking the image by Command or Control dragging corner handles until you achieve a natural look. Then accept the transformation by hitting Return or Enter.

Finally, choose the Crop tool and crop off any blank wedges that you've created along the sides. A beautiful photo now made even more beautiful.

Final Thoughts

There's a lot to consider when working with an image's size. There's the actual image size, which is determined largely by how many pixels Photoshop has to remember. Understandably, more pixels translates to a larger file size. The first two settings in the Image Size dialog box determine the image's actual size.

And then there's the physical dimension of the image when printed on paper. The resolution of your image plays a role here. The tighter the pixels are placed together, the smaller the print size is on paper and vice versa. Make sure image resolution is high enough for the intended output device. Professional printing typically uses a resolution of 300 pixels per inch. A laser printer or inkjet printer performs well with 200 pixels per inch. And web images are typically set to 72 pixels per inch.

There are many ways to change image size. Use the Image Size dialog box to resize an entire image. The Canvas Size dialog lets you add or delete canvas area around the image without changing the size of the image itself. And the Crop tool is a convenient way to resize your image by deleting portions of it or even working hand in hand with the image size dialog box to resample it. Finally, the Transform commands let you resize, rotate, skew, distort, warp or adjust perspective of a selected portion of an image.

3

◂ *Creating Selections* ▸

Phyllis Bankier

Topics

- Create geometric selections using the Marquee tools.
- Draw freehand selections using the Lasso tool.
- Make straight line selections using the Polygonal Lasso tool.
- Create edge-based selections using the Magnetic Lasso or Quick Selection tools.
- Select pixels based on color using the Magic Wand tool or the Color Range command.
- Modify selections to create more natural looking edges.

Preview

Sometimes you want to work with an entire image. Resizing, cropping, rotating and adding canvas are all examples of edits that affect an entire file. But quite often you want to edit just part of an image. Perhaps you want to brighten your main subject and darken the rest for a special effect. Maybe you want to change the color of someone's shirt without affecting the color elsewhere. Or maybe you want to place your subject into a more compelling background. The key to success for any of these scenarios is to start with a well crafted selection. If the selection you use is poor, you'll never end up with a believable result, regardless of how well you execute the rest of the operation.

Photoshop has a wide range of tools and commands dedicated to making clean, believable selections. As you work through the exercises in this chapter, you will discover that all of the methods have their strengths and weaknesses. As a Photoshop user, your job is to make sure that you choose the best solution for the job at hand.

ns
The Selection Tools

The Selection tools are located near the top of the Tools panel in the second, third and fourth slots. The tool you choose depends entirely on the task at hand. Some tools are great for geometric shapes, others are best for irregular shapes, and some create a selection based on luminosity values.

Marquee Selection Tools

▶ *Create a blank document.* Choose File>New to bring up the New Document dialog box. Choose Photo from the Preset menu and Landscape, 5 x 7 from the Size menu. It doesn't really matter which file size you choose for this exercise, but this proportion fits nicely on computer monitors. Click Create.

▶ *Make rectangular or elliptical selections.*

Type M or click on the Rectangular Marquee tool and make sure that the options in your Options bar are set as shown above. Then position your cursor over the canvas and drag diagonally from left to right to form a rectangle. When you release your mouse, you'll see what appears to be a series of dashed lines surrounding the area that you selected. Actually, the dashes are a host of marching ants—at least that's what we always call them in Photoshop circles.

Click and hold on the Rectangular Marquee tool and select the Elliptical Marquee tool from the popup menu that appears. You can also type Shift+M to toggle back and forth between the Rectangular and Elliptical Marquee tools. Drag in the canvas area with the Elliptical Marquee. It works just like the Rectangular Marquee, except that you get an ellipse instead of a rectangle.

Use one of the Marquee tools to create rectangular or elliptical selections. Tool tips help you gauge dimensions.

- *Use keyboard shortcuts to customize your selection.* The same keyboard shortcuts that we learned for the Crop tool and Free Transform command apply to marquee selections as well.

 - Drag to create a selection of any proportion.
 - Shift+Drag to maintain a one-to-one aspect ratio, resulting in a perfect square or circle.
 - Option+Drag (Mac) or Alt+Drag (PC) to create a selection from the center out.
 - Shift+Option+Drag (Mac) or Shift+Alt+Drag (PC) to create a perfect square or circle from the center out.
 - Hold Space as you drag to reposition your selection. Release it to continue resizing the selection.

- *Test the selection.* Return to the Rectangular Marquee tool and drag a rectangle over a portion of your image area. Type B or click on the Brush tool to select it, choose a color by clicking the Foreground color swatch, then scribble over your canvas, making sure to go in and out of the selected area. Notice how your brush strokes appear within the selection but not outside of it. Most often we think of using selections to work *within* specific areas, but they are also equally effective at protecting areas we don't want to change.

Notice how the brush can't paint past the marching ants.
Photoshop won't allow you to paint or edit outside of a selection area.

◀ Creating Selections ▶

Click the Foreground Swatch in the Tools panel to access the Color Picker.

Choose a range of colors from the rainbow Color Slider, then choose a color from the Color Field.

▶ *Fill a selection with the foreground color.* Filling selections is a good way to gain insight into how selections function. Click the Foreground color swatch at the bottom of the Tool panel to access the Color Picker. When the dialog box appears, you'll see a large area of color called the Color Field. Immediately to the right of that is a vertical rainbow called the Color Slider. To pick a color, first click or drag on the Color Slider to select a range of colors, then click on the Color Field to choose the proper color shade. (I chose a bright red, but you don't have to.) Click OK and your new color is now the new Foreground color.

Fill the selection by choosing Edit>Fill and selecting Foreground Color from the popup menu or by using the keyboard shortcut Option+Delete (Mac) or Alt+Backspace (PC).

With the marching ants still visible, type Option+Delete (Mac) or Alt+Backspace (PC) to fill the selection with the foreground color. (You could also choose Edit>Fill from the Main menu, then choose Foreground Color from the Use popup menu, but that really takes too long.) Finally deselect the marching ants by typing Command+D (Mac) or Control+D (PC), or by clicking anywhere outside of the selection. What you have is a well defined rectangle filled with your foreground color.

▶ *Use feathering for a softer look.* Select the Rectangular Marquee tool, change the Feather value in the Options bar to 30 px and drag a new marquee next to the first one. Option+Delete (Mac) or Alt+Backspace (PC) to fill the new selection with the foreground color and compare it to the first. Whereas the first selection had well defined edges, the new one has fuzzy edges. The feather value that we specified caused the fill to fade away over a 30 pixel region along the edges. Feathering is a very useful function when you want a selected area to blend into its surroundings.

▶ *Use anti-aliasing for smooth edges.* The Anti-alias option is grayed out for the Rectangular Marquee tool, and it's checked by default for the Elliptical Marquee tool. Let's see what it does.

Set your Feather value to 0, then create a circular selection and fill it with the foreground color. Now uncheck the Anti-alias option and create a new circle next to the first one. Fill it with the foreground color, then compare the edges of the two circles. The circle created with anti-aliasing should appear smooth, while the one created without anti-aliasing should appear jagged.

Why is this? Zoom in until you can see the individual pixels. Notice how the edge pixels of the non anti-alias circle are either solid red or solid white. The result is a well-defined stair step edge that is easy to see. But the stair steps of the anti-alias circle are filled with combo colors made from shades of red and white. This makes it more difficult for the eye to discern the stair steps, resulting in a smoother looking edge. I recommend that you keep Anti-alias checked unless you are trying for a jagged, pixelated look.

No Feather

30 Pixel Feather

Anti-aliasing applies varying levels of transparency to edge pixels for a smooth appearance.

Without anti-aliasing, the stair step structure of the pixel grid is easy to see.

▶ *Constrain your selection to a fixed ratio.*

Click the Style popup menu in the Options bar and choose Fixed Ratio. Type 2 in the Width field and 1 in the Height field. Now drag with the Marquee tool. You can create a large selection or small selection, but you can't create a selection that is not twice as wide as it is high.

▶ *Constrain your selection to a fixed size.*

Select Fixed Size from the popup menu and type a width of 3 in and a height of 2 in. Click or click and drag in the canvas to make a selection of those exact dimensions. The double arrows between the Width and Height fields let you swap your numbers.

▶ *Return your options to the default settings.*

Be sure to select Normal from the Style popup menu, change your feather value to 0 and check Anti-alias when you're done experimenting. (You have to be on the Elliptical Marquee to check Anti-alias.) Any settings you specify in this and all other Options bars are retained until you change them, even if you quit and restart Photoshop. Nine times out of ten, if your tool is behaving erratically, it's simply because you have some oddball options lurking in the Options bar from the last time that you used that tool.

▶ *Combine multiple selections for unique shapes.* We haven't discussed the first group of four icons in the Options bar. They're for making additional selections that add, subtract or intersect with the current selection. I actually don't recommend using the icons, because it's faster to use keyboard shortcuts instead. Let's try them out to make the shape of a simple house.

- Create a rectangle to form the overall shape of our house.
- Select the Add to Selection icon or hold Shift and add a chimney on top.
- Select the Subtract from Selection icon or hold Option/Alt to draw a window. Remember that you can hold the Spacebar while you drag to reposition your selection. Repeat that process to create a second window and a door.
- Type Option+Delete (Mac) or Alt+Backspace (PC) to fill your selection.

We didn't make use of *Intersect with Selection* in this case, but it functions in a similar manner. The keyboard shortcut to activate it is Shift+Option (Mac) or Shift+Alt (PC).

Selection options include *New* (selected), *Add To*, *Subtract* and *Intersect* functions.

▶ *Select and Mask lets you fine tune your selection.* The Select and Mask option is available only when you have an active selection. It's a powerful tool that lets you take advantage of Photoshop's ability to fine tune a selection based on a sophisticated analysis of the selected pixels. It's particularly useful when trying to ferret out selections defined by low contrast edges, such as those created by hair. We'll cover it in detail when we learn about advanced masking techniques in chapter 11.

Select and Mask is useful for selecting hair.

Hold *Shift* to add to a selection

Hold *Option/Alt* to subtract from a selection

Finished, filled selection

Speaking Photoshop…

Shift+Option+Drag (Mac) or Shift+Alt+Drag (PC).

Option+Drag (Mac) or Alt+Drag (PC), then release Option/Alt but not mouse.

Reapply Shift+Option (Mac) or Shift+Alt (PC). Release mouse before keys. Fill to confirm the result.

Untangling Keyboard Shortcuts for Marquee Selections

The *Shift* and *Option/Alt* keys mean one thing when you make an initial selection and something entirely different when you make additional selections. For example, *Shift* means "constrain to a perfect square or circle" for initial selections, but changes to "add to selection" when making multiple selections. Similarly, *Option* (Mac) or *Alt* (PC) means "draw from the center out" for initial selections, but "subtract from selection" for multiple selections. At first glance that may seem limiting, but you can actually specify both meanings simultaneously if you want to.

Let's say we wanted to create a perfect circle from the center out, then knock a hole in it, also from the center out, to form a donut. We can accomplish the entire procedure using keyboard shortcuts and proper sequencing. Here's how…

1. *Shift+Option+Drag* (Mac) or *Shift+Alt+Drag* (PC) to create the initial perfect circle from the center out.

2. Return to the center point (eyeball it), then begin to *Option+Drag* (Mac) or *Alt+Drag* (PC) to enter "subtract from selection" mode. Now release the *Option/Alt* key but do not release the mouse. As long as the mouse button remains depressed, Photoshop stays in "subtract from selection" mode.

3. Now reapply the *Option/Alt* key. This time it takes on the meaning for initial selections—draw from the center out. Add the *Shift* key as you drag to constrain to a perfect circle. Add the spacebar as necessary to reposition the inner circle.

4. Finally, be sure to release the mouse before you release the *Shift* or *Option/Alt* keys.

The Lasso Tools

Open **Buttercups.psd**, a nice photo taken by Phyllis Bankier and a good image for practicing the Lasso tools. The Lasso tools specialize in selecting irregularly shaped objects. They share similar options with the Marquee Selection tools, such as feathering and anti-aliasing, and you can also add to, subtract from, or intersect with existing selections, even if those selections were originated by a different selection tool.

The Lasso tools come in three flavors, each one more precise than the last.

▶ *Use the Lasso tool for freehand selections.* The biggest advantage of the Lasso tool is its freehand flexibility. The biggest disadvantage of the Lasso tool is, well, also its freehand flexibility. It's ideal for objects that are out in the open, but it's very difficult to get a precise selection using the Lasso tool unless you have an extremely steady hand. Simply drag a complete circle around an object that you want to select. If you release the mouse before completing the circle, it draws a straight line back to the point of origin.

▶ *Use the Polygonal Lasso tool for straight-line precision.* It's easier to be precise with the Polygonal Lasso tool because you don't have to be so steady handed. Instead of dragging, you click with the mouse at strategic corner points in connect-the-dots fashion.

To complete the selection, do one of two things:

- Place your mouse on the starting point and click when the little completion circle appears next to your cursor.
- Double-click anywhere. Photoshop completes the selection with a straight line back to the point of origin.

The Lasso tool is quick and easy for rough selections.

The Polygonal Lasso tool is best suited for straight-line selections.

Phyllis Bankier

▶ *Use the Magnetic Lasso tool to detect edges.* The Magnetic Lasso tool is different from the other Lasso tools in that Photoshop does much of the work for you. It's best for shapes that are clearly defined from their backgrounds. We'll use it here to select the buttercups and copy them onto a different background.

Choose the Magnetic Lasso tool and click with the tip of its arrow on the edge of the buttercup. Then move your mouse around the outer edge of the petals and watch Photoshop as it sets down fastening points along the flowers' edges. The Magnetic Lasso tool is designed to seek out and align itself to edges that are created from sudden changes in color or luminosity. As with the Polygonal Lasso tool, you complete your selection when you either click on the point of origin or double-click anywhere. If you get hopelessly tangled up with the selection, press Escape to abort it and start over.

You may notice an occasional misplaced fastening point as you progress around the flowers. If that happens, retrace your path, hitting Delete (Mac) or Backspace (PC) to remove fastening points as you backtrack past them. Proceed again with your selection after you have deleted your misplaced fastening point.

Another problem you could encounter is that the path does not adhere tightly to the V shapes created where two petals meet. If that happens, create a manual fastening point by clicking in the corner of the V with your mouse.

▶ *Subtract from the selection.* Tracing the flowers' edges with the Magnetic Lasso tool is the first step to selecting them, but we still have to deselect the tiny triangle between the two flowers. Hold Option (Mac) or Alt (PC) then trace around the triangle to subtract it from the selection.

The Magnetic Lasso tool attaches itself to edges formed by changes in luminosity.

▶ *Check your results.* Would the selection we just created look good if we copied and pasted the buttercups onto a different background? That depends on two factors: 1) the precision of the selection and 2) the color of the new background relative to the original one. Let's try it.

Make sure you are still on the *Background* layer (it's highlighted). Then type Command+C (Mac) or Control+C (PC) to copy the buttercups. Now click on the top layer named *Black* to select it and type Command+V (Mac) or Control+V (PC) to paste the selection. You now should have a new layer named *Layer 1* as your top most layer. Rename it by double-clicking the words *Layer 1* and typing Magnetic Lasso.

Turn on the eyeball for *Black* and examine your work. It should look pretty good. Now turn on the eyeball for *White* instead and examine that. Chances are you can see fringe pixels along the edge that were hidden by the *Black* layer. The original background was primarily dark, and it's much easier to transfer objects to similarly colored backgrounds than radically different ones.

Set the visibility of the Layers panel to check the quality of your Magnetic Lasso selection above black or white backgrounds.

The black background helps hide fringe pixels from the original background that cling to the edge of the buttercups.

The white background exposes the dark fringe pixels along the edge of the buttercups.

▶ *Magnetic Lasso tool options.*

The Magnetic Lasso tool has three options all its own: Width, Contrast and Frequency. Take a moment to play with them to get a feeling for what they do.

Width is your promise to Photoshop that you will be within a certain number of pixels from the desired edge as you trace around the image. Think of it as your slop factor. You don't have to be as precise if you use a large value, and that works great if there are few defined edges in your image. But if your image has lots of spikes and wiggles, you'll need to set a small width and be more precise with your tracing. You can change the width one pixel at a time as you trace by typing [to decrease the width or] to increase it.

Contrast lets Photoshop know if it should be looking for a high contrast edge or a low contrast one. Use a low value when the object you are selecting is similar in color to the background surrounding it. Contrast can be changed as you trace by typing < or >.

Frequency determines how many fastening points Photoshop creates. Use a lower value for long sweeping lines and a higher value for twisty-turny lines. Frequency can be changed on the fly by typing ; or '.

When you have finished experimenting with the options, choose File>Save As and rename the file Buttercups Selections.psd. We'll be working on it more with other selection techniques.

▶ *Switch to different Lasso tools with keyboard shortcuts.* With the help of keyboard shortcuts, you can easily switch back and forth among the various Lasso tools while you are in the middle of a selection.

- When using the Lasso tool, Option+Click (Mac) or Alt+Click (PC) to access the Polygonal Lasso tool. Release the Option/Alt key to return to the Lasso tool.

- When using the Polygonal Lasso tool, Option+Drag (Mac) or Alt+Drag (PC) to access the Lasso tool. Release the Option/Alt key to return to the Polygonal Lasso tool.

- When using the Magnetic Lasso tool, Option+Drag (Mac) or Alt+Drag (PC) to access the Lasso tool. Option+Click (Mac) or Alt+Click (PC) to access the Polygonal Lasso tool.

The Quick Selection Tool

The Quick Selection tool is the newest of the lot, and it has become my favorite. It's easy to use, fast and pretty accurate. Like the Magnetic Lasso tool, it also seeks edges as a basis for the selections it creates.

▶ *Use the Quick Selection tool to select the buttercups.*

Continue with *Buttercups Selections.psd* from the previous exercise. Click on the *Background* to select it and turn off the eyeballs of all other layers. Choose the Quick Selection Tool by typing W or clicking on its icon in the Tools panel.

Our first task is to check the settings in the Options bar. The first three icons give you the familiar *New Selection*, *Add to Selection* and *Subtract from Selection* settings, but they work a little differently than they do with the other selection tools. By default, the Quick Selection tool enters the *Add to Selection* mode as soon as you begin to use it. That means it's not necessary to hold down the Shift key to add to a selection as you do with other tools. But you do have to hold down the Option/Alt key as you drag to subtract from the selection, just as you would with other selection tools. Of course, you could also click the *Subtract from Selection* icon in the Options bar, but that's much slower than holding Option or Alt.

Use the next icon to set your brush size, although it's easier and faster to type the square brackets [or] to decrease or increase the brush size as you work. Set your brush size larger to select large areas more efficiently and smaller for detail work. I used a 100 pixel brush to make the initial selection of the buttercups and a smaller size to *Subtract from Selection* when I deselected the background triangle where the two flowers meet.

Sample All Layers enables the Quick Selection tool to use all visible layers as a basis for its selection. Otherwise it selects based on the active layer only.

Auto Enhance helps refine your selection edge by removing roughness or blockiness. Make sure this option is checked for best results. Without it, edges tend to appear pixelated.

Click *Select Subject* to let Photoshop guess what the main subject is. It works best if there is a very clear distinction between subject and background.

With your options set, simply drag inside the buttercups to select them, taking care to drag close to the edge, but not beyond it. As you drag, the Quick Selection tool attaches itself to the closest defined edge it can find. When the buttercups have been selected, reduce your brush size and hold Option (Mac) or Alt (PC) and drag inside the center triangle to subtract it from the selection. Zoom in and check the V-shaped intersections where the petals meet and deselect any residual background pixels that you find there, too.

▶ *Check your results.* With marching ants active, copy the buttercups, activate the top most layer, and paste them to create a new layer. Rename the layer Quick Selection, then check your results against the black and white backgrounds. How did it fare compared to the Magnetic Lasso tool? My results were better, and the procedure took less time.

The black background version fared better than the white, just as it did with the Magnetic Lasso tool.

My results for the Quick Selection tool were better than they were for the Magnetic Lasso tool.

The Magic Wand Tool

This tool has been a Photoshop standby forever. Like the Magnetic Lasso and Quick Selection tools, it also creates a selection based on luminosity and color values, but it differs in that it doesn't seek out edges. Instead it looks for pixels within a certain color/luminosity range, regardless of whether or not they also happen to define an edge. It works best for images that have a distinct solid color.

▶ *Use the Magic Wand tool to select the buttercups.*

Click and hold the Quick Selection tool and access the Magic Wand tool beneath it. Select the *Background* and turn off the eyeballs of all other layers. Our buttercups photo is not really an ideal Magic Wand candidate, because the colors are not as uniform as you would hope. But it's a wonderful image to get a feel for how the Magic Wand options work.

Let's take a look at those options. Choose 3 by 3 Average from the Sample Size popup menu. When you click on the image with the Magic Wand, you will be defining a color that Photoshop is supposed to select for you. The 3 by 3 Average setting takes the average color from the 9 pixels immediately surrounding the pixel that you clicked on. It helps mitigate unpredictable results that could occur if you happened to click on a rogue or noisy pixel that doesn't represent the true color that you are targeting. Leave the other options at their default values.

One click of the Magic Wand selected many, but not all of the yellow shades in the buttercups. *Shift+Click* to add additional colors to the selection. *Option+Click* (Mac) or *Alt+Click* (PC) to reduce the number of colors selected.

Now click on a buttercup to select it, and you should see marching ants swarming around the flowers. You just told Photoshop that you wanted to select the color yellow, but there are many shades of that color in the buttercups, and only some of them were selected. You now have two choices.

The first is to Shift+Click on unselected parts of the buttercup to add new shades of yellow to your selection. Try it and see how that works. If you end up selecting part of the background by mistake, Option+Click (Mac) or Alt+Click (PC) to subtract from the selection.

The second option is to start over and change the Tolerance value in the Options bar. Type a Tolerance of 5 and click again. Darn! We're going in the wrong direction. When you click on a color, Photoshop wants to know how picky it should be as to the exact color. Photoshop is very selective with low tolerance settings and very inclusive with high tolerance settings. Change it to 100 and try again. Depending on where you clicked, you could have selected almost all of the flowers, or you could have selected all of the flowers plus parts of the background. Lower your tolerance value to the default 32, and refine your selection by Shift+Clicking or Option/Alt+Clicking as necessary to add or subtract additional colors from the selection. Eventually you'll get there, but it certainly wasn't as easy as the Magnetic Lasso or Quick Selection tools. Does that make this a bad tool? Not at all! We just have to learn when to use it and when not to use it.

▶ *Check the result.* When you are done refining your selection, copy the buttercups and paste them to create a new top layer. Rename the layer *Magic Wand* and examine the quality of the selection against the black and white backgrounds. Save the file, because we want to use it to compare results from yet another selection method.

As with the other methods, the Magic Wand selection looks good on the forgiving black background.

Edges appear rough and pixelated against the white background—not as clean as the other methods.

◀ Creating Selections ▶

Phyllis Bankier

▶ *Use the Magic Wand for solid color selections.* I sort of set up the Magic Wand for failure by using it to select the buttercups, so let's give it a chance to shine using a different image. Open Wine Glass.psd, an ideal candidate for the Magic Wand because of its uniform background color. Whenever you use the Magic Wand, select the most uniform color, then inverse the selection if necessary. That's exactly what we will be doing here.

Set your options as follows: Sample Size: 3 by 3 Average; Tolerance: 32; Anti-alias and Contiguous: checked; Sample All Layers: unchecked. Make sure the *Glass 1* layer is selected, then click anywhere in the white area surrounding the wine glass. It doesn't get much easier than that—except that we just selected everything *but* the wine glass. No problem. Choose Select>Inverse from the Main menu—or type Shift+Command+I (Mac) or Shift+Control+I (PC)—to select the wine glass instead.

Admire your selection for just a few short seconds, then deselect it by choosing Select>Deselect from the Main menu or by typing Command+D (Mac) or Control+D (PC). Now click on the *Background* layer to select it and click once again in the white area with the Magic Wand. You just selected the entire image, ignoring the wine glass altogether. Photoshop didn't consider the wine glass because it wasn't on the selected layer. Deselect the marching ants once again and check the *Sample All Layers* option. This time when you click in the white area with the Magic Wand, it will select everything but the wine glass, because it used all layers to make its selection.

The *Contiguous* option lets you determine whether or not you want to look inside "donut holes" to find the target color. If Contiguous is checked, Photoshop only selects colors that are adjacent to one another, then it stops its search. That's what we wanted in this case. Photoshop stopped looking when it encountered the dark edge surrounding the wine glass. If Contiguous is unchecked, then Photoshop jumps into "donut holes" and selects similar colors there as well. Try that with our wine glass, and you will see that areas inside the wine glass become selected—not what we wanted in this case.

The top selection was made by clicking on the white area surrounding the wine glass with *Contiguous* checked. The middle selection was then inversed to choose the glass, not the background. Our selection is now complete. The bottom selection was created by clicking on the area surrounding the glass with *Contiguous* unchecked.

Color Range

The Color Range command found under the Select menu is similar to the Magic Wand in that it makes a selection based on a range of colors, but it is more powerful than the Magic Wand in a couple of ways.

▶ *Select the buttercups using Color Range.* Open Buttercups Selections.psd, select the Background layer and turn off the eyeballs to all other layers. Now choose Select>Color Range from the Main menu. Like the Magic Wand, this command is also best suited for selecting uniform colors, but let's take a shot at choosing the buttercups anyway, because you'll get a good idea of how the options work.

When the Color Range dialog box opens, click and hold the Select popup menu and take a look at the predefined color ranges that Color Range could select for you. Occasionally these options are handy, but more often than not you will want to use the Sampled Colors option, so return to that after you have experimented with the other choices.

Towards the bottom of the dialog box is the Display window with radial buttons that let you see the display as a Selection or as an Image. Our goal is to turn the buttercups white and the background black when using the Selection view. Below the Display window is a Selection Preview popup that lets you see your image in various ways. Take a look at the options but leave it set to None at this point.

Choose a color range to select. *Sampled Colors* lets you click the image to select colors.

Choose a view for the display window.

Choose a view for the main image window.

Start the process by clicking or dragging on a buttercup to ask Photoshop to use "buttercup yellow" as a basis for its selection. You can click on the display window inside the dialog box or in the image itself, it doesn't matter. Immediately parts of the buttercup turn white in the Display window, which means that they're selected.

Now drag the Fuzziness slider to the left and right. Fuzziness is similar to Tolerance for the Magic Wand tool, except that it has two advantages. First, it's dynamic, meaning that you can change it at any time, before or after you click. Secondly, it has the ability to *partially* select a color, resulting in a transparent effect. Tolerance, on the other hand, makes all or nothing selections. Adjust the fuzziness to make the buttercups as white as possible without turning the background white.

A. Color range used for selection
B. Face detection mode
C. Narrows search area for similarly colored pixels
D. Defines how similar colors must be to be included
E. Search range used by *Localized Color Clusters*
F. Display window
G. Image window preview

H. Click to complete the selection
I. Click to abort the selection
J. Load a previously saved selection
K. Save selection for future use
L. *Eyedropper, Add to Sample* and *Subtract from Sample*
M. Invert mask for inverse selection

Next try Shift+Clicking to add more colors to the selection or Option+Clicking (Mac)/Alt+Clicking (PC) to subtract colors. As you do that, you will probably want to readjust the Fuzziness.

A third option for refining your selection is to check the Localized Color Clusters box. This option, coupled with the Range slider, lets you restrict a color selection to an area closer to your clicks. Use a combination of the Color Range options to make as clear a selection as possible, turning the buttercups into white and keeping the background black. I was able to get a pretty good selection except for the inner parts of the flowers.

Click OK to accept the selection, then switch to the Lasso tool and Shift+Drag around the center parts of the buttercups to add those to the selection. Just because you begin with one selection method, doesn't necessarily mean that you have to end it with the same method. You can go back and forth between selection tools and commands as much as you want. Copy your final selection and paste it into a layer at the top of the stacking order.

The Color Range selection on black looks pretty clean.

The Color Range selection on white is a little ragged around the edges.

▶ *Use a Layer Comp to determine the best overall selection.* We now have a total of four layers in *Buttercups Selections.psd*, each one displaying a different selection method. They all fared pretty well against the black background, because black does such a nice job of covering up flaws in this case. But which one fared the best against the white background? We'll use a Layer Comp to help us determine that.

Select Window>Layer Comps to display the Layer Comps panel. Layer Comps have the ability to remember three things about layers: visibility, position and appearance (layer styles). In the Layers panel, adjust the eyeballs so that the *Magnetic Lasso* layer shows above the white background. Then click the Create New Layer Comp icon at the bottom of the Layer Comps panel—the icon that looks like a dog-eared piece of paper. Name the Layer Comp Magnetic Lasso, make sure that the Visibility box is checked, then click OK.

Now readjust the layer's eyeballs so that *Quick Selection* shows against the white background. Create a new Layer Comp named Quick Selection, then repeat the process for Magic Wand and Color Range.

To toggle your views, simply click in the empty box to the left of the Layer Comp that you want to see. It makes layer-to-layer comparison much easier. Choose your most natural looking selection to work with further. My best is the *Quick Selection* layer.

Click box to display Layer Comp

New Layer Comp icon

Name the Layer Comp and specify the characteristics it should remember.

▶ *Modify the selection for a more realistic look.* All of my buttercups have a dark edge that makes them appear unnatural in front of the white background. Also noticeable is the fact that the edges of the buttercups seem to be in sharper focus than the flowers themselves. Both of these traits are giveaways that our image was plucked from one background and placed into another. We can modify the selection to help that.

Click on your favorite layer to select it, then duplicate it by choosing Duplicate Layer from the Layers panel flyout menu. Name it Modify Selection. First we have to recover the original selection that we made to create this layer. Fortunately that's easy. All you have to do is Command+Click (Mac) or Control+Click (PC) on the layer thumbnail to load all nontransparent pixels as a selection.

Then choose Select>Modify>Contract from the Main menu and try 3 pixels as the *Contract By* amount in the ensuing dialog box. Three pixels is not a magic number, but it should be enough to shave off the dark edge. If it doesn't work in your case, you'll have to make adjustments and try again. Click OK to accept the value and notice how the marching ants cut into the buttercups ever so slightly.

Command+Click (Mac) or *Control+Click* (PC) on a layer thumbnail to load all nontransparent pixels as a selection.

The next order of business is to soften the edge so it doesn't appear sharper than the details of the flowers themselves. Choose Select>Modify>Feather from the Main menu and try 2 pixels as a feather amount. Again, this is a hit-or-miss estimate. If it doesn't look right, try again with a different value.

Our last step is to inverse the selection—Shift+Command+I (Mac) or Shift+Control+I (PC)—followed by Delete (Mac) or Backspace (PC) to remove the hard dark edge. Compare the results to the original layer—it should look more natural.

Original selection has dark, hard edges that don't look natural.

Edges are removed and softened by contracting and feathering the selection.

Final Thoughts

There are many tools and methods you can use to make a selection when you want to edit or copy just part of an image. Each selection method works splendidly in some instances and poorly in others. It's up to you to understand each tool's strengths and weaknesses and choose the one that is best suited for the occasion. After the selection is made, you can continue to tweak it by switching to other selection tools or using the modify capabilities in the Select menu. Your ultimate goal is to make a selection as precisely and efficiently as possible. If you are placing the selected image on a new background, the modify selection commands available in the Select menu may help make the image look at home in its new surroundings.

> When words become unclear,
> I shall focus with photographs.
> When images become inadequate,
> I shall be content with silence.

> ▸ *Ansel Adams*
> *American Photographer, 1902–1984*

◂ *Levels, Curves, Shadows/Highlights* ▸

4

Caron Gray

Topics

- ▶ Correct exposure using auto adjustments.
- ▶ Set Black, White and Midtone points using Levels.
- ▶ Make multi-point luminosity adjustments using Curves.
- ▶ Brighten shadows and darken highlights with Shadows/Highlights
- ▶ Use Adjustment layers for nondestructive editing.
- ▶ Adjust just part of an image using Layer masks.

Preview

Your quick reactions paid off. You captured that once-in-a-lifetime photo of a seagull catching a starfish, as Caron Gray did in the photo to the left. But darn! You look at the picture and it's way too dark. What was that seagull thinking? Couldn't it have waited for you to tweak your camera settings before it caught the starfish?

Fortunately for you, you're learning Photoshop, so this type of situation is not the problem that it used to be. That's not to say that you should be careless with your camera techniques. It's still better to get something right from the get-go. Nevertheless it's amazing the amount of detail that lurks in a poorly exposed photo.

Photoshop offers many methods that can correct exposure and tease detail out of such images. In this chapter, we are going to explore the capabilities of Photoshop's most powerful luminosity adjustment tools: Levels, Curves and Shadows/Highlights. We'll also look at the auto exposure commands and see how and when they work.

Auto Exposure Adjustments

Making your job easy

It's amazing how smart Photoshop is. It can analyze a photo and know if it's overexposed or underexposed and fix it in seconds. All you have to do is tell it to do so. There are three commands under the Image menu—Auto Tone, Auto Contrast and Auto Color—that do just that. Let's compare them.

Duplicating images makes comparisons easy.

▶ *Create duplicate images for comparison.* Open *Trillium.jpg*, a wonderful photo captured by photographer Bill Elliott. Choose Image>Duplicate from the Main menu and name the file Auto Tone. Duplicate the image a second time and name it Auto Contrast, then a third time and name it Auto Color.

▶ *Apply auto adjustment commands.* Select the *Auto Tone* image and choose Image>Auto Tone. What a difference! Contrast has improved and the trilliums really pop now. And it sure was easy.

Now select the *Auto Contrast* image and apply the Auto Contrast command to it, then the *Auto Color* image and apply the Auto Color command to it.

Auto Tone, Auto Contrast and Auto Color fix your image with no input from you.

◀ Chapter 4 ▶ 87

▶ *Compare the files using 4-up.* We now have our original file and three adjusted versions of that file. Which one do you like best? Let's put them side by side to compare. Choose Window>Arrange>4-up from the Main menu to see them all simultaneously. Notice by the Title bar that the file on the bottom right is the active file. Use your Zoom and/or Hand tools to position it in the window where you like, then choose Window>Arrange>Match All from the Main menu to put all images into the same view. Now you can Shift+Drag with the Hand tool to move them all simultaneously; you can also Shift+Click with the Zoom tool to enlarge them all; and you can Option+Shift+Click (Mac) or Alt+Shift+Click (PC) with the Zoom tool to reduce them all.

4 Up places all four images side by side.

How are these three adjustments different from one another?

- Auto Tone darkens the darks, lightens the lights and allows a shift in color in the process.

- Auto Contrast darkens the darks, lightens the lights and tries to retain the original color.

- Auto Color darkens the darks, lightens the lights and tries to correct the color.

So which one is the best? You get to decide that. Pick your favorite.

Match All orients all images identically.

The *Window>Arrange* menu gives you many options for viewing and comparing multiple files.

◀ Levels, Curves, Shadows/Highlights ▶

Making your job not so easy

You have to admit. Those results were true Photoshop magic, and it couldn't have been any easier. So let's try it again on a different image. Open *Callie.jpg* (my special Border Collie companion) and duplicate it three times, naming the files *Auto Tone*, *Auto Contrast* and *Auto Color*. Then apply the appropriate commands to each file and view them 4-up.

Where's the magic now? My favorite is the original file—it has the clearest detail when you look at Callie's eyes and ears. So what happened? It worked so well before. We'll find out when we learn a little more about the all important histogram and how it helps us (and Photoshop) adjust luminosity levels.

The original image lacks detail in Callie's dark fur.

None of the auto adjustments did much to help. This example is Auto Tone.

The Levels Command

Photoshop's versatility is indispensable. If one thing doesn't work, there's always another method to try. The nice thing about auto commands is that they often work and they're simple to use. Manual adjustments, on the other hand, take a bit longer to execute, but you have more control over the outcome. Close the auto versions of *Callie.jpg*—they aren't worth saving—and return to the original.

▶ *Use Levels to make manual adjustments.* Choose Image>Adjustments>Levels from the Main menu. In the ensuing dialog box, you'll see an Input Levels box with two mountain silhouettes separated by flat land. It's called a histogram, and it's actually a bar chart made up of 256 individual bars, each representing a luminosity value from 0 to 255. Zero is the darkest value (no light, black) and white is 255 (maximum light). You can't see the bars because they are squashed together.

The height of each individual bar is determined by the total number of pixels that share that same luminosity value. If there were a lot of pixels that had a luminosity value of 55, for example, that particular bar would be tall, and so on for each of the luminosity bars. The tiny mountain on the left represents Callie's black fur, and the larger mountain on the right represents all of the bright snow pixels. There are pixels with intermediary values, too, in that flat land area, but not as many of them.

A Histogram is a bar chart that shows the distribution of pixels by luminosity value. There are 256 bars, with luminosity values ranging from 0 to 255. The taller the bar, the more pixels that have that luminosity value.

Bright snow pixels.

Callie's dark fur.

Under the histogram are three Input sliders: the Black Point on the left, the White Point on the right, and the Midtones (or Gamma) in the center. Drag these sliders one by one and watch how you can darken the image or brighten it. The reason this is happening is that you are telling Photoshop to adjust its placement of where the Black, Midtone or White Point should be, then change the image accordingly.

On the bottom is the Output Levels section with its own Black and White Point sliders. Drag the sliders closer together and you diminish the contrast. Place one on top of the other and you'll have a single color. Reverse them, and you'll create a negative. You rarely need these sliders unless you are trying to reduce an image's contrast, which is not usually a desired result.

Levels adjustments can be performed on individual channels or on the overall RGB composite.

Sliders let you redefine where the Black, Midtone and White Points are.

Contrast increases as you drag the Black and White Point sliders closer together.

Dragging the Midtone slider has an overall brightening or darkening effect on the image.

Output sliders let you brighten the darkest blacks or darken the brightest whites. You rarely need to adjust these. Contrast decreases as you drag them closer together.

Speaking Photoshop…

Why do Levels use a scale of 0–255 luminosity values?

Where did this obscure number range come from? Why not use a simple scale of 0–100? It's all tied to the computer's 8-bit processing capability. Using the binary numbering system, 8-bit processing gives you 2^8 or 256 possible values. Adding to the confusion is the fact that computer programmers begin counting with zero instead of one—hence the 0–255 luminosity scale. You'll see these numbers pop up time and time again in Photoshop.

▶ *Reset the Levels values.* Let's start over with a new levels adjustment. Press Option (Mac) or Alt (PC) and note how the Cancel button becomes the Reset button. Click it to revert the dialog box to its original values.

▶ *Adjust the White Point.* Drag the White Point slider to the left and watch how the snow becomes brighter but loses detail at the same time. The reason for this is that you are telling Photoshop to relocate the position of the White Point based on where you dragged the White Point slider. All of the luminosity bars that fall to the right of the slider also become pure white, so where you used to have differences in value, now you only have one single value. All detail in an image is created by *changes* in luminosity value, so where there is no change, the color becomes flat and void of detail. This is known as clipping, and we usually want to avoid it unless we are trying for less detail for some reason. Return the White Point slider to the right.

Cancel becomes *Reset* when you hold *Option* / *Alt*.

Clipping has caused the snow to lose its detail.

All pixels with a luminosity value of 225 or greater would become clipped, making them solid white and void of detail—not a desirable result.

▶ *Adjust the Black Point.* Now drag the Black Point slider towards the middle and watch how Callie's fur becomes even blacker as we clip those values. This is also a counterproductive move, so return it to the left.

▶ *Adjust the Midtones.* Finally, drag the Midtone slider to the left and watch how the detail in Callie's fur brightens and improves. This is a good adjustment, because you can now see her eyes, ears and the shape of her belly much more clearly. If you go too far, her fur begins to look washed out, and we don't want that. Try dragging the Midtone slider to 1.8 (or simply type 1.8 in the Midtone field). We have nice detail but the fur is a little washed out. Now place your cursor in the Black Point field and hit the up arrow on your keyboard. Each touch of the arrow moves the Black Point up one number (Shift+Click would move it by tens, but that's too much.) I felt that a value of 6 restored the richness of her fur without losing too much detail. Click the Preview check box on and off and look at the results. Look at the snow, too. It's lost some detail, but it still looks pretty good.

Okay, we brightened the photo overall, but why did that also cause an improvement in detail in Callie's fur and a degradation of detail in the snow? The reason is this: as soon as we click OK, all of the sliders latch onto the luminosity bars and return to their original "homes," pulling or squashing the bars like an accordion. As the Midtone slider returns to the center, it stretches the darker bars apart, creating more differentiation from one to the next, resulting in better detail. But as that happens, the brighter bars are squashed together, creating less differentiation and less detail. Click OK to accept the adjustment.

Detail was enhanced significantly by moving the Midtone slider to the left, but that also caused some loss of detail in the snow.

▶ *Check the end result.* We made a vast improvement in the photo and accomplished something that the auto commands couldn't achieve. Granted, we lost some detail in the snow, but that was a successful trade-off for the enhanced detail in Callie. After all, she's more important than the snow.

Now type Command+L (Mac) or Control+L (PC) to return to the Levels dialog box and examine the revised histogram. Can you see the individual bars now, stretched out in the darker tones? When you see a histogram stretched out like that, it's not usually a good sign, because it indicates that data has been lost. In this case, we lost information that had created detail in the snow, and we can never fully recover that again. What we did is referred to as destructive editing. Still, the photo looks better than it used to, even though we lost data. Click Cancel, and you can close *Callie.jpg*.

When we clicked OK, the Black Point and Midtone sliders returned to their normal positions, pulling the darker luminosity bars apart but squashing the brighter ones. The result is improved detail in the shadows at the expense of the highlights.

Adjustment Layers

All of the luminosity adjustments that we made thus far—they were actually a bad idea, and I hope you never do them again. Not because they failed to make our images look nicer, but because we could have done the same thing using Adjustment layers. Why is that so important? Adjustment layers offer two indispensable advantages: nondestructive editing and the ability to subdue or mask out the adjustment in areas of the image that don't need it.

You still need to be aware of the more restrictive Image>Adjustment commands, because there are a few instances where Adjustment layers are not available. Just don't use them unless you have to.

Nondestructive Editing

▶ *Apply auto adjustments nondestructively.* Open *Heron.jpg*, a photo taken by Caron Gray, and add a Levels Adjustment layer. There are two places that you can go to accomplish that. 1) Click the black and white circle icon at the bottom of the Layers panel and choose Levels from the popup menu, or 2) click the icon that looks like a histogram in the Adjustments panel. When you do that, Photoshop adds an Adjustment layer in the Layers panel, and the Properties panel opens on screen. It should look familiar to you, because it is almost identical to the Levels dialog box that we just used.

Click the Auto icon, and you have just completed an auto adjustment, but which one? Hold Option / Alt and click it again to get more options. (You could also have chosen Auto Options from the Properties Flyout menu.)

The Levels Adjustment layer can be accessed by clicking on the Adjustment Layers icon in the Layers panel or the Levels icon in the Adjustments panel.

The Properties panel lets you make manual levels adjustments or an Auto adjustment. *Option+Click* (Mac) or *Alt+Click* (PC) on the Auto icon to access the auto adjustment options.

Heron.jpg

▶ *Which auto algorithm setting is which?*

Enhance Monochromatic Contrast is equivalent to the Auto Contrast command that we tried earlier.

Enhance per Channel Contrast is equivalent to Auto Tone.

Find Dark and Light Colors with *Snap Neutral Tones* checked is equivalent to Auto Color.

The *Target Colors and Clipping* section lets you limit how far Photoshop is allowed to drag a Black or White Point Input slider beyond the outer most data points. *Save as defaults* lets you specify a default setting. For now, choose Enhance Monochromatic Contrast and click OK. Do you see how Photoshop stretched the histogram from end to end?

▶ *The Properties Panel icons.* The Properties panel has five icons across the bottom that let you work with the adjustment.

- The icon on the far left, if selected, lets you limit the effectiveness of the adjustment to the layer immediately below the Adjustment layer. It's called a Clipping mask. Otherwise Adjustment layers affect all layers beneath them.

- The arrow/eyeball icon lets you see the effect of your most recent change. Click and hold it to see your image as it was before your change and release it to return to normal view.

- The rotating arrow icon lets you restore the Adjustment panel to its default values. If you have left the Adjustment layer and return to it later and make additional adjustments, you will have to click it twice to revert to the default values, because the first click will only undo the changes you made during the current session.

- The eyeball icon toggles the visibility of the layer.

- The trash icon deletes the Adjustment layer entirely.

▶ *Working with the Adjustment layer.* The Layers panel has an eyeball and trash can, too, that can hide or trash the Levels Adjustment layer just like the equivalent icons in the Properties panel. Whenever the Adjustment layer is selected, you can change any settings in the Properties panel that you want to, even six months from now. That's nondestructive editing, because we haven't permanently thrown away any data.

Auto Adjusted Histogram
Icons from left to right let you:
- Clip adjustments to the layer beneath it.
- View your last state by clicking & holding
- Restore default values
- Toggle Adjustment layer visibility
- Delete the Adjustment layer.

Heron.jpg
With a lack of data in the shadows and highlights, this histogram tells Photoshop that the image most likely lacks contrast.

Callie.jpg
This histogram extends nicely from shadows to highlights, so Photoshop doesn't see a need to correct the image.

▶ *Discovering the Automatic Adjustment Magic.* Using a Levels Adjustment layer to make our auto adjustment lets us peek into Photoshop's magic recipe for success. Click the *Reset to adjustment defaults* icon to return to the default values. Now look at the histogram and compare it to the one we saw for Callie. Notice the lack of luminosity bars in the shadows and especially in the highlights. That's the hallmark of an image that lacks contrast.

So what should a typical, well exposed histogram look like? Take a look around you. Chances are you can see some whites, some blacks and a lot of colors in between. Likewise, a healthy histogram should extend from end to end, have some blacks, some whites, and a lot of values in between. Often a histogram takes on a bell shape and it's usually fairly well balanced, but that varies depending on the subject matter.

That doesn't mean your histogram should always exhibit these tendencies. That only applies for normal pictures. If you took a picture of a black object in a black room, it would be incorrect for your histogram to have tall luminosity bars in the highlights region. Granted, this type of thing doesn't happen very often, because typically you take typical pictures, right?

That's what Photoshop assumes when it applies its auto corrections to images. When you think of it, it makes sense to assume that you're working with a typical image, because it's right more often than not. But when that assumption is wrong, and you're not working with a typical image, then an auto correction falls short. *Heron.jpg* was easy for Photoshop to correct because the histogram was obviously lacking in the highlights and shadows regions. The histogram for *Callie.jpg*, on the other hand, fulfilled the requirements for a typical histogram. It extended from edge to edge, had blacks, whites and a decent number of values in between. Our biggest problem with the Callie photo is that we didn't see enough detail in her black fur. Unfortunately Photoshop didn't realize it was looking at a black dog that needed more detail. It was satisfied because the histogram looked good, and that's why the auto adjustments failed.

► *Use an Adjustment layer to manually correct levels.*

Let's continue to use *Heron.jpg* and make a manual Levels adjustment. Adjustments like this are fairly straight forward.

- Drag the Black and White Point sliders to the beginning of the foothills. If you go beyond that, you'll clip data and lose detail,
- Adjust the Midtone slider to brighten or darken the overall exposure if desired.

That's all there is to it, and guess what. That's basically what the auto functions do as well, except that they often apply the corrections to the individual Red, Green and Blue channels instead of applying them to the composite RGB channel. Try some of the auto settings again, and observe how Photoshop positions the Black, White and Midtone points.

Manual Levels Adjustment

Drag Black and White Point sliders to the foothills of the histogram.

Blue Heron Auto Adjustments using Enhance Monochromatic Contrast

Red Channel Adjustment

Green Channel Adjustment

Blue Channel Adjustment

Composite Channel Result

Adjusting Part of an Image

Sometimes you get an image that looks good in some areas but needs help in others. Have you noticed the white thumbnail that appears in the Layers panel when you add an Adjustment layer? It's a Layer Mask and it gives us the ability to adjust part of an image.

▶ *Using Layer Masks to adjust part of an image.* Open *Dave and Callie.jpg*.

That's me with my friend Callie, fetching water at Peninsula State Park in Door County, Wisconsin. The bright sunlight and dark shadows made this a difficult image for the camera to capture nicely. The exposure looks great for the foliage on the left, but it's too dark elsewhere.

Add a Levels Adjustment layer and brighten the photo to bring out detail in Callie and me. The usual procedure works here. Bring the Black and White points to the foothills, then brighten the overall exposure with the Midtone slider. I cranked the Midtone slider all the way up to 1.87 to get the effect I was after, but then things began to look a little washed out. I addressed that by clipping the Black point slightly to regain the lost contrast. I ended up with a Black Point value of 9.

That certainly looks better, but it's a shame that we washed out that lush green in the foliage. If we didn't have an Adjustment layer with a Layer Mask, I would say that it was a pretty good trade-off, but we don't have to be satisfied with trade-offs anymore.

Adjustment layers have a Layer Mask by default, so you can correct part of an image.

Adjust the sliders to help the shadows.

The foliage to the left is well exposed but much of the photo is too dark.

Levels corrected the dark areas, but now the foliage is too bright.

◄ Chapter 4 ► 99

▶ *How Layer Masks work.* Think of a Layer Mask as a window that lets the adjustment shine through to the image. If we were to cover that window with black, we would prevent the adjustment from coming through, negating our adjustment altogether. Areas of the mask that are white let the adjustment shine through at full strength. If we fill or paint areas with gray, the adjustment would come through at reduced strength. Right now, the Layer Mask thumbnail is totally white, so our adjustment is at full strength throughout the entire image.

Make sure black is the foreground color, then select the Brush tool (B), choose a 100 pixel brush tip at 100% hardness from the Options bar and scribble randomly over the image. Did you see how dark it got where you scribbled? Look at the Layer Mask thumbnail, and you'll see your scribble marks—the black parts of the window where we prevented the adjustment from taking effect.

Switch your foreground color to white and paint over some of your scribble marks to reapply the adjustment at full strength.

By painting black on the Layer mask, we were able to bring back the lush foliage.

Also, try changing your foreground color to gray and paint on the image to apply the adjustment at partial strength. Do you see the flexibility that this gives us? Enough of the playing around, let's try this for real.

Type D or click the tiny white and black icon above the foreground and background swatches to restore your swatches to the default colors. White should be your foreground color now. Then Option+Delete (Mac) or Control+Backspace (PC) to fill your entire mask with white.

Type X or click on the double arrow to switch your foreground color to black, then choose a large brush tip with 0% hardness in the Options bar. I started with a 400 pixel brush and painted the large foliage area to the left, then reduced the brush size as appropriate to pick up some of the smaller sunny patches of foliage. Using a fuzzy, 0% hardness brush is important, because it creates a gentle transition between adjusted and non-adjusted areas for a natural look.

Large fuzzy brushes are good for blending purposes.

Speaking Photoshop…

I chose blue, but the foreground swatch is still gray!

Masks are not compatible with color—they only support grayscale. If you choose a color for your foreground or background while in mask mode, Photoshop will convert the color swatch into its grayscale equivalent.

- *Select different mask views.* Sometimes you may find it helpful to disable the Layer Mask temporarily, and sometimes you may want to view the Layer Mask by itself. Here's how to do that.

 - Shift+Click on the Layer Mask thumbnail to disable the mask and view the image without the mask's effects. Shift+Click again to return to normal view.
 - Option+Click (Mac) or Alt+Click (PC) on the Layer Mask thumbnail to see the mask by itself. This view helps you find masking mistakes that you might otherwise miss. You may still paint on the mask if you like. Option+Click (Mac) or Alt+Click (PC) to toggle back to normal view.

A red X appears on the Layer Mask thumbnail when you *Shift+Click* it to disable it.

Option+Click (Mac) or *Alt+Click* (PC) on the Layer Mask thumbnail to view the mask by itself.

The black areas of this Adjustment Layer Mask prevented the foliage from brightening; the white areas allowed the adjustment to work at full strength, and the gray areas from the brush fuzz partially blocked the effect.

Curves

Curves seem imposing to many, but they aren't really hard to use if you understand what makes them tick. In fact, you already know a fair amount about curves even if you have never used them, because a lot of what we learned for Levels applies to Curves as well. Curves let you do all the same things you can do with Levels plus a little more.

▶ *Use Curves to adjust multiple Midtone points.* Open *Callie.jpg* and add a Curves Adjustment layer, either through the black and white circle icon at the bottom of the Layers panel or by clicking the Curves icon in the Adjustments panel.

You should immediately notice some things that remind you of the Levels panel: a histogram, a Black Point slider and a White Point slider. You can operate the Black and White points in the exact same way as you did in Levels, either by dragging the triangles at the bottom of the Curves graph, or by dragging the Black and White Points themselves on the graph line. There is no Midtone slider, but you can click anywhere on the graph line to add as many Midtone adjustment points as you want. That's the biggest advantage of Curves over Levels—the ability to make several Midtone adjustments.

Here are some general truths that you should know when working with Curves. Try them out and observe the results for yourself.

- Click on the curve and drag up to brighten the image and down to darken it.
- Drag a Midtone point off the curve to delete it.
- A steep curve increases contrast.
- Contrast decreases as the curve becomes more horizontal.
- A perfectly horizontal curve produces a single color.
- A curve that slopes from top left to bottom right creates a negative.
- A curve that goes up and down, up and down, looks just plain goofy.

Add a Curves Adjustment layer through the Adjustment Layer popup in the Layers panel or by clicking its icon in the Adjustments panel.

Click to add a point. Drag it up to brighten the image and down to darken it.

▸ *Input and Output values determine placement on a curve.* As you drag a Midtone point on the curve, notice how your Input and Output values change. Those are the graph's X and Y coordinates, measured in luminosity values from 0 (black) to 255 (white). The X axis of the graph represents the Input values—the luminosity values of the original image. The Y axis represents the Output values—the new luminosity values after the Curves adjustment. It reads similarly to a mileage chart. Draw a straight line down from any point and it will line up with the image's original luminosity value along the X axis. Draw a straight line from the same point to the left, and it will line up with the new luminosity value after curves along the Y axis.

A mathematical graph plots the brightness of pixels. Pixels become brighter whenever the curve rises above the original 45° line and darker if the curve dips below it. Luminosity points can be moved by dragging or by typing input and output values.

▶ *Use Curves to increase detail in Callie's black fur.* Now let's put this information to use and make a nice luminosity adjustment to Callie. Click the Reset icon to return the curve values to their defaults. Notice the left peak on the histogram that corresponds to Callie's black fur. We want that to become more vertical to bring out greater detail. Click in the middle of that peak and use the up arrow on your keyboard to nudge it upwards. As was the case with Levels, we gained detail in Callie but at the expense of the snow. Look how horizontal the curve is as it passes through the snow peak in the histogram. If we can make that more vertical, we can recover some of the lost detail. We could click on the curve at that point and use the down arrow to move the point down, but I want you to try something else this time.

The 45° diagonal slope indicates the starting point, where input equals output.

The entire image is brighter now because the curve is above the 45° diagonal.

A loss of detail in the snow occurred because the slope became more horizontal.

A steeper slope through the dark fur increased detail.

- *Recover detail in the snow.* Click the Scrubber icon just to the left of the RGB popup menu. It's a hand with an up and down arrow. Now position your cursor directly over the snow in the image window and drag downwards to darken it. Photoshop added an Adjustment point at that spot on the graph line, and as you dragged, you moved the point down, creating a more vertical, detail-oriented curve through the snow data.

- *Improve contrast in Callie's white fur.* A quick inspection of the curve reveals one area where the curve is a little too horizontal. We have to be careful of those spots because they indicate a loss of contrast. But where, exactly, did we lose that contrast? Mouse over your image but don't click. If you look at the curve, you should see a bouncing ball indicating where you are relative to the curve. Mouse over Callie's white fur, and you will see that it lands right in the flat spot. Click and drag down to help bring that detail back.

Reestablishing a more vertical slope through the snow helped recover detail, but one part of the curve is still too flat.

Using the Scrubber tool and dragging downward on Callie's white fur helped restore detail. Now the flattest part of the curve is over the smallest number of pixels.

▶ *Keep your curves as simple as possible.* By using three adjustment points, Curves allowed us to improve or retain detail in three critical areas: black fur, white fur and snow. We couldn't have achieved the same result with Levels because it only offers one Midtone adjustment. A word of caution, though—try not to introduce too many Midtone adjustment points. The fewer the better for a natural looking result.

Before Curves

After Curves

Shadows/Highlights

I like this command. It's more versatile than its name suggests, and if we're smart about it, we can apply the command in a nondestructive fashion, complete with Layer Mask. Its intended purpose is to brighten the shadows and darken the highlights for images that combine dark shadows with bright sunlight.

Open *Dave and Callie.jpg*. It's an ideal Shadows/Highlights sort of image. We've talked at length about the advantages of using Adjustment layers, but unfortunately you won't find one for Shadows/Highlights. Does that mean that we have to give up our nondestructive editing and layer mask? Fortunately there is a workaround, and it's called a Smart Object. A Smart Object is a special layer in Photoshop that has the unique ability to remember its origin. That means that whatever we do to it, we can always revert back to the original state if we want to, which makes our editing nondestructive.

Convert to a Smart Object for nondestructive editing.

You can tell a Smart Object by its distinct thumbnail.

▶ *Create a Smart Object.* Control+Click / Right-Click on the Background layer in the Layers panel, then choose Convert to Smart Object from the Contextual menu. You won't see any change in the image, but notice the special Smart Object icon in the Layers panel.

▶ *Make a Shadows/Highlights adjustment.*

Now choose Image>Adjustments>Shadows/Highlights from the Main menu. The image looks instantly better, and we haven't really done anything yet. Talk about easy!

Drag the Shadows Amount slider to the right and watch the shadow portions of the photo brighten further. Drag the Highlights Amount slider to the right and watch the brightest portions of the road darken. That, in and of itself, is pretty impressive, but there's more we can do.

Shadows/Highlights works instantly—simply drag the Amount sliders to taste. But there's more you can do if you click *Show More Options*.

▶ *Adjust the Shadows/Highlights options.* Click the Show More Options check box to reveal further settings. The ensuing dialog box is broken down into three major sections: Shadows, Highlights and Adjustments. The Shadows and Highlights sections are virtually identical—each has an Amount, Tone and Radius slider.

Amount refers to the strength of the brightening (or darkening) effect that Photoshop applies to the image.

Tone lets you tell Photoshop what you consider to be a shadow or highlight. For example, a 50% Tone value in the Shadows section tells Photoshop that the darkest 50% of luminosity values is considered a shadow. If you bumped that value up to 100%, you would be telling Photoshop that the entire image is shadowy and it all needs to be brightened.

Radius is hard to figure out just by observing results. Photoshop uses a radius of pixels to calculate shadow versus highlight. If you had a series of thin shadows produced by twigs, for example, you would probably need to decrease the Radius setting for a natural look. I generally use the default value of 30 pixels. If you see an undesirable halo effect creeping into the image, try changing the radius to remove it.

In the Adjustments section, *Color* changes the saturation of the colors, and *Midtone* boosts contrast in the midtones.

Although it's intended to brighten shadows and darken highlights simultaneously, you can use Shadows/Highlights to brighten an entire photo by increasing the *Shadows Tone* to 100% and setting the *Highlights Amount* to 0. You can also do just the opposite to darken an overall image.

Click the Layer Mask icon and paint or fill with black to block the Shadows/Highlights adjustment or with gray to subdue it.

Double-click *Shadows/Highlights* to edit your adjustment.

Before Shadows/Highlights

After Shadows/Highlights

▶ *Fine tune your settings.* Adjust the settings until you are satisfied with the result. I changed the Shadows Amount to 90%, the Shadows Tone to 60%, the Highlights Amount to 30%, and the Midtone to +40. I left the other values at default. Click OK to accept whatever values you prefer.

Back in the Layers panel, notice how a Smart Filters layer mask has been added beneath the Smart Object layer. You can paint on it with black, white or gray, just like you can with Adjustment layers. You can toggle the visibility by clicking the eyeballs, and you can delete the entire adjustment by dragging it to the trash. Double-click the words *Shadows/Highlights* in the Layers panel if you want to edit your settings at a later time. Thanks to the Smart Object, we have the capabilities of Adjustment layers for the Shadows/Highlights command.

Final Thoughts

It's amazing how much you can improve poorly exposed images. Sometimes an auto correction is all you need, but more often than not you can achieve better results with a manual correction using Photoshop's most powerful adjustment techniques of Levels, Curves or Shadows/Highlights. Each method has its advantages, and it's up to you to choose the one that best fits the situation. Having a good understanding of histograms is essential for doing a good job with Levels or Curves. Also, be sure to use nondestructive methods whenever possible, and use Layer Masks if you want to correct part of an image.

5

◂ *A Color Balancing Act* ▸

Rick Bate

5 ▲ A COLOR BALANCING ACT ▼

Topics

- ▶ Distinguish between the Additive and Subtractive Color Systems
- ▶ Describe how the Color Wheel is used in Photoshop
- ▶ Address color gamut issues when converting color modes
- ▶ Adjust color using Color Balance
- ▶ Adjust color using Levels and Eyedroppers
- ▶ Adjust color with Input and Output values using Curves

Preview

Color. It's a subjective and personal topic. Everyone has their own opinions, their own likes and dislikes. It's elusive, too. How do you look at an image and decide if the color is accurate? And if it needs color correcting, how will you know when it's good enough? When can you finally stop tweaking it and get on to something else?

Many people have developed a good sense for color, and adjusting color seems to come naturally for them. They just do it without much of a thought. I admire those people.

But the majority of us could use some coaching from wise old Photoshop. Because deep down in Photoshop's data lurks much of the information that we need in order to achieve accurate color balance. To access that data, we have to approach color the way Photoshop approaches it. We have to understand how Photoshop sees it, creates it and manipulates it. This chapter gives a comprehensive view of color through the eyes of Photoshop.

How is Color Created?

There are two major ways we create color. One uses light sources and the other uses pigments. The former is referred to as the Additive Color System and the latter the Subtractive Color System. Let's take a look at how they operate.

The Additive Color System

The additive color system is used by any equipment that creates or measures color emitted from light sources. Televisions, computer monitors, scanners, digital cameras and colored theater lights are examples of additive color at work. The primary colors of the additive color system are red, green and blue (RGB), and combining these primaries in various intensities enables us to create a large spectrum of color. Why is it called the additive system? If you combine R, G and B at full strength, you get white.

The Additive Colors combine to create white.

The Subtractive Color System

The subtractive color system is used by equipment that applies pigments or inks to a substrate, such as paper. Offset printing and desktop printers are examples of subtractive color applications. The primary subtractive colors are cyan, magenta and yellow (CMY), and we can mix these colors in various percentages for a full color effect. Combined at full strength they form what I call theoretical black—it's actually more of a dirty dark brown. The reason we don't get a nice rich black is that it's too difficult to manufacture inks that are truly pure. Cyan, for example, has traces of magenta and yellow when measured by spectrographic analysis. Black (K) was added to the printing process to compensate for this shortcoming. That's why we print using CMYK.

The Subtractive Colors combine to create theoretical black.

Why is this called the subtractive system? I like to think of it this way. When printing with the subtractive primary colors, you get white if you *subtract* C, M and Y. We can't get any whiter than the paper we're printing on.

The Color Wheel

Photoshop is fully aware of the additive and subtractive primary colors, and it combines them according to a color wheel model to create all the colors you see on screen or paper. You *must* memorize this color wheel if you wish to become proficient in manipulating colors in Photoshop. It's the key to understanding how Photoshop views color. Fortunately it's easy to memorize if you organize your thoughts by primary colors. Here's how.

Start with the additive colors of red, green and blue. Place red at the very top, then distribute green and blue evenly around the circumference. Relating it to a clock, that would put red at 12 o'clock, green at 4 o'clock and blue at 8 o'clock.

Now let's sprinkle the subtractive colors around the color wheel. Since subtractive is the opposite of additive, we'll start with cyan at 6 o'clock, opposite red. Magenta would then land at 10 o'clock and yellow would end up at 2 o'clock. That's all there is to it. That shouldn't be too hard to memorize, and it will make your life much easier in the future if you take the time to do it now.

R = 255
G = 0
B = 0

R = 255
G = 255
B = 0

R = G = B

Colors can be placed anywhere on the color wheel by changing the intensity of R, G and B.

Hue

Saturation

Brightness

How Colors are Born

There's a lot of excitement surrounding the birth of each pixel in Photoshop. Perhaps you weren't aware of it, but all pixels are born directly in the center of the color wheel. Immediately upon birth they are attached by bungee cords to R, G and B, and a grand tug of war ensues. The pixel's ultimate color is determined by the intensity with which R, G and B pull.

For example, if R pulls at full strength (255), and G and B don't pull at all (0), then the pixel will be dragged to pure red. If R and G pull at full strength (255) and B doesn't pull at all (0), then the pixel will become pure yellow, and so on. If R, G and B all pull at the same strength, then the pixel doesn't move off dead center. It could be white (R, G and B equal 255); it could be black (R, G and B equal 0); or it could be some gray in between, but it will always be a neutral color. That happens to be the most important formula used for color correction: if R = G = B, then the resulting color is neutral.

Measuring Colors in the Color Wheel

Notice how the color changes from red to yellow to green, and so on, as you spin around the color wheel. We refer to this as a change in *hue*, or core color, and it's measured in degrees from 0–360.

As you move from the center to the periphery of the color wheel, you increase a color's intensity, or *saturation*. Colors in the center are fully desaturated, and colors along the outer edge are fully saturated. We measure saturation in percentages from 0–100.

There's one more component to specifying color. The color wheel only gives us a portion of the story, because it's really just a cross section of the brightness cylinder. Let's say you take a red book and you toss it overboard into the ocean. As it sinks, it gets darker and darker until it appears black, just like everything else does at the bottom of the ocean. Is it still a red book? Sure, but it appears black from lack of light. Conversely, if we launched the book up into the sun, it would eventually appear white due to the blinding sunlight. We refer to this as *brightness*, and it's measured in percent from 0–100.

In short, as you spin around the color wheel, you affect a color's *hue* as measured in degrees. As you move in and out of the center, you change a color's *saturation*, measured in percentage. And as you move up and down the cylinder, you change a color's *brightness*, also measured in percentage. This is known as the HSB (Hue, Saturation, Brightness) Color Model.

The more things change, the more things stay the same.

These color theories are nothing new. In fact, Adobe owes a big debt of gratitude to a Scottish Physicist named James Maxwell, who, in 1855, described how he created the world's first color photograph. He took three black and white photos of a scene: the first with a red filter over the camera lens, the second with a green filter, and the third with a blue filter. Then he placed the film in three projectors equipped with similar filters and aimed them at the same spot on the wall. The result was a color image created using the additive color system. Things haven't really changed that much since then. Photoshop still uses this system today.

Finding the Color Wheel in Photoshop

You'll find the color wheel with its primary additive and subtractive colors interspersed throughout Photoshop. Let's take a look.

▶ *Create a new Photoshop document.* Launch Photoshop and type Command+N (Mac) or Control+N (PC) to start a new document. We're going to create overlapping circles of primary colors and watch how they blend. Choose Default Photoshop Size from the Photo Preset menu and click Create.

The Shapes tools let you create vector shapes similar to Illustrator.

Select Shape mode, click the Fill icon, then click the Color Picker icon.

▶ *Create circles filled with the primary additive colors.* The Shapes tools are located just above the Hand tool. Click and hold the Rectangle tool, then scroll down to choose the Ellipse tool. Make the following settings in the Options bar.

- Choose Shape from the Mode popup menu.
- Click the Fill swatch, then the Color Picker icon.

When the Color Picker opens, take a moment to study the contents. Do you see signs of the color theories we have been talking about? Three of the methods that Photoshop offers for specifying color—HSB, RGB and CMYK— relate directly to the color wheel.

HSB stands for hue, saturation and brightness; RGB are your primary additive colors; and CMY(K) are your primary subtractive colors. Use the RGB fields and type in the following values: R=255, G=0 and B=0. There's our bungee cord tug of war, with red pulling at full strength, and green and blue not pulling at all. Press Return / Enter to accept the color, then once again to dismiss the Fill popup menu in the Options bar. Now move your cursor over the canvas and Shift+Drag to create a perfect red circle.

Switch to the Move tool. Place the cursor over the red circle, then Option+Drag (Mac) or Alt+Drag (PC) diagonally down towards the right, leaving some overlap. Option / Alt+Drag once again towards the left to create a third overlapping circle. You should now have three red circle layers in the Layers panel.

Double-click the middle layer thumbnail to open the Color Picker and change the color to green: R=0, G=255, B=0. Then double-click the top layer thumbnail and change that color to blue: R=0, G=0, B=255. There are our primary additive colors.

Option+Drag (Mac) or Alt+Drag (PC) to duplicate a fill layer.

▶ *Create circles filled with the primary subtractive colors.* Click on the canvas with the Ellipse tool to create our first subtractive color circle. The Ellipse tool remembers the diameter of the last circle you created, so click OK to accept the values given in the Width and Height fields. Double-click the thumbnail on the new layer and change the color to solid cyan: C=100, M=0, Y=0, K=0.

Option / Alt+Drag the new circle upwards to the left to copy it, then double-click the thumbnail and change that color to magenta: C=0, M=100, Y=0, K=0. Finally, Option / Alt+Drag a third circle directly to the right. Double-click its thumbnail and change the color to yellow: C=0, M=0, Y=100, K=0. We now have both sets of primary colors. In case you hadn't noticed, I positioned all of the colors in the approximate positions of the color wheel.

Double-click a layer thumbnail to change the fill color.

▶ *Blend the colors.* Do you remember how I said that R + G + B = White and C + M + Y = Theoretical Black? We can make that happen by changing Layer Blending modes. Before we begin, click the eyeball for the *Background* layer to turn its visibility off. Otherwise it will interfere with our blending experiment. The checkerboard pattern you see is Photoshop's way of indicating transparency.

Starting with the CMY Colors, select the yellow layer and change the Blending mode popup menu from Normal to Multiply. Do the same for the magenta layer. It's not necessary to do it for the cyan layer, because it's the lowest layer of the group, and blending only affects how colors mix with underlying layers. The Multiply mode simulates how inks mix when they overlap.

Drag-copy the cyan circles in this direction so they align with the color wheel.

Now change the Blending mode for the green and blue RGB colors to Screen. The Screen blending mode simulates how lights mix when they overlap. We now have the primary colors, along with various mixtures of the colors, placed in the approximate positions that they occupy on the color wheel.

The Multiply mode simulates ink on press. The Screen mode simulates light.

▶ *Why don't these colors match?* Take a close look at the color combinations created by the additive versus subtractive colors. Do you notice a discrepancy? In the RGB group, for example, we have cyan where the green and blue circles overlap. In the CMY group, we have cyan as a primary color. Yet the two cyans don't match. Why not? It's due to the impurity of our inks. Photoshop is fully aware of our ink manufacturing shortcomings, and it's trying to give us an accurate representation of how cyan would look when printed on paper. In other words, Photoshop is giving us real world limitations, not theoretical perfection. That's a good thing.

▶ *Change Hue, Saturation and Brightness.* Let's have a little fun with the colors. Select the top most layer, then choose Hue/Saturation from the Adjustment Layer icon to add a Hue/Saturation layer at the very top. In the Properties panel, drag the Hue slider and watch what happens as you spin around the color wheel. Drag the Saturation slider and move back and forth between the center of the color wheel to its periphery. Drag the Lightness slider and climb up and down the cylinder. Yet another affirmation that Photoshop is always thinking color wheel.

The Hue/Saturation adjustment layer is yet another way that Photoshop lets you move pixels around the color wheel.

The RGB additive colors blended using Screen mode.

The CMY subtractive colors blended using Multiply mode.

Gamut! We Have a Problem.

▶ *Understanding RGB Color Channels.* Open *Flowers.jpg*, another beautiful photo from Phyllis Bankier. Do you remember the three black and white photos that James Maxwell took using RGB filters, then blended together using filtered projectors to create the first colored photo? Those black and white photos are right here in Photoshop, functioning just the way that they did back in Maxwell's day.

Click on the Channels panel or, if you can't find it, choose Window>Channels from the Main menu. There they are, the three filtered black and white photos loaded into red-, green- and blue-filtered projectors. Click the word Red to see the photo taken with the red filter, then click Green and Blue to take a look at those photos. Clicking on the RGB composite channel is like turning on all three projectors at once, each with its own red, green or blue filter in front of the lens. In the case of your computer monitor, the filters have been replaced by individual red, green and blue light sources. So you see? Photoshop is really rooted in 1850's technology.

Photoshop files give you the *illusion* of color. What they really contain is a mixture of grayscale images that filter red, green and blue light.

Phyllis Bankier

Red **Green** **Blue**

The color photo above was created from the grayscale images contained in the Red, Green and Blue color channels.

Here's how Photoshop channels work in RGB color mode. Focus on the beautiful violet colored flowers, then view each channel independently and compare the differences. Do you see how much brighter the violet colors are on the blue channel? Each channel acts like a mask that determines where the light can and cannot pass through. Light passes freely through white areas but is blocked by dark areas. By viewing the individual channels, you can tell that the violet is made up of a strong blue color component with lesser amounts of red and green.

▶ *Understanding CMYK Color Channels.*

Let's move over to the world of subtractive color, a world where inks are blended using cyan, magenta, yellow and black. When we convert to CMYK color mode, we'll have four channels instead of three. Which color mode do you think will give us a larger color range? Doesn't it make sense that you could create more color combinations with four channels than with three? Let's make the conversion and find out.

Choose Image>Mode>CMYK Color from the Main menu. Click OK if you encounter a warning indicating that you are about to convert to the *U.S. Web Coated (SWOP) v2* profile. What happened to the violet colors? Didn't they become duller? Choose Edit>Undo CMYK Color or type Command+Z (Mac) or Control+Z (PC) to toggle back and forth between RGB and CMYK modes.

What would happen if we left it in CMYK mode and later decided to convert it back to RGB? Would we regain the vibrant color that we lost? Make sure you are in CMYK mode (look at the Title bar), then choose Image>Mode>RGB Color and watch what happens. Nothing! Gamut! We have a problem.

The CMYK mode has a smaller range of colors, called a color gamut, than the RGB mode, and it relates directly to the impurities in our inks. When we shift from RGB to CMYK color mode, Photoshop has to move all of the out-of-gamut RGB colors into the smaller CMYK gamut. If we later convert back to RGB, the lost colors aren't recovered, because Photoshop doesn't remember where they originated from.

We cannot replicate all of the colors in nature using either RGB or CMYK technologies, but RGB has a larger gamut than CMYK.

There are two important lessons to be learned from this.

- Just because it looks good on screen doesn't necessarily mean that it will look good in print. Be careful of this when you make promises to people you are doing work for.
- Work in RGB color mode for as long as possible, because you often lose data when you convert to CMYK. Also, always save a copy of the original RGB document, so you can revert back to it for future use.

One more item. Take a look at the individual CMYK color channels. They form the basis for the individual printing plates used on press. As additive is the opposite of subtractive, so are CMYK channels the opposite of RGB channels. Now dark areas indicate a prominence of color, because those are the areas with the most ink coverage.

For CMYK channels, black is solid ink and white is no ink.

Cyan Magenta Yellow Black

CMYK color is created using Cyan, Magenta, Yellow and Black plates. Darker areas have a higher density of ink.

Balancing Color

Now it's time to take all of this color knowledge and put it to use balancing color. As always, there are many ways you can do this. We'll be focusing on the Color Balance Adjustment layer, Eyedroppers in Levels or Curves, and using input and output values in Curves. Each method deserves its moment in the spotlight. It's up to you to understand them all and choose the method that best matches the situation.

Making an initial color analysis

Regardless of the color adjustment method you use, you should always begin with a visual assessment and histogram analysis.

▶ *Make a visual assessment.* Open *Scott and Danielle.jpg*, my nephew and his wife. Does this image need color correcting? If so, what colors are off? Look for objects that contain a target color that you can identify with. Neutral gray is the easiest target color to work with, because it has the known formula of R = G = B. It's also easier to detect a color cast on top of neutral colors than on other colors. If you can't find a neutral color, look for *memory colors*, which are identifiable colors, such as skin tones or food, that are easy to relate to.

Try to focus on neutral colors when making a visual color assessment. The collar of Scott's T-shirt is probably the most reliable color reference in this photo. Also check for good skin tone color.

▶ *Analyze the histograms.* Choose Window>Histogram to bring up the Histogram panel. Then from the Histogram flyout menu, choose All Channels View and Show Channels in Color, so you can compare all channels at once. Can you find any weaknesses in the histograms? As we learned in the last chapter, a typical healthy histogram extends from end to end and is fairly well balanced. Furthermore, an image with good color balance usually has histograms that are similar from channel to channel. In our example, the red and green histograms extend more completely into the highlights than the blue channel. That's a red flag that there may be a color balance problem. It appears that our image could also benefit from an overall luminosity adjustment, because all channels are a little lacking in the highlights region.

Armed with that information, we're ready to pick a color balance method and proceed. We're going to start with Color Balance—an obvious choice because of its name—and then we'll compare it to other methods.

The Red and Green channels look quite similar, but the Blue channel looks much weaker in the highlights. This is a clue that we may have a color balance problem.

Color Balance Adjustment Layer

▶ *Add a Color Balance Adjustment layer to the image.* This is the common choice for those who feel they have an innate ability to correct color. Take a look at the settings in the Properties panel. It's the color wheel once again. Do you notice how complementary colors are placed opposite each other on sliders? When you adjust those sliders, you're dragging the pixels around the color wheel, very much like the tug of war analogy that I used earlier.

The Tone popup menu lets you concentrate your efforts on the Midtones, Shadows or Highlights. It's no coincidence that Midtones is the default selection, because that should always be your first adjustment. As Midtones come into color balance, so do Shadows and Highlights. Only if that doesn't happen, should you make a special effort to adjust Shadows or Highlights independently.

Sometimes your image gets darker or lighter as you make color adjustments. If that happens, you can check the Preserve Luminosity box to maintain a constant overall exposure.

From here you're on your own to adjust as you see fit—which brings up one of the weaknesses of this procedure. This method has you making all of your decisions based on what you *see*. What if your monitor is poorly calibrated? Then you're basing your decisions on inaccurate information. For this reason, Color Balance is not usually the preferred method for color professionals. Nevertheless, you can become pretty efficient with Color Balance through trial and error, as you learn from experience how your final prints compare to what you saw on screen. If you plan on using Color Balance regularly, I would recommend investing in good color calibration software.

Color Balance seems to be the obvious choice if you want to balance color.

Try it out. Adjust the color to the best of your ability. How well did it work? Leave the adjustment layer intact, but turn off the eyeball. We're going to compare your Color Adjustment results with three other methods.

The sliders of complementary colors let you shift the color balance of your image. Adjust Midtones first, then Shadows and Highlights if necessary. Remember that we identified a weakness in the blue histogram. The Yellow/Blue slider would probably be a good place to start. Other than that, you're on your own. I can't give you any magic numbers.

Manual Levels Adjustments

▶ *Add a Levels adjustment layer.* Rename the layer Manual Levels, then look at the individual RGB histograms in the Properties panel. The red and green channels lack pixels in the highlights region, but not to the extent of the blue channel. It has a much larger void in highlight pixels, indicating a potential color balance problem. Correct that by dragging the Black and White Point sliders to the foothills for each channel. Do *not* adjust the composite RGB histogram because that would be making a double adjustment. Adjusting the RGB composite is really just a shortcut to adjusting the red, green and blue channels in exactly the same way. In this case, we want to adjust the RGB histograms individually. You'll notice that the Composite RGB histogram spreads out after you adjust individual channels.

Your photo should look much cleaner after the adjustment—void of the yellowish cast that plagued it before. It's amazing how often this little trick works, but it won't always. As with auto corrections, this technique presumes that the image is "typical."

Now turn off your *Manual Levels* eyeball in preparation for making an *Eyedropper* adjustment.

Adjust histograms in the Red, Green and Blue Channels only.

Original

Color adjusted by dragging individual White and Black points

Gray Point Eyedropper

▶ *Add a new Levels adjustment layer.* **Rename it** Eyedropper. The Levels Properties panel has three eyedroppers that let you click in the image to set the Black Point, Gray Point and White Point. The primary function of the Black and White Point Eyedroppers is to improve your image's contrast, although they also can affect color balance to a degree. Basically, the Black Point Eyedropper moves the Black Point slider for each channel in an effort to make the point you clicked truly black. The White Point Eyedropper does the same for the White Point. The purpose of the Gray Point Eyedropper is different. Its attempts to neutralize the point that you click by averaging its R, G and B values and making them all equal. We can watch that happen.

Choose the Color Sampler tool from the Tools panel. It's located underneath the Eyedropper. The Color Sampler tool lets you monitor RGB values in strategic spots of your image and compare before and after results when making an adjustment.

Click on Scott's T-shirt to set a color sampler point there. It's a safe bet that the T-shirt should not have a color cast. Open the Info panel and you should see the RGB values of the spot you just clicked. If you don't see it, make sure that *Color Samplers* has a check mark next to it in the Info panel flyout menu. The values from the point I clicked are R = 152, G = 163 and B = 120. Your values will vary depending on the specific point that you clicked.

The Color Sampler tool lets you monitor RGB values.

The RGB values for the color sample point are 152, 163 and 120. The values after the slash will change after we make an adjustment.

Add a Color Sampler Point to the T-shirt.

Now select the Gray Point Eyedropper from the Properties panel and click the sample point on Scott's T-shirt. Your image should look instantly better, and the Info panel should now have a new set of values with balanced numbers, plus or minus a couple. The RGB values that I got were 146/146/145. How did Photoshop do that? Simply by moving the Midtone slider for each channel until it brought the R, G and B values into balance.

By identifying part of the image that should be neutral and clicking on it with the Gray Point Eyedropper, we were able to bring the photo into color balance. If you have a reliable neutral point in your image, correcting color is fast and easy. Color professionals love gray.

Click on a neutral color in your image with the Gray Point Eyedropper to remove an unwanted color cast.

The numbers after the slash represent the adjusted values after the Eyedropper.

Original

Color adjusted using the Gray Point Eyedropper.

This Info panel shows two sample points. Numbers before and after the slash are identical, because no adjustment has been made as of yet.

Correcting Color with Curves

The ability of Curves to make multiple midpoint adjustments also makes for greater precision when it comes to color balance. The procedure we are going to use is similar in concept to the Gray Point Eyedropper, but with Curves, we'll be able to correct more than just one gray point.

▶ *Open Race Car 1.jpg.* Taken at the Milwaukee Mile by former WCTC student Billy Knight, this photo, with its wide expanse of pavement, gives us the opportunity to make multiple gray point corrections. It's a color corrector's dream come true.

Add a Curves adjustment layer, then using the Color Sampler tool, place one sample point on a bright part of the pavement and another on a dark part. When using this method, it's important to avoid creating sample points that are too close in luminosity value, because it can cause erratic curve behavior. It's also best to stay in the midtone range. Don't select black or white objects.

Look at the Info panel. The RGB values before the slash are the Input values, the image's values before the Curve's adjustment. We want to average those, so that the values after the slash are all equal to one another. Those are the Curve's Output values. The RGB values that I have for my first point are 165, 175 and 205. I'm going to average them and choose 182 as my new target value.

Select the Red channel in the Properties panel and click on the Brightness curve to add a point. It doesn't matter where you click, because we are going

Adjusted Red Points · Adjusted Green Points · Adjusted Blue Points

to place the point numerically. Type the red value before the slash into the Input field, then type your new target value into the Output field. My red Input/Output numbers are 165/182. Now repeat the procedure with the Green and Blue channels. Remember to always add a point first, then type the Input value from the Info panel followed by your Output target value.

After you have finished point one, start all over again with point two. The only difference is that you have to place your new point in the proper curve segment relative to point one. For example, if your second point is brighter than your first, make sure to add your new point in a higher, brighter part of the curve.

This is the most precise of the color correction procedures that we discussed, and it's very quick to boot. The catch is that you need to have a reliable neutral source or other known target color to use. Then it's simply a matter of typing in the appropriate Input and Output values.

The RGB numbers before the slash show the values before the curves adjustment. The numbers after the slash show the adjusted values.

This photo shows the original before using curves. Place color sample points on a light and dark portion of the concrete.

Color was brought into balance by neutralizing light and dark points on the concrete.

Final Thoughts

In order to be competent when it comes to working with color, you have to be able to understand and view color the way Photoshop does. That means having a full understanding of how the primary additive and subtractive colors blend to create the full spectrum of color that we see on screen or in print. It also means understanding the Hue/Saturation/Brightness model depicted with the color wheel. If you feel comfortable with these topics, then correcting and manipulating color is not such a mysterious, hit-or-miss chore.

As always, Photoshop gives you a wide choice of methods you can use to achieve your goal. Each method has its advantages and disadvantages. A Color Balance Adjustment layer lets you adjust color based on your own visual assessment. Auto color adjustment techniques are quick and easy but only work if you are dealing with a typical image, and they don't afford you any input. Neutralizing gray tones using the Gray Point Eyedropper or Input/Output values in curves is highly accurate, but you can't use it if your image doesn't contain a gray object for you to target. Your initial color assessment of an image is an important factor in determining which color adjustment method is best for that particular situation.

> *The source and center of all man's creative power... is his power of making images, or the power of imagination.*
>
> ▸ *Robert Collier*
> *American motivational author, 1885–1950*

‹ *Retouching* ›

6

Mitch Potrykus

Topics

- ▶ Create colorful backgrounds using the Gradient tool.
- ▶ Create custom gradients using the Gradient Editor.
- ▶ Specify Brush Tips by size and hardness.
- ▶ Use custom Brush Tips for special effects.
- ▶ Use the Brush panel to modify Brush Tip settings.
- ▶ Create custom Brush Tips from artwork.
- ▶ Remove red eye with the Red Eye tool.
- ▶ Use the Clone Stamp, Healing Brush, Spot Healing Brush and Patch tools to retouch an image.
- ▶ Brighten teeth using Hue/Saturation.

Preview

I remember back in my early ad agency days bringing photos to the retouching studio to prepare them for use in ads or brochures. We had the retouchers remove blemishes, add lettering, enhance or subdue detail, airbrush new backgrounds, all sorts of things. I always admired the dexterity of the airbrush artists—they did things I never ever dreamed of doing. But then my visits to the retouching studio began to decline soon after Photoshop was introduced. Suddenly I could do things I hadn't been able to do before—all because of Photoshop. And I was having fun doing it. I never considered myself an artist, and I still don't. For the artistically inclined, the sky is the limit! Do you see that chipmunk on the left? My former student, Mitch Potrykus, created it from scratch using brushes in Photoshop! The proper tools in the proper hands is a surefire recipe for success.

6 ▲ RETOUCHING ▼

An Overview of the Retouching Tools

The tools that we will be covering in this chapter reside in the Tools panel starting with the Spot Healing Brush and going down through the Dodge tool. We won't be touching on all of them, but we will hit the major ones.

Gradient Tool

At the ad agency, we often used airbrushed gradient backgrounds to feature industrial type products in a more pleasing setting. Creating such a background was a time consuming process requiring a steady hand and an airbrush that didn't spit. Photoshop makes this task easy.

▶ *Create a linear gradient.* Create a new document of any size. Select the Gradient Tool, the sixth tool in the retouching tools group. Click the Foreground and Background Color swatches at the bottom of the Tools panel and choose a couple of colors from the Color Picker—any colors, your choice.

In the Gradient Tool Options bar, click the down arrow to the right of the Gradient Sample icon to view the Gradient Picker. When the pop-up menu appears, click the very first gradient swatch—Foreground to Background—then hit Return/Enter to accept that. Now click the next icon to the right to choose a Linear Gradient style.

With your options all set, simply drag in the canvas area with the Gradient tool. You have just created a perfect airbrush-style linear gradient background. Drag a few more times, changing the length and direction of your drag. Do you see how that works? The starting point is your foreground color, the ending point is your background color, and the area in between blends evenly from foreground to background.

Retouching Tools, Gradient Tool selected.

Click to set Foreground and Background colors.

The Gradient Picker lets you choose from several predefined Gradient Swatches. The first one is Foreground to Background.

Gradient Tool Options

Gradient Preset | Gradient Sample | Gradient Picker | Linear | Radial | Angle | Reflected | Diamond | Blending Mode | Opacity | Reverses order of colors | Reduces banding | Activates transparency stops

▶ *Create other gradient styles.* Click the other gradient style icons in the

◀ Chapter 6 ▶ 135

Options bar and try those out as well. This includes Radial, Angle, Reflected and Diamond. That's a lot of choices. How many gradients have you created so far? It used to take airbrush artists hours to do one.

Choose from five gradient styles.

▶ *Select other gradients with the Gradient Picker.* Click the down arrow next to the Gradient Sample and test out the other swatches. Each time you drag, you replace your old gradient with a new one. That is, until you try the last three gradient samples. They have transparency built into them, so you will still be able to see remnants of your previous gradient underneath.

Linear Gradient

Radial Gradient

Angle Gradient

Reflected Gradient

Diamond Gradient

Drag with the Gradient tool to specify a starting point, ending point and direction for the gradient. These gradients were all created by dragging down to the right, as indicated.

▶ *Use the Gradient Editor to create a custom gradient.* Now click the Gradient

Click the Gradient Sample to access the Gradient Editor.

Opacity Stops

Color Stops

Color Stop Text Fields

Opacity Stop Text Fields

Noise gradient

Sample itself, not the down arrow next to it. This brings you to the Gradient Editor where you can design and save your own custom gradients.

The first section, labeled *Presets*, is just a repeat of the gradient swatches that you can access directly from the Options bar. The section below, labeled *Gradient Type*, lets you modify any of the existing presets to create your own custom gradient. As you click different gradient swatches, you can see the recipe that was used to create that particular gradient.

Solid Gradient Type

Choose Solid as the Gradient Type if it's not already selected and leave the Smoothness at 100% for gentle transitions between colors.

The icons below the gradient bar are color stops. Here are some ways you can edit one:

- Drag a color stop to relocate it.
- Drag a color stop away from the gradient bar to delete it.
- Click below the gradient bar to add a new color stop.
- Option+Drag (Mac) or Alt+Drag (PC) to copy a color stop.
- Double-click a color stop to change its color.
- Select a color stop and use the text fields below to change its color or location.

The icons above the gradient bar are opacity stops. You work with an opacity stop in similar fashion.

- Drag an opacity stop to relocate it.
- Drag an opacity stop away from the gradient bar to delete it.
- Click above the gradient bar to add a new opacity stop.
- Option+Drag (Mac) or Alt+Drag (PC) to copy an opacity stop.
- Select an opacity stop and use the text fields below to change its opacity or location.

Noise Gradient Type

Change the Gradient Type to Noise for a new set of options. Noise gradients are all randomly generated. You can impose some restrictions as to how Photoshop creates them, but you can't really control the results. If you don't like a gradient, click the Randomize button to change it. The *Roughness* setting affects how smoothly colors transition from one to the other.

In the *Color Model* section, you can specify a color model for Photoshop to use, and you can restrict the color palette by dragging the black and white sliders on the color bars closer together. Photoshop will not use any color outside of the sliders.

The two check boxes in the *Options* section let you restrict the saturation of the colors in the gradient or randomly add transparency stops.

▶ *Save a gradient preset.* If you want to save a gradient you created, give it a name and click the New button. Your gradient is now a member of the presets, and you can choose it at any time from the Options bar.

If you want to transfer the gradient to another computer, click Save to create a *.grd* file of your entire group of presets, then use Load from the Gradient Editor on a different computer.

Gradient Editor with the Solid Gradient Type
Solid gradients give you smooth transitions from color to color. Color stops let you specify colors and location.

Gradient Editor with the Noise Gradient Type
Noise gradients are created from randomly generated colors. Drag the RGB sliders closer together to restrict the colors used to generate the gradient. Click *Restrict Colors* to prevent colors from oversaturating.

The Brush Tool

The Brush tool itself works pretty much like a standard brush, but wait until you see the wealth of options and how many brush tips you have at your disposal. You can even create your own custom brush tip.

▶ *Brush Preset picker.*

Type B to choose the Brush tool and look at the Options bar. The very first icon lets you choose from Tool Preset options or save your own. The next icon opens the Brush Preset picker, where you choose a brush tip and alter its size and hardness. The brush tips you'll use most often are in the General Brushes folder. The first two are standard soft and hard brush tips for mouse users. The next six offer pressure sensitive capabilities for tablet users. Below that are several folders containing specialty brush tips from dry and wet media brushes to special effects brushes and more.

Specify brush size and hardness.

Recently used brushes.

A wide selection of brush tips lets you paint in a variety of ways.

The Brush Preset picker lets you select and adjust a brush tip. Choose *Import Brushes* or *Get More Brushes* from the Flyout menu for additional brush tip libraries.

▸ *Brush Mode.* The Mode option lets the brush blend in different ways as you paint over the top of other pixels. I rarely specify a brush blending mode, because you have more flexibility if you use the blending modes in the Layers panel instead.

▸ *Opacity.* Opacity creates a transparent effect as you paint. But here again, I prefer to paint on a separate layer and use the layer's opacity option instead. The icon to the right of Opacity enables pressure sensitivity for tablets.

▸ *Airbrush and Flow.* The next two icons let your brush function like a traditional airbrush. Click the Airbrush icon to put your brush into Airbrush mode. Flow controls the intensity of the spray. Click and hold with your brush to see the spray effect. If Airbrush mode is not selected, then Flow works similarly to Opacity.

▸ *Smoothing.* The smoothing options are a wonderful way to hide the inevitable jittery look of freehand drawing. Control the degree of smoothing by specifying a smoothing percentage. Then click the Smoothing Options icon and select a smoothing technique. All of the smoothing techniques introduce a slight delay as you paint, giving Photoshop the opportunity to smooth your stroke as you paint.

▸ *Pressure Sensitivity.* The last icon lets you change brush size when working with pressure sensitive tablets.

▸ *Brush drawing techniques.* Here are a couple of techniques you can use to enhance your brush precision.

- Drag to create a freehand brush stroke.
- Shift+Drag to draw a perfect horizontal or vertical line.
- Shift+Click to draw straight lines in connect-the-dots fashion.
- Use the Rotate View tool to draw lines at a set angle. Let's say you wanted to draw a line at a 45° angle. Type R to select the Rotate View tool and type 45° in the Options bar to rotate the canvas view. Now Shift+Drag a horizontal line with the Brush, followed by Escape to exit Rotate View mode.

An alternative to using Brush Blending modes is to use the Blending options in the Layers panel.

Reduce opacity for a transparent effect.

Flow controls the intensity of an airbrush spray.

Smoothing takes the jitters out of your brush strokes.

▶ *Customize brush tips with the Brush Settings panel.* Click the Brush Settings panel icon in the Options bar or choose Window>Brush Settings from the Main menu to open the Brush Settings panel. This panel not only lets you choose a brush preset, but you can customize its features as well.

In typical Adobe fashion, you have a list of categories along the left side, complemented by a set of controls on the right. Click on a category to select it, then change the settings on the right as desired. A check mark to the left of a category indicates that its features are actively contributing to the brush tip's appearance. If there is no check mark, the category's effects are not being applied. The large brush preview at the bottom updates as you adjust your settings. You really have to experiment with this panel to get a feel for its capabilities. Here's a brief summary of what the various categories do.

Brush Tip Shape controls the size, angle, roundness, hardness and spacing of a brush tip. When Photoshop lays down a brush stroke, it doesn't create a continuous line but rather a series of "ink droplets". The line is smoother with tight spacing, but it requires more processing power and may cause stuttering as you draw. A larger spacing spreads the droplets apart.

Shape Dynamics lets you dynamically change the size, angle and roundness of the brush tip through the use of jitter options. Think of jitter as a degree of randomness. For example, if you set your size jitter to 100%, your brush diameter would continually change as you draw. Use the minimum diameter to control how small it could get.

Brush Tip Shape: Angle, Roundness and Spacing

Shape Dynamics: Size, Angle and Roundness Jitter

Scattering spreads ink droplets like throwing grass seed.

Texture lets you superimpose a texture onto your brush stroke.

Dual Brush lets you place one brush tip inside another. Brush number one is the brush you specified in Brush Tip Shape. Brush number two is the brush you specify using the Dual Brush controls.

Color Dynamics lets you introduce randomness of color.

Transfer controls randomness of opacity and flow.

Brush Pose adjusts tilt, rotation and pressure for certain brushes.

Noise adds a speckle effect along the edges of soft brushes.

Wet Edges gives you a finger painting effect when using soft brushes.

Build-up simply turns on the airbrush option in the Options bar.

Smoothing turns the smoothing function on or off.

Protect Texture helps assure a consistent texture pattern when using textured brushes.

▶ *Create custom brush tips from artwork.* So you have all these brush tip options and you still can't find the right one! Don't worry. Photoshop lets you create your own. It's easy.

- Create black on white artwork any way you want. It can even be type. If you use color, your brush tip can never look opaque.
- Drag a rectangular marquee around the artwork.
- Select *Edit>Define Brush Preset* from the Main menu and name it. Your new brush tip will now be the last item in the Brush Preset picker.

Define the brush with black artwork.

Paint with any color you want.

Red Eye Tool

Select the Red Eye tool.

Click on the red part of the eye.

▶ *Remove Red Eye.* Open *Girl.jpg*, a photo of an attractive young girl taken by Shari Kastner. Chances are that the first thing that strikes you is the glaring red eye that frequently plagues users of today's compact digital cameras. Fortunately Photoshop makes it very easy to eradicate.

Zoom in on the eyes to get a better view, then select the Red Eye tool, which is located under the Spot Healing Brush. Click on the red part of her eyes, and just like that, the problem disappears. The tool is programmed to seek out red and darken it. If you still see a slight red ring around the pupils, try increasing the *Pupil Size* or *Darken Amount* in the Options bar. If the pupils enlarge too much, try a smaller Pupil Size or Darken Amount. I have rarely had to do either of those two options. The default seems to work quite reliably.

Speaking Photoshop…

What causes red eye?

Red eye is a fairly common problem with today's compact cameras. It happens when light from the flash reflects off the back of the eyeball and back into the camera's lens. The red you see is actually blood. In order for red eye to happen, the flash and lens have to be close enough together to allow the light to travel *in and out* through the pupil. If the angle is too wide, light does not reflect back out, and you have no red eye problem. There are two ways you can prevent red eye.

1. Move the flash further away from the lens to create a wider flash-to-eyeball-to-lens angle.

2. Make the pupil smaller for a narrower target. Red eye reduction features on cameras do just that by firing preflashes intended to contract the pupil.

David Espurvoa

Clone Stamp Tool

The next thing that a Photoshopper is likely to do when working on close-ups is remove any blemishes that can be found. There are many ways we can do this, and I want you to get a feel for the pros and cons of the various methods. For years and years, our best and almost only option was to use the Clone Stamp tool. It lets us copy portions of an image (the source point) and deposit them elsewhere (the destination). Even though there are now other tools that can remove blemishes easier, you'll still find the Clone Stamp tool to be the best option under certain circumstances.

▶ *Clone Stamp tool options.*

Select the Clone Stamp tool—it's in the third slot down in the retouching tools section. The first order of business is to set options in the Options bar. You'll notice that many of the options are identical to the brush options.

Click the Brush Preset picker and choose the first soft round brush tip. If you use a hard brush to remove blemishes, it's too easy to see where your cloning starts and stops. A soft, fuzzy brush helps blend source and destination points together. You can drag the Size slider to adjust the size, but in most cases you'll find it easier to use keyboard shortcuts as you clone. Type [to decrease the diameter or] to increase it. You can also Control+Option+Drag Right or Left (Mac) or Right-click+Alt+Drag Right or Left (PC), just as you can with the brush.

The Clone Source panel lets you set specific source-to-destination cloning options such as distance, size and angle. We won't be needing these.

Leave the Mode set at normal, and the Opacity and Flow at 100%.

Aligned should be checked. It establishes a fixed position between source and destination points.

The Sample option lets you choose between *Current Layer*, *Current & Below* or *All Layers*. Change this to Current & Below. That will allow us to create a blank layer to accept our cloning edits and give us nondestructive editing. If we left it at Current Layer, we could only clone onto the layer we are working on, making it more difficult to recover parts of the image that we inadvertently damage.

Clone Source Panel

Aligned causes source and destination points to move in tandem.

Current and Below lets the Clone Stamp tool sample the active layer and layers beneath it.

Ignore Adjustment layers prevents double adjusting sampled areas.

Be sure to set the Clone Stamp tool options to *Current & Below* or *All Layers* when cloning to a separate layer.

The next option tells the Clone Stamp tool to ignore Adjustment layers when it clones. You usually want to select that option. Otherwise the Clone Stamp tool deposits an *adjusted* sample as you clone. The problem is that the Adjustment layer is still actively affecting all layers beneath it, so that particular area receives a double adjustment.

Before we get down to the serious business of removing blemishes (she doesn't have that many), let's have a little fun as we learn about the tool's capabilities.

▶ *Experiment with the Clone Stamp tool.* This little warm-up exercise will help you get a feel for the Clone Stamp tool. But first, we want to set up our cloning edits in a nondestructive fashion. Click the New Layer icon to add a blank layer above the background and rename it Clone Stamp. This lets us clone without destroying the Background layer, provided we specified Current & Below or All Layers in the Options bar, so double check that setting.

▶ *Use the Clone Stamp tool at add a mustache.* Working with the Clone Stamp tool is a three step process. First we have to establish a source point, then a destination point, then we have to do our cloning.

1. *Define the source.* Option+Click (Mac) or Alt+Click (PC) on a section of the girl's hair. This lets Photoshop know what part of the image you would like to copy.

2. *Define the destination.* Click on her upper lip to let Photoshop know that's the area you want to clone to. Not only does this deposit one brush full of source material, but it also establishes a source-to-destination relationship. Those two points are now connected as if with a stiff wire.

3. *Complete the clone.* Continue to click or drag to add to the mustache. As you do so, watch how the source and destination points move in tandem. That's because we selected the *Aligned* option earlier. If we hadn't, each new click would return to the original source point. As you work you may find it necessary to reestablish a new source-to-destination relationship. To do that, simply Option+Click (Mac) or Alt+Click (PC) to start the process over again.

◀ Chapter 6 ▶ 145

Option+Click (Mac) or *Alt+Click* (PC) to define the source.

Click to define the destination. Continue clicking or dragging to complete the clone. Source and destination points move in tandem.

Continue to experiment on your own until you feel comfortable with the process. Perhaps you want to add a third eye onto her forehead. The Greeks used that to symbolize clairvoyance. When you're done messing around, type Command+A (Mac) or Control+A (PC) to select all the pixels on the *Clone Stamp* layer and hit Delete/Backspace to erase them. Deselect the marching ants, then we'll get down to some productive work.

▶ *Remove the blemishes.* This is a much more practical application for the Clone Stamp tool. Magnify the girl's face and clone out any blemishes you can find. There are a couple of things to keep in mind as you do this:

- Use a fuzzy brush for a good blend and make it slightly larger than the blemish you want to delete.
- Set a source point close to the blemish to assure a good color match. Pay particular attention to shadow lines.

Remove blemishes with a soft brush and keep source and destination points close together.

- *Remove the necklace.* Now for a more challenging exercise. Use the Clone Stamp tool to remove her necklace. Here are some things to keep in mind as you tackle this:

 - Use a large brush for areas out in the open, then switch to a smaller size for tight quarters.
 - Be careful of repeating patterns creeping into your clones. Reset your source point more frequently if this happens.
 - The hardest areas to achieve a natural look are along sharp shadow lines. Pick your source and destination points carefully. A larger brush blends these areas better, because it has more fuzz than a small brush. Unfortunately a larger brush doesn't work well in congested spots where necklace meets hair, meets skin. Those areas will be your toughest challenge.

When you are done, turn off the eyeball for your Clone Stamp layer. We're going to do it all over again with a different tool.

Pay close attention to the shadow lines as you clone away the necklace.

Shari Kastner

Healing Brush Tool

The Healing Brush tool is located in the first slot of the retouching tools underneath the Spot Healing brush. Unlike the Clone Stamp tool, the Healing Brush has a blending function to help cloned pixels blend into their surroundings. Because of that, it's not necessary to use a soft brush, and the *Aligned* option is turned off by default. That's because you don't have to be as picky about matching your source and destination points.

▸ *Create a new layer for nondestructive editing.* Add a new layer and name it Healing Brush. Make sure that Current & Below or All Layers is selected in the Options bar, so we can use the new layer.

▸ *Remove the blemishes.* Option+Click (Mac) or Alt+Click (PC) anywhere on the skin to set a source point. Select a brush size that is slightly larger than the blemishes and click away. Even if the color from the source point doesn't match exactly, the blending capability of the Healing Brush more than makes up for it. Notice that the original source point is used every time you click. Without *Aligned* checked, there is no "stiff wire" connection between source and destination. For removing blemishes, the Healing Brush tool is easier to use than the Clone Stamp tool.

▸ *Remove the necklace.* Experiment with different options as you remove the necklace. I liked using a soft brush and switching from Normal to Replace mode. Results should be good in open areas but less effective along the hairline. That's because the blending function becomes a detriment in areas of detail. Turn off the eyeball to the Healing Brush layer; we're going to try yet another tool.

The Healing Brush left a dark smudge where the necklace was and had trouble along the hairline. This is an example of where blending capabilities are a hindrance.

Spot Healing Brush

The Spot Healing Brush automatically samples its source from surrounding pixels, so you don't have to set a source point like you do for the Clone Stamp and Healing Brush tools. There are three different ways it can sample pixels, and they are listed in the Type section of the Options bar.

- **Content Aware** performs a sophisticated analysis of the surrounding area and tries to recreate patterns formed by key details and object edges. It's the default sample type and probably your best bet.
- **Create Texture** samples pixels inside the brush tip as its source.
- **Proximity Match** samples surrounding pixels to use as a source.

▶ *Create a new layer for nondestructive editing.* Add a layer and name it Spot Healing Brush. Make sure that *Sample All Layers* is checked in the Options bar, so we can use the new layer.

▶ *Remove the blemishes.* Removing blemishes was the original intent for this tool. Just click. The Spot Healing Brush figures out which pixels are unlike the others, and it gets rid of them.

▶ *Remove the necklace.* Simply click and drag to remove the necklace. It does a nice job, but again has difficulty in areas where there is too much going on.

The Spot Healing Brush left a smudged appearance as it tried to blend the necklace with the skin tones. It also had difficulty creating a nice edge along the hairline.

Patch Tool

The Patch tool, located right below the Healing Brush, is intended for larger areas. Since it was never meant for removing small blemishes, we'll just test it on the necklace. Be sure to select *Content Aware* and *Sample All Layers* in the Options bar. That's the only combination of options that lets you patch onto a different layer for nondestructive editing. There is no *Sample All Layers* check box in the *Normal* patch mode.

▶ *Remove the necklace.* Add a layer and name it Patch Tool. Select the Patch tool and draw a circle around part of the necklace just as you would if you were using the Lasso tool. Then drag the selection to a source patch of skin and release the mouse. Photoshop analyzes the source and uses it to blend the patch area.

Select part of the necklace and drag it to an open area of skin. Repeat until the entire necklace is gone.

Adjust Structure and Color while your selection is still active.

If you are not happy with your result, you can tweak Structure and Color in the Options bar before you deselect your marching ants. A high Structure value preserves source pixels more completely, and a high Color value increases the amount of color blending applied. It's helpful to hide your marching ants using Command+H (Mac) or Control+H (PC) as you adjust Structure and Color. Don't forget to deselect the marching ants (Command+D on the Mac or Control+D on the PC) before moving on.

Repeat this procedure with other necklace pieces until you are done. Once again, you'll have areas that prove to be more difficult than others.

Which Tool is the best Cloner/Healer/Patcher?

The point of this exercise is to learn the strengths and weaknesses of these similar tools. All of them did well with some of the tasks, but none of them performed perfectly for all of them. That's just the point. When you are faced with a task like this, you'll probably want to use more than one tool to get the job done. It's your responsibility to choose your tools based on the strengths and weaknesses of each.

The Patch tool fared the best of the healing tools, but there's still some clean up work to do around the edge of the hair.

Use the Blur, Sharpen and Smudge tools for small areas.

The Dodge and Burn tools affect brightness. The Sponge tool affects saturation.

Blur, Sharpen and Smudge Tools

The Blur, Sharpen and Smudge tools are all in the second lowest slot of the retouching tools. The tools are fairly straight forward and function as their names suggest. To use them, simply drag over the areas that you would like to blur, sharpen or smudge. To use them in a nondestructive manner, create a new blank layer for the blur, sharpen or smudge edits and check the *Sample All Layers* option in the Options bar. These tools are best suited for editing small parts of your image.

Dodge, Burn and Sponge Tools

The Dodge, Burn and Sponge tools are also intended for selected areas and are fairly simple to use. Unfortunately they do not have a *Sample All Layers* option for use on a blank layer, which means that any editing you do is destructive. As a precaution, you may want to work on a duplicate layer.

The Dodge and Burn tools harken back to the darkroom days of photography. The Dodge Tool brightens pixels as you drag over them, and the Burn tool darkens them. The Sponge tool saturates or desaturates pixels, depending on the option selected in the Options bar. Try them out and get a feel for how they work. But be careful, it's easy to overdo the effect. It's safest to use a low Exposure setting when working with the Dodge and Burn tools and a low Flow setting for the Sponge Tool.

Where might you use these tools? You could use the Dodge and Sponge Tools in tandem to brighten this girl's teeth, for example. Drag over her teeth a couple of times with the Dodge Tool to brighten the teeth, and then a few times with the Sponge Tool—set to Desaturate mode—to remove the yellow cast. If her teeth begin to look gray, you'll know you've gone too far.

Using the Dodge and Sponge Tools is not my preferred method to whiten teeth. I like to use a Hue/Saturation Adjustment layer instead.

Brightening Teeth with Hue/Saturation

The two most obvious advantages of using a Hue/Saturation Adjustment layer to whiten teeth are its nondestructive editing and masking capabilities. Yet another advantage is that you can target your adjustments to a specific color range. There are two ways to do this. If you already know which color you would like to adjust, simply change the color range pop-up menu from *Master* to the color of your choice. If you're not sure which color range you want to adjust, you can let Photoshop determine that by using the Scrubber Finger icon.

▶ *Brightening teeth with Hue/Saturation.* Select the teeth using any selection method you want (I used the Quick Selection Tool). Then add a Hue/Saturation Adjustment layer and *resist the temptation* to drag the Saturation slider all the way down to –100. Did you actually try that? Looks ugly doesn't it? If we remove all color from the teeth, they turn an unsightly gray. We don't want to do that, we just want to create a natural white. The easiest way to achieve that is to target the problematic colors and leave the others alone. If we knew exactly what those problem colors were, we could simply choose that color from the Color Range pop-up menu. But in those instances where you are not quite sure, you can use the Scrubber Finger. Click the Reset icon to restore the default values.

▶ *Use the Scrubber Finger to target a color range.* Click the Scrubber Finger towards the top left of the Properties panel, place your cursor over the girl's teeth and drag to the left slightly to desaturate the teeth. Look at the Color Range pop-up menu. Depending on where you clicked, Photoshop either chose the *Yellows* color range or a variation of Yellows called *Yellows 2*. Drag to the left to reduce the saturation, but don't drag too far. If the teeth begin to look gray, back off a little bit. Finish the job by dragging the Lightness slider to the right to add brightness. Again, if you go too far, the teeth will begin to look gray.

Reducing the saturation across all colors turns the teeth gray. The Scrubber finger lets you target specific colors.

Click with the Scrubber Finger in the image to select the color that you want to target. Then *Drag* to adjust the saturation or *Cmd+Drag* (Mac) or *Control+Drag* (PC) to adjust the hue.

Final Thoughts

The retouching tools in Photoshop give you the ability to enhance your image in many ways. Create colorful blended backgrounds with the Gradient tool. Use the Brush tool with custom brush tips to simulate a wide range of painting techniques. Remove red eye quickly with the Red Eye tool. Copy parts of an image and paste them into new areas with the Clone Stamp tool. Use the Healing Brush, Spot Healing Brush and Patch tools to seamlessly blend source pixels with their new surroundings. All of these skills, that used to reside solely in the hands of seasoned airbrush artists, and now at your fingertips using Photoshop.

Images adorn our inner life and carry great power there.

▸ *William Shirley*
British Politician, 1694–1771

7

◂ *Layers & Layer Effects* ▸

Pet Personalities

Topics

- Differentiate between a Background layer and a Regular layer.
- Use layer blending modes, opacity and fill to blend image pixels.
- Lock layers to prevent unwanted edits.
- Link layers and move them as one.
- Enhance a layer's appearance with layer effects.
- Align and distribute layers.
- Add layer masks or clipping masks to hide portions of an image.

Preview

Without question, the ability to work in layers is the biggest improvement Adobe ever made to Photoshop since its inception. Layers were first introduced with Photoshop 3, and I remember how liberated I felt when I first began to use them. In a nutshell, they give you the ability to edit your compositions quickly and easily. Before layers, even the simplest change, such as correcting a misspelled word, was a major revision sometimes requiring hours of work.

Today layers give you more than just editing flexibility. They also let you change the overall appearance of pixels through layer effects, or control how they interact with other layers through blending or masking. It's well worth your time to familiarize yourself with all of the advantages that layers offer. It will make your Photoshop work much easier and more productive.

◂ Layers & Layer Effects ▸

Background Layer versus Regular Layer

There are two types of Pixel layers in Photoshop: Background layers and Regular layers. In addition to Pixel layers, Photoshop also features Adjustment layers, Type layers, Shape layers, and Smart Object layers. We will be focusing primarily on Pixel layers in this chapter.

Basic Layer Construction

▸ *Toggling visibility.* Open *Kids and Kittens.psd*, a photo that my wife took years ago of our nephew, son and niece at a farm in Red Granite, Wisconsin. They appear in front of a landscape that I photographed years later in Colorado. Click on the Layers tab to make it active. If you can't find it, choose Window>Layers from the Main menu.

Notice that the image contains four layers: Mike, Kevin, Jenny and Background. Turn off the visibility for Background by clicking its eyeball, and you should see a gray checkerboard pattern in its place, indicating transparency. If you see white instead, refer to *Speaking Photoshop* on the next page to change your preferences. Toggle the visibility of the other layers, too, by clicking the respective eyeballs to get a feeling for how this image was composed.

The image to the right is a composite containing a Background layer and three Regular layers.

The Background is the only layer that has no transparency, which is the major difference between a Background layer and a Regular layer. Regular layers are like transparent sheets of acetate that let you see pixels beneath them. The Background is equivalent to a solid sheet of paper at the very bottom of the stack.

Speaking Photoshop…

Changing Transparency Preferences!

It's helpful to know which areas of a layer are transparent as you work on your images. By default, Photoshop indicates transparency with a light gray checkerboard pattern, but sometimes the gray checkerboard obscures your view of the image. Because of this, Photoshop lets you change the color and size of the pattern, or turn it off altogether. This doesn't affect your actual file in any way—it just changes your view of the image.

To specify how you view transparency, type *Command+K* (Mac) or *Control+K* (PC) to access Photoshop's preferences. Click the *Transparency & Gamut* section to reveal the Transparency Settings, then select your preferred Grid Size and Grid Colors from the pop-up menus. The default values are *Medium* and *Light*, respectively. If you don't like one of the predefined color schemes, you can customize your colors by clicking on the two color swatches to access the Color Picker.

Default Transparency Settings

▶ *Moving and Rearranging layers.* Photoshop's layered construction makes it possible to move, transform, or otherwise edit individual layers without affecting the rest of the composition. With the Move tool, select a Regular layer, place your cursor on the canvas, and drag to reposition Mike, Kevin or Jenny. However, if you select the Background layer and try to move it, you get an alert saying you "could not use the move tool because the layer is locked." This is another significant difference between a Regular layer and the Background layer.

Select the Mike layer and drag him towards the right so he overlaps Kevin. But what if we wanted Kevin to be in front of Mike? No problem. In the Layers panel, simply drag the Kevin layer above the Mike layer, so Kevin appears in front. You can change the stacking order of layers to suit your fancy with one exception: you can never place a Regular layer beneath the Background layer.

In the composition to the right, Mike was moved towards the center until he overlapped Kevin. Then the Kevin layer was moved to the top of the layer stacking order, placing Kevin in front of Mike.

Background Layer Attributes

What can and can't be done with a Background layer? In the previous exercise, we discovered that the Background layer could not be moved because it is locked. But is it locked for all types of edits? Let's try a few things, but first click the Foreground and Background color swatches and choose red for the foreground and green for the background.

▶ *Transform the Background layer.* Click the Background layer to make it active, then choose Edit>Transform from the Main menu. Well, that's easier said than done, because all the transform commands are grayed out. Not only is the Background layer locked when it comes to moving, it's also locked for transformations.

▶ *Paint on the Background layer.* Type B to select the Brush tool, then make a few scribbles directly on the image and watch how the pixels turn to our current foreground color, red. The Background layer is not locked when it comes to painting with the Brush or any other retouching tool for that matter.

The Brush paints on a Background layer with the foreground color.

The Eraser paints on a Background layer with the background color.

▶ *Erase the Background layer.* Now type E to switch to the Eraser tool and try to erase portions of the image. Once again, Photoshop doesn't prevent your attempts to erase the Background layer, but did it really erase the image as you expected? When applied to the *Background* layer, the Eraser tool actually "paints" with the background color.

▶ *Edit selected portions of the Background layer.* Type M to choose the Rectangular Marquee tool and select a small portion of the image. Switch to the Move tool (V) and drag the selection to a new location. It worked, didn't it? Unfortunately it left a green patch in its wake, because green is our current background color.

When a selection is moved on the Background layer, the resulting hole is filled with the background color.

With the selection still active, choose Edit>Transform from the Main menu. Now you can scale, rotate, skew or make any other transformations you wish. As with the Move tool, any "holes" you create with these maneuvers are filled with the background color.

We could have actually moved or transformed *all* of the image pixels on the Background layer by invoking a Select All command first. It's just the *Background* layer itself that is locked from moving or scaling, not the pixels sitting on it.

▶ *Other Background options.* With the *Background* layer still active, check the Flyout menu and various icons in the Layers panel. Did you notice how many options are grayed out? Blending modes, Opacity, Fill, Layer Effects and Layer masks are all incompatible with *Background* layers. You can actually add a Layer mask to a *Background* by clicking the "Add layer mask" icon, but Photoshop converts your *Background* into a Regular layer first.

When a Background layer is selected, many of the Layer panel's icons are grayed out, and so are many commands in the flyout menu.

Regular Layer Attributes

You can do many more things with a Regular layer than you can with a Background layer, because they support transparency and you can change their stacking order.

When a selected part of a Regular layer is moved, transformed or erased, the resulting hole is transparent.

▶ *The Similarities between Regular and Background layers.* Click the Mike layer to select it, then see how it reacts when you perform the same tasks that we just attempted with the Background layer. Do the following:

- Move it with the Move tool.
- Transform it (Command+T/Control+T).
- Paint on it.
- Erase parts of it.
- Select part of the layer, then move, transform, paint or erase the selection.

You'll find that Regular and Background layers are identical in two ways:

- Foreground color is applied when you paint on them.
- Selected portions can be moved, transformed, painted or erased.

▶ *The Differences between Regular and Background layers.*

- An entire Regular layer can be moved with the Move tool.
- An entire Regular layer can be transformed.
- The Eraser tool erases to transparency instead of the painting with the background color.
- When you move or transform a selection, the resulting hole is filled with transparency instead of background color.

Converting between Background and Regular Layers

Converting a Background to a Layer

Converting a Layer to a Background

Converting a Background layer to a Regular layer is easy. Simply double-click the Background layer and rename it or click on the padlock. An alternate, but slower way, is to choose Layer>New>Layer from Background from the Main menu.

If a file has no Background layer, you can convert a Regular layer into the Background layer by choosing Layer>New>Background from Layer from the Main menu. A file can only have one Background layer.

Blending Modes, Opacity and Fill

With the Mike layer selected, check the Flyout menu and various icons in the Layers panel. Because we have a Regular layer selected, we can now take advantage of blending modes, opacity and fill.

▶ *Change the Blending mode.* Blending modes cause a layer to mix with the colors beneath it in various ways. With the Mike layer still selected, click the pop-up menu, currently set to *Normal*, and cycle through the other blending options. The *Normal* blending mode is opaque, and *Dissolve* creates a pixelated effect. The second group of blending modes—*Darken* through *Darker Color*—all darken the image in some way. The next group—*Lighten* through *Lighter Color*—all brighten the image. The *Overlay–Hard Mix* group changes an image's contrast; The *Difference–Divide* group inverts luminosity values to create new colors; and the *Hue–Luminosity* group changes overall color.

Which is the proper mode? Who knows? Results are rather unpredictable. Just try them all, and if you stumble on an effect that looks pleasing, then that's the right choice. Since choosing a Blending mode is often a hit-or-miss proposition, it's helpful to use keyboard shortcuts to cycle through the modes. Shift+Plus cycles downwards through the blending mode list, and Shift+Minus cycles upwards. There's just one caveat when you use these keyboard shortcuts. Make sure you don't have a retouching tool selected, such as the Brush, that has blending modes in its Options bar. In those cases, the keyboard shortcuts will change the tool's blending mode, not the layer's blending mode.

▶ *Change the Opacity.* There are a number of ways that you can change the opacity of a layer to create a ghost effect.

- Place your cursor over the word Opacity and drag left or right when the double-arrow Scrubber icon appears.
- Change the value by typing in the Opacity field.
- Click the down arrow to the right of the Opacity field and drag the Opacity slider.
- Select the layer and type a number between 0 and 9:
 1 = 10%, 5 = 50% and 0 = 100%.
 Type two numbers in quick succession for more specific values:
 5 + 2 = 52%.

Normal Blending Mode

Vivid Light blends Mike in a colorful way with the background.

Kevin appears ghostly with 60% opacity.

Opacity Scrubber

Opacity Slider

Opacity lightens the drop shadow effect but Fill does not.

When using the keyboard shortcuts, the same caveat applies here that applied to the blending mode keyboard shortcuts. Make sure that you do not have a retouching tool selected that features Opacity in its Options bar. If you do, the keyboard shortcut will change the tool's Opacity, not the layer's Opacity.

▶ *Change the Fill.* Fill is almost identical to Opacity. In fact, you'll find the results to be virtually identical unless you are using layer effects. The difference is that Opacity affects both the layer contents *and* the layer effects, whereas Fill affects only the layer contents. The keyboard shortcuts are even the same, except that you have to add the Shift key. For example, Shift+7 is 70% fill.

Locking and Linking Layers

▶ *Locking layers.* As we learned, the *Background* layer is really only locked when it comes to moving or transforming. Regular layers let you lock 1) transparent pixels, 2) image pixels, 3) position, or 4) everything.

With the Mike layer selected, click the Lock transparent pixels icon, the checkerboard icon to the right of the word *Lock*. Select the Brush tool and scribble on the image. The Brush only paints directly on Mike, not the transparent pixels. Now select the Eraser and erase part of Mike. Instead of erasing to transparent, the Eraser paints with the background color. When transparent pixels are locked, you can't convert any transparent pixels into non-transparent pixels and vice versa.

Deselect the Lock transparent pixels icon and select the Lock image pixels icon (the brush). Now you can't paint or erase anything on the layer.

Deselect the Lock image pixels icon and click on the Lock position icon. Now you can't move or transform the layer, but you could paint or erase it.

The Auto-nesting icon prevents nesting in artboards, and the Lock all icon, the padlock, locks everything. You can no longer edit the layer in any way.

▶ *Linking layers.* The chain icon at the bottom left of the Layers panel lets you link two or more layers together, so they move or transform as one. For example, you might want to link a company logo on one layer to the company's name on a text layer, so you can't move or transform one independently of the other. To do that, simply select the layers you want to link and click the *Link layers* icon. To unlink a layer, select the layer and click the *Link layers* icon to remove it from the linked group. Close *Kids and Kittens.psd*. We'll be creating a file from scratch as we explore layer effects and layer styles.

Click the chain icon to link layers. The Mike and Kevin layers have been linked here.

Layer Effects and Layer Styles

Take a look at the simple black and white artwork below: two gray rectangles, a black brush stroke, and white type. That's it, not very interesting. Now look at the artwork beneath it. All of its color and texture were added using Photoshop's layer effects. At its core, it still has the same rectangles, brush stroke and type.

Layer effects let you transform even the simplest image into stunning artwork, then tweak it whenever you want a fresh look. What's more, the process is completely nondestructive, so you can't go wrong by experimenting to your heart's content. If you find a combination of layer effects that you like, you can save them as a layer style, which can be applied to different artwork with a click of the mouse. A layer style is simply a combination of layer effects.

Simple grayscale artwork without layer effects.

This is the same artwork as above, spruced up with layer effects.

▶ *Create a Type layer.* Create a new document, 8" x 4" with a resolution of 300 ppi. Choose the Type tool (T) and pick a font, style and size from the Options bar. Also select a color other than black (I chose red) and click the Center text icon. Now click once in the center of the canvas with the Type tool (you should see a blinking cursor) and type your name, or any other inspiring phrase you think of. If necessary, switch to the Move tool and drag your type into position. We now have a Type layer, and we can begin adding layer effects.

▶ *Bevel & Emboss.*

Click the *fx* icon at the bottom of the Layers panel and choose Bevel & Emboss, an effect that is frequently added to type. The resulting Layer Style dialog box is arranged in typical Adobe fashion. You have a list of features along the left side with corresponding settings to the right. Click a different item on the list and the settings change to reflect the new item selected. The list items also have check boxes which, when checked, indicate that the effect is being applied. If you don't want to apply a certain effect, just make sure that the box is not checked.

Bevel & Emboss Settings

The Layer Style dialog box has a list of effects on the left with corresponding settings to the right. The settings shown here were used to produce the Bevel & Emboss image above.

Click on Bevel & Emboss in the list to make sure that it is highlighted. Then select a style, technique, depth, direction, size and soften value in the Structure section. Experiment with different settings.

The Shading section controls the direction and intensity of the light source. *Use Global Light* synchronizes the light source for all of the effects that depend on a light source: Bevel & Emboss, Inner Shadow and Drop Shadow. Changing the angle in any one of those effects changes it for all of them. Leave *Use Global Light* unchecked if you want to simulate multiple light sources. Gloss contour changes how shading is applied to the surface of the image.

Bevel & Emboss has two subcategories. *Contour* changes the shape of the bevel, and *Texture* lets you alter the surface finish of the bevel. Experiment with the settings until you have an effect that you find attractive.

▶ *Stroke.*

Click on *Stroke* from the Styles list, then turn off the eyeball for *Bevel & Emboss* to hide its effect. The Stroke settings are pretty straight forward. The *Structure* section lets you control the stroke's size, position, blend mode and opacity. The *Fill Type* section lets you create a stroke from a single color, gradient or pattern. The Plus sign lets you apply additional stroke effects, with the top most stroke appearing above any strokes below it. Click the arrows at the bottom to change the stacking order of your strokes, or click the trash can to delete a Stroke.

Stroke Settings

The Stroke effect lets you create strokes from a solid color, gradient or pattern and blend it with its surroundings. The settings shown here were used to produce the Stroke image above.

▶ *Inner Shadow.*

Inner Shadow

Click *Inner Shadow* in the Styles list and turn off the eyeball to *Stroke*. This effect casts a shadow on the object itself, at least that's what it does by default. However, if you change the blend mode to Screen and the color to white, you can create an inner highlight instead. Choosing a different Contour curve can give you some interesting ripple effects. Add noise for a speckled effect.

Inner Shadow Settings

Inner Shadow casts a shadow on top of the layer content as opposed to the Drop Shadow, which casts a shadow behind the content. The settings shown here were used to produce the Inner Shadow image above.

▶ *Inner Glow.*

Inner Glow

Deselect the check box for *Inner Shadow* and click *Inner Glow*. This effect creates glowing edges or a glowing center, depending on the source selection that you choose in the Elements section. If you wanted to create a darkening effect instead of a glowing effect, you could change the blend mode to Multiply and pick black for a color. Unlike *Inner Shadow*, *Inner Glow* is not directional and is therefore not influenced by your Global Light setting. Once again, the contour settings can create some interesting ripple effects.

◀ Chapter 7 ▶ 167

Inner Glow Settings

The ripple effect shown on the Inner Glow lettering was created by specifying the Ring-Double contour curve.

▶ *Satin.*

Uncheck the *Inner Glow* effect and select *Satin*. This effect simulates the sheen of satin material by applying random shadows to the image. It's good for creating backgrounds that are more interesting than flat colors, yet not too busy or overbearing.

Satin Settings

Satin casts shadows to simulate a satin sheen, but you could create highlights instead by changing the blend mode to Screen and color to white.

▶ *Color Overlay.*

Color Overlay

Uncheck the *Satin* effect and select *Color Overlay*. With Normal blend mode and 100% opacity selected, Color Overlay simply changes the color of the layer content. If the blend mode or opacity is changed, then it mixes with the content color. For now, choose a color that you like and select Normal blend mode and 100% opacity.

Color Overlay Settings

Color Overlay changes the color of the layer content or can be used to blend with the Gradient and Pattern Overlay effects.

▶ *Gradient Overlay.*

Gradient Overlay

Uncheck *Color Overlay* and select *Gradient Overlay*. Now instead of applying a color, you can apply a gradient. You can even blend the Color Overlay and Gradient Overlay effects together if you use an appropriate opacity or blend mode. Click back on *Color Overlay* to activate it. Do you see how it covers up the gradient overlay that you just applied? That's because layer effects have a stacking order just like layers do, and when Color Overlay is set to Normal blend mode at 100% opacity, it completely covers any Gradient Overlay you have applied. If you want to apply both effects, set the Color Overlay blend mode to something other than Normal and/or reduce the opacity, so you can "see through" to Gradient Overlay beneath it.

Gradient Overlay Settings

Gradient Overlay replaces the content color with a gradient or can be used to blend with Pattern Overlay.

▶ *Pattern Overlay.*

Uncheck *Color Overlay* and *Gradient Overlay* and click *Pattern Overlay* to superimpose a pattern on top of the layer content. Click the Pattern swatch and choose a pattern from the ensuing dialog box or use the flyout menu to load a pattern swatch library. Choose a blend mode or lower the opacity to let your pattern blend with the content color. Keep in mind that a Color Overlay or Gradient Overlay set to Normal blend mode at 100% opacity will obscure any pattern you apply here because of the layer effects stacking order.

Use the Pattern Swatch flyout menu to manage patterns or load pattern swatch Libraries.

Pattern Overlay Settings

In this example, the selected pattern has been used in multiply mode to blend with the red content color.

▶ *Outer Glow.*

Add a Fill layer between the Type and Background layers and choose black.

Outer Glow creates a backlit effect. Different colors and blend modes produce a wide variety of effects.

Click OK to leave the Layer Style dialog box. We're going to add a black Fill layer to make it easier to watch Outer Glow in action. Click the Background layer to activate it, then choose Solid Color from the black and white *Fill or Adjustment layer* icon at the bottom of the Layers panel. Choose black when the Color Picker appears and hit Return/Enter or click OK to accept the color. Reselect the Type layer and choose Outer Glow from the *fx* menu to return to the Layer Style dialog box. The last two effects, Outer Glow and Drop Shadow, are applied beneath the layer content. The layer effects we have worked with thus far have been applied above the layer content. Outer Glow creates a backlit effect. Try different colors and experiment with the Contour curves to produce some interesting ripple effects.

Outer Glow Settings

▶ *Drop Shadow.*

Click OK or hit Return/Enter to exit the Layer Style dialog box and turn off the visibility to the black Solid Color layer that we just added. We want to see the type against a white background again. With the Type layer still selected, choose Drop Shadow from the *fx* pop-up menu to return to the Layer Style dialog box. By default, this effect adds a black shadow behind your layer content. You can change the nature of the shadow by altering its blend mode, opacity, angle, distance, spread or size. You can even click on the image itself and drag the shadow to a new location. Once again, the Contour curves can produce some interesting results.

Drop Shadow Settings

Using black with Multiply mode gives you the most realistic looking shadow, but other colors and modes can be used as well.

▶ *Put it all together.*

Turn the visibility on and off to view various combinations of effects and tweak the individual settings until you find a layer style that you really like. Then click OK to apply the results.

If you want to change the effects later, simply double-click an effect in the Layers panel to reopen the Layer Style dialog box.

▶ *Edit the effects in the Layers panel.*

Although four effects have been applied, the visibility of Outer Glow has been disabled.

Drag the *fx* icon to another layer to move it, or Option/Alt+Drag to copy it.

The Layers panel lets you work with effects in a number of ways:

- Double-click an effect to edit its settings.
- Click the triangle next to the *fx* icon to expand or collapse the list of effects.
- Click an eyeball next to an effect to toggle its visibility.
- Drag an effect to the trash to delete it.
- Drag an effect from one layer to another to move it.
- Option+Drag/Alt+Drag an effect to another layer to copy it.

▶ *Add a Layer Style to the Styles panel.* Layer styles can be added to the Styles panel and reapplied to different layers with the click of a button. Choose Window>Styles to bring up the Styles panel. Select the layer containing the style you want to save, then click the Create new style icon in the Styles panel. Name it and specify if you want to include layer effects, blending options or both. Click OK to close the New Style dialog box, and your layer style is added to the end of the Styles panel. The Styles panel lets you do the following:

- Click a style swatch to apply it to a layer.
- Drag a style swatch to the trash or Option+Click/Alt+Click it to delete it.
- Shift+Click a style swatch to add its effects onto a current layer's effects.
- Click the Clear style icon to remove layer effects.
- Use the flyout menu to manage or load styles.

Clear style Delete style
Create new style

Organizing and Moving Layers

Working with a large number of layers can become confusing. How do you keep track of them all, and how do you position them exactly where you want them? Photoshop gives you a number of ways to organize and manipulate layers in an efficient manner.

▶ *Layer Groups.* Open *Layer Organization.psd*, a document that contains eight layers of randomly spaced shapes, plus a white Background. Layer groups are your first line of defense to tame a document with an excessive number of layers, because they let you organize layers in folders called layer groups. To create a layer group, do one of the following:

- Click the Create a new group icon at the bottom of the Layers panel to add a layer group. Then drag the appropriate layers onto the *Group* layer in the Layers panel. If you hold the Option/Alt key as you Click, the New Group dialog box will appear, giving you the option to name the layer group and set its color, mode and opacity. The *Pass Through* mode means that no blending is applied to the group at large, but individual layers within the group can still have a blending mode.

- A better way to create a layer group is to select the layers that you want to group, then Click the Create a new group icon to combine the layers into a layer group. Hold down Option/Alt as you Click to bring up the New Group dialog box. This saves you the trouble of dragging the layers into the group.

- You can also choose New Group or New Group from Layers from the Layer panel's flyout menu.

This particular file would be easier to work with if the layers were placed into two layer groups. Select the top four layers (Click on Black Circle and Shift+Click on Red Square), then Option+Click (Mac) or Alt+Click (PC) on the Create a new group icon and name the group Diverse Objects. Now select the remaining four layers (not the Background) and combine them into a layer group named Uniform Objects.

Having a group gives you the option of working with a group as a whole or as individual layers. You can toggle the group's visibility by clicking its eyeball.

Select layers to be grouped, then *Option+Click/Alt+Click* to combine them into a layer group.

New Group from Layers dialog box.

Click the triangle to expand or collapse a layer group.

◀ Layers & Layer Effects ▶

▶ *Layers and Move tool options.*

When checked, Auto-Select will select a layer or group, depending on where you click in the image.

Places a bounding box around the image that can be transformed.

Align layer icons

Distribute layer icons

The Move tool has a number of options that can help you select, transform, align or distribute layers. Type V or click the Move tool to select it and look at the Options bar. The first section lets you specify how to select a layer or group. If *Auto-Select* is checked, then clicking in the image will also automatically select the layer that contains the pixels you clicked. It's pretty intuitive. If you want to move the green oval, just click it and drag. The pop-up menu just to the right of Auto-Select lets you specify if you want to select an individual layer or a layer group.

If Auto-Select is not checked, then you have to click the layer or layer group in the Layers panel to select it. This is the easier method if your layers overlap significantly.

▶ *Show Transform Controls.* This option places a bounding box around your layer's contents. If you move one of the handles, you automatically enter Transform mode, as if you had typed Command+T/Control+T. I prefer to leave this option unchecked.

▶ *Aligning layers.* The next series of six icons lets you align layers to one another. Turn off the visibility to the *Diverse Objects* group. Expand the *Uniform Objects* group, if necessary, and select the individual layers. Click the Align top edges icon and watch what happens. Which object or objects moved, and which object or objects remained still? Type Command+Z/Control+Z to undo the alignment, then try the remaining five alignment icons, undoing each as you go. In each case, pay attention to which objects move and which don't.

What you should have noticed is this: The extreme most object always acted as an anchor point. In other words, all of the objects aligned to the left-most object for left align, the top-most object for top align, and so on. The center align options used an overall center as an anchor point.

But what if you wanted to align to a specific layer? To do that, link the layers first by selecting them all and clicking the *Link* icon. Now select only the layer to be used as an anchor and click the alignment icon. The selected layer will remain stationary and the others will move.

The Blue Rectangle layer acts as an anchor for alignment here, because the layers are linked and Blue Rectangle is selected.

▶ *Distributing layers.* Select the four *Uniform Objects* layers and align their horizontal centers. Then try the first three distribution icons: distribute top edges, distribute vertical centers, and distribute bottom edges. Be sure to undo each distribution before you try the next one, and pay attention to which objects move and which don't.

In each case, you should have noticed that the middle layers moved and the outer layers didn't. Also, each distribution method produced identical results in this case, because the objects are all the same size and shape.

Turn off the visibility to the *Uniform Objects* group and select the layers from the *Diverse Objects* group. Start by aligning their horizontal centers, then try the distribute top edges option. What a mess! Yet if you were to take a ruler and measure the distance between the top edges, you would find that it worked just like it was supposed to. Distribution options aren't very helpful if your objects are different shapes and sizes.

Uniform objects distribute nicely. This option shows distribute top edges.

Non-uniform objects don't appear to be distributed properly even though they are, if you look at the guides.

Layer Masks

We already worked with layer masks when we learned how to adjust part of an image using adjustment layers. The concept here is the same, except instead of showing or hiding a levels or curves adjustment, we are actually showing or hiding pixels. It's like using the Eraser tool to erase part of a layer so you can see what's beneath it. But a layer mask is far better than the Eraser tool, because you can always unerase what you previously erased. Because of that, you should almost never use the Eraser tool. Use a layer mask instead.

Car.jpg

Field.jpg

▶ *Drag-copy an image onto a new background.* Open *Car.jpg* and *Field.jpg*. We want to take the car out of the parking lot and place it in the field. Click the *Car.jpg* tab to make that image active, then place the Move tool cursor on the canvas and drag it up to the *Field* tab to make that image visible. Without releasing the mouse, drag the cursor onto the *Field* canvas. Now release the mouse. Drag the car into position so the shadow extends off the left edge of the image. If you hold the Shift key before releasing the mouse, the two images would be center-aligned.

With the Move tool, drag the *Car.jpg* image onto the *Field.jpg* tab.

When the *Field.jpg* image appears, drag the cursor to the canvas and release the mouse.

- *Select the car before adding a layer mask.* This step is actually optional—you can add a layer mask without making a selection—but it's a time saver. Use any selection tool that makes sense to you (I chose the Quick Selection tool), and select the car and the shadow beneath it. Do the best you can, but we'll be able to fix imperfections later.

- *Add the layer mask.* Click the Add a mask icon at the bottom of the Layers panel. Two things just happened here. The car's old background was "erased" allowing us to see the field behind the car, and a layer mask thumbnail was added to the car layer. The black portion of the mask thumbnail is the area that is hidden, and the white portion is the area that we can see.

- *Touch up the mask.* Magnify the image and examine the edges of the car. Chances are you'll find some areas that need improvement.

 - Click on the layer mask thumbnail to make sure that it's selected. You should see a border around it.
 - Paint with black to hide or "erase" portions of the car layer.
 - Paint with white to reveal or "unerase" parts of the car layer.

Click the *Add a mask* icon to add a layer mask.

Start at the hood and work your way counterclockwise around the car. As you work on perfecting your mask, type X to switch between your black and white foreground colors. Also choose a brush hardness and size that matches the focus of your image. If your image is blurry and out of focus, your mask edge should look the same. I used a brush size of 10 pixels and a hardness of 0%. For fuzzier edges, choose a larger brush.

Use the connect-the-dots drawing technique for straight lines. Click on the starting point, then Shift+Click on successive points to connect the dots.

- *Viewing layer masks.* As you work around the windshield wipers, it's often difficult to know what should be added and subtracted. Using different layer mask views can help.

 - Shift+Click the layer mask thumbnail to temporarily disable the mask. You may continue to paint on the layer mask in this view. It's particularly useful for tracing around the windshield wipers or adding pieces missing from the car. Shift+Click the layer mask thumbnail again to return to normal view.

Shift+Click a layer mask to disable it.

 - Option/Alt+Click the layer mask thumbnail to view the mask by itself. This helps reveal flaws that could otherwise escape detection. Option/Alt+Click again to return to normal view.

Option/Alt+Click a layer mask to view it by itself.

▸ *Paint with gray for a transparent look.* The outer edge of the car should look pretty good by now, but bricks are still visible through the windows. By painting on the layer mask with gray, we'll be able to create the illusion that we are seeing the trees through the glass.

Click the foreground swatch and choose a light gray by typing H/S/B values of 0/0/60. Those aren't magic numbers—I experimented with a number of grays until I found the shade I liked. Paint over the glass for a semi-transparent look. The darker the gray, the more vivid the trees appear. Check the accuracy of your mask from time to time by Option+Clicking/Alt+Clicking on the layer mask thumbnail.

Our final task is to make the shadow more realistic. We want to see some grass in the shadow, and the edge needs to be fuzzier. Change the foreground color to H/S/B values of 0/0/88, and paint over the shadow to let the grass emerge. Finally, select a 100 pixel fuzzy brush and "tickle" the shadow edges for a more diffused look.

The layer mask uses black to hide, white to reveal, and gray for a transparent effect.

The finished composition makes it look like the car is parked on the field.

Clipping Masks

Whereas a layer mask hides part of the layer it's on, a clipping mask uses a layer to mask a layer or layers immediately above it. We're going to use a clipping mask to place an image inside of type.

▶ *Create a new document.* Type Command+N/Control+N to access the new document dialog box and create an 8½ x 11 inch document at 300 ppi.

▶ *Set type.* Choose a fairly large, bold font and type the word TREES.

▶ *Add an image.* Open *Field.jpg* and drag-copy it to our new file. You now should have a *Layer 1* containing the field above your type layer. If that's not the case, change the stacking order of the layers.

▶ *Clip the field layer to the type layer.* Hold the Option/Alt key and place your cursor between the two layers, then click when you see the icon change to a little box with a downward arrow. The field should now be visible only inside of the letters. Drag the field layer to position it where you want it. Option/Alt+Click between the layers again if you want to unclip the layers.

You could have also selected the top layer and chosen Create Clipping Mask from the Layer panel's flyout menu, or used the keyboard shortcut Opt+Command+G (Mac) or Alt+Control+G (PC).

Option/Alt+Click between two layers to create a clipping mask.

A downward arrow indicates a clipping mask.

Left: Place the image to be clipped above the mask layer.

Below: Drag the layer(s) into the desired position.

Final Thoughts

Layers are essential to working effectively in Photoshop. First and foremost, they let you edit a portion of your image without affecting other parts of the image. They also add a lot of creative flexibility. You can move them, change their stacking order, alter their opacity or blending mode, or add layer effects for a unique appearance. Finally, layer masks and clipping masks let you hide or reveal portions of your image to create a new composition from multiple images. Take advantage of the many capabilities that layers offer you. It will make your Photoshop life much easier.

Digital imaging allows both groups to rise above the limitations of mess and clutter and mechanics, and apply our talents to creating images limited only by our imaginations.

▸ *Buffy Sainte-Marie*
Singer/Songwriter, 1941–

◀ *Smart Objects, Filters & Vanishing Point* ▶

8

Billy Knight

Topics

- Convert pixel layers to Smart Objects
- Place an Adobe Illustrator file as a Smart Object
- Maximize quality by transforming Smart Objects
- Use Smart Filters for nondestructive editing
- Apply multiple filters using the Filter Gallery
- Sharpen images using Smart Sharpen and Shake Reduction
- Apply surface textures using the Displace filter
- Create cloudy skies with the Clouds filter
- Edit in perspective using Vanishing Point

Preview

Meet the playful side of Photoshop—filters. Photoshop offers over 100 filters that can pinch, twirl, sharpen, blur, or convert your image to anything from painted artwork to cut glass. And since you can apply multiple filters to a single image, the possibilities are truly endless. Use filters with Smart Objects, and you have the added advantage of nondestructive editing and masking capabilities.

Most filters are easy to use. Apply them, adjust the settings and you're done. The hardest aspect of filters is becoming familiar with all of them, and getting a feel for what they can and can't do.

This chapter is all about self-exploration. If you are using the *Speaking Photoshop Workbook*, you will be trying all of the filters and creating a resource booklet of the results using Bridge. Then in the future, when you try to remember how to get that certain "look", you can page through your filter booklet and locate the filter or filters that can get the job done.

Smart Objects

We had a brief encounter with Smart Objects back in Chapter 4 when we were working with Shadows/Highlights. The benefits they gave us were nondestructive editing and a mask to adjust just part of the image. But Smart Objects are actually smarter than that. They help preserve an image's quality when you make multiple transformations, they let you apply filters in a nondestructive way, and they even retain the benefits of vector images for placed Adobe Illustrator files.

So what makes a Smart Object so smart? *It remembers its origin.* That's it! Remember that key phrase, and all the Smart Object advantages we touch on in this chapter will make perfect sense.

Smart Objects and Raster Images

▶ *Converting pixel layers to Smart Objects.* Open *Smart Butterfly.psd*, a beautiful photo taken by Shari Kastner, which I duplicated onto two layers. We're going to leave the *Butterfly* layer as is and convert the *Smart Butterfly* layer into a Smart Object. Then we'll test their abilities to make multiple transformations.

These two butterflies are duplicates, except the image on the right has been converted to a Smart Object.

Select the *Smart Butterfly* layer, then do one of the following:

- Choose Convert to Smart Object from the Layers panel flyout menu.
- Choose Layer>Smart Objects>Convert to Smart Object from the Main menu.

Compare the images, and you won't see a difference, except for the Smart Object symbol on the layer thumbnail. But there's more to a Smart Object than meets the eye.

The *Smart Butterfly* layer has the Smart Object symbol on its thumbnail.

The *Smart Butterfly* layer has just gained a memory like you wouldn't believe. Let's test it out.

▶ *Scale the layers to 10%.* Select the *Butterfly* layer and type Command/T (Mac) or Control+T (PC) to enter the Free Transform mode. In the Options bar, click the W to access the Set horizontal scale field and type 10% to reduce the butterfly's width. Click the chain link icon to apply the same reduction to the H (Set vertical scale) field and hit Return twice, once to accept the change in height and once to exit Free Transform mode.

Now repeat the exact same process on the *Smart Butterfly* layer. After you are done, type Command+1 (Mac) or Control+1 (PC) to view the image at 100%, then drag the horizontal scroll bar back and forth to compare the quality. Still no difference!

The quality of the pixel layer and Smart Object remain identical after scaling the layers down to 10%.

▶ *Return to the original size.* You've changed your mind, and you want your original butterfly back. That small size just didn't do the photo justice. Select the *Butterfly* layer and type Command+T (Mac) or Control+T (PC) to enter Free Transform mode. Enter 1000% in the W and H fields to return it to its original size, and hit Return twice to exit Free Transform mode.

Select the *Smart Butterfly* layer and enter Free Transform mode. Look at the W and H fields now. Instead of 100%, it shows 10%. Why? Because a Smart Object remembers its origin. Enter 100% to return it to its original size, then compare the quality of the two layers.

The Smart Object is as sharp as ever, but the regular pixel layer is blurry and choppy. When we reduced the *Butterfly* layer to 10%, Photoshop discarded nine out of ten pixels. When we enlarged it to 1000%, Photoshop had to guess as it remanufactured pixels. But there was no guessing with the Smart Object, because Photoshop never forgets the original pixels. Pixel data is lost every time an object is transformed, but the Smart Object's ability to access the original data keeps the image quality at a high level, no matter how often you transform it.

After returning to the original size, the regular layer on the left became jagged, but the Smart Object on the right retained its original sharpness.

▶ *Limitations of Smart Object quality.* The Smart Object performed admirably in our previous exercise, but what if we wanted to enlarge the image beyond its original size? In that case, the Smart Object wouldn't have helped. Smart as it is, a Smart Object can never fabricate a quality that is better than the original. It can only remember and retain the original quality.

Smart Objects and Vector Images

▶ *Working with Adobe Illustrator files.* Photoshop can work with Adobe Illustrator vector files in two ways: as a raster object that has been converted to pixels, or as a Smart Object which remembers its vector origin. Create a new Photoshop file and specify U.S. Paper as the Preset and name it Logos. We're going to compare an Illustrator raster object with an Illustrator Smart Object.

▶ *Open Illustrator artwork as a raster file.* In Photoshop, choose File>Open to open *Bate Logo.ai*. This Illustrator file is made from vector paths that have been filled with color. But Photoshop is primarily a raster program, so when Photoshop opens an Illustrator file, an *Import PDF* dialog box appears that converts vector artwork into pixels. At this point, we could specify any size and resolution, and the resulting quality would be very good. For now, accept the size as is, make sure that the resolution is 300 pixels/inch and click OK to open the file. Now use the Move tool to drag the logo into our Logos file.

When you open an Illustrator file, the Import PDF dialog box lets you specify a size and resolution before converting it into pixels.

▶ *Open Illustrator artwork as a Smart Object.* With the Logos file still active, choose File>Place Embedded to place the *Bate Logo.ai* into our Logos document. The *Open As Smart Object* dialog box appears, but notice how it won't let us specify a size or resolution. Bummer! Click OK to accept the defaults. The new layer has automatically been named *Bate Logo*, reflecting the Illustrator file name (that was smart). Notice, too, that we are in Transform mode, as evidenced by the bounding box and Options bar. Okay, we weren't given the option to resize our artwork in the *Open As Smart Object* dialog box, but we have that option now. The resolution automatically conforms to our current settings, which is 300 ppi in this case. Hit Return/Enter to accept the default transform values, and compare the Smart Object to the pixel version. There should be no difference in quality.

Specifying size and resolution for an Illustrator file placed as a Smart Object is not necessary, because it remains vector artwork.

When you *place* an Illustrator file into Photoshop, it automatically converts the file to a Smart Object. We could also have placed *Bate Logo.ai* as a Smart Object by dragging and dropping it from Bridge. Alternatively, we could have opened the file as a Smart Object by choosing File>Open as Smart Object from the Main menu and then dragged it into our Logos document.

A Smart Object layer derives its name from the original file.

▶ *Enlarge the artwork.* Select Layer 1, the raster logo, and scale it to 500%, then do the same for the Bate Logo layer. Type Command+1 (Mac) or Control+1 (PC) to view the file at 100% and examine the edges.

Use Photoshop's *Bird's Eye View* to make an apples-to-apples comparison. Press and hold the H key, then click and hold the mouse to zoom out. Reposition the rectangle view indicator over the area you want to examine, then release the mouse to return to 100% magnification. Repeat the process to examine the exact same section of the other logo.

Did you notice the difference? The Smart Object stayed sharp, because it was able to access the original vector data. The edges of the pixel logo, on the other hand, became soft, because Photoshop had to guess when it added new pixels.

Rectangle Indicator in Bird's Eye View

The Smart Object on the left retained its sharpness because it could access the vector data, whereas the pixel layer on the right became soft and blurry.

Editing Smart Objects

Another advantage of Smart Objects is the ability to create multiple duplicates (also called instances) and edit them simultaneously. In this exercise, we're going to place 4 copies of a photo on one 8" x 10" sheet of photo paper.

▶ *Place a Smart Object in an 8" x 10" document.* Create a new file with the following parameters:

- Name: Town Hall Prints
- Preset: Photo
- Size: Landscape, 8 x 10

Choose File>Place Embedded from the Main menu and select Town Hall.jpg, a photo that I took of the Town Hall in Tangermünde, Germany. Hit Return/Enter to accept the default transformation and drag the photo to the upper left corner using the Move tool. *Placing* the file—as opposed to *opening* it—automatically converted it to a Smart Object.

Town Hall.jpg

▶ *Duplicate the Smart Object.* Select the Move tool and Option/Alt+Drag the photo to the upper right corner. When you Option/Alt+Drag a Smart Object, Photoshop automatically creates a duplicate layer. That's one way to duplicate a Smart Object. Here's another.

Select both layers in the Layers panel and type Command+J/Control+J or drag the layers down onto the Create a new layer icon to duplicate them. With your two top layers still selected, use the Move tool to drag the duplicates down to the bottom of the canvas. It looks like we have four separate photos of the Town Hall, but we actually have four *duplicates,* or *instances,* of one Smart Object.

Duplicate a Smart Object by *Option/Alt+Dragging* with the Move tool.

▶ *Edit the contents of a Smart Object.* We're ready to print the photos, but when we show them to our friend, his first comment is, "Looks nice, except that the building is slanting." He's right—we have a keystoning problem—and we really should have corrected the original file. But since we are dealing with a Smart Object, there's no need to undo what we have done. We can make one correction that will ripple through all duplicates.

Double-click the thumbnail of any one of the four layers or choose Edit Contents from the Layers panel flyout menu. *Townhall.jpg* opens in a new window.

Select the entire Background layer by typing Command+A (Mac) or Control+A (PC), then type Command+T (Mac) or Control+T (PC) to enter Free Transform mode. Command+Drag (Mac) or Control+Drag (PC) the upper left Bounding Box handle to correct the vertical along the left side of the building, and Command/Control+Drag the top right Bounding Box handle a little, too.

Double-click a Smart Object's thumbnail to edit it.

When you are finished with the keystoning adjustment, close the file and click Save when prompted. The changes that you made are immediately reflected in the *Town Hall Prints* document.

Command+Drag/Control+Drag the Bounding Box handles until the building looks straight.

▶ *Exporting a Smart Object's contents.* That worked out well. Our *Town Hall Prints* document is ready to print, and we have corrected the keystoning problem in the bargain. Or have we? Switch to Bridge and look at *Town Hall.jpg*. The keystoning is still there, even though we just corrected it! When you edit the contents of an Embedded Smart Object, you are working on a copy of the file, not the original, and that copy is tucked away in a "secret hiding place" on your hard drive. In order to save an Embedded Smart Object as a stand-alone file, Control+Click (Mac) or Right+Click (PC) on the Smart Object layer (not its thumbnail) and choose Export Contents from the contextual menu. Choose an appropriate location on your hard drive, and save. The Export Contents command is also available in the Main menu under Layer>Smart Objects>Export Contents.

Choose *Export Contents* to save Smart Object edits as a stand-alone file.

Speaking Photoshop…

My Smart Objects didn't update

Smart Objects update successfully only when the file name and location remain unchanged after you edit the Smart Object. This becomes a problem if your edits require a different file format, because that also results in a name change. For example, if you add an adjustment layer to a JPEG file (or any other layer for that matter), Photoshop will convert your file to the PSD format, because JPEGs don't support layers. If you use the *Save As* dialog box and alter the name or location of your Smart Object, the update will fail. There are two remedies for the *Save As* dilemma.

1. If you receive a warning that the document can't be saved to its original format, flatten the file and resave it.

2. Use the *Save As* dialog box and accept the format change. Upon returning to the original document, *Control+Click* (Mac) or *Right+Click* on the Smart Object layer (not its thumbnail) and choose *Replace Contents* from the contextual menu. Select your updated file and click *Place* in the ensuing dialog box to complete the update.

Town Hall.jpg, 4-up, and ready to print.

Using Smart Filters

Most filters can be applied to Smart Objects, offering you the advantages of nondestructive editing and masking capabilities. That's the "smart" way to work. We did that back in Chapter 4 when we used a Smart Object to apply Shadows/Highlights (technically a filter). That gave us a layer mask which enabled us to apply the effects to just part of the image, and it also let us edit our settings by double-clicking *Shadows/Highlights* in the Layers panel. Whenever possible, it's best to apply filters to Smart Objects.

Paint on the Smart Filter mask to edit just part of an image and double-click *Filter Gallery* to edit the filter's settings.

Working with Filters

Welcome to the diverse and exciting world of Photoshop filters! With over 100 Photoshop filters, plus many third party filters, the possibilities are truly endless. You can even create cool effects that you didn't know existed!

Working with filters in and of itself is not complicated—most of them are pretty intuitive. Just experiment. If you like your results, you did it right. If you don't, you did it wrong. It's as simple as that. The hardest part is getting a handle on what's available. We won't be covering every filter in Photoshop, just a few that aren't self-explanatory and a few that have practical every-day uses. The best way to learn about filters is to explore on your own.

An Overview of Filters

▶ *Become familiar with the Filter menu.* As you might expect, Photoshop's filters are accessed through the Filter menu. Open *1 Barn.jpg*, a stunning photo taken by Billy Knight of an old barn in Wisconsin.

The first menu item, *Last Filter,* is a shortcut that lets you reapply the last filter that you used. It changes its name to reflect the most recently used filter. Below that is the *Convert for Smart Filters* command, which is identical to the *Convert to Smart Object* command located in the Layers flyout menu. What follows is a long list of filters, starting with Filter Gallery.

▶ *Using the Filter Gallery.* Start out by selecting Convert for Smart Filters so we can take advantage of nondestructive editing. The Layers panel should now contain a Smart Object named *Layer 0*.

Now choose Filter Gallery from the menu. Filter Gallery is actually not a filter at all, but rather a collection of many filters that you can apply in one operation. Click the reveal triangle next to the Artistic folder and you'll see a collection of 15 filters all dedicated to producing some sort of artistic effect. Notice how the image preview changes as you click on the various filter thumbnails. Notice, too, how the controls in the right hand panel change to reflect the filter you selected. Adjust the controls to fine-tune your effect.

Also in the right hand panel, just below the controls, is a layers panel listing the filter or filters that you have applied. Click the eyeball to toggle the filter's visibility. Click the *New effect layer* icon at the bottom of the panel, and you now have a duplicate filter. Then click a different filter thumbnail to change it, resulting in two separate filters, one applied on top of the other. (A faster way to add a new layer is to Option/Alt+Click on a filter thumbnail.) The stacking

order of the filters affects the appearance of your image. Drag a layer up or down to change the order in which the filters are applied. If you want to delete a filter, select it and click on the trash can.

Spend some time experimenting with the various filters to become acquainted with the realm of possibilities. Experimentation is the best teacher.

When you're satisfied with the results, click OK to apply the Filter Gallery filters. The Layers panel now has a layer mask, giving you the option of applying the filters to just part of the image. Click the mask thumbnail to select it, then paint with black to hide the filter effect, white to reveal it, or gray to partially apply it.

In the Layers panel, double-click *Filter Gallery* to edit the settings you applied. You can also add additional filters to the list by selecting them from the Filter menu. The stacking order of filters can be changed in the Layers panel as well. Only one mask is permitted per layer.

▶ *Applying non-Filter Gallery filters.* Of the 100+ filters, only 47 of them have a special Filter Gallery membership. The others are accessed on an individual basis through the Filter menu. Filters followed by an ellipsis (…) sport a dialog box with settings. The ones without an ellipsis have no settings to tweak.

A. Preview
B. Filter category
C. Filter thumbnail
D. Filters pop-up menu
E. Options for selected filter
F. Filter selected and applied
G. Filter not applied
H. New effect layer
I. Delete effect layer

The Sharpen Filters

Most filters produce fancy, artistic results, but the sharpen filters are work horses of everyday life in Photoshop. We're going to cover the two newest and most advanced sharpen filters: *Smart Sharpen* and *Shake Reduction*.

▸ *Sharpen an image using Smart Sharpen.* Open Shari Kastner's *Smart Butterfly.psd* once again and convert the *Butterfly* layer to a Smart Object so we can apply nondestructive sharpening. With the Butterfly layer selected, choose Filter>Sharpen>Smart Sharpen from the Main menu. Smart Sharpen is a newer, more advanced version of Unsharp Mask. They both create the illusion of sharpness by increasing contrast along edge pixels.

The Smart Sharpen dialog box lets you preview your results in two ways. The preview window in the dialog box shows you the result of your sharpening. Click and hold your mouse on the preview to see the unsharpened image. Drag in the preview window to examine different parts of the image, or click the + or – magnifying glasses to change the zoom. Increase the size of the Smart Sharpen dialog box for a larger preview area.

The document window also shows you before and after results, depending on whether or not the Preview check box is checked. Having two previews lets you examine your image using different magnifications. Use the keyboard shortcuts Command/Control+Plus or Command/Control+Minus to change the magnification of the document window. An on-screen magnification of 100% is best for viewing Web images, but a 50% magnification more closely matches the appearance of a printout.

Now for the settings. Remember, Photoshop is merely increasing contrast along edge pixels to make the image appear sharper, and to that end, Photoshop has two questions for you:

1. *How much* should it increase contrast?
 This is the Amount value. A larger number creates more contrast. Typical values range from 100–200%.

2. *How close* must pixels be before they are considered an edge?
 This is the Radius value. A larger radius results in fatter edges. A typical value for a 300 ppi image is 1–2 pixels; the value for a 72 ppi image is typically 0.5–1.

Sharpening sometimes creates unwanted noise. If this happens, Reduce Noise can help keep it in check. A typical amount is 10% or less.

Use Smart Sharpen to sharpen images.

Enter 200% for the Amount, 1.0 px for the Radius and 0% for Reduce Noise. Immediately you should see an improvement in the butterfly's wings. Let's exaggerate the effect to watch it work.

Drag the Amount slider all the way to the right (500%) for maximum contrast. Do you see the thin white line surrounding the butterfly's antennae? Now increase the Radius to 4.0 and watch how the line gets thicker. This halo effect is the hallmark of an over sharpened image, and it's something you want to avoid.

We have yet another bad side effect from our sharpening—excessive noise, especially noticeable in the background. Slowly increase Reduce Noise until the problem disappears. When working with Smart Sharpen, start with Reduce Noise at 0% and set your Amount and Radius, taking care not to introduce a noticeable halo effect. Then increase Reduce Noise only as far as necessary to correct any problems.

The Remove popup menu gives you a choice of *Gaussian Blur*, *Lens Blur* and *Motion Blur*. Lens Blur is more advanced than Gaussian Blur and should be used in most cases. Motion Blur is intended for moving objects.

The Shadows/Highlights section lets you selectively reduce sharpening by increasing the *Fade Amount*. *Tonal Width* lets you adjust your definition of a shadow or highlight, and *Radius* determines the number of pixels that Photoshop uses as it looks for shadow and highlight regions.

After you have a good feel for how the controls operate, set the Amount to 200%, the Radius to 1.5 pixels, Reduce Noise to 10%, and Remove to Lens Blur. Click OK to accept the results, then toggle the Smart Sharpen visibility in the Layers panel to compare the sharpened and unsharpened butterfly.

Set the Amount and Radius first, then use Reduce Noise to remove any excess noise. The Shadows/Highlights controls can reduce sharpening in the background if it's significantly brighter or darker than the main subject.

Sharpened with an Amount of 200%, a Radius of 1.5 px and Reduce Noise at 10%. Detail improved significantly without noticeable side effects.

Sharpened with an Amount of 500%, a Radius of 4.0 px and Reduce Noise at 0%. Over sharpening like this produces a halo effect and excessive noise.

▶ *Sharpen an image using Shake Reduction.* Open *Beer Mug.jpg*, a blurry photo due to camera movement. Let's see if Photoshop's Shake Reduction filter can help rescue this image.

Start out by converting the image to a Smart Object for nondestructive editing, then choose Filter>Sharpen>Shake Reduction from the Main menu. The dialog box opens with a rectangle surrounding part of the mug and plate. That's Photoshop's *Blur Estimation Region*—the area that Photoshop analyzes to detect and erradicate motion blur. Already you should see a substantial improvement in sharpness.

A. Use the Blur Estimation or Blur Direction tool to manually create Blur Estimation Regions.

B. The Blur Estimation Region is used to calculate motion blur characteristics.

C. Blur Trace Settings let you fine tune Blur Trace Bounds and noise suppression.

D. The Advanced section lets you add, select or trash additional Blur Estimation Regions.

E. The Detail preview lets you check detail in specific regions.

The controls along the right let you tweak Photoshop's automatically generated settings in the quest for further improvement. I must admit that I have rarely been able to improve on Photoshop's default settings, but here's what they do:

- Preview and Artifact Suppression. Check Preview to compare before and after results. Check Artifact Supression to help remove excess noise.

- Blur Trace Bounds. Use the slider to resize the region that Photoshop uses in its calculations.

- Source Noise. Use Auto to let Photoshop determine the nature of the image noise, or choose Low, Medium or High to manually identify the noise condition.

- Smoothing and Artifact Suppression. Both settings reduce noise. Smoothing concentrates on high frequency noise and Artifact Suppression concentrates on medium frequency noise.

- Advanced. This section lets you add additional Blur Estimation Regions. Click the *Add suggested Blur Trace* icon to let Photoshop generate a new blur trace. You can also manually add Blur Estimation Regions using the *Blur Estimation Tool* or the *Blur Direction Tool*. As new areas are added, click on the check boxes below their thumbnails to preview the results. Click the *Trash* icon to delete them.

- Detail. The Detail preview lets you zoom in on specific areas. Click anywhere in the main preview window to display that region in the Detail window. Click and hold on the Detail preview for before and after comparisons.

When you are finished tweaking your settings, click OK to apply the filter. Click the Shake Reduction eyeball in the Layers panel to compare before and after results. Photoshop did indeed come to the rescue for this blurry image. You'll find it works best on well lit images with low noise.

Shake Reduction settings let you fine tune how Photoshop removes camera motion blur.

The Displace Filter

The Displace filter has some practical implications, but it's not intuitive. Using it, you can give an object an uneven distorted surface. For example, you can make something look like it's floating under water or graffiti on a rock. It's a two step process—define a displacement map, then apply it.

▶ *Create a displacement map.* Open *Loon.jpg*, a photo taken by nature photographer, Caron Gray. We're going to add a caption and make it look like it's floating under water. Our first task is to find a section of rippling water and define it as a displacement map. Then we'll use our new displacement map as we apply the Displace filter.

Use the Crop tool to crop the trail of water in the loon's wake, then save it as Water Displace.psd. Displacement maps must be saved in the native Photoshop format in order to work.

Crop the section of rippling water and save it as a native Photoshop file to use as a displacement map.

▶ *Apply the Distort filter.* Close *Water Displace.psd* and reopen *Loon.jpg*, then do the following:

- Type T to select the Type tool and choose a font and color from the Options bar. (I used Myriad Pro Black, light green.)

- Click below the loon and type The Common Loon. Reposition the caption with the Move tool if necessary.

- Convert the caption to a Smart Object, then choose Filter>Distort>Displace from the Main menu.

- In the Displace dialog box, the Horizontal and Vertical Scales determine the intensity of the effect, and the remaining options determine how to fit the map to the image. There's no way to know the end result, so accept the defaults by clicking OK.

- In the *Choose a displacement map* dialog box that appears, find and double-click the Water Displace.psd that we just created in the previous step.

Sure enough, the caption has picked up a little water ripple, but not very much. Double-click the Displace layer to bring up the Displace dialog box again and increase the Horizontal and Vertical Scales. Keep experimenting with values until you find the ripple effect you like. I used 30%.

Our final objective is to blend the caption into the water. With the caption layer selected, cycle through the Layer Blending modes until you find an effect you like. You may also want to tweak the opacity. I used Overlay at 100% opacity, but your results will vary depending on the color you chose.

Horizontal and Vertical Scales affect the intensity of the displacement effect.

Apply the Displace filter and choose a blending mode and layer opacity to make the caption appear like it's under water.

The Displace filter distorted the caption to make it look like it was floating in water. A blending mode of Overlay finished the effect.

The Clouds Filter

As its name implies, the Clouds filter lets you create a cloudy sky. Choose sky blue for your foreground color and cloud white for your background color. Then choose Filter>Render>Clouds and Photoshop replaces the contents of your current layer with a random cloud pattern. If you don't like the pattern, type Control+Command+F/Alt+Control+F to run the filter again for a different pattern. For a more stark cloud pattern, hold Option/Alt as you choose the filter.

The cloud pattern looks a little tight for my tastes when used with a 300 ppi document. For a more diffused look, select a small portion of the clouds with the Marquee tool and enlarge it using Free Transform.

Despite its name, the Clouds filter can produce some interesting photo backdrops when you use different foreground and background colors.

The Clouds filter generates a random foreground/background pattern.

The Clouds filter using sky blue and white as foreground and background colors.

A small section of the image above, enlarged for a more diffused look.

The Clouds filter using red and black as foreground and background colors.

Vanishing Point

Vanishing Point is a wonderful filter that lets you edit images with perspective. Clone, heal, paint, duplicate, transform—do whatever you need to—and Photoshop puts it all into perspective for you. It's actually a mini application in its own right that happens to reside inside of Photoshop.

▶ *Prepare to enter Vanishing Point.* Open *Building.jpg*, a photo taken by my brother, Rick Bate. Here's the scenario. An architect has been asked to renovate this building for its new tenant, Kate's Kafe. Kate wants two new windows in the second floor, a sign on the left wall, and an accent stripe below the roof line on the right wall. Vanishing Point is going to make these revisions a snap.

Before entering Vanishing Point, always create a blank layer for the edits. Vanishing Point is one of the filters that cannot work with a Smart Object, but its ability to work with multiple layers gives us nondestructive editing anyway. Option/Alt+Click the New Layer icon and name the layer Vanishing Point. Leave the other *New Layer* options at their default settings. With your new layer selected, choose Filter>Vanishing Point from the Main menu, or type Option+Command+V/Alt+Control+V.

▶ *Establish perspective planes.* The Vanishing Point dialog box has a lot to offer—so much so, that Adobe has supplied you with your own private tutor to lead you along the way. I'm talking about the working tips area just below the Options bar that says, "Click the four corners of a perspective plane or object in the image to create an editing plane. Tear off perpendicular planes from the stretch nodes of existing planes." What, exactly, does that mean, you ask? It's telling us that Photoshop needs our help. Although we can see the perspective in this photo, Photoshop only sees pixels, and it needs our assistance to define the perspective.

Take a look at the overall work space. In typical Adobe fashion, you have a tool box along the left and an Options bar across the top. Notice that the second tool, the Create Plane tool, is preselected, and most of the other tools are grayed out. Our first responsibility is to use this Create Plane tool to help Photoshop understand where the perspective lines lie.

Using the Create Plane tool, click on four corners to establish horizontal and vertical perspective lines in the photo. I used the area defined by the blue grid in the image below. Precision is important. Just before you are ready to click on a corner point, hold the X key to double your magnification temporarily.

When you click on the fourth point, Photoshop automatically selects the first tool, the Edit Plane tool, and our tutor has a new message for us: "Select, edit, move and resize planes." You'll also see a grid that has four corner nodes and four center edge nodes. Grids come in one of three colors:

- **Blue grid**. Photoshop thinks you did a good job, and you have its permission to continue working.

- **Yellow grid**. True, Photoshop can't "see" perspective, but it can do math, and it thinks your math is fuzzy. One or more of the corner nodes is off. Use the Edit Plane tool and adjust the grid until it turns blue.

- **Red grid**. Your math is off again, but this time the aspect ratio is wrong. Once again, use the Edit Plane tool to adjust the grid until it turns blue.

Our grid extends all the way to the right corner of the building, but it needs to extend more to the left. With the Edit Plane tool, drag the edge node until the grid extends all the way to the left, then drag the top edge node to extend the grid to the top of the building. If necessary, adjust the four corner nodes, too. Resist the temptation to align the vertical with the edge of the photo. That's not usually an accurate vertical.

Now we're ready to define the perspective plane that extends off to the right side of the picture. This is the "Tear off perpendicular planes…" part of the message that our tutor referred to earlier. Hold **Command** (Mac) or **Control** (PC) and drag the right edge node to the right, which creates a Child plane at a 90° angle from the Parent plane we just created. Now we have to help Photoshop understand the perspective in this direction by dragging the two right corner nodes until we have accurate verticals and horizontals with a blue grid. Use the roof line for the horizontal and the edge of the building for the vertical. Finally, extend the grid to the right by dragging the right edge node.

Drag edge nodes to extend the grid horizontally and vertically.

Command+Drag/Control+Drag an edge node to create a perpendicular plane, then adjust the corner nodes for perspective.

The finished grid should cover any area that you intend to edit.

Command+Drag/Contrtol+Drag the sign to replace it with a clean piece of wall.

▶ *Remove the Franklin sign.* We are going to use the Marquee tool to remove the Franklin sign. It's similar to the one in Photoshop proper except that it can understand perspective and double as the Patch tool. Click it, and our tutor now says, "Click & drag in a plane to select an area of that plane. Opt+drag (Mac) or Alt+drag (PC) a selection to copy an area to a new destination. Cmd+drag (Mac) or Cont+drag (PC) a selection to fill an area with the source image."

Drag a rectangle around the Franklin sign. Do you see how the shape conforms to the perspective grid we created? Place your cursor inside the selection, drag it to the other plane, and watch how it wraps around the corner. That's Photoshop showing off its math skills and making sure that your perspective edits look realistic, no matter where you place them.

Position the marquee over the Franklin sign once again, then Shift+Command+Drag (Mac) or Shift+Control+Drag (PC) to the left to replace the selected area with a clean piece of wall. The Command/Control key makes the Marquee tool function like the Patch tool, and the Shift key constrains the movement horizontally or vertically. Release the mouse when the selected area looks good. Another way to make the Marquee function like the Patch tool is to change the Move Mode from Destination to Source.

Notice the Feather, Opacity and Heal options in the Options bar. They work like the options in Photoshop proper, except that they remain live. This means that you can adjust them before or after you create the marquee. Check out the three heal options. *Off* doesn't try to blend the source with the destination; *Luminance* blends based on brightness only; and *On* blends brightness and color. In this case, Off and On work the best. Experiment with the other options to get a feel for how they work, then choose settings that make the Franklin sign disappear without a trace.

▶ *Copy a window with the Marquee tool.* We're ready to install a new window in the second story. Drag a Marquee around a window on the right wall and Shift+Option+Drag (Mac) or Shift+Alt+Drag (PC) to the left to copy it. The Option/Alt key does the copying, and the Shift key keeps the new window aligned horizontally. As you drag, the window automatically wraps around the wall as it enters the Parent perspective plane. Position it directly over the window in the first story. Try the various Heal options and choose the one that looks the most natural.

Option+Drag/Alt+Drag a selection to duplicate it.

▶ *Transform and duplicate the window.* Perhaps you've noticed two problems: the window is facing the wrong direction and it's higher than the other windows along the left wall. We can correct both of those problems with the Transform tool, but only as long as the window stays selected.

Type T to select the Transform tool, and click Flop in the Options bar to change the window's direction. Now place your cursor over the top center bounding box handle and drag downwards to make the window about as tall as the windows to its left.

When the window is flopped and sized the way you want, Shift+Option+Drag (Mac) or Shift+Alt+Drag (PC) to the right to create a duplicate window and center it over the lamp. Type Command+D/Control+D to deselect the marching ants.

▶ *Choose a color for the accent stripe.* We want to add a green accent stripe just below the roof line on the right wall. Type I or click the Eyedropper tool to select it, then click on the green molding to sample a green color.

Two windows copied, flopped, and reduced in height. The blend mode, set to *On*, blends the windows in their brighter setting.

▶ *Paint an accent stripe.*

Type B or click the Brush tool and set the options for diameter, hardness, opacity and heal mode. Brush options have to be set before you make a brush stroke. For our accent line, choose the following settings:

- Diameter: 10
- Hardness: 70
- Opacity: 100%
- Heal: Off

The diameter, opacity and heal settings are pretty self-explanatory, but why the 70% hardness? I wanted the accent stripe to be a hard-edged line, but 100% hardness made the line appear more in focus than the surrounding area. That's a giveaway that we tampered with the photo. I felt that 70% matched the focus of the photo more closely. In other words, it was a trial and error decision.

Shift+Drag with the Brush to paint a horizontal line beneath the molding.

Shift+Drag with the Brush to constrain the line horizontally.

Use the Type tool to create a 2D sign.

Command+Click/Control+Click the type layer's thumbnail to load all nontransparent pixels as a selection, then copy.

Bring the sign into Vanishing Point by pasting it, then drag it onto the grid to give it perspective.

Transform the sign to fit.

▶ *Accept the Vanishing Point edits.* We're done with all of our tasks except for the sign, which has to be created outside of Vanishing Point. Click OK to exit Vanishing Point and accept the edits.

Click the eyeball on the Vanishing Point layer and check your work. Does everything look natural? If not, use the Eraser to erase the spot you don't like and re-enter Vanishing Point to give it another try. That's the beauty of nondestructive editing. If we hadn't created a blank layer before entering Vanishing Point, all of our edits would have permanently altered the Background layer, making it difficult to repair any mistakes we made.

▶ *Create a 2-dimensional sign.* Sample a green color with the Eyedropper tool, then select the Type tool and type Kate's Kafe in two lines. I used Caflisch Script Pro Bold, but choose any font that you think Kate would like. Select a size that is about right or slightly larger than the sign you want to create. We'll be adjusting the final size in Vanishing Point.

▶ *Copy the sign's pixels.* Vanishing Point only works with raster art, so vector art, which includes type, has to be converted to pixels first. Choosing Type>Rasterize Type Layer from the Main menu would do the trick, but there's a faster way to copy the type's pixels. Simply Command+Click (Mac) or Control+Click (PC) on the thumbnail of the Kate's Kafe layer to select the layer's pixels. Then type Command+C/Control+C to copy the pixels. Type Command+D/Control+D to deselect the marching ants and click back on the Vanishing Point layer to select it.

▶ *Bring the sign into Vanishing Point.* Re-enter Vanishing Point by typing Option+Command+V/Alt+Control+V. Notice that the grid that we created earlier remains intact, so we won't have to do that part again.

▶ *Paste the sign's pixels.* Paste the sign by typing Command+V/Control+V. You should see a floating selection of the sign in the top left corner of the image preview. Be sure not to deselect it.

▶ *Position the sign on the grid.* Drag the sign onto the grid and watch how its shape and size automatically conform as you move it about. Position it below the lamp on the left wall.

▶ *Transform the sign.* Type T to access the Transform tool and size the sign to fit. When you have finished, type Command+D/Control+D to deselect the sign. Once deselected, you can no longer move or resize it.

▶ *Use the Stamp tool to remove the For Rent sign.* That *For Rent* sign in the window to the left of the sign is rather distracting. It makes it look like poor Kate has already gone out of business, when in fact she hasn't even moved in yet. Type S or click the Stamp tool to select it. This tool is actually a hybrid of the Clone Stamp and the Healing Brush tools in Photoshop proper. If Healing is Off, it's like the Clone Stamp tool; if healing is set to Luminance or On, it's like the Healing Brush. The biggest difference is that the Stamp tool changes its brush size and angle to honor the perspective grid.

▶ *Set the Stamp tool options.*

| Diameter: 30 | Hardness: 70 | Opacity: 100 | Heal: Off | ☑ Aligned |

Use the Stamp tool options shown above. The Hardness value of 70 was chosen to match the focus of the image.

▶ *Clone out the sign.* Align the cross hairs on the right edge of the brown shape immediately above the sign, and Option+Click/Alt+Click to establish the source point. Move the cursor down over the sign, making sure that the brown shape maintains a straight edge, and click to clone out the top left part of the sign. Continue moving down along the edge of the brown shape, clicking as you go, until you reach the bottom of the window. You now should have a nice straight edge to the brown shape. The rest of the sign is more out in the open and should be easier to clone.

When the sign is gone, look for telltale spots that form a repeating pattern—a typical problem of cloning. Change the Heal option to On, uncheck Aligned, and Option+Click/Alt+Click on a clean looking source point, and "heal away" any pattern pixels you see.

Use similar techniques to clone out the For Rent sign in the window to the right as well. When you are done, click OK to accept the Vanishing Point edits.

Carefully work your way down the edge of the brown shape, clicking as you go.

Use a black Color Fill layer at reduced opacity to tone down the reflections in the windows.

▶ *Darken bright reflections.* We have a nice looking, remodeled building certain to please Kate. But there's one more detail that would help, and it's easy to fix. The two windows that displayed the For Sale signs are extremely reflective, to the point of being distractive. We want the reflections, because they make the glass look realistic. We just need to tone them down.

Select the glass portions of the windows using any selection tool you want. Then click the black and white *Create new fill or adjustment layer* icon at the bottom of the Layers panel to add a Solid Color fill layer. Choose black as the color.

The resulting Color Fill layer got rid of the bright reflections all right, but the solid black looks fake. Reduce the opacity of the layer to allow the reflections to reappear without becoming overbearing.

Kate's Kafe remodeled.

Speaking Photoshop…

My Vanishing Point grid doesn't align with the entire photo!

This can be frustrating, and there's not much you can do about it either, except understand it. As I mentioned earlier, Photoshop can't see the perspective line in a photo like we can, but it definitely understands the math behind perspective. Often your grid will align perfectly with the center portion of your photo, but the edges are way off. Correct the edges, and the main part of the grid is wrong. The problem is not with Photoshop—it's lens distortion. If you run into this dilemma, adjust the grid to accurately reflect the portion of the photo that you are editing at that time. Readjust it, if necessary, when you move to a different portion of the photo.

Final Thoughts

There's a lot you can do with Smart Objects and filters in Photoshop—a lot of fun things. Some of the filters, such as Smart Sharpen and Shake Reduction, have practical every day uses, but most filters are all about adding artistry to your creations. It's definitely a world worth exploring. Learn about them now, because there's no telling when you will need to use them in the future.

◂ *Distort, Warp & Content Aware* ▸

9

9 — DISTORT, WARP & CONTENT AWARE

Topics

- Use the Liquify filter to drag, twirl, pucker, and bloat pixels.
- Manipulate limbs and joints using Puppet Warp.
- Automatically fill a selection with background images using Content Aware Fill.
- Scale an image disproportionately without distorting key elements using Content Aware Scale.
- Use the Content Aware Move tool to replace backgrounds vacated by a moved object.
- Use the Content Aware Move tool to extend images.

Preview

This chapter is all about moving and replacing pixels in our quest to make a more perfect or fun filled world. As I'm sure you're aware by now, there's true reality, and then there's Photoshop reality—a world that can be any way we imagine it.

There are many ways to distort or move pixels in Photoshop, starting with basic transform functions to the more sophisticated Liquify filter and Puppet Warp. Photoshop professionals use these techniques to make things look natural in places where they don't belong…to make models appear trimmer than they really are…or to create caricatures by exaggerating key features.

Sometimes we want to move or remove objects from their surroundings and make it appear as though they were never there. For these instances, Photoshop has Content Aware Fill and Content Aware Move. We will also be looking at Content Aware Scale, which lets us scale an image disproportionately without distorting the main subject.

212 ◀ Distort, Warp & Content Aware ▶

Liquify

Liquify is a filter that lets us move individual pixels in a number of ways. It's a favorite of portrait photographers, who use it to make their subjects appear a little trimmer, and it's also used by caricature artists, who use it to exaggerate key features. We'll be exploring its capabilities in the next exercises.

Use *Shift+Command+X/Shift+Control+X* to access the Liquify filter.

▶ *The Liquify workspace.* Open *Gentleman.jpg*, a portrait photo taken by Rick Bate. As is the case with most other filters, we want to work on a Smart Object for nondestructive editing, so Control+Click/Right+Click on the Background layer and choose Convert to Smart Object. Then select Filter>Liquify from the Main menu.

A typical Adobe dialog box appears, with a tool box along the left side, a large Preview window in the center, and tool options in a pane along the right. There's a lot that this filter can do.

▶ *Forward Warp tool.* Select the *Forward Warp* tool, if it's not already selected, and move your cursor over the image. The circle with the cross hairs is your current brush size, which you can change by typing [or] to reduce or enlarge it. You can also change the brush size in the Brush Tool Options pane, as well as the Brush Density, Brush Pressure, and, for some tools, Brush Rate.

Brush Pressure is similar to Opacity—a low pressure reduces the brush's effectiveness. Brush Density is similar to Brush Hardness. A low value creates a feathered effect on the outside edge of the brush. Brush Rate is only applicable to tools that work as you hold the mouse down in one spot. The Twirl tool is an example of this. The faster the rate, the faster the twirl.

Select a brush size and drag with the Forward Warp tool on the image. It's like dragging your finger through wet paint. Option+Drag/Alt+Drag to erase what you have done. Used with a fairly large size brush, the Forward Warp tool can be used to shed pounds from someone's cheeks, neck or torso.

Use the Size slider to specify the diameter of a brush. Pressure affects a brush's power.

Density affects the intensity of a brush along the edge, similar to feathering. Brush Rate regulates how quickly an effect is applied.

Using the Forward Warp tool is like dragging through wet paint.

▶ *Reconstruct tool.* The Reconstruct tool is similar to Option+Dragging/Alt+Dragging with the Forward Warp tool. It erases any liquifying you have done.

The Reconstruct tool restores your image back to normal.

▶ *Smooth tool.* The Smooth tool removes spikes in areas that you have already liquified. It works by dragging or clicking and holding the mouse.

▶ *Twirl Clockwise tool.* As its name implies, the Twirl Clockwise tool twirls pixels as you click and hold the mouse over them. Add the Option/Alt key to twirl counterclockwise. Change the Brush Rate in the Brush Tool Options to regulate the twirl speed.

▶ *Pucker tool.* Click and hold with the Pucker tool to draw pixels to the center of the brush. Add the Option/Alt key to send them away from the center (bloat). Used with a large brush, the Pucker tool can perform a tummy tuck.

▶ *Bloat tool.* This is the opposite of the Pucker tool. Click and hold to bloat, and add the Option/Alt key to pucker. Used carefully, the Bloat tool can sometimes open squinty eyes.

▶ *Push Left tool.* Drag upwards to push pixels to the left, or downwards to push them to the right. Drag right to push pixels up, or left to push them down. The Option/Alt key reverses those directions.

▶ *Freeze Mask and Thaw Mask tools.* The Freeze Mask tool lets you protect areas that you do not want to liquify, and the Thaw Mask tool lets you remove a Freeze Mask area. These tools are option-opposites. If you hold down the Option/Alt key as you drag, the Freeze Mask tool becomes the Thaw Mask tool and vice versa.

▶ *Face Tool.* If you take portrait photos, you'll love this tool. Its facial recognition capabilities let you modify eyes, nose, mouth and face with ease. You can operate it in one of two ways.

Drag the sliders in the *Face-Aware Liquify* pane and watch your subject spring to life. Make him wink by reducing his eye size or look surprised by increasing his eye height. Drag the smile slider as you say something funny and watch him admire your joke. These sliders are fun to play with.

You can also manipulate your subject by mousing over his face and dragging. Tool tips appear and coach you through your efforts.

The jawline and face width have been slimmed down in this example.

- ▶ *Load Mesh Options.* Photoshop attaches an invisible mesh to your image when you enter Liquify. As you use the Liquify tools, you are actually manipulating the mesh, which in turn alters the pixels. The *Load Mesh Options* let you save a mesh and load it for future use.

- ▶ *Mask Options.* The icons across the top let you inverse or ignore selections or masks that were active when you entered Liquify. *None* removes all protected areas, *Mask All* protects all areas, and *Invert All* swaps protected and unprotected areas.

- ▶ *View Options.* The *Show Guides* check box lets you see any guides that were placed in the original image. *Show Face Overlay* shows Face Tool guides. *Show Image* displays your liquified image in the preview pane. *Show Mesh* reveals the underlying mesh attached to your image. *Mesh Size* and *Mesh Color* can be changed using the pop-up menus.

 Show Mask toggles the visibility of freeze mask areas. You can also change your mask color.

 Show Backdrop creates a layered effect of before and after results. So far we have been seeing the post-liquify results in the preview pane, but if we view the Backdrop, the preview pane can show us the pre-liquify results as well. It's useful if you want to glance at the original to determine how much editing you have done. Show Backdrop doesn't affect the actual image, only its preview in Liquify mode. Click the Show Backdrop check box and enter an Opacity of 50% to see an equal before/after mixture of your Liquify results. Change the opacity to see one version more clearly than the other. The *Use* option lets you define which layers are included in the Backdrop. The *Mode* pop-up menu offers three options:

 - *In Front* places the backdrop layer above the liquify edits.
 - *Behind* places it below the edits.
 - *Blend* lets you switch the stacking order of the layers by changing the opacity.

▶ **Brush Reconstruct Options.**

> ▼ Brush Reconstruct Options
>
> Reconstruct... Restore All

Click *Reconstruct* and a dialog box pops up, letting you choose the degree with which you would like to erase your liquify edits. An amount of 0% results in total reconstruction and 100% does not do any reconstruction. *Restore All* results in a total reconstruction.

The *Brush Reconstruct Options* do not affect any edits you created using the Face tool. If you want to undo Face tool edits, click the *Reset* button in the *Face-Aware Liquify* pane to restore all values to zero.

▶ **Editing Liquify.**

Because we were working nondestructively on a Smart Object, we can reenter Liquify at any time by double-clicking the word *Liquify* in the Smart Filters layer. We could also paint on the layer mask to selectively apply the result.

We have been messing around with this poor gentleman all chapter long, but when applied gently with a large brush size, Liquify can effectively trim cheeks, necklines or torsos, so people can concentrate on the real essence of an individual, not hunt for minor flaws. The finished portrait on the right was completed by Rick Bate.

Before Liquify After Liquify

Rick Bate

◀ Chapter 9 ▶ 219

Puppet Warp

Puppet Warp lets you manipulate arms, legs or other limbs as if you had them tied to puppet strings. Technically it's a filter, so it works best when applied to a Smart Object. But before we do that, we need to isolate the "puppet" on its own layer and have a full background beneath it.

▶ *Isolate the image for Puppet Warp.* Open *Elephant.psd*, a photo taken by Rick Bate. Type Command+J/Control+J to duplicate the Background and name it *Puppet Elephant*. We'll use a layer mask to isolate the elephant. I've already made a selection for you, so choose Select>Load Selection from the Main menu and choose Elephant for the Channel. When the marching ants appear, click the Add Layer Mask icon.

Selections are stored as Alpha Channels and can be reloaded as needed.

Any selection that has been saved can be loaded at a later time using Load Selection.

The elephant has been isolated on the *Puppet Elephant* layer with a layer mask. The next step will be to remove the elephant from the Background.

◂ Distort, Warp & Content Aware ▸

This setting adds five pixels to the periphery of the selection.

▶ *Fill a selected area with Content Aware Fill.* We now have the elephant isolated on its own layer for Puppet Warp, but we have to remove it from the Background layer, so we don't see two elephants as we manipulate the top one. We'll do that using Content Aware Fill, a process whereby Photoshop analyzes surrounding pixels and guesses at what the area behind the elephant should look like.

Turn off the eyeball to *Puppet Elephant* and click on *Background* to select it. Load the Elephant selection again, then choose Select>Modify>Expand and choose 5 pixels in the ensuing dialog box. That gives us a little breathing room beyond the edges of the elephant when we fill it.

Choose Edit>Fill or type Shift+Delete/Shift+Backspace to open the Fill dialog box and select Content Aware from the *Contents* pop-up menu. Leave the Blending mode at Normal, the Opacity at 100%, and click OK.

Not bad. Photoshop knew enough to add trees behind the elephant, but if you look closely, you can still see the elephant shape and find a few anomalies. You'll also have to add shadow where the elephant's feet were.

Content Aware Fill did a credible job at guessing what the background behind the elephant should look like. Touch up work is still required and the shadow has to be extended into the area previously occupied by the feet.

It's pretty amazing what Photoshop can do with Content Aware Fill, but it's not fool proof by a long shot. You almost always have to clone or heal select areas to finish the process. There are many effective ways to clean up these details. You can:

- Select problem areas with the Lasso tool and run Content Aware Fill again.
- Use the Healing Brush with a fairly large diameter.
- Use the Patch tool.
- Use the Clone Stamp tool.

Even though Content Aware Fill didn't do the job perfectly, it still did 80% of the work in a matter of seconds. Continue working on the background using any or all of the afore mentioned techniques until it looks natural.

▶ *Enter Puppet Warp mode.* Click *Puppet Elephant* and choose Convert to Smart Object from the Layers flyout menu. Then choose Edit>Puppet Warp from the Main menu to enter Puppet Warp mode. Immediately you'll notice that the elephant is wrapped up in a net. That's the mesh grid, and it serves a similar purpose to the mesh in Liquify.

Puppet Warp uses a mesh grid to manipulate underlying pixels.

▶ *Set Mesh options.*

The first four options in the Options bar deal with the mesh. *Mode* lets you change how elastic the mesh is. *Density* lets you control how many points the mesh has. *Expansion* lets you expand or contract its overall size. And *Show Mesh* lets you hide it. I recommend that you start out with the default values and change them if you run into problems. For now uncheck Show Mesh.

◂ **Distort, Warp & Content Aware** ▸

Adjustment pins interact with other pins, either as pivot points or anchors.

▸ *Add Adjustment Pins.* Click on the tip of the elephant's trunk and notice how your cursor suddenly resembles a stick pin. We want to strategically place pins on the elephant so we can move it. The pins actually serve three purposes.

- They serve as an attachment point that you can drag to move and distort pixels.
- They provide a point of rotation.
- They act as an anchor.

The best place to add adjustment pins are at joints and the ends of limbs. We already clicked at the tip of the elephant's trunk to add an adjustment point there. Drag it and the entire elephant moves, stiff as a board. Just as puppets need more than one string, we need multiple adjustment pins to effectively manipulate the elephant.

Add a new pin just below the elephant's tusk, then drag the first pin again. Do you see how pin number two acts as a pivot point, letting you flip the elephant on its back if you want to? Somehow this gives me a real sense of power. Only in Photoshop could you flip an elephant so easily. What a program!

Now add adjustment pins to the joints and ends of the legs as shown below. Add a couple of pins to the tail as well, then select the end pin on the elephant's tail and drag it in front of his hind leg, as if he's swishing a fly off his leg. Amazing, isn't it? But there are flies on his right hind leg, too. What's a poor puppet elephant to do in such a situation?

Add adjustment pins to joints and the ends of limbs.

▶ *Adjust the Pin Depth.* In the Options bar is a segment called *Pin Depth*. Pins have a stacking order, with the most recently added pin being on top. The tail went in front of the leg because we added that pin last. With the tail pin still selected, click the icon with the down arrow to send it down the stacking order. Now drag the tail to whisk the flies off of his right leg.

You can also rotate around any given adjustment pin. Hold the Option/Alt key and move your cursor slightly away from the pin until you see a circle and a double arrow. Now drag to spin around the adjustment pin. Continue playing with the various adjustment pins until you feel comfortable with the process. If you have a pin that you no longer need, Option+Click/Alt+Click on it, or select it and hit Delete/Backspace.

Adjust the Pin Depth to change which pins appear on top of the other.

Option/Alt+Drag near a pin to rotate.

When you are finished with your adjustments, you can do one of three things:

- Click the check mark or press Return/Enter to apply the distortions and exit Puppet Warp.
- Click the slash-circle or press Escape to abort the changes and exit Puppet Warp.
- Click the backwards rotating arrow to remove all pins and start from scratch.

Option/Alt+Click a pin to delete it.

For now, place your elephant in a pleasing pose and hit Return/Enter to apply the changes and exit Puppet Warp mode.

▶ *Change the Puppet Warp effect.* Because we applied Puppet Warp to a Smart Object, we now have the familiar Smart Filter layer with a layer mask. Paint on the layer mask with black to undo the warp in select areas, or double-click on *Puppet Warp* to reenter Puppet Warp mode and make further pin adjustments.

Double-click Puppet Warp to return to Puppet Warp mode.

An outstretched trunk and swishing tail were easy for Puppet Warp.

Content Aware Scale

Yet another in Adobe's Content Aware series, Content Aware Scale makes it possible for Photoshop to scale an image disproportionately without distorting the main subject. How could Photoshop possibly know which pixels represent the main subject and which ones represent the less important background area? You have to hand it to those Photoshop software engineers!

The way Content Aware Scale works, is that it tries to scale areas void of detail while protecting areas of detail. There are three different ways that you can apply Content Aware Scale. Let's test them out and compare them to normal scaling.

▶ *Duplicate the layers for comparison.* Open *Girls at Lake.jpg*—a photo of two pretty girls taken by Phyllis Bankier—and duplicate the Background layer four times by typing Command+J/Control+J. Name the first layer Normal Scale, the second Content Aware Scale, the third Skin Protect, and the fourth Alpha Protect.

Duplicate the Background four times, so we can compare different scaling methods.

Girls at Lake is a nice photo, but we want it to be wider for our brochure layout.

▶ *Add to the Canvas size.* We want this photo to be 15 inches wide to extend across a two-page spread for a brochure we're working on. The first thing we have to do is add to the canvas size. Choose Image>Canvas Size from the Main menu or type Option+Command+C/Alt+Control+C to access the Canvas Size dialog box. Click in the left column of the Anchor proxy, uncheck the Relative check box, and enter 15 Inches in the Width field. Click OK, and we now have room to grow on the right side. At this point, we could go to work cloning more background, but that would be very time consuming. Let's see if scaling the image can save us some time.

Use Canvas Size to change the width to 15 inches.

▶ *Scale using Free Transform.* Click the Normal Scale layer to select it, and turn off all the eyeballs above it, so we can see it. Type Command+T/Control+T to enter Free Transform mode and drag the right center handle to the edge of the canvas. Hit Return/Enter to accept the transform and look at the results.

Granted, those two girls are still really cute, but you could find yourself in trouble for scaling people like that. It's certainly not an acceptable solution. Turn off the eyeball.

Drag the right center handle to the edge of the canvas.

Enlarging the width without enlarging the height makes everything appear too wide.

Reducing the Amount reduces the effectiveness of Content Aware. At 0%, it is identical to normal transform scaling.

Content Aware Scale helped the girls' faces but at the expense of other areas.

Click the human figure icon to protect skin tones from scaling.

The Skin Protect option helped immensely for this photo.

▶ *Scale using Content Aware Scale.* Click the Content Aware layer and choose Edit>Content Aware Scale from the Main menu. Drag the right center handle, as you did before, to the edge of the canvas.

That's better—in parts anyway—but it's still far from acceptable. Notice the improvement in the detail areas, such as the girls' faces and the breakwater. Unfortunately that pink blouse really took a hit. We could bring it into better proportion by reducing the *Amount* value in the Options bar. Amount controls the degree to which Content Aware technology is applied.

▶ *Use Content Aware Scale with Skin Protect.* Click the Skin Protect layer and choose Content Aware Scale again. Towards the right of the Options bar is a pop-up menu labeled Protect. Click it…and you have no choices. Just to the right of that is a human figure. That's Content Aware's *Skin Protect* function, and it tells Content Aware to exempt skin tones from scaling. Click it, and scale the image as before.

Now that's pretty good. The girls look pretty much unchanged, because the scaling was applied almost entirely to the background. Skin Protect is ideal for a photo like this, because the girls are dressed for summer. If they had jackets on, this option would not have worked as well.

▶ *Use Content Aware Scale with Alpha Protect.* We want to use that *Protect* pop-up menu—the one that offered no choices before—but we need to create an Alpha channel first. What's that? An Alpha channel is a saved selection, like the Elephant channel that I saved for you for the Puppet Warp exercise.

Select the Alpha Protect layer and turn on its eyeball. Then use the Quick Selection tool to select the girls, including the area between their arms and bodies. With the selection active, choose Select>Save Selection from the Main menu and name it Girls. Look in the Channels panel, and you'll see your *Girls* Alpha channel at the bottom. Alpha channels don't print or alter an image, they are only used to store selections. Now we're ready to proceed.

The *Girls* Alpha channel is a saved selection in the form of a mask.

Deselect the marching ants, click the Alpha Protect layer and choose Content Aware Scale again. Make sure Skin Protect is turned off, select Girls from the Protect pop-up menu, then scale as before.

The *Girls* Alpha channel will prevent the girls from scaling.

That worked great, even a little better than Skin Protect. Compare the two, and you'll see how Skin Protect enlarged the pink shirt just a little. Using the Alpha Protect option is your most powerful choice for Content Aware Scale, but there comes a point when even Alpha Protect falls short. There's a limit to how far you can disproportionately scale an image, even with Content Aware Scale.

Leave the *Girls at Lake* file open for the next exercise, or if you need to take a break, save it as *Girls at Lake Content Aware.psd*. If you save it as a JPEG, you will lose your *Girls* Alpha channel.

The Alpha Protect option left the girls at their original size.

Content Aware Move

The Content Aware Move tool is a combination of the Move tool followed by Content Aware Fill. As with other Content Aware applications, it's not always perfect, but it's worth a try.

▶ *Move a selection with the Move tool.* To provide a frame of reference, we're going to move a selection with the standard Move tool first. Duplicate the Alpha Protect layer of the *Girls at Lake* file and name it Content Aware Move. Turn off the eyeballs to all other layers, then use the Lasso tool to draw a loose selection around the girl on the left and drag her further to the left.

The problem we have should be immediately apparent. The area she used to occupy is now a gaping hole. If we were on the Background layer, that hole would have been filled with background color. Undo that move. We can do better with the Content Aware Move tool.

▶ *Move a selection with the Content Aware Move tool.* Select the Content Aware Move tool. It's hiding in the first slot of the retouching tools under the Spot Healing Brush. The Options bar gives you a choice of two Mode settings. Make sure that Mode: Move is selected. Also deselect Transform on Drop unless you want to scale or rotate your subject as you move it.

If your selection is still active, you can use it. Otherwise draw a new selection using the Content Aware Move tool. It works just like the Lasso tool—drag it to make a freehand selection or Option+Click/Alt+Click to create a selection of straight line segments.

The *Content Aware Move* tool is located under the *Spot Healing Brush*.

Select *Move Mode*.

Uncheck *Transform On Drop*.

The Move tool (left) leaves a hole in its wake, but the Content Aware Move tool fills the hole.

With the selection active, drag the girl to the left and wait a second. Photoshop does some analyzing, then presto, the hole fills with a manufactured background. In effect, the Content Aware Move tool did three things: move the girl, reselect the hole she vacated, and fill using Content Aware Fill.

Look at the Options bar and locate the features called *Structure* and *Color*. *Structure* determines how strictly the source pixels are preserved. Adjust it and you may see the girl's shape change slightly. *Color* helps blend color shifts between source and destination. Increasing it permits a larger change in the source color. These are live settings, meaning that you can adjust and compare them as long as the selection remains active. If you don't like the results you got with the initial settings, try other values and choose the best.

Adjust *Structure* if you notice any distortion in the moved image. Use *Color* to remove noticeable color shifts.

The final photo, expanded with Content Aware Scale and adjusted with Content Aware Move.

- **Copy a selection with the Content Aware Move tool.** Also in the Options bar is a feature called Mode, and it offers two choices: Move (which we just did) and Extend, which, in my opinion, could have been called *Copy*. If you were using the normal Move tool, you would Option+Drag/Alt+Drag to make a copy of the selection. But since the Content Aware Move tool starts out acting like the Lasso tool, an Option+Drag/Alt+Drag subtracts from the selection instead. In order to copy a selection, you have to be in Extend mode.

Choose Extend mode to copy a selection.

Open a fresh copy of *Girls at Lake.jpg*. Type Command+J/Control+J to copy the Background layer and name it Extend. Use Canvas Size to expand the width to 15 inches, except this time, add the extra width to both sides by leaving the Anchor point in the center. Use the Rectangular Marquee tool to select the background area to the left of the girl with the pink shirt. Switch to the Content Aware Move tool, specify Extend for the Mode, and drag the selection to the left. Repeat that until you have covered the left side of the canvas. Now do the same for the right side of the canvas.

In *Extend* mode, the Content Aware Move tool creates a copy of the selection and blends it with the surroundings.

This image gives you a good insight into where the tool excels and where it has problems. The water and the skyline extended beautifully because they were uniform, but the rocks in the breakwater didn't fare so well. Those would need to be hand-retouched to bring them up to acceptable standards. Still, the Content Aware Move tool did a lot of the busy work for us, so we have to consider it a success.

Content Aware Extend did well with the water and skyline. The repeating figures and the shape of the breakwater still need attention.

Final Thoughts

Distorting, moving, and replacing pixels are all part of the Photoshop game. And true to Photoshop's modus operandum, there are several ways you can accomplish this. Distortion choices include simple transform commands, Liquify and Puppet Warp. Each has its own advantages and disadvantages.

Moving and replacing pixels can be accomplished using the standard Move tool, or the more sophisticated Content Aware commands. Become comfortable with all of these methods, so you will be able to choose the best solution for the task at hand.

> *There are three key things for good photography: the camera, lighting and…Photoshop.*

▸ *Tyra Banks*
TV personality, actress, model, 1973–

10

◀ *Camera Raw, Photomerge & HDR* ▶

Rick Bate

10 ▲ CAMERA RAW, PHOTOMERGE & HDR ▼

Topics

- Use Adobe Camera Raw to correct white point balance, exposure, clarity and saturation.

- Adjust parts of an image in Camera Raw with the Adjustment Brush, Graduated Filter or Radial Filter.

- Straighten and crop an image in Camera Raw using the Straighten and Crop tools.

- Clone or heal an image in Camera Raw using the Spot Removal tool.

- Use Camera Raw as a filter in Photoshop.

- Create panoramas using Photomerge.

- Create images with high dynamic range using HDR Pro.

Preview

Photoshop has many tools to help photographers in their quest for that once-in-a-lifetime shot. In this chapter we'll be introducing the many powerful capabilities of *Adobe Camera Raw*. You'll learn how to bring out the absolute best that your camera has to offer, even if some of the settings were wrong when the photo was taken. We'll also take a look at *Photomerge,* an automated feature that lets you combine multiple images into a seamless panorama. For those set-ups that are difficult to expose properly, we'll be talking about *Merge to HDR Pro*. With it, you can combine multiple exposures into one high dynamic range photo. You'll appreciate its ability to achieve incredible detail throughout the entire range of midtones, shadows and highlights.

Camera Raw

An Overview of Camera Raw

Digital cameras typically save images in JPEG format, but many mid- to high-end cameras also have the ability to save images in Camera Raw format. Photoshop can work with both format types, but there are some distinct advantages to working with Raw files.

Digital cameras are part hardware and part software. As light streams through the camera's lens, it is captured by an array of sensors (hardware). Some of these sensors are sensitive to red light, others to green light, and others to blue light. Do you remember back in chapter 5, when we talked about how the first color photograph was created by blending individual black and white photos taken through red, green and blue filters? This is merely a variation on that theme.

Anyway, for any given spot of a photo, the sensors report the amount of red, green and blue light to the camera's software, which converts the raw data into a JPEG file of colored pixels. That conversion process is influenced by the camera's setting for white balance, contrast, saturation and sharpness. For example, if your camera's white balance setting is wrong—you told the camera that you were shooting in daylight when you were really shooting under tungsten light—then the data would be processed improperly. Sure, we could correct that in Photoshop, but then we're creating a faulty image first and correcting it after the fact, giving us second generation quality.

The Raw format lets us ignore the bad settings and hand off the processing responsibilities to Photoshop. So you shot the photo using the wrong white balance? No problem, because Photoshop can take the raw data and process it properly for you. Now our file is right from the start, and we have first generation quality.

The other advantage of Raw is higher bit depth. Most Raw files contain 12 or more bits per channel of data. JPEGs, on the other hand, only have 8 bits per channel. A higher bit depth means more information to work with, resulting in higher quality.

```
Raw data is captured  →  Camera software processes data  →  Finished JPEG.
by camera's sensors.     according to camera's settings.
         ↓
                         Adobe Camera Raw intercepts     →  Finished file in the
                         the Raw data and processes it.     format of your choice.
```

▶ *Opening a Raw file.* There are two ways you can open a Raw file: through Photoshop or through Bridge. The Adobe Camera Raw interface and capabilities are identical in either case, so it really doesn't matter how you do it.

Use Bridge and locate *Leopard 1.dng* and *Leopard 2.dng*, Camera Raw files taken by Rick Bate using a Canon camera. By default, if you double-click on a Raw file, it will open in Photoshop's Camera Raw module. To open it using Bridge's Camera Raw module, type Command+R/Control+R, or choose File>Open in Camera Raw from the Main menu.

▶ *An Overview of the Adobe Camera Raw workspace.* Select Leopard 1.dng and Leopard 2.dng and open them in Bridge's Camera Raw module by typing Command+R/Control+R. The Camera Raw workspace has a filmstrip of open documents along the left, tools across the top, and a pane along the right side. The pane contains a histogram and displays one of ten different control panels, each represented by a tab icon. The first of those, the Basic tab, displays by default when you first open a file.

Click the triangles at the top of the histogram to view clipped areas of the image.

▶ *Working with the histogram.* The histogram in Camera Raw shows you where the different color channels fall and warns you of any clipping that may occur. In the top corners are two triangles. Click the triangle to the right and red spots appear on the image, telling you where the highlights are being clipped. The triangle on the left displays blue spots to indicate clipping in the shadows, but there aren't any such areas in this particular image. Click the triangles again to turn off the clipping warnings.

Adjusting White Balance

Colors shift depending on the type of light source that is shining on them. Compared to daylight conditions, an object under tungsten light would appear too yellow, under fluorescent light too green, or in the shade too blue. Cameras use white balance settings to compensate for this. For example, if you photographed an image under tungsten light, and you had the camera's white balance set accordingly, the camera's software would know to remove yellow from the image. The result would be more natural looking color. But what if the camera setting were wrong? If it were a Raw file, it wouldn't matter much, because Camera Raw lets you correct that setting before the image is processed. If you took the photo as a JPEG, however, it would be processed wrong by the camera, and you would have to correct the mistake after the fact, giving you second generation quality.

Different White Balance presets result in different temperature and tint values.

▶ *Adjust the White Balance with Color Temperature Presets.* The top section of the Basic tab is all about white balance. The White Balance pop-up menu on top has nine choices. As Shot uses the camera's settings at the time of the photograph. Auto is Camera Raw's best guess as to what the lighting conditions really were. The other choices, ranging from Daylight to Flash, are all calibrated for specific light sources.

Try the different pop-up menu settings and watch how the color changes. As it turns out, this zoo picture looks too yellow, because the camera's *As Shot* white balance was set for 5600°K (basically daylight), but it was really taken under tungsten light. Select the Tungsten preset and watch how the excess yellow disappears.

The leopard on the left is shown with the *As Shot* white balance. The white balance for the leopard on the right was changed to *Tungsten*.

▶ *Set a Custom White Balance with the Temperature and Tint sliders.*
Now turn your attention to the *Temperature* and *Tint* sliders. Instead of choosing a preset white balance from the pop-up menu, we can determine our own values using the sliders.

Do you see the color wheel in action here? It's working just like it did when we discussed color correction in chapter 5. The only difference is that it uses two perpendicular axes—blue/yellow and green/magenta—instead of the individual red, green, and blue points to shift colors around the color wheel. Often times, you'll start with a good preset value, then fine tune the color by adjusting the sliders. Whenever you move a slider, the White Balance pop-up menu displays *Custom*. Camera Raw always remembers the last Custom values used, so you can easily return to them without having to remember the settings.

Blue/Yellow Axis Green/Magenta Axis

▶ *Correct the White Balance with the White Balance tool.* There is one other way that we can correct white balance, but it only works if we can identify an object in the photo that should be neutral gray. The procedure is pretty simple.

Select the White Balance tool (Eyedropper), and click on a part of the image that should be neutral gray. We have a number of logical options for this photo: the darkest parts of the rocks, the leopard's black spots, or the leopard's mouth. Try them. They all produce similar results to the Tungsten setting. Find a white balance that looks good and try boosting the *Contrast* value, too. (We'll talk about contrast in the next section.)

White balance can be adjusted by clicking on a neutral color in the image with the White Balance tool.

Leopard photo shown as shot with the camera's settings.

Leopard photo with corrected white balance and enhanced contrast.

Synchronize Settings with Other Photos

▶ *Apply settings to Leopard 2.* Now we can take all of the work we have done on this photo and apply it to the other leopard photo. Make sure that our revised leopard photo is showing in the Preview window, then Command+Click/Control+Click on the thumbnail for Leopard 2.dng so both thumbnails are selected. Click the Filmstrip Dropdown menu and select Sync Settings. In the ensuing dialog box, choose all of the settings that you want to synchronize. In this case, White Balance and Contrast are the only settings we have altered, but it's okay to leave the others checked, too. Click OK, and the settings are automatically transferred to the second leopard photo.

With the corrected image showing in the Preview window, select the images to be synched and choose *Sync Settings*. Specify the synching options in the ensuing dialog box.

◀ Chapter 10 ▶ 239

Exiting Camera Raw

When you are finished adjusting the Camera Raw settings, there are a number of things you can do.

▶ **Click *Done.*** If you are using a Canon or Nikon raw file, Photoshop creates a separate XMP file of the Camera Raw settings and links this file to the original Raw file. The next time you open the file in Camera Raw, it looks for its linked XMP counterpart and reapplies the settings. If the XMP file is lost or renamed, the link will be broken and the settings will be lost. If you are using Adobe's Digital Negative file (DNG), then the settings are embedded within the file, making an XMP file unnecessary. It's important to note that clicking Done does not *apply* the settings to the actual image. That part of the process occurs when you open the file in Photoshop or save it to a JPEG, TIFF or Photoshop file.

▶ **Click *Cancel.*** This closes Camera Raw, leaving everything untouched as if you had never been there.

Option+Click *Cancel*/Alt+Click *Cancel*. If you hold down Option/Alt, the *Cancel* button becomes the *Reset* button. Click it, and all the settings revert to the way they were when you started the Camera Raw session.

▶ **Click *Open Image.*** This applies the Camera Raw settings and opens the image in Photoshop for further editing. You can save the file from Photoshop, but you will always have your original Raw file to fall back on. You cannot save over a Raw file.

Shift+Click *Open Image*. If you hold down the Shift key, *Open Image* becomes *Open Object*. This option converts the file to a Smart Object as it opens it.

Option+Click *Open Image*/Alt+Click *Open Image*. When you hold down the Option/Alt key, *Open Image* becomes *Open Copy*. This applies the Raw settings and opens the image just as *Open Image* would, except it does not update the Raw settings in the linked XMP file. I guess you would do this if you wanted to open the image in Photoshop, but you think that your settings were so terrible, that you never want to use them again.

▶ **Click *Save Image.*** Do this if you want to save your revised photo, but you don't want to edit it in Photoshop. Clicking *Save Image* lets you create a file that can be placed into InDesign, for example, without needing to open and save it from Photoshop. There are four file formats to choose from: Digital Negative (DNG), JPEG, TIFF and Photoshop.

Click the link to access Workflow Options.

▶ *Use Workflow Options to specify how Raw files open.*

Click on the blue underlined link directly below the image preview, and a *Workflow Options* dialog box opens, letting you specify how Raw files open in Photoshop. You can set the Color Space, Bit Depth, File Size, Resolution, and sharpening options. You can also make opening images as Smart Objects the default by checking the *Open in Photoshop as Smart Objects* box. These settings remain in effect for subsequent images.

Set your workflow options for the way you would like your images to open in Photoshop.

▶ *Apply the Leopard settings.* Click Done to apply the Camera Raw edits to the two leopard photos and exit the Camera Raw module. We'll be working on a different photo as we explore the exposure settings.

Tone Controls

The next group of settings in the Basic tab deals with Tone controls, or general exposure. Unfortunately, you can only undo so much damage to improper exposure settings on your camera. White balance only affects how data is interpreted, but Exposure affects the way data is captured. For example, the shutter speed determines the length of the data collection process, and the aperture affects the depth of field. Both of these are irreversible.

Default values, which are determined by the camera's settings, are all mapped to 0.

Nevertheless, using Camera Raw to make tone corrections has its advantage. You get to work with the maximum bit depth captured by the camera (12 bits per channel or more), instead of trying to correct the tone with a subset of that information (typically 8 bits per channel). Having more information results in smoother luminosity transitions and less noise.

> ◀ Chapter 10 ▶ 241

Speaking Photoshop...

My Tone Control Settings look different!

If your settings are different, perhaps you are looking at on older version of Camera Raw. Adobe updated the Tone controls in Adobe Camera Raw 7, which bundled with Photoshop CS6. The changes included:

1. An improved, more sophisticated method of processing adjustments.

2. New terminology that is more consistent with the terminology used in Photoshop.

3. New Adjustment sliders that place all default values at zero, replacing previous arbitrary defaults, such as +25 for Contrast. This makes it easier to know where you started and what you have changed.

If your Tone settings include *Recovery*, *Fill Light* and *Brightness* instead of *Highlights*, *Shadows* and *Whites*, then you are using an earlier process version. If this is the case, you will see an exclamation point icon in the bottom right of the preview window. Click it, and you will update to the current process. The process version can also be changed under the Camera Calibration tab.

▶ *Open Lighthouse Cliff.* Select Lighthouse Cliff.NEF—a Nikon Camera Raw photo taken by Shari Kastner—and open it in Bridge's Camera Raw workspace by typing Command+R/Control+R. In this case, the white balance was set to Auto on the camera, resulting in an accurate white balance.

This lighthouse photo has a good white balance, but we'll be able to enhance the exposure.

> ▶ *An overview of the Tone settings.* There are two underlined links at the top of the Tone section: *Auto* and *Default*. *Auto* triggers Photoshop's best guess as to how the photo should be adjusted, and *Default* uses the camera's settings. Click Auto. Instantly you see more depth and drama, particularly in the sky and water. Now click Default to return to the camera's settings. Let's see what we can do making individual slider adjustments instead.

Camera Raw's Auto exposure brought out considerably more detail.

> As you drag the exposure sliders to the right, you increase brightness. As you drag them to the left, you decrease brightness. The only exception is the Contrast slider, which increases in intensity as you drag to the right and decreases in intensity as you drag to the left.
>
> ▶ *Adjust Exposure.* The first adjustment, *Exposure*, adjusts the overall brightness of the image and is similar to the Gamma or Midpoint slider in Levels. Watch how the histogram conforms to your new setting. Double-click the slider to return it to its default value of 0.
>
> ▶ *Adjust Contrast.* Contrast does just as its name implies. It's equivalent to bringing the Black point and White Point sliders closer together in Levels to stretch out the tonal values. Again, you can watch the result unfold in the histogram.
>
> ▶ *Adjust Highlights.* This slider is equivalent to the highlights portion of Shadows/Highlights. You usually use this control to darken and improve detail in the highlights, but you can brighten highlights as well.

▶ *Adjust Shadows.* This is equivalent to the shadows portion of Shadows/Highlights. It's primarily used to brighten and improve detail in the shadows, but you can darken shadows as well.

▶ *Adjust Whites.* This is equivalent to adjusting the White point slider in Levels. Watch how the highlights in the histogram become clipped as you brighten this setting. You would typically use Whites to make sure that the highlights *do not* become clipped.

▶ *Adjust Blacks.* This is equivalent to the Black point slider in Levels. Use it to address any clipping issue you might have in the shadows.

▶ *How to determine which adjustments to make.* Now that you know what the individual controls do, let's put them together to improve the photo. Click Default to return to the camera settings. With so many settings, where do you start? Here's a good procedure to follow.

1. Make a visual assessment of the photo. It looks pretty contrasty. The darks don't have much detail, and the sky is awfully bright.

2. Check the histogram. The tones are spread out nicely from end to end, but notice the red triangle on the right, indicating clipped highlights. Click the triangle and you will see a few red spots on the image of clipped areas, but it's not bad.

3. Based on your visual assessment and histogram analysis, start with the top slider and move down, making any adjustments that you feel are necessary.

The histogram doesn't point to any big problems except for a little clipping in the highlights.

Red spots indicate areas of clipped highlights.

There are no magic formulas or numbers to enter. Each image is different. If you make an adjustment that you like, it was right. If you didn't like it, it was wrong. Remember, you can always double-click a slider to return to the default value. Here is a step by step description of the corrections I made and why I made them. Type P to toggle the preview and view the changes you make.

- Exposure. I left it at its default value. The overall exposure looked pretty good, and I didn't want to brighten the highlights any further, nor darken the shadows.

- Contrast. I reduced the contrast to −33, just enough to remove the clipping warning in the highlights. Detail improved in both the rocks and the bright part of the splash. Type P to see it.

- Highlights. In an effort to coax more detail out of the bright areas, I reduced the highlights to −50. The clouds show improved definition and the splash is toned back nicely.

- Shadows. I brightened the shadows to +45 to bring out detail in the rocks.

- Whites. Looking at the histogram, I noticed that the White point could be moved slightly to the right to make use of the full range of luminosity values. I changed it to +10.

- Blacks. I changed the Blacks value to −20 to extend the histogram a little to the left.

Type P to preview your before and after results. We've come a long way and added a lot of drama to an already nice photograph. Once again, I want to stress that the numbers I chose here are not important. Rather it's the concept behind why I chose the numbers. If I did this exercise again tomorrow, I would come up with a slightly different result. Always focus on the effect you are trying to achieve, and know which adjustment can help you realize it.

Clarity, Vibrance and Saturation

The third section in the Basic tab adjusts a photo's sharpness and color intensity. Apply these values after making corrections to the white balance and tone.

▸ *Clarity.* This effect is similar to Unsharp Mask or Smart Sharpen, except it does a better job at avoiding the halo effect caused by over sharpening. This particular photo benefits from increased Clarity (I liked +40), but skin tones in portrait photography often benefit from reduced Clarity to minimize flaws.

- *Vibrance.* Vibrance increases saturation primarily in low saturation colors. It's a more delicate control than Saturation and is often helpful in correcting skin tones without oversaturating them.

- *Saturation.* This setting increases saturation for all colors equally. If not used carefully, it can result in oversaturation and loss of detail.

- *Accept the Camera Raw settings.* Click Done to accept these settings. Remember, you can never really change a Raw file, only its settings. If you want to return to the camera's original white balance and exposure, just choose As Shot in the White Balance section and click Default in the Tone section. You can also just trash the XMP file to delete all Camera Raw settings applied to an image.

Thanks to Camera Raw, we were able to adjust this photo to add clarity and more intense color.

Shari Kastner

Other Adjustment Tabs

Most of your adjustments will be accomplished in the Basic tab, but there are a few gems hiding in the other tabs that you should be aware of.

- *Tone Curve Tab.* This tab basically duplicates the tone capabilities in the Basic tab, but it's geared for people who are comfortable with Curves. The Parametric tab uses sliders to adjust the curves, and the Point tab works similarly to the standard Curves panel in Photoshop.

- *Detail Tab.* This tab offers sharpening similar to Unsharp Mask or Smart Sharpen. Of particular interest is the Noise Reduction section, which is effective at reducing noise found in photos shot with high ISO ratings.

- *HSL/Grayscale Tab.* This tab lets you change the hue, saturation and luminance of pixels within specific color ranges. (Yes, it's the color wheel at work again.) Click the *Convert to Grayscale* check box, and you can get some very dramatic black and white prints from your color photo. Just drag the sliders back and forth and watch the drama develop.

Tone curves can be adjusted by dragging sliders in the Parametric pane, or by adding points to the curve in the Point pane.

The Detail pane sharpens an image or reduces noise.

The HSL/Grayscale pane lets you adjust hue, saturation and luminance, or control how images convert to grayscale.

► *Split Toning Tab.* This tab lets you change the hue and saturation specifically in the highlights or shadows regions. You have to drag the saturation slider before you see a difference in the hue values. Drag the Balance slider to adjust the intensity of the shadows and highlights adjustments.

► *Lens Corrections Tab.* This tab lets you correct distortion or vignetting found in many lenses. Problems can be corrected automatically if Camera Raw recognizes the lens you used, but manual corrections can also be made.

► *Effects Tab.* This tab lets you introduce noise to simulate film grain or add a black or white vignetting effect around the edges of your image.

Split Toning lets you adjust hue or saturation in highlight or shadow regions.

Correct lens-specific flaws automatically if you have a lens profile for your lens, or make manual corrections by using the sliders in the Manual tab.

Introduce film grain or create a vignette effect.

- *Camera Calibration Tab.* This tab lets you select which Camera Raw processing version you want to use to process a Raw file. It also enables you to choose Camera Raw color adjustments for a specific make and model of camera, or make your own custom adjustments.

- *Presets Tab.* Save frequently used settings by clicking on the New Preset icon at the bottom of the panel. Apply it to other images by selecting it from the list.

- *Snapshots Tab.* Similar to taking a Snapshot in the History panel in Photoshop. Use it to save settings that you may want to return to later.

Select a processing version and choose a camera profile for color conversion, or make manual color adjustments using the sliders.

Save frequently used settings in Presets.

Saving Snapshots makes it easy to compare different settings.

Adjusting Part of an Image

We've seen how you can adjust an image for white balance and tone, but what if you only wanted to adjust part of an image? There are three tools for that. One uses a brush to define the area of adjustment, the second uses a gradient mask, and the third uses an oval shape.

▸ *Adjustment Brush.* Locate Butterfly.NEF and open it in Camera Raw. Taken by Shari Kastner, this photo doesn't require any adjustments to make it beautiful, but it would be nice to draw more attention to the butterfly.

Click the Adjustment Brush or type K to select it. The Adjustment Brush panel appears on the right, and it bears a striking resemblance to the Basic tab we have been working with. Mouse over the butterfly, and a brush cursor appears. Type [or] and watch the brush get smaller or larger. Type Shift+[or Shift+] and watch the feathering change. You can also change the brush's Size, Feather, Flow and Density using the Adjustment Brush panel, down near the bottom.

Adjust the controls, select a brush, and paint areas to apply the adjustment.

Click the *Swap Before/After* icon to compare the edited version to the original.

The first icon gives you a two-up view of before/after results. The third icon lets you reset your *Before* results, and the fourth icon toggles the settings to their default.

New creates a new adjustment.
Add edits a current adjustment.
Erase erases a current adjustment.

Before we use the Adjustment Brush, we have to make some sort of adjustment in the panel. We want to brighten the butterfly, so drag the Exposure slider to the right. Just take a guess as to how much. We won't be able to see the result until we begin painting. Choose a brush size that is as big as the butterfly and set the Feather amount to 100 for a smooth transition. Then click on the butterfly, and it brightens. Go back and adjust the Exposure value until you like what you see. Click the Swap Before/After icon to compare your edits to the original.

At the top of the panel are three radial buttons: *New*, *Add* (currently selected), and *Erase*. With the current selection of Add, if we were to paint on other areas with the Adjustment Brush, they would brighten also. Paint on the flower to brighten it as well. If you go too far, choose Erase, set the brush size for the Eraser, and drag to erase the brightening effect. You can also hold down the Option/Alt key to access the Eraser without choosing the Erase radial button.

The brightening helps, but it would be nice if the foliage were darker. In order to do that, we need a new Adjustment Brush. Select the New radial button and change the Exposure to a negative value. Use a larger brush with 100% feather and paint around the outside edges. You can go back and forth between the brightened and darkened areas. Just click on the appropriate pin to select it first.

When you are through experimenting with the darkening effect, select the pin and hit Delete/Backspace to remove it, but leave the pin that caused the brightening effect. We'll darken the edges using the Radial Filter later.

Pins appear in the first spot you click when you make an adjustment. Click a pin to select it. Press *Delete/Backspace* to delete a selected pin. The pin on the butterfly has a brightening effect, and the other pin has a darkening effect.

▶ *Graduated Filter.* The principle of this tool is similar to the Adjustment Brush, except that it applies its effect using a linear gradient. Type G or click the Graduated Filter to select it, then click and drag in the image. Your effect is applied at full force where you begin dragging (green circle) and diminishes to nothing where you stopped dragging (red circle). As with the Adjustment Brush, you can click the *New* radial button and add additional areas.

The Graduated Filter is good for making linear adjustments that gradually fade away.

▶ *Radial Filter.* Yet another variation on the theme, the Radial Filter applies adjustments based on a radial gradient. Type J or click the Radial Filter to select it, drag an oval around the butterfly and darken the Exposure. Adjust the size of the oval and the feather value for a smooth transition. The *Effect* option lets you apply the adjustment to the outside or inside of the oval. Make sure to select Outside, otherwise you'll darken the butterfly instead of the background.

The Radial filter lets you adjust part of an image based on an oval selection.

Cropping and Straightening

▶ *Straighten an image with the Straighten tool.* Open *Another Lighthouse.NEF*, another nice photo from Shari Kastner. We want to do a couple of things to this image: straighten it, crop it for a 4" x 6" print, and retouch some spots on the lighthouse.

Type A or click the Straighten tool to select it. In order for this tool to work, we need to drag along a horizontal or vertical reference line in the image. With the Straighten tool selected, drag along the horizon. A rotated bounding box appears, parallel to the reference line we drew, and the Crop tool is automatically selected.

Drag along any horizontal or vertical reference line with the Straighten tool.

▶ *Crop to a specific proportion.* The Crop tool in Camera Raw works much like the Crop tool in Photoshop. Drag a bounding box handle to define the area to be cropped, or place the cursor outside of the bounding box to rotate it. It has many of the same crop options, too. Click and hold the Crop tool to reveal a pop-up menu of proportion choices. In our case, we want to create a 4" x 6" print, so select the 2 to 3 proportion. Select a crop area you like by dragging the handles or dragging inside the bounding box to reposition it. When you are satisfied, hit Return/Enter to accept it.

When you choose a different tool, the crop bounding box straightens up, dragging the image along with it.

Choose a crop proportion. Normal lets you crop at any proportion.

What if you change your mind and want to include more background? No problem. Remember, you can't change a Raw file. Simply click on the Crop tool again, and readjust the crop. If you want to get rid of it entirely, press the Delete/Backspace or Escape key.

Transform Tool

The Transform tool is particularly useful for images that have obvious horizontal and/or vertical distortion. It contains five presets that address different distortion problems as well as multiple sliders that let you fine tune your settings. Before you use this tool, you should check *Enable Profile Corrections* in the Lens Profile panel. This helps Camera Raw calculate the transformations more accurately. The next step is to choose one of the following presets:

- Auto. Applies a blend of perspective corrections.
- Level. Applies perspective correction to rotate the image.
- Vertical. Applies level and vertical perspective corrections.
- Full. Applies level, vertical, and horizontal corrections.
- Guided. With this option, draw at least two reference lines along horizontal and/or vertical references.

Select a preset, then make further manual adjustments if necessary.

There is no single best method. Just cycle through the presets and choose your favorite. You can also manually adjust the photo using the sliders for Vertical, Horizontal, Rotate, Aspect, Scale, X Offset, or Y Offset.

Spot Removal Tool

Basic healing or cloning can be done in Camera Raw, but it works a little differently than in Photoshop. Type B or click the Spot Removal tool to select it. The Spot Removal panel on the right offers the following options:

- Type. Choose *Heal* or *Clone*.
- Size. Choose a brush size before you click or drag in the image.
- Feather. Set the brush feather value.
- Opacity. Lower the value for a partial heal or clone.
- Visualize Spots. Click to have Photoshop reveal potential spots.
- Show Overlay. Deselect this option to hide the Spot Removal cursors.
- Clear All. Deletes all Spot Removal edits.

Select the Zoom tool and magnify the lighthouse. There are four blemishes that we want to remove, as indicated in the figure below. Make your brush a little larger than the sign and click on it. Two circles appear: a green one that represents your starting point (source) and a red one that represents your stopping point (destination). Move the green circle if necessary to find a suitable source point or type / to let Photoshop suggest a source. You can also still adjust your Type or Opacity settings, and you can resize the green and red circles by dragging their edges.

Use the same technique to remove the other spots. You can also drag with the Spot Removal tool if your blemishes are not circular in nature. To delete a Spot Removal edit, simply select it and hit Delete/Backspace. Click Done to accept the Camera Raw edits.

Spot Removal options

Click on the spot to be healed.

Place the green source circle in an appropriate location.

The figure on the left shows 4 spots that we want to heal. The figure on the right shows the end result.

Yet another lighthouse photo fixed up in Camera Raw. This time it was straightened, cropped and retouched.

Shari Kastner

Other Tools

Color Sampler tool

Targeted Adjustment tool

Red Eye Removal, Preferences and Rotate Image tools

▶ *Color Sampler Tool.* It's like the Color Sampler tool in Photoshop. Use it to place up to nine sample points and monitor their RGB values.

▶ *Targeted Adjustment Tool.* This tool works hand in hand with the Parametric Curve tab or the HSL/Grayscale tab. Choose an option from the tool's drop-down menu, place your cursor over a specific part of the image, and drag. Moving up or right increases the value, and moving left or down decreases it. You can see the sliders move on the panel to the right as you drag in the image.

▶ *Red Eye Removal Tool.* Drag a selection box around the red portion of the eye. Adjust the *Pupil Size* and *Darken* options if necessary.

▶ *Camera Raw Preferences.* Click to access the Camera Raw Preferences dialog box. You can also use the keyboard shortcut Command+K/Control+K.

▶ *Rotate Image Tools.* Click to rotate the image clockwise or counterclockwise.

Using Camera Raw as a Filter

Most of Camera Raw's features are also available in Photoshop's standard workspace by using the Camera Raw Filter. You don't have the ability to prevent bad camera settings from being applied, like you do when you open a Raw file, but you can still take advantage of the Camera Raw controls.

▶ *Convert to a Smart Object for nondestructive editing.* Open *Egret.jpg*, a wonderful photo taken by Phyllis Bankier of an egret searching for its lunch. As is the case with most filters, we want to use a Smart Object for nondestructive editing. Control+Click/Right+Click on the Background layer and choose Convert to Smart Object from the contextual menu.

▶ *Apply the Camera Raw Filter.* Now choose Filter>Camera Raw Filter from the Main menu. A preview window opens, revealing most of the settings from the Camera Raw interface. Adjust the Tone Controls to enhance luminosity and detail, then click OK when you're done. If you want to make further edits, simply double-click *Camera Raw Filter* in the Layers panel.

Apply the Camera Raw Filter to a Smart Object. Double-click it in the Layers panel to edit it later.

Creating Panoramas with Photomerge

Photomerge lets you take a series of overlapping photos and merge them into one, seamless panorama. It's actually a combination of two commands: Auto Align Layers and Auto Blend Layers. When photographing for Photomerge, be sure to take all of the photos from one vantage point, swiveling just your hips and overlapping the shots by 25–30%. Photoshop will place the individual photos on layers, overlap them, and blend the photos by compensating for shifts in exposure and perspective. It's pretty impressive. And all you have to do is sit back and watch.

▶ *Create a panorama.* In Bridge, open the folder titled *WCTC Panorama* and select all of the photos by Clicking on the first and Shift+Clicking on the last. Now choose Tools>Photoshop>Photomerge from the Main menu. At this point, the Photomerge dialog box opens, giving you a variety of options. You can also access this command from Photoshop by choosing File>Automate>Photomerge.

These photos were all taken from the same location with areas of overlap.

The Photomerge dialog box lets you choose different layout styles, add or subtract files, and specify other options.

Along the left side is a series of layouts that can be used to create the panorama. I've had good luck with the first one, Auto, which in essence lets Photoshop choose the best method for you. The different layouts are as follows:

- **Perspective**. This layout uses the middle image as a basis for perspective and flares the outer images for a bow tie effect.
- **Cylindrical**. Cylindrical wraps the images around a virtual cylinder. It's a good choice for panoramas.
- **Spherical**. This method maps the images to the inside of a virtual sphere and is a good choice for 360° panoramas.
- **Collage**. Not as sophisticated as the other layouts, Collage scales and rotates only and does not attempt to correct for distortions in perspective.
- **Reposition Only**. Images are moved into alignment only.

The *Source Files* pane lists the photos you chose in Bridge, but still gives you the opportunity to add or remove files if necessary. *Blend Images Together* should remain checked. This triggers the *Auto Blend Layers* portion of Photomerge. *Vignette Removal* and *Geometric Distortion Correction* compensate for certain lenses. If Photoshop recognizes a lens with these particular problems, they would be checked automatically. Leave them unchecked here. Our work is almost done. Just click OK, and watch Photoshop do its magic.

Try the various layouts and use the best result.

Add or delete files from the panorama.

Check *Blend Images Together* for a smooth look. The next two options address lens distortion issues, and *Content Aware Fill Transparent Areas* fills transparent wedges.

The five photos have been layered, overlapped and blended to create this panorama.

Photomerge layers use layer masks to blend the image together.

▶ *Apply the finishing touches.* We have one building, just as it should be. Well, almost. Notice how the flag poles and lamp posts are leaning, and of course we have big wedges of transparency around the edges.

Select all the layers and type Command+T/Control+T to enter Free Transform mode. Command+Drag/Control+Drag the upper bounding box handles outwards, and the bottom handles inwards to correct the verticals. Finally, choose the Crop tool and crop out the areas of transparency.

Use Free Transform and *Command+Drag/Control+Drag* the four corner points to correct the verticals. It's helpful to use guides as a reference.

The final Photomerge image, cropped with verticals corrected.

Merge to HDR Pro

As sophisticated as our technology has become, it still pales when compared to the capabilities of human eyesight and the human brain. This is particularly noticeable when trying to photograph an image that contains bright highlights and dark shadows. If you expose the photo so that the highlights have sufficient detail, then the shadows become black blobs. If you try to expose the shadows properly, then the highlights become blasted out. The answer to this dilemma is to take multiple exposures and let Photoshop blend the best of each. That's what HDR Pro is all about. HDR stands for High Dynamic Range.

- *Taking photos for HDR Pro.* When taking photos for HDR Pro, it's important to keep the following in mind:

 - Use a tripod. Even the slightest motion or shift can cause problems.
 - Change exposures by varying the shutter speed. If you change the exposure by varying the aperture, you change the depth of field, causing focus problems.
 - Don't use the camera's auto-bracket feature because the exposure changes are too small. Vary exposures by at least 1 stop (1 EV) or more.

- *Merging photos with HDR Pro.* In Bridge, open the folder called *Porch HDR*, select all the photos and choose Tools>Photoshop>Merge to HDR Pro. (From Photoshop use File>Automate>Merge to HDR Pro.) Click OK if you get a dialog box suggesting that you use Camera Raw files. Photoshop thinks a bit and displays a preview combining the various exposures. Below the preview are five thumbnails representing the original five photos. The center thumbnail is mapped to an Exposure Value of 0 (EV 0.00). The thumbnails to the left have positive EV values, and the ones to the right have negative EV values.

Initial HDR photos

The Merge to HDR Pro dialog box lets you adjust the HDR conversion to maximize detail and luminosity.

The panel on the right offers settings that let you tweak the results.

- **Preset Menu.** The presets offer various possibilities if you are looking for special effects. I prefer to make my own settings.

- **Remove Ghosts.** Fortunately we don't have a ghost problem with this image, so leave it unchecked. Ghosts are anomalies caused when motion is detected from one image to the other. If you see ghosts, check the *Remove ghosts* box, and a green border appears around the thumbnail that is being used as a reference to remove the ghosts. Click the other thumbnails to view different reference points and choose the one that provides the best results.

- **Mode.** I recommend 16-bit and Local Adaptation. The 32-bit mode captures all of the high dynamic range data, but has limited adjustments for proper display on a monitor. The 8-bit mode has less data to work with than 16-bit, so the results are not quite as good. Local Adaptation offers the best options for image adjustment.

- **Edge Glow.** The Radius and Strength settings are used to determine the size and contrast of local brightness regions. I recommend the default values for this image.

- **Tone and Detail.** Gamma adjusts the contrast, Exposure adjusts the overall luminance, and Detail sharpens the image. I left Gamma and Exposure unchanged, but increased the Detail.

- **Advanced.** Shadow and Highlight are similar to the Shadows/Highlights command. I darkened the Shadow amount a little for a richer black in the furniture, and I darkened the Highlight to bring out detail in the lamp. Vibrance and Saturation both adjust the intensity of colors. Adjust them to taste if desired.

- **Curve.** Lets you make adjustments with curves.

When you are finished adjusting the options, click OK to accept the results. Photoshop applies your settings and merges the photos into one, 16-bit per channel file that is far better than any one of the original photos.

HDR Settings

The final Merge to HDR photo has wonderful detail throughout the entire spectrum of luminosity values, better than any of the originals.

Final Thoughts

Camera Raw, Photomerge and Merge to HDR Pro are all wonderful tools to help photographers make the most out of their shots. Camera Raw helps ensure that the highest possible quality is maintained, even if some of the camera settings were incorrect. Photomerge lets you create panoramas that couldn't be captured with one shot. And Merge to HDR Pro lets you capture detail throughout the entire range of midtones, highlights and shadows.

Being in the right spot at the right time is the first step to capturing that once-in-a-lifetime shot. Photoshop's Camera Raw, Photomerge, and Merge to HDR Pro can help you develop that shot into the true masterpiece you envision.

11

◂ *Extracting Images—A Hairy Proposition* ▸

11 — EXTRACTING IMAGES—A HAIRY PROPOSITION

Topics

- ▶ Extract images from their original background and place them into a new background.
- ▶ Use manual masking techniques to create a soft edge for hair.
- ▶ Mask using a custom "hair" brush.
- ▶ Blend hair strands into new surroundings with Select and Mask.
- ▶ Remove stubborn fringe pixels left over from the original background
- ▶ Adjust an image's brightness to fit new surroundings.
- ▶ Adjust an image's color palette to fit new surroundings.

Preview

One of the more difficult tasks to perform in Photoshop is to extract an image with hair and make it appear natural in new surroundings. I'm sure you've all seen the result of a poorly extracted image, looking as though it were cut with scissors and taped on top of a different photo. Don't let that be the hallmark of your work! With a little practice in advanced masking, you can make your image look at home in any new environment.

This chapter covers manual masking techniques and Photoshop's Select and Mask command which helps an extracted image blend seamlessly into a new background. Then we'll discuss compositing techniques that help your image look natural in surroundings featuring different exposures or color palettes.

Manual Masking Techniques for Hair

We have already used layer masks in a number of ways. In Chapter 4, we used layers masks on adjustment layers to adjust just part of an image. In Chapter 7, we used layer masks to extract a car from a parking lot and plop it into a field. That was pretty straight forward, because the car had well defined edges to work with. In this chapter we'll be tackling the added challenges caused by three different types of hair: fuzzy, spiky and wispy.

If the hair is relatively short and uniform, you can do a nice job with manual masking techniques. That's where we'll start.

▶ *Working with fuzzy hair.* Open *Foxes.jpg*, the cute Caren Gray photo of two playful foxes that we used in chapter two. They have the type of hair that I refer to as fuzzy. It's uniform in length, and individual strands don't stick out. This is the easiest type of hair to deal with, and we can extract the foxes from their background simply by painting on a layer mask. Our goal with this photo is to place the foxes on a white background.

The foxes' fur is relatively short and uniform in length, making it a candidate for manual masking.

- *Add a white background and layer mask.* Double-click the Background layer to convert it into a regular layer, then add a layer mask by clicking on the *Add layer mask* icon. Now we need a white background. Click the *Create new fill or adjustment layer* icon, select *Solid Color* from the pop-up menu and specify white in the Color Picker dialog box. Finally, drag the white layer below the foxes layer.

- *Remove the grass.* Click the layer mask thumbnail to select it, choose a 0% hardness brush tip and carefully paint around the foxes with black to hide the grass. How large should the brush be? That's the key to success. You have to match the fuzziness of the brush to the fuzziness of the foxes' fur. If you need more fuzz, use a larger brush. Vary the brush diameter as needed. For example, you don't want the nose to look as furry as the body or tail.

 After you have created a white outline around the foxes, you can quickly hide the remaining background by drawing a rough selection around the foxes with the Lasso tool, inversing the selection (Shift+Command+I/Shift+Control+I) and filling it with black.

 As you work, you do not have to retain every trace of hair, but be careful to mask out any remnants of background. The final result should look natural.

- *Remove the blades of grass.* Use whatever retouching method you prefer to remove the few pieces of grass that remain.

The layer mask on the foxes layer exposes the white fill layer beneath it.

Create a border around the foxes, then use the fill command to complete the mask.

The finished result should have a soft looking edge.

▶ *Working with spiky hair.* Now things begin to get a little hairier, so to speak. Open two images: *Bear Stream.jpg* and *Bear.jpg*. The bear stream photo was taken by Shari Kastner, and the bear comes to us courtesy of Caron Gray. Take a close look at the bear and you'll notice that the hair is wet and spiky. This presents an added challenge that we didn't have with our foxes, but we can still get a good result using manual masking techniques.

I prefer to consolidate images in one document before I begin masking. It gives you a better frame of reference as you make your masking decisions. Use the Move tool to drag *Bear.jpg* onto *Bear Stream.jpg* via the *Bear Stream* tab. Click OK if you get a Profile Mismatch warning. Photoshop is aware that these photos were taken with different cameras and have different color spaces. Hold Shift before you release the mouse button to center the documents relative to one another. That happens to be a nice spot for the bear in its new surroundings. If you prefer, you could also copy and paste *Bear.jpg* onto *Bear Stream.jpg*. Save the file as a Photoshop document and name it Bear Final.psd.

Drag-copy *Bear.jpg* onto *Bear Stream.jpg*. Hold *Shift* before releasing the mouse.

Bear Stream.jpg

Bear.jpg

▶ *Make an initial selection and add a layer mask.* Use any tool or method you want and select the bear on Layer 1. I used the Quick Selection tool in this case. With the completed selection still active, click the Add layer mask icon to add a layer mask. As far as initial hair selections go, this one looks better than most, partially because the bear's hair is wet. Yet, if you examine the edges, you will find areas that need attention, such as pieces of grass that don't belong, or chunks of missing hair, depending on how accurate your initial selection was.

Clean up is required around the nose, and the bear's fur needs attention.

Fringe pixels of green grass can be seen through the fur.

Part of the bear's hind leg is missing, and the pine needles need to be cloned out.

Use the outer portion of your brush at 0% hardness and "tickle" the edges to delete chunks of background.

Use the Clone Stamp tool to remove blades of grass and restore the missing section of the bear's hind leg.

Cloning restored part of the bear's hind leg, but notice the green fringe pixels left over from the pine needles. We'll deal with those later.

▶ *Revise the mask by painting on the layer mask.* We're going to approach the bear photo a little differently. We want to use a 0% hardness brush and clean up the mask as before. Then we'll add the spikes later with a special "hair" brush. With that in mind, carefully work around the edges, painting with white to add more bear, or black to hide grassy background. For the purpose of this exercise, begin with the ear and work counterclockwise around the bear. I'll be pointing out different problem areas as we go.

Here are some masking techniques to keep in mind to make your job easier:

- Type D to specify default foreground and background colors.
- Type X to swap foreground and background colors as you work on the mask.
- Shift+Click on the mask thumbnail to disable the mask and look at the original bear photo for reference. You can continue to paint on the mask, even when it's hidden.
- Option+Click/Alt+Click on the mask thumbnail to view the mask by itself. This lets you catch tiny errors that are otherwise hard to catch. You can paint on the mask in this view, too.

As you come to the bear's feet, you'll see some blades of grass that can't be masked away. Use the Clone Stamp tool to eliminate those. There's also a sizeable chunk of the bear's right hind leg that's missing, because it was covered by pine branch needles. Use the Clone Stamp tool there, too, to add more leg. You'll need to temporarily disable the layer mask by Shift+Clicking on its thumbnail before you restore the leg. Otherwise you'll be cloning to a masked area that you can't see. When you have finished cloning the leg, Shift+Click on the mask thumbnail again to return to normal view, then open up the mask by painting with white to reveal the newly repaired leg.

The front right leg is also particularly challenging, because it has some well defined strands of hair that would be nice to keep, but you can easily see green grass through them. Those stubborn background pixels that cling to the foreground are called fringe pixels. We'll address that problem later.

Another problem is that the bear looks fuzzy and dry at the edges, but the rest of his fur is clearly wet and spiky. Let's address that problem first.

▶ *Create a "hair" brush.* We want the hair to look wet and spiky, but it's certainly not reasonable to mask each individual hair strand using a 2 or 3 pixel diameter brush. You don't want to be late for breakfast tomorrow, do you? Here's a chance to use the brush skills we introduced in chapter 6. We're going to create a *Bear Hair* scatter brush.

Shift+Click the layer mask to disable it and zoom in on the bear's spiky hair to examine it. Notice how the hairs come to a point and are scattered about at various angles. That's what we want our brush to look like.

Add a new layer, call it *Hair Test*, and fill it with white. You can delete the layer when we're done experimenting with the hair brush. Choose a 10 pixel wide hard brush and paint a black line about ¼" long. Now switch to white and shave off either side of the tip to make it pointy. That will be the basis of our brush.

Use the Rectangular Marquee tool to select the line, choose Edit>Define Brush Preset from the Main menu and name the brush Bear Hair. Choose the Brush tool and, in the Options bar, click the Brush Preset Picker icon and select the brush you just created. It should be the last one on the list. We have the basic shape, but we still have to size it and make lots more of them.

One bear hair, trimmed to a point.

The Bear Hair brush should be the last one in the Brush Preset panel.

Open the Brush Settings panel.

Click the Brush Settings panel icon in the Options bar to display the Brush Settings and select the following options:

- Increase the spacing to about 170% to reveal individual hairs.
- Set the size to 26 pixels, long enough for the longest hairs.
- Click Shape Dynamics and add some size and angle jitter.
- Click Scattering to scatter the hairs and adjust their count value.

Activate the *Hair Test* layer and paint with your new brush. It should resemble the tips of bear hair. If not, feel free to go back and tweak the above settings. When you're satisfied, choose New Brush Preset from the Brush Settings panel flyout menu and name it Bear Hair Scatter.

Adjust the brush angle to the direction of the hair.

▶ *Add Bear Hair to the mask.* Now we have to apply bear hair to the mask at the appropriate angles. Click the mask thumbnail to activate it and choose white for the foreground color. Then adjust the angle of the brush by dragging the *Angle and Roundness* icon in the Brush Settings panel under the *Brush Tip Shape* category. Carefully paint to add the hair spikes along the edge of the mask, adjusting the angle as you go. If you sprinkle too much hair, delete it from the mask with a round black brush.

The bear has regained its hair spikes, but they look too sharp and well defined.

▶ *Refine the fuzz factor.* Your bear should look better with spikes, but they're sharper and more in focus than the rest of the bear's hair. With the layer mask still selected, choose Filter>Blur>Gaussian Blur and blur to taste. I used a radius of 2.0, but your brush may look better with a different value.

Hair spikes are too sharp.

Hair spikes look softer.

Hair spikes look more natural now, but you can still see a greenish cast from the fringe pixels.

▶ *Remove the fringe pixels.* Now it's time to remove that stubborn greenish cast caused by the green grass and pine needles. Fringe pixels, such as these, are a common problem with extractions, particularly when edges are not cleanly defined. Since fringe pixels are virtually impossible to eliminate, the easiest solution is to convert them to an appropriate foreground color, in this case bear brown. It's not hard. Just follow these steps:

- Add a new layer above the bear, name it Fringe Pixels.
- Change the layer's blending mode to Color.
- Option+Click/Alt+Click on the line separating the *Fringe Pixels* layer and the *Bear* layer to form a clipping mask.
- Select the Brush tool and Option+Click/Alt+Click on the bear to make brown the foreground color. When the Brush is active, holding Option/Alt temporarily accesses the Eyedropper tool.
- Paint over the green fringe areas and watch them disappear.

Place the Fringe Pixels layer in Color mode and clip it to the bear layer.

Green fringe pixels were colored brown by painting on a layer in Color mode.

The *Shadow* layer helps ground the bear in his new surroundings.

This works like a charm most of the time, but not always as we'll see later. So what happened here? Color mode converts a pixel's hue and saturation to match the foreground color, but it doesn't alter the pixel's luminosity, leaving detail intact. (Yes, it's color wheel stuff again.)

The clipping mask restricted our painting to the area defined by the layer mask on the bear layer. That allowed us to paint "outside the lines" without changing the color of the background image.

It was not the case here, but sometimes painting in Color mode can overdo the effect. If that happens, simply reduce the opacity of the *Fringe Pixels* layer. You can even erase parts of the *Fringe Pixels* layer with the Eraser if you need to. Adding this layer gave us nondestructive editing.

▶ *Add a shadow.* The bear should be casting a shadow on the ground just as he did when he was walking on the grass. Add a new layer below the bear layer, name it *Shadow*, and place it in Multiply mode. Paint on it with a large fuzzy black brush and lower the layer opacity until it looks natural.

The bear is now comfortably strolling through a stream in his new environment.

◀ Chapter 11 ▶

Splitting Hairs with Select and Mask

We can only accomplish so much using manual masking techniques. If the hair is whispy, tussled or wild, then Select and Mask is a good option. Yet Select and Mask has its limitations, as do all tools, so you'll often find yourself doing some final clean-up on the mask using a brush. That's why it's so important to be comfortable with the manual masking techniques we just discussed. Select and Mask may have helped with the foxes and bear photos, but I wanted you to become familiar with manual masking techniques first.

▶ *Open the images.* Open *Dina's Sunset.jpg* and *Dina.jpg*. *Dina's Sunset* is yet another wonderful photo from Shari Kastner. Dina is a former colleague of mine, and I took this picture of her in the hallway at WCTC when Refine Mask (now Select and Mask) first came out. Since then, I've sent Dina to countless locations in my virtual Photoshop world. She's been on mountain peaks, on glaciers, in front of water falls, and numerous other places. Nothing seems to fluster her. No matter where I send her, she always appears comfortable and natural in her surroundings, thanks in part to Select and Mask.

Dina's Sunset.jpg

Dina.jpg

▸ *Prepare the images for Select and Mask.* Our Select and Mask extraction starts out just as it did when we did manual masking.

- Drag *Dina.jpg* onto *Dina's Sunset.jpg*. In this case, you won't need to hold Shift to center Dina on the sunset scene. Place her where you like.

- Select Dina using the selection method of your choice. I used the Quick Selection tool. As you make the selection, take care not to include the shadow behind her right arm. I had to Option+Drag/Alt+Drag with the Quick Selection tool to exclude the shadow.

- Add a layer mask.

- Save the file in Photoshop format and name it Dina Final.psd.

Not very good, is it? There's that cut-with-scissors look that we need to avoid. Can you imagine manually masking around each individual hair to fix that? Fortunately, Select and Mask can isolate those hairs for us.

Option+Drag/Alt+Drag to deselect the shadow.

The problems are pretty obvious. The hair doesn't blend with the background, and there's a fine white line along her left sleeve.

► *Enter Select and Mask.* Double-click the layer mask thumbnail and the Properties panel opens, displaying either the *Select and Mask* workspace or the *Masks* properties. If your *Masks* properties is displayed, click the Select and Mask button to enter the *Select and Mask* workspace. You can specify your default acton for double-clicking the layer mask thumbnail under *Preferences>Tools*.

► *Select and Mask Tools panel.* Notice the Tools panel along the left side. It contains one specialty tool and few old favorites. The top tool is the Quick Selection tool. That's the tool that we originally used to select Dina before we created our layer mask. Alternatively, we could have entered the Select and Mask workspace first, then used this Quick Selection tool to generate the mask. I find it easier to use the Quick Selection tool before entering Select and Mask. The Lasso tool gives us yet another way of creating and/or revising our selection. Just above that is the Brush tool, which lets you modify the selection as if you were painting directly on a layer mask. Here again, I find it easier to edit layer masks outside of the Select and Mask workspace. The Hand and Zoom tools let you resize and reposition your image just as you would expect. That leaves just one tool: the Refine Edge Brush tool. It's the specialty tool that I referred to earlier and it lets us fine tune our radius. More on that later.

► *Select and Mask Properties.* The Select and Mask panel is organized into four sections: *View Mode, Edge Detection, Global Refinements* and *Output Settings*. *View Mode* lets you view your image in various ways. Click the down arrow to the right of the View icon to reveal a selection of backdrops. Choosing the proper backdrop is important, because masking flaws can be profoundly noticeable against some backgrounds, yet all but disappear against others. Notice, for example, how much better Dina looks against the white background compared to the black background. That's because Dina's original background was basically white. Whenever you extract an image from one background and place it into a similarly colored background, your job is much easier. Our best viewing option is On Layers (type Y). This is the background that we want Dina to blend with. The check boxes, *Show Edge*, *Show Original* and *High Quality Preview*, don't work now because we haven't done any mask refining yet. We'll come back to those.

The Select and Mask panel helps blend hair into new surroundings.

The View pop-up menu lets you see your image on various backgrounds.

This setting creates an 8.2 pixel radius around the edge of the mask, where Photoshop decides what is revealed and what is hidden.

▶ *Edge Detection section.* The *Edge Detection* section is where most of your work will be done. In a nutshell, it divides your image into three regions:

1. An area that is completely revealed by the mask.
2. An area that is completely hidden by the mask.
3. A transition area, where Photoshop decides what is revealed or hidden. This area can include transparency.

We made our preliminary decision regarding the areas to be revealed and hidden when we created our initial, rough selection. Now we have to define that transition area, and we do that by creating a *Radius*.

Drag the Radius slider to the right and watch how Dina's hair begins to blend into the surroundings. But as the hair loses that dreaded cut-with-scissors look, other problems begin to creep in. If you go too far, the edges of her sweater begin to look ghostly and that shadow along her right arm reappears. What's going on?

Click the Show Edge check box back in the *View Mode* section. The highlighted region represents the radius we just defined, and that's the area where we are asking Photoshop to make the masking decisions for us. Drag the Radius slider back and forth and watch that region shrink and grow. Uncheck Show Edge when you want to see the full image.

The problem with using the Radius slider for this particular image is that it creates a uniform radius throughout the entire image. But what we really need is a large radius around Dina's hair, but little to no radius along the well defined lines of her sweater.

A large radius makes the hair blend better, but it adds transparency to the sweater.

Click Show Edge to view the area where Photoshop makes the masking decisions.

Smart Radius narrows the radius in areas that have well defined edges.

The *Smart Radius* check box tries to address this problem. Adjust the Radius slider so it surrounds the edges of Dina's hair (approximately 70 pixels works), then click the *Smart Radius* check box. Did you see how the radius changed? Photoshop narrowed the radius for well defined areas and enlarged it for hairy areas. But notice how that shadow along her right arm is still showing. As far as Photoshop is concerned, the color of the shadow is a closer match to Dina's sweater than it is to the white wall behind her. So it's logical that Photoshop would include that in the visible portion of the mask. We need to tell Photoshop that the shadow doesn't belong there. Here's how we do that:

Smart Radius attempts to vary the edge detection area as needed.

1. Deselect the Smart Radius option and reduce the Radius slider until the shadow along her right arm disappears.

2. Select the Refine Edge Brush tool from the Tools panel. This tool allows us to define our radius region manually. It's much more flexible than the Radius slider or the Smart Radius option, because we can make the radius as wide or narrow as we want, where we want. Paint over Dina's hair until it blends nicely. Change the brush size using the square bracket keyboard shortcuts ([or]) and make sure you include part of her hair and part of the background as you paint. Photoshop analyzes the colors of Dina's hair and the wall behind it, then makes a pixel-by-pixel decision as to what is revealed and what is hidden. If you mistakenly create a radius that is too large, Option+Drag/Alt+Drag with the Refine Radius Brush tool to erase it. You could also select the Restores Original Edge icon (the brush with the minus sign) in the Options bar to do the same thing.

Paint with the Refine Edge Brush tool to increase your radius in areas that need it.

Refine Edge Brush options let you add to or subtract from the radius.

Use a large radius in areas that need it, such as the hair, but leave it narrow for well defined lines.

Global Refinements lets you make overall changes to your mask.

New Layer with Layer Mask gives you the flexibility to edit the refined mask manually or go back to the original.

Decontaminate Colors works similarly to the "Fringe Pixels Layer" trick, but applies the changes destructively to the image, limiting the possibility for future edits.

The improvements are obvious, but Dina's hair looks a little flat in some areas, there's a holy spirit aura about her, and there's a thin white line along her left sleeve.

▶ *Global Refinements section.* The *Global Refinements* section lets you fine tune your mask in a number of ways. *Smooth* removes jagged edges in the mask, not needed in this case. *Feather* applies an overall softening to the entire mask edge, also not needed here. *Contrast* is sometimes useful in bringing back ghosted edges of well defined areas caused by high radius values. Unfortunately, increasing the contrast can also cause hair to look too wet, so use it carefully. *Shift Edge* is probably the most used option. Slide it to the left to contract your selection, and slide it to the right to expand it. *Shift Edge* is often used to reduce color fringe by contracting the selection. In this case, it helps remove the fine white line along her left arm but at the expense of the hair. Leave all of the *Global Refinements* values at zero.

▶ *Output Settings.* What do you want to do with your Select and Mask edits? The *Output To* pop-up menu lets you alter your existing *Selection* or *Layer Mask*, or you could create a *New Layer*, *New Layer with Layer Mask*, *New Document*, or *New Document with Layer Mask*. Select New Layer with Layer Mask.

The Decontaminate Colors check box eliminates fringe pixels similarly to the manual method discussed with the bear, except that it applies its color directly to the image, not on a clipped layer above it. I prefer the nondestructive method we talked about earlier. It's almost as easy and it's more flexible. Leave *Decontaminate Colors* unchecked.

▶ *Check the final result.* Back in the *View Mode* section, click the check box for Show Original to compare before and after results. We've come a long way. Just out of curiosity, cycle through the various View options and take note of how nice Dina looks against a white background.

We've accomplished what we can in the Select and Mask panel. Click OK to accept the results.

▶ *Remove the thin white line.* Select and Mask did a great job, but chances are you'll find a few spots in need of attention. That's why it's so important to become well versed in the manual masking techniques we discussed earlier. Let's start by fixing the thin white line along Dina's left arm.

Make sure the mask thumbnail is selected and has a border around it. Select the Brush tool, choose a small brush size with 0% hardness, and make your foreground color black. Not only does the sleeve have that thin white line, it also appears to be more in focus than the right arm. How large should the fuzzy brush be in order to achieve the proper focus? That's strictly a trial and error proposition. I ended up using a 25 pixel diameter brush and eliminated the white line by clicking on the bottom of the sleeve, then moving upwards and clicking again while holding Shift to "connect the dots." Carefully work your way up the sleeve. If you make a mistake, correct it by painting with white.

Magnify the image and carefully remove the white line by *Clicking* and *Shift+Clicking* your way up the sleeve.

▶ *Examine the mask for imperfections.* Option+Click/Alt+Click on the mask thumbnail to view it by itself. Here you're apt to find some problem areas that might otherwise go undetected. Most likely, you'll find some gray areas well within Dina's hair. Those are areas that Select and Mask attempted to blend but shouldn't have. Option+Click/Alt+Click the mask thumbnail to return to normal view, and you'll see that those areas are void of contrast and look too flat. Return to mask view and carefully clean those areas by painting with white. Check for missing pieces of sweater, too. I had a few of those spots that needed attention. Work carefully and stay away from the outer most edges of frizzy hair. Those areas should look grayish. Work in proper context by toggling constantly between mask view and normal view.

Mask View lets you discover and correct imperfections that would otherwise be hard to catch.

▶ *Remove the fringe pixels.* Our mask should be pretty good by now, but take a look at Dina. She's still exuding a little bit of holy spirit aura. That's caused by those pesky fringe pixels, and it's similar to the greenish color cast problem we had with the bear. Removing the green fringe pixels ended up being a fairly simple process. Let's try the same procedure here.

- Add a new layer above Dina and name it *Fringe Pixels*.
- Change the layer's blending mode to Color.
- Option+Click/Alt+Click on the line separating the *Fringe Pixels* layer and Dina's layer to form a clipping mask.
- Select the Brush and Option+Click/Alt+Click on Dina's hair to make brown the foreground color.
- Paint over the white fringes with the fuzzy edge of your brush to remove them.

Great! That didn't do a darn thing. She still looks like a holy spirit. What went wrong?

Remember, Color mode converts a pixel's hue and saturation to match that of the foreground color, but it leaves the luminosity untouched. That was just the ticket for the bear, but we don't have a hue or saturation problem with Dina's photo. Instead we have a luminosity problem. Color mode can't help with that, but fortunately there's a blending mode that can. Change the layer blending mode from Color to Multiply and watch her hair darken. It worked! A little too well, in fact. Reduce the opacity of the Fringe Pixels layer until it looks natural. Now Dina looks like a mere mortal again.

Painting with a dark color in Multiply mode works well if fringe pixels need to be darkened. Reduce the layer opacity if the effect is overdone.

By painting on a clipped layer in Multiply mode, we were able to eliminate the white glow around Dina's head.

- *Adjust the color palette.* Unfortunately Dina still looks a little odd and out of place, and it's because we have a white balance problem. Her picture was taken indoors with flash, which is color balanced to 5500°K, like daylight. But the background photo was taken during sunset which has a much warmer look than daylight. We need to bathe Dina in orange sunset light to make her appear natural in this setting. There's a command that can do just that.

Click Dina's thumbnail and choose Image>Adjustments>Match Color from the Main menu. Before entering this command, you always have to select the layer that you want to change. This is referred to as the *Target* layer. If the *Match Color* command is grayed out, perhaps you selected the layer mask thumbnail by mistake.

The top section of the *Match Color* dialog box lets you adjust the *Destination Image*. Make sure that Dina's layer is listed as the *Target*, but leave the *Image Options* settings alone.

The bottom *Image Statistics* section lets you specify a Source for the color. Click the Source pop-up menu and choose Dina Final.psd (our current file). In the Layer pop-up menu below that, choose Background for the layer. That's where our sunset colors are.

Choose Match Color to apply the colors of one layer to a different layer.

In the Image Statistics section, choose *Dina Final.psd* for the Source and *Background* for the Layer.

A Fade of 80 undoes 80% of the effect.

Look at poor Dina now. She's even more orange than the sunset. That won't do. In the *Image Options* section, move the Fade slider to the right to reduce the effect. I decided on a Fade value of 80. Click OK to accept the Match Color adjustments.

Match Color was applied at full strength in the image on the left and faded to 80% for the image on the right.

▶ *Adjust the overall luminosity.* One final tweak. Dina looks a little too bright for sunset conditions, especially the white patterns on her sweater. Add a Curves adjustment layer above the *Fringe Pixels* layer and Option+Click/Alt+Click between the layers to clip it to the Dina layer. We want to darken her, not the background photo.

Click the White Point on the Brightness curve and drag it downwards to darken the image overall. I moved it down until my Output value reached 230. Choose a setting that looks right to you. This adjustment toned everything down, but mostly the whites.

Drag the White Point down for an overall darkening effect, concentrating more heavily on the highlights.

The final composition has a natural look to it, blending into the background and fitting into the lighting conditions.

Final Thoughts

Extracting an image and placing it into a new background is far more involved than a simple cut and paste, especially if hair is involved. But with good masking techniques, a few compositing tricks, and a good measure of patience, your images will feel at home in their new locations.

Don't forget to help yourself with a little good planning, too. If you know in advance that you will be placing your subject into a new background, take your photo using a background that is similar to your destination image. Placing an image into a similarly colored background is relatively easy. Failing that, choose a non-textured backdrop that contrasts nicely with the subject's hair. Then let your Photoshop skills take care of the rest.

12

◀ *Photoshop's Vector Capabilities* ▶

Melissa Staude

12 — PHOTOSHOP'S VECTOR CAPABILITIES

Topics

- Differentiate between raster and vector images.
- Create vector shapes using the Shapes tools.
- Stroke and fill vector shapes.
- Create vector paths.
- Select paths with the Selection tool.
- Edit a path's shape with the Direct Selection tool.
- Create paths with the Pen tool.
- Stroke and fill paths.
- Use paths to make selections.
- Use vector masks to view part of an image.
- Create Point type, Paragraph type and Type on a Path.

Preview

We're going to switch gears a little in this chapter. I've been saying all along that Photoshop is a raster based program, and its images are made from a gridwork of pixels. But Photoshop has vector capabilities, too. They aren't as extensive as you'll find in Illustrator or InDesign, but they're very useful when you want to combine vector art with raster art. This chapter explores Photoshop's abilities to create paths, shapes, strokes and type.

Vector versus Raster Art

If Photoshop's strength is working with pixels, why would we want to use vector art? The underlying difference between raster and vector art is this: Raster art is made up of individual pixels of color, and although they may be similar to one another—even identical—they are truly individual specks of color that are totally unrelated to surrounding pixels. Vector art, on the other hand, uses mathematical formulas to define entire objects. There are advantages and disadvantages to each.

The ability to scale artwork is much better with vector art. Take any vector formula you want and multiply it by two, for example, and you have something that is twice as large as before, yet it's still as precise as ever. Raster art, on the other hand, gets blurrier and more pixelated as you enlarge it.

Editing is also more straight forward with vector art, because you can work with complete objects. If you have vector art of a flower, you can click it and edit the entire flower as a whole. But if that flower is made up of thousands of tiny pixels, it's more difficult to accurately select and edit just the pixels you want.

When it comes to fine nuances in shading, the pixel structure of raster art has the upper hand. It's not practical to write a mathematical formula that shifts color in increments of $1/300^{th}$ of an inch, as you can with 300 ppi raster images. Any image that requires feathering is a candidate for raster art.

Create a document of any size to experiment with Photoshop's vector capabilities.

These two circles began as vector shapes, but the one on the right was rasterized. Then they were both enlarged to 1000%. Notice how soft and pixelated the raster circle is compared to the vector circle.

Vector Tools

There are four vector tool slots in Photoshop's Tools panel. The first slot is occupied by the Pen tool and Pen tool accessories. Together they let you create and edit Bézier shapes or paths in any form imaginable.

The second slot contains various Type tools which let you create horizontal type, vertical type or type on a path.

The third slot contains the tools necessary to select a path, move it, or edit its shape. There are two choices:

- Path Selection tool (Black Arrow). This tool selects an entire path when you click it. It's handy if you want to move it or select it as a part of a multi-path selection.

- Direct Selection tool (White Arrow). Use this tool to select part of a path: a point, multiple points or a path segment. You can also select an entire path by holding Option/Alt as you click.

The fourth slot contains a selection of five Shapes tools: Rectangle, Rounded Rectangle, Ellipse, Polygon, Line and Custom Shape. They function very much like the Marquee Selection tools.

- Drag in the image to create a shape of the desired size.
- Shift+Drag to maintain a one-to-one aspect ratio.
- Hold Space while dragging to reposition the shape.
- Click in the image and enter the appropriate values in the ensuing dialog box for numerical precision. The Line tool does not offer a "click" dialog box.

Pen tool

Type tool

Path Selection tool

Rectangle tool

Pen tools

Type tools

Selection tools

Shapes tools

The star on the left was created by dragging. The dialog box on the right was opened by clicking in the canvas area. Its settings would create an identical star.

Shape, Path or Pixels

Click on any Shape tool, and the first choice to be made in the Options bar is *Shape*, *Path* or *Pixels*. A *Shape* is a vector path that includes fill and stroke attributes, similar to the Shapes found in Adobe Illustrator. You can vary the stroke width and change your fill and stroke colors at any time.

A Path differs from a Shape in that it has no stroke or fill and does not print. If you want, you can stroke or fill a Path with pixels, but the pixels retain no link to the Path. If you edit the Path, the fill or stroke does not update. Paths can also be used to clip images that you place in InDesign. It's handy if you want to create a non-rectangular image that knocks out an InDesign background.

The Pixels option fills the path you create with color, then deletes the path. This leaves you with a group of pixels that are no longer vector-editable. I never use this option.

Choose Shape, Path or Pixels before you create your vector object.

Vector Shapes

The Vector Shapes Options bar lets you work with shapes in many different ways.

▶ *Creating Vector Shapes.* Select the Rectangle tool and make sure the Shape mode is selected in the Options bar. Drag in the canvas to create a rectangle or Shift+Drag to create a square. (Choices! Choices!) Now look at the Layers panel, and you'll see that Photoshop created a Shape layer that contains the object you just made. Each time you drag you'll create a new Shape layer.

A new Shape layer is created each time you draw a shape.

▶ *Fill the shape.* Click the Fill icon in the Options bar to open the Fill panel. The icons across the top let you specify *No Color*, *Solid Color*, *Gradient* or *Pattern*. The icon to the far right sends you to the Color Picker. The Flyout menu lets you manage your swatches. Experiment with the Fill options and choose a fill that you like.

Click to display the Fill panels.

Solid Color Fill Panel Gradient Fill Panel Pattern Fill Panel

▶ *Add a stroke.* There are three stroke settings in the Options bar. The first one lets you stroke your object with a color, gradient or pattern, just like the fill options. The next option lets you specify the *Stroke Width*. Usually strokes are specified in points (pt), but you can specify inches by typing "in" or pixels by typing "px" after the number. The third option is the *Stroke Type*. Click it and a panel appears with a selection of preset strokes and a list of stroke attributes. The *Align* attribute lets you place the stroke to the *Inside*, *Center* or *Outside* of the path. The *Caps* attribute controls the ends of open paths. You can have the stroke end flush with the end of the path (*Butt*), or extend beyond it slightly with a *Round* or *Square* cap. The *Corners* attribute lets you specify *Miter*, *Round* or *Bevel* for corner points. Click More Options and, in addition to the above, you can create a custom dashed line by setting dash and gap lengths. If you like what you create, click Save to add it to your presets.

Stroke options include fill, weight and type.

Click *More Options* to customize a dashed line. You can specify up to three rotating pairs of Dash and Gap lengths.

Enter values for width and height.

These options help you work with multiple paths.

Path Operations lets you combine multiple shapes to create a new shape.

Align or distribute multiple paths.

Click Path Arrangement to change stacking order.

▶ *Change the object dimensions.* The next section of the Options bar lets you change the object's dimensions by typing width and height values. Click the chain link icon to constrain the width-to-height aspect ratio.

▶ *Work with multiple paths.* The next three icons let you manage multiple paths that appear on the same layer. Click the Path Operations icon and you'll be presented with six choices:

- New Layer. With this option, each new shape you create is placed on its own layer.
- Combine Shapes. This places new shapes that you create on the same layer and blends them into one shape if they overlap. You can also combine shapes by Shift+Dragging while in *New Layer* mode.
- Subtract Front Shape. Draw a shape on top of another to knock a hole in the lower shape. You can also Option+Drag/Alt+Drag in *New Layer* mode to subtract from a shape.
- Intersect Shape Areas. Only overlapping areas are retained. You can also Shift+Option+Drag/Shift+Alt+Drag in *New Layer* mode to intersect shapes.
- Exclude Overlapping Shapes. Overlapping areas are knocked out.
- Merge Shape Components. A compound shape created by combining, subtracting, intersecting or excluding multiple shapes is still live, which means that you can still manipulate each individual component or select a different path operation to change the end result. If you no longer need that editing flexibility, choose Merge Shape Components to create one simplified path.

▶ *Path Alignment.* This option lets you align multiple shapes both horizontally and vertically, provided they are on the same layer. It works similarly to the Layer Alignment commands we discussed earlier. Select the paths with the Selection tool and choose an alignment option. You can also distribute shapes based on their vertical or horizontal centers.

▶ *Path Arrangement.* Shapes on the same Shape layer have a stacking order determined by when you created them. The most recent shape is always on top. Choose one of the options under the Path Arrangement icon to change the stacking order.

▶ *Path Options.* This menu lets you change the appearance of a path or constrain your shape to a fixed proportion or size. If *From Center* is checked, the shape will be drawn from the center out. Holding Option/Alt as you drag toggles the *From Center* setting.

▶ *Align Edges.* We need to change the default Photoshop Preferences before you can see *Align Edges* work. Type Command+K/Control+K to access the Preferences dialog box and, in the Tools section, uncheck the Snap Vector Tools and Transforms to Pixel Grid option. Click OK to accept the new preferences.

The Path Options menu lets you alter the *appearance* of a path by changing its thickness or color. This has no effect on the path's functionality. It also lets you restrict a shape or path to a specific size or proportion.

Uncheck *Snap Vector Tools and Transforms to Pixel Grid* for this exercise, then turn it back on again for smoother vectors.

Now enlarge your view by entering 3200% in the *Magnification* field in the lower left corner of the workspace. Draw a rectangle and examine the edges. Check and uncheck the Align Edges check box and watch how the edge changes. When Align Edges is checked, your rectangle's edge should look sharp and precise. When it's unchecked, you should see anti-alias pixels surrounding the rectangle. As you may recall from chapter 3, anti-alias pixels form whenever pixels are partially selected, and they use transparency to mix the foreground and background colors. If you don't see a difference as you check and uncheck Align Edges, there are only two possibilities:

- You didn't uncheck Snap Vector Tools and Transforms to Pixel Grid in Preferences, so the object was forced to adhere to the pixel grid as you drew it.

- You are a very, very lucky person and happened to draw a rectangle that fell exactly along the pixel grid. Be sure to buy a lottery ticket if you can do that more than once.

Return to Photoshop Preferences (Command+K/Control+K) and turn Snap Vector Tools and Transforms to Pixel Grid back on. That way your graphics will always look their sharpest. I would leave Align Edges checked as well, just for extra insurance.

Type Command+0/Control+0 to zoom out and fit your view on screen.

Align Edges checked.

Align Edges unchecked.

Adjust rounded corners with the Radius.

Specify the sides before you create the polygon.

The Polygon tool can create triangles, polygons and stars.

A 60 pixel wide line, stroked with black.

Choose a shape from the Shape picker or access Shapes libraries through the panel's Flyout menu.

The Custom Shape tool can create any number of interesting shapes.

▶ *Rounded Corners.* Select the Rounded Rectangle tool, and you'll find one new setting in the Options bar: *Radius*. This option must be set before you create your rounded rectangle. The larger the number, the more rounded the corner. A value of 0 is the same as creating a regular rectangle.

▶ *Polygon tool options.* The Polygon tool also has a few options of its own. The *Sides* field in the Options bar lets you create objects containing anywhere from 3 to 100 sides. If you Click with the Polygon tool in the canvas, you'll get an Options dialog box.

- Smooth Corners changes Corner Points to Smooth Points for a rounded look.

- Star turns the polygon into a star and enables a few more options. *Indent Sides By* lets you control the pointiness of the star. A large value gives you a pointy star and a low value gives you a fat star. *Smooth Indents* rounds the corners of the indents. If you add the *Smooth Corners* option from above, you'll get a pudgy star. Lots of possibilities.

▶ *Line tool.* The Line tool creates something that looks like a line, but it's actually a rectangle whose width is controlled by the *Weight* option in the Options bar. Once drawn, your "line" can have a fill and stroke just like any other shape.

▶ *Custom Shape tool.* This is a fun tool. It has a Shape pop-up menu in the Options bar that gives you access to a Shape Picker panel containing a number of preset shapes. Simply select the shape you want and drag in the canvas. If you can't find the shape you want in the presets, perhaps you'll find it in one of the libraries listed under the Flyout menu. Click a library to select it, then choose Append to add it to the existing presets, or OK to replace the existing presets. You can also add your own custom shape to the presets by selecting it with the Selection tool and choosing Edit>Define Custom Shape from the Main menu.

Paths and the Pen Tool

There are many reasons why you might want to create a path. With paths you can:

- Create a selection.
- Stroke it using a Brush or any other retouching tool.
- Fill it.
- Use it as a Vector mask.
- Set type on it.

Creating Paths

▶ *Create a path with the Pen tool.* Any of the Shapes tools can create a path, but nothing gives you path creation flexibility like the Pen tool. A Pen path can be any length or shape and have pointy corners, smooth corners, or a combination of both. Working with the Pen tool is not particularly intuitive, but when you get used to it, you'll come to admire its precision and editability. The Pen tool creates its shapes by using different types of points. Over the years, I've come up with my own jargon to describe them.

All path illustrations have all been stroked for clarity purposes.

▶ *Create straight line segments with Corner points.* Select the Pen tool (P) and choose the Path mode in the Options bar. Creating Corner points is really easy. Click to set your starting point then Click in a new location, and the two points are connected with a straight line. Each time you Click you add another straight line segment.

Click with the Pen tool to create Corner points with straight line segments.

▶ *Closed paths versus open paths.* There are two types of paths that you can create with the Pen tool: a *closed path* and an *open path*. A closed path is a complete circle (more or less) that has no beginning or end. To close a path, click on your starting point with the Pen tool. After a path has been closed, your next click begins a new path that is unattached to the first.

A Closed path is completely enclosed. Click on the first path point to close a path.

An open path has a distinct beginning and end. To end an open path, Command+Click/Control+Click on the canvas. Now your next click would start a new path.

Command+Click/Control+Click in an open area of the canvas to end an open path.

Sometimes you may need to extend an open path that has already been completed. To do that, hover over one of the end points with your Pen tool until you see a little circle next to the cursor. Click the point to re-establish the connection, then continue clicking to add more points.

To add segments to an existing open path, click on an end point to re-establish the connection, then add new points.

Drag in the direction that the curve should go as it exits the point.

- *Create curved line segments with Smooth points.* Curves are created with Smooth points. To create one, Click+Drag with the Pen tool in the direction that you would like the curve to go. As you drag, you'll see a line extend out from the Pen tool point. Many people mistakenly believe that it's the beginning of your path, but it's only a directional handle. You need a minimum of two points to create a line segment. The directional handle simply establishes the direction and height of the curve as it exits point 1.

 Release the mouse and move to the area where you want your first curve segment to end, then Click+Drag. Again you'll see two directional handles extending out of the point. One of them defines the shape and height of the curve as it *enters* point 2, and the other defines the shape and height of the curve as it *exits* point 2. Before you release the mouse button, move your cursor back and forth and watch how the incoming and outgoing directional handles move in teeter totter fashion. Notice how the curve grows larger if you make the handles longer, and notice how the curve slope changes if you change the handle's angle. Release the mouse to accept the curve.

Hold *Command/Control* and adjust your curve before adding the next point.

- *Edit points on the fly with the Command/Control key.* The shape and height of the curve segment we just created is defined by the outgoing handle from point 1 and the incoming handle from point 2. Chances are you'll want to tweak one or both of those handles to place the curve exactly where you want it. When you hold down the Command/Control key, your cursor becomes the Direct Selection tool (white arrow), giving you the ability to select and move directional handles or points. Continue to hold Command/Control as you make your adjustments, then release it when you are ready to add new points with the Pen tool.

 It's important to edit your curve on the fly like this. It's far more difficult to edit a completed curve that was sloppily drawn. If you adjust point number 5, that often affects point number 4. When you edit that, you often have to go back to point 3, and so forth. Always correct your curves as you create your path.

 Continue to Click+Drag to add more curve segments to your path until you feel comfortable with the process. Don't forget to hold Command/Control as needed to access the Direct Selection tool.

◀ Chapter 12 ▶ 297

▶ *Create Corner/Smooth points.* Shapes aren't always compartmentalized neatly into straight lines or curves. Photoshop lets you change your mind midstream and create a combination point. We can tell Photoshop that we're changing our mind as we create a point by holding the Option/Alt key. Here's how it works:

1. Click to place the initial Corner point #1.
2. Click to place the Corner/Smooth point #2. For now, it's just a Corner point.
 Hold Option/Alt to indicate you're changing your mind and…
 Click+Drag a directional handle out of the point to establish the outgoing segment as a curve.
3. Click+Drag Smooth point #3 to complete the curve segment.

Practice this a few times. It takes a little getting used to.

Point #2 comes in as a Corner point and exits as a Smooth point.

▶ *Create Smooth/Corner points.* The formula for creating a Smooth/Corner point follows as you would expect.

1. Click+Drag to place the initial Smooth point #1.
2. Click+Drag to place the Smooth/Corner point #2. For now, it's just a Smooth point.
 Hold Option/Alt to indicate you're changing your mind and…
 Click on the point to eliminate the outgoing directional handle and make the outgoing segment straight.
3. Click to add Corner point #3 to complete the straight segment.

Point #2 comes in as a Smooth point and exits as a Corner point.

▶ *Create Broken-Handle Smooth points.* The final combination point is a Smooth point coming in and going out, but the directional handles are not connected in teeter totter fashion. I call it a Broken-Handle Smooth point. The formula to create this follows the same logic.

1. Click+Drag to set the initial Smooth point #1.
2. Click+Drag to place the Broken-Handle Smooth point #2.
 Hold Option/Alt to indicate you're changing your mind and…
 Click+Drag a new directional handle out of the point to establish a new direction for the outgoing curve segment (or Click+Drag on the directional handle and swing it into place).
3. Click+Drag to set Smooth point #3.

Point #2 is a Broken-Handle Smooth point, created by *Option+Dragging/Alt+Dragging* a new handle out of the point.

The Freeform Pen tool is easy to use but only as accurate as your hand is steady.

The Curvature Pen tool creates straight lines with a double click or curved lines with a single click.

Click a line segment to add a point.

Click a point to delete it.

With Auto Add/Delete checked, you don't need to select the Add or Delete Anchor Point tools.

▶ *Freeform Pen tool.* Located under the Pen tool, the Freeform Pen tool lets you draw a freehand path. Although more intuitive, it's not nearly as precise as the Pen tool.

▶ *Curvature Pen Tool.* The Curvature Pen tool lets you create accurate paths in a more intuitive fashion than the regular Pen tool.

- Double click to place Corner points for straight line segments.
- Single click to place Smooth points for curved line segments.
- Click an existing line segment to add a new Smooth point. Drag it to a new location to adjust the height or direction of the curve.
- Double click a Smooth point to convert it to a Corner point, or a Corner point to convert it to a Smooth point.

▶ *Adding and subtracting points.* Existing paths can be edited using the tools underneath the Pen tool. The Add Anchor Point and Delete Anchor Point tools let you click on a path to add or delete points respectively. However, if the *Auto Add/Delete* option is checked in the Pen tool's Options bar, then these tools are not necessary. With *Auto Add/Delete* checked, if you click on a line segment with the Pen tool, you will add a point. Click on a point and it will be deleted.

▶ *Converting points.* The Convert Point tool lets you change a Corner point to a Smooth point, and a Smooth Point to a Corner point or Broken-handle Smooth point. We were actually using this tool whenever we held Option/Alt as we were editing paths on the fly. Here's how it works.

- Click+Drag a Corner point to convert it to a Smooth point.
- Click a Smooth point to convert it to a Corner point.
- Click+Drag the handle of a Smooth point to break the teeter totter effect and convert it to a Broken-handle Smooth point.

Drag a Corner point to convert it to a Smooth point.

Click a Smooth point to convert it to a Corner point.

Drag a handle to create a Broken-handle Smooth point.

◀ Chapter 12 ▶ 299

Putting Paths to Use

Now that we have created paths, let's put them to use. Most of that work is done through the Paths panel.

▶ *Create a new path.* Make a new path (be sure you're in Path mode, not Shape mode) and look at the Paths panel (Window>Paths). There you'll see the path you just created. It's named *Work Path* and is highlighted, indicating that it is selected. Create a second path, and it's added to *Work Path*. Technically we now have one path, *Work Path*, composed of two subpaths. Now deselect *Work Path* by clicking below it in the Paths panel, and draw a new one. Immediately your first *Work Path* is gone, never to be seen again (except by an Undo). If you want to save a path, double-click it and name it. Photoshop always creates a *Work Path* as you draw a new path, but it's only temporary, as new paths always replace the existing *Work Path*.

Work paths are temporary. This path contains two subpaths.

Double-click a path and give it a name to save it.

▶ *Fill a path.* The first icon across the bottom of the Paths panel lets you fill a path. With the path selected, Click the Fill Path icon, and your path immediately fills with the foreground color. But it's not the same type of fill that we experienced in Shape mode. Select the Direct Selection tool and move one of your path points. Do you see the difference? In Shape mode, the fill would have updated as you altered your path, but when you fill a path this way, there is no link between the path and the fill.

Option+Click/Alt+Click the Fill Path icon. This time you are greeted with a dialog box of options. Now you can fill your path with any color you want, or use Content Aware, a Fill pattern or a History state. You can also choose a blending mode, opacity or feather value.

The disadvantage of filling a path as opposed to filling a shape is that your fill does not maintain a link with the path. The advantage is that you have more fill choices, such as Content Aware and feathering.

Select a path, then click the *Fill Path* icon to fill it with foreground color.

A filled path does not update if you alter the path.

The Fill Path dialog box has content, blending and feathering options.

The path above was stroked using the Leaves brush tip.

▶ *Stroke a path.* With a path still selected, Click the Stroke Path icon to stroke your path with the foreground color. The nature of the stroke you create depends on the last tool and brush size that you selected before clicking the Stroke Path icon. Be sure to make those selections before you click.

Alternatively you could Option+Click/Alt+Click on the Stroke Path icon for a dialog box that lets you select from a variety of tools. Nevertheless, you still have to set the brush tip for that tool before you Option+Click/Alt+Click.

Again, the disadvantage of stroking in this fashion is that the path art does not update if you edit the path after it was stroked. The advantage is that you can stroke with a wide variety of brush tips and tools.

The Stroke Path dialog box offers many different tool options.

▶ *Create a selection.* With a path selected, Click the Load Path as Selection icon to surround your path with marching ants. Alternatively you could Command+Click/Control+Click directly on the path in the Paths panel. If you Option+Click/Alt+Click on the Load Path as Selection icon, you can feather your selection or add, subtract or intersect with a current selection.

Convert your path into marching ants by clicking the Load Path as Selection icon.

Option+Click/Alt+Click on the Load Path as Selection icon for selection options.

▶ *Create a path from a selection.* Take the Lasso tool and draw a free-form selection anywhere in the canvas. Now Click the Make work path from selection icon. Photoshop creates a path in the same shape as your selection. Option+Click/Alt+Click it, and you can set a tolerance level to control the accuracy of the path. A small value gives you a more accurate path with many anchor points. A larger value gives you a less complicated, more efficient path with fewer anchor points.

The *Make work path from selection* icon is grayed out unless you have an active selection.

Tolerance controls the precision of the path.

▶ *Add a layer mask and vector mask.* Open *Safari.jpg*, double-click *Background* and rename it *Elephant*. Then add a new layer, fill it with a color and drag it below *Elephant*. Select the *Elephant* layer once again. Choose a Shape tool, make sure that it is in Path mode and create a path. Go to the Paths panel and verify that your new path is selected, then click the *Add layer mask* icon twice. With the second click, the elephant will be cropped by the path you drew.

Return to the Layers panel and look at the Elephant layer. It now has two mask thumbnails. Our first click created a blank layer mask which we could use by painting or filling it. The second click applied a vector mask using the selected path at the time. To add a vector mask without having an extraneous layer mask, choose Layer>Vector Mask from the Main menu.

We could have done the exact same thing using the *Add layer mask icon* in the Layers panel instead. It's the same icon that happens to appear in two panels.

Click the Add layer mask icon twice to add a layer mask, then a vector mask.

Each layer can have one layer mask and one vector mask.

Any vector path can be used to mask an image.

The *Create a new path* icon creates a blank path layer.

- *Create a new path.* Return to the Paths panel and Click the turned up page icon. Photoshop gives you an empty path layer upon which you can create a path. In essence, you are saving your path before you create it. Option+Click/Alt+Click it, and you have the option of naming it.

- *Delete a path.* As you would expect, the trash icon lets you delete paths. Select a path and Click the trash icon or Drag the path to the trash.

- *Create a Clipping path.* A Clipping path is used in conjunction with a page layout program such as InDesign. Because of its raster structure, all Photoshop files are rectangular. We can't change that. But what if you wanted to create an image that has a non-rectangular shape and place it in InDesign? A Clipping path can create that effect for you.

Select a path and choose Clipping Path from the Paths' Flyout menu. This doesn't work with a *Work Path*. You have to save it first. Immediately you'll notice that the path has been elevated to a special status, because its name appears in bold type. You can only have one Clipping path per document. If you were to place this file in InDesign, it would be cropped according to the Clipping path. If you want, you can change how the Clipping path interacts within InDesign by choosing Object>Clipping Path>Options from the InDesign Main menu.

Use a clipping path to make certain parts of your image appear transparent in a page layout program.

A clipping path is indicated with bold type.

Setting Type

Setting type is not Photoshop's strength. That distinction belongs to InDesign. I would never recommend using Photoshop for setting large amounts of type, such as body copy. Yet if the type you're setting also doubles as artwork, then Photoshop, with its image editing capabilities, may be your best bet. If you are an InDesign user, many of Photoshop's type features will be familiar to you. There are three ways to set type in Photoshop: point type, paragraph type and type on a path.

Point Type

▶ *Set point type.* Type T or click the Type tool to select it. Now move your cursor over the canvas and Click to set a blinking insertion point. As you type, the characters extend from the insertion point to the right, left or in both directions, depending on whether you chose left align, right align or center. When you are finished typing, press Command+Return/Control+Enter to accept it or click on a different layer.

Every time you add new type, Photoshop creates a Type layer. When the Type layer is selected, you can reposition it by dragging in the canvas with the Move tool. If you want to edit the type, select the Type tool and click on the text to set the blinking type cursor.

Point type is the easiest and most practical way to set a headline or photo caption. There are no boundaries or overset text to worry about.

Click and type

Click on the canvas where you want your point type to begin.

Type layers are created each time you create new type.

Point type aligns to the spot that you first click. Type layers can be repositioned at any time using the Move tool.

Paragraph Type

Drag with the Type tool to define an area for paragraph type.

▶ *Set paragraph type.* Paragraph type has a text frame that controls text flow and word wrap. Select the Type tool and Drag diagonally in the canvas to create a text frame, then enter the characters. If you enter more type than will fit in the frame, a little plus sign appears in the bottom right corner, indicating an overflow. Adjust the size of the text frame with the Type tool by dragging one of the handles on the bounding box. Hold Command/Control as you drag to resize the frame *and* the type inside it.

This is paragraph type. Text automatically wraps inside the text frame.

If there is too much type for the frame, a plus sign appears at the bottom right to

Type Options

Click the *Toggle text orientation* icon to switch between horizontal and vertical type.

VERTICAL

▶ *Set horizontal or vertical type.* The second icon in the Options bar changes horizontal type to vertical type and back again. This option is better suited for point type. If you use it for paragraph type, your type will read from top to bottom, right to left. You can also set vertical type by choosing the *Vertical Type tool* from the Tools panel.

Choose the Vertical Type tool to set vertical type.

▶ *Choose a font, style and size.*

The next three options let you choose the *font*, *style* and *size* of your type. If the type layer is selected and you do not have an active type cursor, the changes affect all of the characters. If you want to change individual characters, Click+Drag with the text cursor to select them first.

▶ *Select a type color.* The color swatch icon lets you change the color of your type. Click it, and Photoshop takes you to the Color Picker. If the layer is selected and there is no visible type cursor, the color will apply to all characters. To change the color of individual characters, select them first with the type cursor. You can also type Option+Delete/Alt+Backspace to fill letters with the foreground color, or Command+Delete/Control+Backspace to fill letters with the background color.

Select letters with the Type tool, then click the color swatch and choose a color.

Color, Warp and Character/Paragraph icons

▶ *Warping type.* Select a type layer and Click the Create warped text icon. The *Warp Text* dialog box appears, giving you several presets for warping text. Each preset lets you control the bend, horizontal and vertical distortion of the effect. To edit a warp, simply click the *Create warped text* icon again and change the settings. Text remains editable, even in its warped state.

Click the *Create warped text* icon, choose a warp preset and adjust the settings.

▶ *Character and Paragraph panels.* The next icon brings up the Character and Paragraph panels. The Character panel gives you control over size, leading, kerning, tracking, horizontal and vertical scaling, and more. Paragraph panel options include justification, space before, space after, indents and hyphenation.

Character and Paragraph panels give you more typographic control.

A diagonal line appears when you hover over a path with the Type tool.

Type on a Path

▸ *Set type on a path.* Select the Pen tool and draw a wavy path. Then select the Type tool, hover over the path and Click when you see a diagonal line through the cursor. Begin typing and watch the characters follow the path. A small X appears on the left of the path indicating your left margin. The black circle on the right represents the right margin. A diamond appears in the center if your type is center aligned.

The margins can be adjusted to change the position of the type relative to the path. Select the Path Selection tool, position it over one of the margins and drag. If the path disappears, you may have to reselect it in the Paths panel. You can also flip the type above or below the path by dragging across the path.

Kerning and tracking adjustments are often required as type flows through hill and dale. Where type crests over a hill, negative tracking or kerning is often necessary. For example, I applied a –140 kerning value to tighten the word "on" in the first example. In the second example notice how crunched "Circular Type" is when it's forced inside the path. We would want to apply a positive tracking value to rectify that.

The path itself can also be edited. Click on the path with the Direct Selection tool and adjust the points or directional handles as necessary. The type will automatically reflow.

Type can be repositioned with the Path Selection tool by dragging the margins or center point.

Drag across the path with the Path Selection tool to flip the text.

◂ Chapter 12 ▸ 307

Putting it all Together

Let's take some of Photoshop's vector capabilities for a test spin. We're going to create the ad shown below for African Safari Tours, Inc.

Compose the Main Graphic

▶ *Create a new document.* Choose File>New and set the following:

- Name: Safari Ad
- Size: 8" x 10.5".
- Resolution: 300 ppi.
- Color Mode: RGB Color, 8 bit.
- Background Contents: White.

▶ *Place the main image.* Choose File>Place Embedded to import Safari.jpg as a Smart Object into our new document. Press Return/Enter to accept the default size and drag it towards the top of the document with the Move tool. This is an actual African safari photo taken by Melissa Staude.

Safari.jpg, taken by Melissa Staude

▶ *Create a shape for the gold rim.*

- Using the Ellipse tool in Shape mode, create an oval that crops the elephant's head as shown.

- Choose a Fill of None and a Stroke of 50 points. The color of the stroke doesn't matter at this point. Click the Align option and choose Align Center from the popup menu to center the stroke over the path.

Align the stroke to the center of the path. That will make it easier to set type on the path later.

- Use Free Transform (Command+T/Control+T) to adjust the ellipse shape if necessary.

- Center the ellipse horizontally. Select the Move tool, Click the Ellipse layer and Command+Click/Control+Click the Background layer to select them both, then click the Align horizontal centers icon in the Options bar. Since the Background layer can't move, this positions the Ellipse in the horizontal center of the document.

Align horizontal centers can center a layer if the Background is one of the layers selected.

- Drag the Safari layer with the Move tool to center the elephant inside of the oval.

▶ **Add a metallic fill to the rim.**

- Select the Ellipse layer, click the *fx* icon and choose Gradient Overlay. Click the Gradient ramp to open the Gradient Editor.

- In the Gradient Editor, click the Presets pop-up menu and Append the Metals library. Click the gradient named Gold to apply it and click OK to close the Gradient Editor dialog box.

Click the Gradient swatch in the Layer Style dialog box, then choose *Metals* from the Gradient Editor pop-up menu.

▶ **Add dimension to the rim.**

- Click Bevel & Emboss and choose Style: Inner Bevel; Technique: Smooth; Depth: 1000; Direction: Up; Size: 25; Soften: 0.

- Click OK to accept the *Gradient Overlay* and *Bevel & Emboss* settings.

Add dimension to the gold rim with Bevel & Emboss.

Use the Character panel to access baseline shift and tracking.

- ▸ *Add text on the upper portion of the rim.* Select the Type tool, choose Center Align in the Options bar, and click on the center top of the Ellipse path. When you see the blinking cursor, type "AFRICAN SAFARI TOURS, INC." I used 26 point Copperplate Gothic Bold, but feel free to substitute a different font.

 The text followed the oval nicely, but it's a little too high and it would look nicer if it were stretched out a bit. Open the Character panel, select all the letters and enter a negative value for Baseline Shift to bring the letters down. I ended up with a value of –8, but your result may vary, depending on your font.

 Use a positive tracking value to add letter space and stretch the letters out. I tracked my example to +150. Again, use a value that looks good for your specific font. Type Command+Return/Control+Enter to accept your settings. Then turn off the eyeball to the layer to avoid confusion with the next step.

Initially the baseline of the type rests on the path.

Baseline Shift brings the type down and tracking increases the letter spacing.

Click on the bottom of the path and type.

- ▸ *Add text on the lower portion of the rim.* Select the Ellipse layer to expose the path once again. This time click on the bottom center of the path and type "FACING ADVENTURE HEAD-ON FOR 50 YEARS." If your type cursor jumps to the top of the path, don't worry. You can move it later. Manipulating type on a path is a bit finicky.

 There are two items we need to address: The phrase is too long, and it's upside down. Select the letters and reduce the point size (I chose 20 point), then use the Path Selection tool and drag across the path to flip the letters and center them across the bottom. (If you have trouble selecting the path with the Path Selection tool, try selecting a different layer, then reselecting the type layer.) Finally, adjust the Baseline Shift to center the letters vertically in the rim.

▶ *Choose a dark gold font color.* Select the *African Safari Tours, Inc.* layer, click the *fx* icon and choose Color Overlay. Click the color swatch to open the Color Picker, then click on one of the darker gold areas of the rim to select it. That's the basic color we want except we need it to be darker. Place your cursor in the Brightness field, hold the Shift key and hit the Down Arrow to reduce the brightness value in 10% increments. Choose a color that looks good to you.

Sample a color from the gold rim, then reduce its brightness

▶ *Add Bevel & Emboss to the letters.* Click Bevel & Emboss in the effects list and experiment with the settings. Choose Down for the Direction so the letters appear carved into the rim. Be sure to try the different Style types. Some of them will give you a delicate effect and others will be more bold. There's no correct answer. Choose your favorite and click OK when you're done.

▶ *Copy the effects to the other type layer.* When you're satisfied with your effects, Option+Drag/Alt+Drag the *fx* icon from your *African Safari* layer to your *Facing Adventure* layer to copy it.

Option+Drag/Alt+Drag the *fx* icon to copy the layer effects.

▶ *Add a vector mask to the Safari layer.* We can use the Ellipse shape layer as a basis for a vector mask to crop the elephant, but we have to convert it into a regular path first. Select the Ellipse layer, then click the Paths panel to activate it. There you will see the Ellipse Shape 1 Path. If it's not there, go back and select it in the Layers panel. Shapes layers only appear in the Paths panel when they are selected in the Layers panel. Drag it to the Create new path icon to duplicate it, then rename it Oval. *Oval* is now a saved, regular path. Make sure that *Oval* is selected, then return to the Layers panel.

Convert the Ellipse Shape into a Path by dragging it to the *Create new path* icon.

Click the Safari layer to select it, then choose Layer>Vector Mask>Current Path from the Main menu. Now our elephant only appears through the rim opening. The main graphic is now complete. Be sure to deselect Oval in the Paths panel before you proceed to the next step.

The vector mask hides the area of the photo that falls outside of the path.

Add a Gradient Background

Add a Gradient Fill layer.

▶ *Add a Gradient Fill layer.* Click the Background layer to select it, then choose Gradient from the Create new fill or adjustment layer icon. In the Gradient Fill dialog box that appears, choose Radial for the Gradient Type, then click the gradient swatch to open the Gradient Editor. We want to create a basic two-color gradient, so start by clicking the first preset, Foreground to Background.

Double click the left Color Stop to open the Color Picker and enter the following CMYK values: C = 0, M = 100, Y = 80, K = 0. That gives us a rich red that falls within the CMYK printing gamut.

Now double-click the right Color Stop and enter the values C = 0, M = 100, Y = 80, K = 100. By leaving magenta and yellow at their full values, the gradient will retain its rich saturated look as it darkens. Otherwise the transition from red (100M and 80Y) to black (100K) would look very bland. Click OK once to accept the Color Picker settings and a second time to close the Gradient Editor. But don't close the Gradient Fill dialog box yet.

You should see a rich red-to-black radial gradient, but the red is centered on the page, and we want it to create a glowing effect behind the elephant. No problem! Mouse over the gradient in the image and drag it upwards. Then broaden the red by increasing the scale slightly (I went to 110%). Click OK when you are happy with the results. You can come back and change these settings whenever you want by double-clicking the Gradient Fill thumbnail in the Layers panel.

Drag the gradient upwards to place the glow around the elephant.

The final Gradient Fill dialog box should have a red-to-black gradient in Radial style, scaled to create a red glow around the main graphic.

Double-click the color stops and change them to red and black.

◀ Chapter 12 ▶ 313

Create a Map of Africa

▶ *Create a map shape with the Pen tool.* Open *Africa.tif*. Select the Pen tool, place it in Shape mode, then trace around the map to create a Shape layer. It's easiest if you choose a stroke of .5 pt. and a fill of none as you work. If your stroke is too large or if you have a fill, your shape will often obscure the image beneath it, making it difficult to trace. We'll modify the stroke and fill after we place it in our ad.

▶ *Drag-copy the map shape layer to the Safari Ad.* With the Shape layer selected, place the Move tool in the canvas, drag it up to the Safari Ad tab, then down onto the Safari Ad canvas. Position the map in the bottom left corner.

Use the Pen tool to trace Africa.

▶ *Delete the stroke.* With the Shape layer and a Shape tool selected, change the Stroke to No Color in the Options bar.

Set the map shape to a fill of red and a stroke of no color.

▶ *Choose a red fill.* Click the Fill swatch in the Options bar, then click the Color Picker icon in the Fill panel. From the Color Picker, click on a bright red part of the gradient to sample it. We want to have a related color, only brighter. Click in the HSB Brightness field and type Shift+Up Arrow to increase the brightness to taste. Click OK when you have a nice red fill color.

Sample a bright red from the gradient and brighten it further.

▶ *Add Bevel & Emboss.* Choose Bevel & Emboss from the *fx* icon and adjust the settings to taste. It should have a little depth to it, but not too much.

▶ *Add location stars.* These tours are offered in four locations throughout Africa. Choose the Polygon tool, draw a small star to indicate the first location and fill it with white. Then select the star with the Path Selection tool and Option+Drag/Alt+Drag it to copy it to new locations. Place the stars anywhere you want. We don't have any real locations to worry about.

Option+Drag/Alt+Drag a star with the Path Selection tool to copy it.

The finished map is filled with red, has a Bevel & Emboss effect and is sprinkled with white stars.

Set the Type

Use Point type to set the headline.

Select the type layer and the Background. Then click *Align horizontal centers* in the Move tool Options bar.

Use the Type tool to drag a text frame.

▶ *Set the headline with Point type.* Before we set any type, open the Character panel once again and change our Baseline Shift value back to 0 and our Tracking value back to 100%. Now with the Type tool selected, choose Center text in the Options bar, and click in the center of the document under the elephant. Just estimate the center point for now. Type "Golden Anniversary Specials" using any font you want—I chose Copperplate Bold once again.

To center the headline exactly, switch to the Move tool and select the headline and Background layers. Then click the Align horizontal centers icon in the Move tool Options bar.

▶ *Add Bevel & Emboss and Gradient Overlay effects.* Click the *fx* icon and find a Bevel & Emboss setting that you like. Be sure to try the different Styles. Then click Gradient Overlay and choose the Gold gradient.

▶ *Set the subhead.* With the Type tool, drag a text frame to the right of the map for the body copy. Click the Toggle Paragraph and Character panels icon in the Options bar to bring up the Character and Paragraph panels. In the Character panel, choose:

- Font: Myriad Pro Bold or something similar
- Size: 12 pt
- Leading: Auto
- Color: White
- Baseline Shift: 0

In the Paragraph panel, choose:

- Left Alignment
- Space Before: 6 pts
- Space After: 2 pts

Now type the subhead "Balloon Safaris."

▶ *Create a Subhead Paragraph Style.* We have two other subheads that are going to use the same settings, so we'll create a paragraph style to make our life easier. Choose Window>Paragraph Styles to bring up the Paragraph Styles panel. Highlight the entire subhead, then click on the turned-up page icon at the bottom of the panel to create a new paragraph style based on our current subhead. Immediately *Paragraph Style 1* appears in the panel. Double-click it and rename it Subhead.

If you didn't highlight the entire paragraph before creating your new style, then you may see a plus sign after the style name, indicating an override. Overrides occur when a mixture of styles appears within a paragraph. This isn't always a bad thing. Sometimes you may want to override a font style and change a special word to italics, for example. But if the override was not your idea, select the entire paragraph and click the Clear Override icon in the Paragraph Styles panel. If paragraph styles don't work smoothly, an override is often the culprit.

The plus sign after Subhead indicates an override situation.

When you create a new paragraph style, the settings of your selected text are automatically applied. You can change or add to those settings using the Paragraph Style Options dialog box.

▶ *Set the body copy.* Place the cursor at the end of the subhead and press return to begin the body copy paragraph. In the Character panel, change the settings to Myriad Pro Regular, 11 pt. (or something similar).

In the Paragraph panel, change the Space Before and Space After to 0. Then type the first body copy paragraph:

Absolute serenity and the best vantage point of landscape and wildlife.

To apply a Paragraph Style, highlight the entire paragraph and click on a style.

Apply Subhead and Body Copy paragraph styles as you type.

- *Create a Body Copy Paragraph Style.* Now highlight the paragraph and in the Paragraph Style panel, click the Create new paragraph style icon to make a paragraph style for the body copy. Name the new style Body Copy.

- *Finish typing the copy.* The rest of the copy is as follows:

 Hiking Safaris
 Immerse yourself in the sights, sounds and smells of African nature.

 Photo Safaris
 Come face to lens with the world's most spectacular wildlife and scenery.

 Apply the appropriate paragraph style as you type. If you see any overrides along the way, select the entire paragraph and click the Clear Override icon in the Paragraph Styles panel.

 When you are finished typing the copy, adjust the text frame to optimize the width and height, then Command+Drag/Control+Drag it into position.

- *Set the closing tag with Point type.* Click in the center of the document towards the bottom of the ad and type the closing tag line. Choose Center Align and type the phrase below. On a Mac, type Option+8 for the bullets. On a PC, type Alt+0149 on the numeric keypad.

African Safari Tours, Inc. • 800-760-5252 • www.AfricanSafariToursInc.com

A PSD vector image enlarged to 1000% in InDesign shows pixelation.

A PDF vector image enlarged to 1000% in InDesign remains vector sharp.

- *Save the finished file.* Your ad should now be complete and look just like our example on the next page. Be sure to save it in a format that retains your editing flexibility. I recommend one of these three formats:

 - PSD file. This is Photoshop's native file format. All of your layers will remain in tact and editable.

 - TIFF file. TIFF files also support layers, giving you editing flexibility. There is a slight file size advantage when used with the LZW or ZIP compression options.

 - PDF file. PDF files have the distinction of retaining full vector detail when printed from a page layout program, such as InDesign. For example, if you enlarge a vector graphic to 1000% in InDesign, the printout will remain perfectly sharp. This is not true for placed PSD or TIFF files.

 The downside is that PDF files open in Acrobat or Preview by default. If you want to save a PDF file that defaults to Photoshop, simply change its extension to .PDP.

Final Thoughts

Vector art adds a whole new dimension to Photoshop's unparalleled pixel editing capabilities. It lets you create razor sharp paths, shapes and type that can be combined with pixel art, giving you unlimited design possibilities. Yet vector art is not Photoshop's strength. I'm a strong advocate for using the program that best fits the design you're creating. If you want to create fancy vector art, use Adobe Illustrator. If you want to set type, you're better off in InDesign. Nevertheless, there are many instances where you'll want to add vector flourishes to an overwhelmingly raster image. For that, there's no better option than Photoshop.

◂ Output for Print & Web ▸

13

Bill Elliott

Topics

- ▶ Print individual images from Photoshop.
- ▶ Prepare images for offset printing.
- ▶ Create spot color images that color separate properly.
- ▶ Optimize and save images for use on the Web.

Preview

We've covered a lot of ground since chapter one. You know how to crop, resize and transform. You know how to improve your image's luminosity values and color balance. You know how to retouch an image to accentuate the best it has to offer. You can apply stunning layer effects. You can extract images and place them convincingly onto a new background. And you know how to take advantage of the precision and sharp lines of vector images. But none of this does you a whole lot of good…unless you can show your masterpieces to others.

That's the focus of this chapter. You'll learn how to output your work so it looks as good to others as it did on your computer screen. To that end, we'll be discussing the limitations of print and web, and how to make the most of the medium you plan to use.

13
▲ OUTPUT FOR PRINT & WEB ▼

Printouts

If you have been working on a photograph and you want a few prints, you'll probably make those prints directly from Photoshop.

▶ *Print to a desktop printer.* Open *Navy Girl.jpg*, a photo of a very cute girl taken by Bill Elliott. Who wouldn't want a nice enlargement of this photo hanging on the wall, particularly if it's your granddaughter, as is the case with Bill? For individual photos like this, you'll probably want to print them directly from Photoshop.

Type Command+P/Control+P (the universal print command) to bring up the Print dialog box. The left side gives you a large preview of your image as it will appear on the printed page. The gray diagonal lines around the edge indicate the margins that your printer requires. Most printers can't print to the very edge of the paper. The right hand column lets you specify the printer you're using and lists five categories featuring various printing options.

▶ *Printer Setup.* The Printer Setup section lets you choose your printer, specify the number of copies, and access your printer driver software. Whenever you print a document from Photoshop (or any other program for that matter) the file data is handed off to the software that comes with your printer. This software, called the printer driver, then instructs your printer how and where to place all the droplets of ink or specks of toner.

Click the Print Settings icon and you'll be transported to your printer driver software. Make any printer-specific settings you want and when you're finished, you'll be returned to Photoshop's print dialog box.

The *Layout* icons let you switch between portrait and landscape orientation.

Printer Setup controls printer-specific options.

▶ *Color Management.* The Color Management section lets you determine how the colors in your image are laid down on paper. In chapter five, we discussed the problems of color gamut. The RGB colors you see on screen are manufactured in a completely different way than the CMYK colors of your printout. Unfortunately some of those colors don't match up precisely. Compounding this problem is the fact that your printer might not even use standard CMYK inks. Many inkjet printers have six or more colors. At any rate, we need to translate the file's RGB colors to the color space for your particular printer. The *Color Handling* pop-up menu gives us three choices to do that:

- **Printer Manages Colors**. This is usually your safest bet, as Photoshop hands off the responsibility of color conversion to your printer driver. When you hit Print, your file's RGB colors are converted on the fly according to the settings in your printer driver software. Printer manufacturers spend a lot of time tweaking this color conversion, and results are usually very good.

Color Management controls how colors are converted for printing.

Printer Manages Colors is a safe color handling option to choose.

- **Photoshop Manages Colors**. This setting lets Photoshop apply the color conversion, but you have to choose the appropriate Printer Profile from the pop-up menu. Many inkjet manufacturers have profiles to match specific paper types. If you let Photoshop apply the color conversion, be sure to disable color management in your printer driver software. Otherwise your image will be subjected to a double conversion.

Choose the Printer Profile for your printer.

- **Separations**. It's unusual to create color separations from Photoshop. That's usually done from InDesign, Acrobat or the commercial printer's RIP software. If you choose this option, be sure to convert your file to CMYK mode first.

The next pop-up menu offers two choices:

- **Normal Printing.** Use this setting for normal printouts. *Rendering intent* controls how colors that are out of gamut are moved into the printer's gamut. *Perceptual* creates the most natural looking results.

- **Hard Proofing.** Use this setting to simulate results from a different printer. Select the appropriate profile from the *Proof Setup* pop-up menu.

Finally, the Description section gives you useful information when you mouse over an item in the print dialog box. There are a lot of choices, and *Description* helps you make sense of it all.

▶ *Position and Size.* By default, your image prints in the center of the page, but if you deselect the *Center* option, you can drag the image wherever you like, or type in coordinates in the *Top* and *Left* fields.

This photo is positioned to print .25" from the top left edge of the page.

You can resize your printout by entering an amount in the *Scale*, *Height* or *Width* fields. Try entering smaller and larger values in each of the fields and as you do, watch how the Print Resolution changes. Any resizing you do in the Print Dialog box merely expands or contracts the spacing between pixels.

Scale to Fit Media is handy. Click it, and your image enlarges or reduces to fill the available print area.

Scale to Fit Media enlarges small images or reduces large images to fit the print area. In this case, it enlarged our photo to 117.33% to fill the available space.

Four triangles appear around the image preview if *Print Selected Area* is checked. Drag the triangles and you can crop the printout. If you have an active selection before you invoke the print command, the triangles will automatically mark the selected area.

The *Units* pop-up menu lets you specify units of measure for all coordinate and dimension fields.

Crop your image by dragging the *Print Selected Area* triangles.

▶ *Printing Marks.*

Typically used when printing color separations, the *Printing Marks* section lets you add crop marks and other information outside of the image area.

▶ *Functions.*

The *Emulsion Down* and *Negative* options are for printing to devices that create film. The three buttons below give you some more options:

- Click Background and the Color Picker opens, letting you choose a matte color for around your image.

- Click Border and you can place a border around your image to any width you specify. Borders only come in black.

- Bleed lets you move your crop marks in by a given amount. It's used for offset printing to make sure that the image bleeds, or prints, off the edge of the page.

▶ *Accept your settings, or not.*

When you have finished making your settings, you have three choices:

- Cancel. This ignores any settings you made as if you never came to the print dialog box. As with other dialog boxes, if you hold Option/Alt, the *Cancel* button becomes a *Reset* button.

- Done. You like the settings you made and want to keep them, but you're not ready to print.

- Print. You like the settings and you want to print.

Preparing Images for Offset Printing

CMYK Images

Images headed for offset printing have to be converted into CMYK mode for color separation purposes. Yet my recommendation is to work with the file in RGB mode for as long as possible, then save a copy in CMYK mode for the printer. This workflow offers a number of advantages:

- Remaining in RGB mode guarantees that you have the largest color gamut to work with. Some colors are permanently lost when you convert to CMYK. Also, some Photoshop editing capabilities are unavailable in CMYK.

- Nowadays most images used for print are also used for the Web, which requires RGB. Your Web quality will be better if you don't convert to CMYK then back to RGB.

▶ *What you see isn't what you get.* It's important to know that images printed with offset printing will not necessarily match what you see on your computer's monitor. This is particularly true for bright, almost fluorescent looking colors. Never show a client your work on screen and tell him that his printed piece will look the same. You're setting him up for disappointment, and you're setting yourself up for an uncomfortable, after-the-fact explanation. There are a couple of steps you can take to avoid this.

RGB and CMYK Color Gamuts

If your image contains colors inside of the RGB gamut but outside of the CMYK gamut, then your printout will look different than it does on screen.

– – – RGB
——— CMYK

Gamut problems can be a source of frustration and disappointment when printing your images.

These flowers contain bright colors that are out of the CMYK color gamut. They look nicer on screen than they do in this book.

Proof Setup can give you a glimpse of what your image will look like when it's viewed on different computer monitors or printed.

Proof Colors toggles your Proof Setup view, and Gamut Warning highlights the problem areas on the image.

Areas highlighted in gray are out of the CMYK gamut.

▶ *Dealing with gamut problems.* Open *Flowers.jpg*, the photo taken by Phyllis Bankier that we used back in chapter 5 when we talked about gamut limitations. I like to use it because it has more out-of-gamut colors than most images. Do you remember how dull the violet colors got when we converted the file to CMYK? Wouldn't it be nice if we knew about those limitations from the start? There are three commands under the View menu that can give you some valuable insight: *Proof Setup*, *Proof Colors* and *Gamut Warning*.

▶ *Use Proof Setup to choose your output media.* Choose View>Proof Setup from the Main menu. Photoshop offers three Proof Setup categories: one for CMYK printing, one for Web applications and one for color blindness. Choose Working CMYK, and watch the violet color become bland and lose detail. We now have a realistic picture of how well CMYK printing technology can replicate this photo.

▶ *Use Proof Colors to see the results.* The Proof Colors command is just an on/off switch that activates whatever option you chose under Proof Setup. It has a check mark by its name now, because Photoshop activated it for us when we accessed the Proof Setup command. Type Command+Y/Control+Y to toggle the proof view on and off.

We haven't made any changes to this image whatsoever. We are only changing our view of it. We still have a larger color gamut and more editing flexibility because we haven't left RGB mode. But at the same time, we have a realistic view of the quality we can expect when the image comes off press.

▶ *Use Gamut Warning to highlight problem areas.* Choose View>Gamut Warning from the Main menu, and Photoshop highlights areas that are out of the CMYK printing gamut. In this case, it covers much of the flowers.

- ***Optimize your color settings.*** Check with your printing company before you convert your files to CMYK. Some printers like to receive CMYK files, yet others prefer to make the CMYK conversion using their own software. If the printer wants you to make the CMYK conversion, choose Edit>Color Settings from the Main menu and select U.S. Web Coated (SWOP) v2 from the CMYK pop-up menu. That's the standard color conversion profile used in the United States.

 U.S. Web Coated (SWOP) v2 is the setting used most often in the U.S.

 There are two presets that you can also select that will serve you well.

 - North America General Purpose 2. This preset is ideal if you do a combination of print and Web work. The RGB color space is set to *sRGB IEC61966-2.1*, the profile used by the vast majority of Web users. The CMYK color space uses *U.S. Web Coated (SWOP) v2* for reliable CMYK conversions.

 - North America Prepress 2. This preset uses the *Adobe RGB (1998)* color space, which is larger than the sRGB color space. On the one hand, it's nice to have a larger RGB color gamut, but you run the risk of seeing things on screen that the standard Web viewer won't see. If you do Web work, my recommendation is to stick with sRGB.

 General Purpose settings use sRGB for standard Web display.

 Prepress settings use Adobe RGB for a larger color gamut.

- ***Synchronize the color settings in Bridge.*** It's actually better to choose a color preset in Bridge instead of Photoshop. Bridge synchronizes the settings throughout the entire Adobe Suite. From Bridge, choose Edit>Color Settings from the Main menu. Select a preset and click Apply.

The Channels panel shows the CMYK color separations.

▸ *Make the conversion to CMYK.*
With your color settings in place, simply choose Image>Mode>CMYK to complete the conversion. Save this new file as a copy and keep the original RGB file for Web use or future editing.

▸ *View the color separations.* Take a look at the Channels panel (View>Channels) to see the color separations that the printer uses to create his printing plates. Each channel is a grayscale image. Dark areas represent heavy ink coverage, and light areas represent sparse ink coverage.

Duotones

If you are working with a two-color job, you may want to add a little color to your image using a duotone. Duotone images are made with two colors, usually black plus a special Pantone ink. You don't have to use black, but if you are preparing an ad for a publication, you're charged for black whether you use it or not. Also, you usually want to use black for your copy. Therefore duotones usually contain black, but they don't have to.

▸ *Convert an image to Duotone.* Open *Frog.jpg*, a wonderful close-up of a frog posing for Phyllis Bankier. To convert the photo to duotone, choose Image>Mode>Duotone.

But wait. It's grayed out. Choose Image>Mode>Grayscale first and Discard the color information. Now you can complete your conversion to Duotone.

When the Duotone Options dialog box appears, you'll realize that the word duotone is used rather loosely by Adobe, because under the *Type* pop-up menu, you can actually choose a monotone, duotone, tritone or quadtone, requiring one, two, three or four inks respectively.

Choose Duotone, and a second ink option appears, ready for you to specify its value. Do the following:

- Click the Color Swatch to open the Color Picker.
- In the Color Picker, click the Color Libraries button and choose Pantone+ Solid Coated from the Book pop-up menu. These colors represent how the Pantone inks look when printed on coated paper.
- Click a color in the list, or type its name/number to select it. Where do you type the name? I don't know. Just type it, and the color appears. I think Adobe should add a *Color* text field to make this part of the operation more intuitive. Our frog had a nice orange color, so I typed "orange" and got *Pantone Orange 021*. Choose a color you like and click OK.
- Immediately your image takes on a color cast corresponding to the color you chose, but it's just a very even color cast. We can make it more interesting.

You have to convert to Grayscale before you convert to Duotone mode.

The Duotone command lets you create monotones, duotones, tritones or quadtones.

Specify the ink color by clicking on the swatch.

Scroll through the list or type a name to find a specific color.

Click a curve icon to adjust the distribution of ink.

▶ *Adjust the duotone curves for visual interest.* Right now the black and orange ink coverages are identical, which creates a bland, rather boring result.

- Click the Black curves icon to open the Duotone Curve dialog box. Try reducing the intensity of the black in select areas by dragging downwards on the curve. Experiment and see what you come up with.

- Adjust the curve for your second color, too. Try increasing it in select areas to give it more color intensity. Click OK when you are satisfied with your results.

The black curve has less intensity in the midtones.

The orange curve has more intensity in the midtones.

▶ *Check the color separations.* You would expect to see separate color channels in the Channels panel just as we did for the CMYK image, but that's not the case. Our duotone image has just one channel named *Duotone*. However it will still color separate properly for the printer, provided that you save the file in the proper format. PSD, EPS and PDF files all work, but I recommend PSD. If you place this image in InDesign, any Pantone colors you specified will automatically be added to the InDesign Swatches panel.

Duotones appear as one channel in the Channels panel but separate properly into two colors.

Duotones offer a way to add color to an image when working with just two colors.

Spot Color Images

Duotones are nice, but they're rather limiting. The only control you have over how the ink is laid down is through the curves in the Duotone Options dialog box. Spot Color channels let you deposit ink anywhere with the exact coverage you need. We're going to recreate a scaled down version of the two-color Portfolio Review poster shown below. It was created by Mélanie Lévesque, the winner of WCTC's poster design competition in 2012. Mélanie created the background image in Photoshop and added the type using InDesign.

This poster was created using black and Pantone 3105.

▶ *Create a new document.* The poster consists of black and a teal color made from Pantone 3105. Because we want our file to color separate properly, we'll start with grayscale (for the black plate), then add a Spot Color channel using Pantone 3105 (for the teal plate). Don't mix RGB mode with spot colors. They might look fine on screen, but they won't color separate properly.

In Photoshop, type Command+N/Control+N and create a document with the following specifications:

- Name: Portfolio Poster
- Size: 8" x 11"
- Resolution: 300 ppi
- Color Mode: Grayscale, 8 bit
- Background Contents: White

▶ *Add the pattern.* Open *Pattern.jpg*—you'll find it in the Poster folder—then Shift+Drag it onto the *Portfolio Poster* document. Make sure you continue to hold Shift when you release the mouse, so it centers properly. Name the layer Pattern and reduce its opacity to 15%.

▶ *Add the type.* I took Mélanie's type from InDesign and converted it to a Photoshop document for you. Open *Type.tif*, Shift+Drag it onto *Portfolio Poster* and name the layer Type.

Drag the Pattern and Type images into the new document.

Pattern.jpg

Type.tif

▶ *Add the teal color channel.* Choose New Spot Channel from the Channels panel Flyout menu, then do the following:

- Click the color swatch to open the Color Picker.

- In the Color Picker, click the Color Libraries button and choose Pantone+ Solid Coated from the Book pop-up menu.

- When the Color Libraries dialog box appears, type 3105 (quickly) to select *Pantone 3105 C* and hit OK.

- Back in the New Spot Channel dialog box, notice how the name field has been filled in. I strongly recommend that you do not change the name, especially if you plan on importing your image into InDesign. Messing with the name can cause unnecessary confusion between the programs, creating an extra printing plate. Also, leave the Solidity at 0% for an accurate view of how inks overprint in offset printing. Click OK to accept your new second color.

Choose New Spot Channel from the Channels Flyout menu to add a spot color.

▶ *Add a teal background to the image.* Working with spot color channels is not as intuitive or versatile as working in a standard color mode, such as RGB, CMYK or Grayscale. For one, you can't use Layers for your spot color. Layers are only compatible with Default Color channels, the channels that are determined by your color mode. The default channel for our document is *Gray*. Any teal we add must be placed on the *Pantone 3105 Spot Color* channel and no where else. Spot Color channels are similar to CMYK or Gray channels in that they contain a grayscale image that controls ink coverage. Black indicates total ink coverage, white indicates no coverage, and gray indicates partial coverage.

We now have two colors, but at the moment there is no ink on the Pantone 3105 channel.

The Pantone channel is filled with black, creating solid ink coverage.

The red highlight indicates that the layer is not truly selected. Spot Color channels are not compatible with layers.

Mélanie's design calls for a solid Pantone 3105 background. Select the Pantone 3105 channel, type D to specify the default Foreground/Background colors, then type Option+Delete/Alt+Backspace to fill with the foreground color black. We now have 100% Pantone 3105 ink coverage in the background.

If you switch to the Layers panel, you'll see a red tinted layer, indicating that it is no longer selected. Click a layer to select it, then return to the Channels panel, and you'll notice that the Gray channel is now selected. If you are on an active layer, you can't be on a Spot Color channel and vice versa. That can be confusing. In a way, Spot Color channels act like their own layer and a channel all at once.

The Pantone color has been added, but we lost our white lettering.

▶ *Knock out the type on the Pantone channel.* I'm sure you've noticed by now that our white lettering is solid teal. If we could place our Pantone channel under the white letters in the Layers panel, that wouldn't be a problem. But since we can't, we'll have to manually delete the teal wherever we want white.

Command+Click/Control+Click on the *Type* thumbnail in the Layers panel to load it as a selection. Then switch to the Channels panel, select the Pantone channel, and with white as the Background color, hit Delete/Backspace to delete any Pantone ink from the selected area.

If we wanted to, we could have left solid Pantone ink under the black letters. All channels function as if in Multiply mode, with the ink from one channel overprinting the ink from other channels. If we had left the letters solid black plus solid Pantone, they would have been a richer looking black.

▶ *Create an oval to darken the edges.* Mélanie darkened the edges slightly to focus attention toward the middle of the design. Do the following:

- Add a Solid Color layer between the *Pattern* and *Type* layers and fill it with black (100K).

- Select the layer mask thumbnail, create an oval selection over the image with the Elliptical Marquee tool, and fill it with black to mask away the center fill area.

- We have two problems to address here. The mask edge is much too sharp, and the black fill is much too dark. Mélanie was looking for a subtle effect. Let's work on the mask edge first.

- Choose Convert to Smart Object from the Layers Flyout menu so we have nondestructive editing. Deselect the marching ants, then choose Filter>Blur>Gaussian Blur from the Main menu. Increase the Radius until you have a nice soft edge (Mélanie used 300 pixels). We could have accomplished the same result by feathering our selection by 300 pixels when we first created the oval, but that would have required substantial trial-and-error work.

- To reduce the intensity of black, simply lower the opacity of the layer. Mélanie used 25%.

Command+Click/Control+Click on a layer thumbnail to select its pixels.

The type has been knocked out of the Pantone channels, creating white letters.

Make an oval selection and mask out the black fill.

Use a Gaussian Blur to create a soft transition.

▶ *Check the color separations.* Turn the eyeballs on and off in the Channels panel to see the two separate printing plates. Save it as a PSD file, and it will color separate properly for the printer.

Gray Channel

Pantone 3105 Channel

Completed 2-color Poster

Saving Images for the Web

When saving images for use on the Web, you'll want to choose one of four file formats: GIF, PNG-8, JPEG or PNG-24. As you would expect, there are advantages and disadvantages to each. Let's take a closer look.

Understanding Web File Formats

▶ *Use GIFs or PNG-8s for line art.* GIFs and PNG-8s are almost identical. GIF stands for *Graphic Interchange Format*, and PNG stands for *Portable Network Graphic*. They are similar in many ways:

- They are best used for flat-color line art, such as logos or type.
- They use Indexed Color Mode, which stores color information in a color table containing up to 256 colors. They are 8-bit files.
- They support single-level (binary) transparency. This gives you the ability to place artwork, such as a logo, on a Web page that has a solid, single color background.

Their differences are as follows:

- GIFs are slightly more compatible than PNGs for older browsers. This difference continues to become less important.
- PNGs are usually slightly smaller files than GIFs.
- GIFs support animation, and PNGs don't.

▶ *Use JPEGs for photographs.* JPEG stands for *Joint Photographic Experts Group*. Here are some things you should know about JPEGs.

- They are best used for continuous tone images, such as photographs.
- They feature lossy compression that reduces file size by combining similar colors into a single color. Compression occurs each time you save the file. Over-compression can lead to blotches of color, referred to as JPEG artifacts.
- They feature 24-bit Color Mode which displays up to 16.8 million colors. They do not support transparency.

▶ *Use PNG-24s for multi-level transparency.* PNG-24 files support 24-bit color like JPEGs, but their file sizes are much larger, making them an undesirable alternative to JPEGs for photographs. Here are their main features:

- They use lossless compression that preserves image quality but at the expense of large file sizes.
- They are the only file format that supports multi-level (alpha) transparency. If you wanted to add a drop shadow to your artwork and place it on top of a multi-colored background, PNG-24 files are the only format you could use.

Optimizing Line Art

When you build a Website you want it to be beautiful, but you also want it to be practical. If users have to wait too long for a graphic to download, they may give up and go elsewhere, never to see your masterpiece. When you optimize an image, you are trying to strike the perfect balance between high quality and fast download times. Photoshop's *Save for Web* makes that easy to do.

▶ *Convert vector art to raster art.* Open *Il-Dolce.ai*, a logo for the Il Dolce String Quartet. As is typical, this logo was created using Adobe Illustrator, and it's a vector file. To be viewable by a browser, we have to turn it into raster art and save it in one of the Web-compatible formats.

In Photoshop, choose File>Open from the Main menu and select Il-Dolce.ai. The *Import PDF* dialog box appears, giving you control over the conversion process from vector to raster. Select the following options:

- Size: 400 x 400 pixels. Inches, centimeters and points have no meaning for Web applications. It's all about pixels. If you know the target pixel count for your Web page, enter that in this dialog box.

- Resolution: 72 ppi. This is the common resolution used for Web images, but in reality resolution values are ignored by all but a few Web authoring software packages.

- Mode and Bit Depth: RGB, 8 bit.

- Click OK to convert the Illustrator vector file to raster art.

This logo is a vector image created in Adobe Illustrator.

Use the Import PDF dialog box to specify the number of pixels, resolution and RGB color mode.

◀ Chapter 13 ▶ 339

The file opens in Photoshop on a layer with transparency, which gives you the capability of placing it on a colored page on the Web.

▶ *Optimize the logo as a GIF.* Because this is line art, our two best formats for saving this logo are GIF and PNG-8. Both will result in small file sizes and support for single-level transparency. Let's try a GIF first.

Choose File>Export>Save for Web (Legacy) from the Main menu to open the *Save for Web* dialog box. Across the top are four tabs: *Original*, *Optimized*, *2-Up* and *4-Up*. Click 2-Up. I like using the 2-Up view, so I can compare the quality of the original to the quality of the optimized file. The *4-Up* view would give you the original plus three optimized versions to compare.

The logo has been converted to pixels on a transparent background.

Along the right side is a control panel that lets you choose your file format and optimization options. The top *Preset* pop-up menu lets you choose from selected optimization packages, but I prefer to create my own. Click the Optimized file format pop-up menu immediately below that and select GIF.

Choose 2-Up to compare the original to the optimized version.

Use the settings panel to optimize the size and quality of your image.

Save for Web lets you optimize files for the Web. The file size and estimated download time are displayed under the thumbnail of the optimized image.

The logo turns black with two colors.

The logo looks good with 16 colors.

When using Transparency, set the Matte color to the color of the Web page.

File size and download time.

The most important setting to make when optimizing a GIF file is the number of colors, because that has a direct impact on the file size. I generally leave the other settings at Photoshop's default values. Our goal is to specify the fewest number of colors possible without hurting the visual quality.

Choose 2 from the Colors pop-up menu, and the logo will turn black. That's because the color table only has two colors to work with: black and transparent. If you look below the *GIF* thumbnail, you'll see that the file size is a mere 4.24K (your value might be slightly different) and the download time using a 56.6 Kbps data rate is just 2 seconds. Yet the visual quality is obviously not acceptable, so we need more colors.

Choose 4 from the Colors pop-up menu and notice how the file size increases slightly to 6.88K. We have our red color again, but notice how pixelated the cello strings are. That's because Photoshop can't apply anti-aliasing effectively with so few colors. This result is still unacceptable.

Choose 8 from the Colors pop-up menu, and the cello strings improve.

Choose 16 from the Colors pop-up menu, and the strings improve some more.

Choose 32 from the Colors pop-up menu. Now we've reached the point where I can't see a noticeable difference.

Return to the 16 colors setting. This is the tipping point where small file size meets good quality. When optimizing files, start with the absolute smallest file size available, then increase the quality until you no longer see an improvement.

▶ *GIF Transparency options.* If you intend to place this logo on a colored Web page, make sure that the Transparency box is checked, and that the Matte color matches the page color. To specify the Matte color, click the Matte color swatch to bring up the Color Picker and type in your color value.

When you have completed your optimization and transparency settings, click Save, and Photoshop saves a GIF copy of the file. Our final file size for the logo is 9.997K, and the download time using a 56.6 Kbps data transfer rate is 3 seconds. Click the flyout menu to the right of the download time if you want to compare the speed using other connections.

▶ *Optimize the logo as a PNG-8.* Type Shift+Option+Command+S/ Shift+Alt+Control+S to bring back the *Save for Web* dialog box. This time choose PNG-8 from the Optimize file format pop-up menu. PNG-8 options parallel GIF options, so leave all the settings as they are and click Save.

If you compare the PNG-8 logo to the GIF logo, the only difference is a small improvement in file size. Whereas the GIF logo was 9.997K, the PNG-8 logo is 8.343K. The Download time using a 56.6 Kbps data rate is two seconds. Not a real significant difference.

Choose PNG-8, but leave the other options the same.

The PNG-8 is slightly smaller than the GIF.

Optimizing Photos

Photos compress better and have better quality if you use JPEGs.

▶ *Optimize a photo as a JPEG.* Open *Fiery Race.jpg*, an exciting photo taken by Billy Knight. This time we'll use *Save for Web* to create an optimized JPEG and change the image dimensions at the same time. The Web Master has asked us to make the photo 600 pixels wide.

Photographs and other continuous tone images are best saved as JPEGs.

Type **Shift+Option+Command+S/Shift+Alt+Control+S** to open the *Save for Web* dialog box and choose **JPEG** from the **Optimized file format** pop-up menu. The process you use to optimize a JPEG is similar to the one used for GIFs and PNG-8s. You reduce the quality to its lowest point, then increase it until you stop seeing an improvement.

The **Quality** setting is the key to compressing JPEGs to a small file size. Reduce the value to **0** and examine the result. Blotchiness appears, especially noticeable in areas of relatively flat color, such as the track and the fence behind the car. Those are JPEG artifacts caused by compressing too many similar colors into one. The file size is 34.96K, but the quality is not acceptable.

This magnified view shows the blotchiness of JPEG artifacts at 0% Quality.

With your cursor in the Quality field, press **Shift+Up Arrow** to increase the **Quality** setting to **10%**. Examine the photo again, then continue to increase in 10% increments until you stop seeing an improvement. I settled for a **Quality** of **30%**. It's a judgement call.

Notice the *Blur* field below the *Quality* field. With it, you can blur JPEG artifacts into oblivion and reduce the file size even further. I don't use it.

Now we have to reduce the photo to 600 pixels wide. Type **600** in the **Width** field in the *Image Size* section. That reduces the file size is 40.36K and the download time to 8 seconds at 56.6 Kbps.

JPEG artifacts are not as apparent at 50% Quality.

- *JPEGs can simulate transparency.* Even though JPEGs do not support transparency, you can still use the Matte feature in the *Save for Web* dialog box to colorize any transparent pixels to match the background color of a Web page. But unlike GIFs or PNG-8s, if you reopen the JPEG, there won't be any transparency at all—just one flattened Background layer.

Choose a Matte color to fill any transparent areas.

- *Save the optimized JPEG.* When you are satisfied with your settings, click Save to save a JPEG copy of your image. Always keep your original for future edits. Resaving JPEGs to JPEGs deteriorates the quality.

Final Thoughts

The final step to any Photoshop project is to output your image to print or to the Web in such a way that it retains all of the quality that technology offers.

Becoming aware of the gamut limitations of CMYK printing is essential if your image is going to find its way into a brochure, an ad or other printed material. Even though you can't circumvent the limitations of print, you can at least take on the challenge with your eyes wide open and plan accordingly.

If your image is headed for the Web, it's important to know how to maximize the quality without bloating download times. Using the features in *Save for Web* is the key to success here.

Regardless of the media you choose to distribute your work, be sure to put as much thought into outputting your file as you did in editing it in the first place.

INDEX

A

additive color, 112, 115
Adjust Edge, 277, 280
Adjustment Brush, 233, 249–251
Adjustment layer, 94–98, 101, 118, 122, 124–126, 128, 130, 144, 150–151, 170, 208, 267, 284, 312
adjustment pins, 222–223
algorithm, 95
Align Edges, 293
aligning, 174–175
Alpha channel, 227
Alpha Protect, 224, 227–228
anchor points, 301
anti-aliasing, 63, 67, 340
Application bar, 6–7, 19, 23
auto adjustment, 86, 94, 96
Auto Color, 86–88, 95, 130
Auto Exposure, 85–86
Auto Tone, 86–88, 95

B

background, 51, 55, 59, 68–74, 76–82, 99, 106, 134, 144, 155–160, 162, 170–171, 173, 176–177, 189, 195, 200, 206, 211–212, 219–221, 224–226, 228–229, 252, 254, 257, 265–267, 270, 274, 277, 279–280, 283–285, 290, 293, 301, 305, 308, 312, 314, 319, 324, 331–335, 337, 343
background color, 76, 134, 158–160, 162, 200, 228, 305, 335, 343
Background layer, 69, 76–77, 106, 144, 155–160, 162, 170, 189, 206, 212, 220, 224, 228–229, 257, 267, 308, 312, 343
balancing color, 122
Bevel & Emboss, 164–165, 309, 311, 313–314
bit depth, 234, 240, 338

Black Point, 90–92, 98, 101, 126, 242–243
blending, 117, 139, 147, 155, 159, 161–162, 172–173, 180, 199, 220, 234, 273, 282, 299
blending modes, 117, 139, 155, 159, 161, 199
Bloat tool, 215
Blur, 150, 183, 195–197, 272, 335, 342
Bridge, 2–7, 10–11, 13–15, 17, 20–23, 25, 30–31, 34, 41, 49, 51, 55, 183, 187, 190, 235, 241, 258–259, 261, 327
Brightening teeth, 151
brightness, 114, 116, 118, 128, 130, 151, 204, 242, 262, 265, 284, 311, 313
brush tip, 99, 133, 138–141, 143, 148, 267, 272, 300
Brush tool, 61, 99, 138, 147, 152, 159, 162, 205, 271, 273, 281
Burn tool, 150

C

Camera Calibration Tab, 248
Camera Data, 21
Camera Raw, 7, 23, 232–237, 239–241, 245, 247–249, 254–257, 261, 263
Camera Raw Filter, 257
Camera Raw workspace, 235, 241
Canvas Size, 33, 41–43, 45–46, 57, 225, 229
channels, 26, 97, 119–121, 123, 125, 129, 227, 236, 328, 330–331, 333–336
Character, 305, 310, 314–315
circles, 60, 63, 115–118, 255
Clarity, 233, 244, 295
clipping, 45, 91, 95, 98, 155, 179–180, 236, 243–244, 273–274, 282, 302
clipping mask, 95, 179, 273–274, 282
Clipping path, 302

344

Clone Stamp tool, 143–147, 152, 207, 221, 270

Clouds filter, 183, 200

CMYK, 112, 116, 120–121, 312, 321, 325–328, 330, 333, 343

color, 14, 20, 30, 35, 42–44, 50, 59, 61–63, 68–70, 73–74, 76–80, 86–88, 90–91, 95, 99, 101, 107, 110–130, 134, 136–137, 141, 145, 147, 151, 158–166, 168–171, 173, 178, 187, 199–200, 204–206, 208, 228, 234, 236–237, 240, 244, 246, 248, 256, 265, 267–268, 272–274, 277, 279–284, 288, 290–291, 293, 299–301, 305, 308, 311–314, 319, 321, 324–337, 340, 342–343

color analysis, 122

Color Balance Adjustment layer, 122, 124, 130

Color channel, 332–334

color gamut, 111, 120, 321, 325–327

Color Management, 321

Color Overlay, 168–169, 311

Color Range, 59, 77, 79–80, 120, 151, 277

Color Sampler tool, 126, 128, 256

color separations, 321, 324, 328, 330, 336

color wheel, 111, 113–118, 124, 130, 237, 246, 274

combination point, 297

Content Aware, 148–149, 210–211, 220–221, 224, 226–230, 299

Content Aware Fill, 211, 220–221, 228–229

Content Aware Move, 211, 228–230

Content Aware Scale, 211, 224, 226–227

contrast, 65, 70, 86–88, 90, 95–96, 98, 101, 104, 107–108, 126, 161, 194–195, 234, 237–238, 242, 244, 262, 280–281

Converting points, 298

Corner point, 56, 202, 297–298

Crop, 33, 45–52, 56–57, 61, 198, 233, 253–254, 260, 311, 319, 323–324

Crop tool, 33, 45–52, 56–57, 61, 198, 253–254, 260

Crop tool options, 50

Curvature Pen tool, 298

Curves, 84–85, 101–103, 105, 109, 111, 122, 128, 130, 170–171, 176, 246, 262, 284, 296–297, 330–331

custom brush tip, 138

Custom Shape, 289, 294

D

desaturate, 150–151

deselect, 11, 62, 68, 72, 76, 145, 162, 166, 205–206, 227, 255, 279, 299, 311, 322, 335

desktop printer, 320

Detail Tab, 246

Displace filter, 183, 198

distort, 39, 51, 53, 55, 57, 199, 210–211, 222

Distributing layers, 175

dng, 235, 238–239

Dodge Tool, 134, 150

Drop Shadow, 39, 165, 170–171, 337

Duotones, 328, 331

duplicate, 16, 54, 81, 86, 88, 150, 189, 192, 201, 205, 219, 224, 228, 311

E

Edge Detection, 277–279

effects, 39, 100, 133, 154–155, 159, 162–166, 168–172, 180, 191–192, 247, 262, 311, 314, 319

Effects Tab, 247

Ellipse, 60, 116–117, 289, 308–311

Elliptical, 60, 63–64, 335

exposure, 12, 17, 20, 85–86, 97–98, 124, 150, 233, 240, 242, 244–245, 250, 252, 258, 261–262

Extracting Images, 264

Eyedropper, 125–128, 130, 205–206, 237, 273

F

Face tool, 216
Fade, 63, 195, 284
feathering, 63, 67, 81, 249, 288, 299, 335
File Properties, 21
fill a path, 290, 299
Fill a selection, 62, 211
Filter, 17–18, 119, 183, 191–194, 196–201, 211–212, 219, 223, 233, 250–252, 257, 272, 335
Find command, 18
Flow, 139, 141, 143, 150, 249, 304
foreground color, 61–63, 99, 134, 159–160, 178, 200, 272–274, 281–282, 299–300, 305, 334
Forward Warp tool, 213
Freeform Pen tool, 298
Free Transform, 51, 53–54, 61, 185–186, 189, 200, 225, 260, 308
Freeze Mask, 216–217
fringe pixels, 69, 265, 270, 273–274, 280, 282, 284
f-stop, 261
Fuzziness, 78–79, 267

G

Gamma, 90, 242, 262
gamut, 111, 119–120, 312, 321–322, 325–327, 343
Gamut Warning, 326
Gaussian Blur, 195, 272, 335
GIF, 336–337, 339–341
Gradient, 133–137, 152, 165, 168–169, 249, 251–252, 291, 309, 312–314
Gradient Fill layer, 312
Gradient Overlay, 168–169, 309, 314
gradient preset, 137
Graduated Filter, 233, 251
Gray Point Eyedropper, 126–128, 130
Grayscale, 246, 256, 328–329, 332–333
group, 3, 7, 12–13, 16–18, 25–27, 54, 65, 117–118, 134, 137, 139, 161–162, 173–175, 240, 290, 337

H

Hand Tool, 28–29, 71, 87, 116
HDR, 232–233, 260–263
heal, 201, 204–205, 207, 221, 233, 255
Healing Brush tool, 147
high dynamic range, 233, 260, 262
highlight, 9–10, 71, 107, 125, 166, 195, 262, 315–316, 326
histogram, 88–90, 93–96, 101, 103, 122–123, 125, 235–236, 242–244
History, 47, 54, 248, 299
HSB, 114, 116, 313
HSL, 246, 256
Hue, 114, 116, 118, 130, 133, 150–151, 161, 246–247, 274, 282

I

Illustrator, 4, 35, 183–184, 187, 287, 290, 317, 338
Image Size, 33–37, 39, 41, 48, 57, 342
Info panel, 126–129
inkjet printers, 321
Inner Glow, 166–167
Inner Shadow, 165–166
Input, 89–90, 95, 102, 111, 122, 128–130
Interface Appearance, 30
interpolation, 37
Invert, 217, 277
IPTC Core, 21
isolate, 17, 219, 276

J

JPEG, 23, 227, 234, 236, 239, 336–337, 341–343

K

keystoning, 55, 189–190

keyword, 15, 17, 23

Knock out, 335

L

label, 13–15

Lasso tool, 59, 67–68, 70–72, 79, 149, 221, 228–229, 267, 301

layer, 50–51, 54–55, 69, 71–72, 75–77, 79–81, 85, 94–101, 106, 108–109, 117–118, 122, 124–126, 128, 130, 143–151, 154–164, 168–174, 176–180, 184–194, 199–201, 206, 208, 212, 217–220, 223–229, 257, 266–267, 269–274, 276–277, 280, 282–284, 290, 292, 301–305, 308–313, 319, 332, 334–335, 339, 343

Layer Comp, 80

layer effects, 154–155, 159, 162–164, 168–170, 172, 180, 319

layer group, 173–174

layer mask, 98–100, 106, 108, 159, 176–179, 191, 193, 218–219, 223, 266–267, 269–272, 274, 276–277, 280, 283, 301, 335

Layers panel, 51, 54–55, 80–81, 94–95, 98, 101, 106, 108, 117, 139, 158–159, 161–162, 164, 170–174, 177, 185, 189, 191–193, 195, 197, 208, 257, 290, 301, 311–312, 334–335

Layer Style, 163–164, 170–172

Levels, 84–85, 88–91, 93–98, 101, 103, 105, 109, 111, 122, 125–126, 176, 242–243

linear gradient, 134, 251

Line tool, 289, 294

Liquify, 211–212, 216–218, 221, 230

Load Selection, 219

Locking and Linking Layers, 162

Luminance, 204, 207, 246, 262

luminosity, 60, 68, 73, 85, 88–89, 91–92, 94, 96, 102–103, 107, 123–124, 128, 161, 240, 244, 257, 274, 282, 284, 319

M

Magic Wand, 59, 73–78, 80

Magnetic Lasso tool, 68, 70, 72

Main menu, 5–7, 9, 12–13, 18, 23–24, 26–27, 35, 41, 62, 76–77, 81, 86–87, 89, 106, 119–120, 140–141, 156, 159–160, 185, 187–188, 190, 194, 196, 199, 201, 206, 212, 219, 221, 225–227, 235, 257–258, 271, 283, 294, 301–302, 311, 326–327, 335, 338–339

Marquee, 28–29, 59–61, 63–64, 66–67, 141, 159, 200, 204, 229, 271, 289, 335

masking, 65, 100, 151, 155, 183, 191, 265–266, 268, 270, 275–278, 281, 285

masks, 85, 98–99, 109, 155, 159, 176–177, 179–180, 217, 266, 277, 287

Matte, 44, 324, 340, 343

Merge to HDR Pro, 233, 260–261, 263

metadata, 3–4, 20, 22, 31

Midtone, 85, 90, 92, 97–98, 101–102, 105, 107–108, 127

Move tool, 44, 50, 54, 117, 158–160, 164, 174, 176, 187–189, 199, 211, 228–230, 268, 303, 308, 313–314

Moving Layers, 173

multi–level transparency, 337

multiple selection, 11

Multiply, 117, 166, 274, 282, 288, 335

INDEX

N

neutral color, 114, 122

Noise Gradient, 136

Normal blend, 168–169

O

opacity, 136, 139, 141, 143, 155, 159, 161–162, 165, 168–169, 171, 173, 180, 199, 204–205, 208, 213, 217, 220, 255, 274, 277, 282, 299, 332, 335

Open command, 4, 23

Optimizing Line Art, 338

Optimizing Photos, 341

Options bar, 24–25, 28, 34, 44, 47–49, 52–53, 60, 63–65, 71, 74, 99, 116, 134–144, 147–150, 161–162, 164, 174, 185, 187, 199, 202, 204–205, 221, 223, 226, 228–229, 271, 290–292, 294–295, 298, 304, 308, 310, 313–314

Outer Glow, 170

Output, 36, 57, 90, 102, 111, 122, 128–130, 277, 280, 284, 318–319, 326, 343

Overlay blend, 168

P

panorama, 233, 258–259

Pantone, 328–330, 332–335

Paragraph, 287, 303–305, 314–316

paragraph style, 315–316

paragraph type, 287, 303–304

paste, 69, 72, 75, 79, 152, 206, 268, 285

Patch tool, 149, 204, 221

path, 6–7, 10, 14, 68, 287, 289–292, 295–296, 298–303, 306, 308, 310–311, 313

Path Alignment, 292

Path Arrangement, 292

Path bar, 6–7, 10, 14

pattern, 141, 156, 165, 169, 200, 207, 291, 299, 332, 335

Pattern Overlay, 169

Pen tool, 287, 289, 295–296, 298, 306, 313

perspective, 33, 51, 53, 55, 57, 183, 201–204, 207, 258–259

perspective planes, 202

Photomerge, 232–233, 258–259, 263

Pin Depth, 223

pixels, 20, 34–37, 40, 48, 50, 52, 57, 59, 63, 65, 69–70, 72–73, 81, 89, 107, 114, 124–125, 139, 145, 147–148, 150, 152, 155, 157, 159, 162, 174, 176–177, 186–188, 194–195, 202, 206–207, 211–212, 214–215, 217, 220, 222, 224, 230, 234, 246, 265, 270–271, 273–274, 279–280, 282, 284, 287–288, 290–291, 293, 323, 335, 338, 341–343

PNG, 337

Point type, 287, 303–304, 314, 316

Polygonal Lasso tool, 59, 67–68, 70–71

Polygon tool, 294, 313

Preferences, 13, 22, 30, 156, 256, 293

Prepress, 327

Presets Tab, 248

primary color, 118

print, 37, 40, 47, 57, 112, 121, 130, 189–190, 227, 253–254, 290, 318–325, 327, 343

Printing Marks, 324

printouts, 320, 322

Proof Colors, 326

Proof Setup, 322, 326

Properties panel, 21, 94–95, 101, 118, 124–128, 151, 277

Pucker tool, 214–215

Puppet Warp, 211, 219–221, 223, 227, 230

Push Left tool, 215

Q

Quick Selection tool, 71–73, 151, 177, 227, 269, 276

R

Radial Filter, 252
radial gradient, 252, 312
Radius, 107, 194–195, 262, 272, 277–280, 294, 335
raster art, 206, 287–288, 338
raster image, 317
Rasterize, 206
rating, 14–15, 17
Raw, 7, 23, 232–237, 239–241, 245, 247–249, 254–257, 261, 263
Rearranging layers, 158
Reconstruct tool, 213
Rectangular Marquee tool, 60–61, 63, 159, 229, 271
Red Eye, 133, 142, 152, 256
Refine Edge Brush tool, 279
Regular layer, 55, 155–161, 267
Resample, 35, 37, 40, 48, 57
Resetting workspaces, 27
resize, 10, 27, 39–40, 48, 55, 57, 187, 197, 203, 206, 255, 304, 319, 323
resolution, 20, 33–37, 40, 48, 57, 164, 187, 240, 308, 323, 332, 338
retouching tools, 134, 143, 147, 150, 152, 228
RGB, 97, 104, 112, 116–121, 125–128, 256, 308, 321, 325–328, 332–333, 338
rotate, 3, 7, 10–11, 28–29, 33, 49, 51–53, 57, 139, 159, 223, 254, 256
Rotate View, 28–29, 139
Rounded Corners, 294

S

Satin, 167–168
saturation, 107, 114, 116, 118, 130, 133, 137, 150–151, 233–234, 244–247, 262, 274, 282
Save for Web, 338–339, 341–343
Scale, 14, 33, 39, 51–54, 159, 185, 188, 211, 224–227, 288, 312, 323
Screen mode, 117
Select and Mask, 65, 265, 275–281
selection, 11, 17, 27, 51, 59–82, 124, 149, 151, 159–160, 166, 177, 204, 206, 208, 211, 219–220, 227–229, 250, 256, 267, 269, 276–278, 280, 287, 289, 291–292, 294–296, 299–301, 306, 310, 313, 323, 335
Selection tools, 59–60, 67, 71, 73–74, 79, 82, 289
Shadows, 84–85, 96, 98, 106–109, 124, 167, 184, 191, 195, 233, 236, 242–244, 247, 260, 262–263
Shake Reduction, 196–197, 209
shapes, 60, 65, 68, 116, 139, 173, 175, 287, 289–290, 292, 294–295, 297, 317
Shapes tools, 116, 287, 289, 295
Sharpen, 150, 183, 194–196, 209, 244, 246
Shield, 50
single-level transparency, 339
skew, 33, 51–53, 57, 159
Skin Protect, 224, 226–227
Smart Filter, 223
Smart Object, 106, 108, 156, 183–192, 194, 196, 199, 201, 212, 218–219, 221, 223, 239, 257, 308, 335
Smart Radius, 279
Smart Sharpen, 183, 194–195, 209, 244, 246
Smooth point, 297–298
Snapshot, 248
source point, 143–148, 207, 255
Split Toning Tab, 247

349

INDEX

Sponge Tool, 150
Spot Color, 319, 331–334
spotlight, 122
Spot Removal tool, 233, 255
stacking order, 79, 158, 160, 168–169, 179–180, 192–193, 217, 223, 292
stacks, 12
star, 294, 313
Straighten, 33, 49, 233, 253
stroke, 139–141, 163, 165–166, 205, 287, 290–291, 294–295, 300, 308, 313
Stroke a path, 300
Subtract from Selection, 65–66, 71
subtractive color, 111–112, 117, 120

T

target color, 76, 122, 129
Targeted Adjustment Tool, 256
teeth, 133, 150–151
Temperature, 236–237
Thaw Mask tool, 216
thumbnail, 10, 12, 14, 23, 41, 47, 54, 81, 98–100, 117, 177–178, 185, 189–190, 192–193, 206, 238, 261–262, 267, 270, 272, 281, 283, 312, 335, 340
TIFF, 23, 239, 316
Tolerance, 74, 76, 78, 301
Tonal Width, 107–108, 195
Tone Controls, 240, 257
Tone Curve, 246
Tools panel, 24–25, 28, 60, 62, 71, 126, 134, 289, 304
tracking, 305–306, 310
Transform, 33, 51–55, 57, 61, 158–160, 162–163, 174, 185–187, 189, 200–201, 205–206, 211, 225, 230, 260, 308, 319
Transform tool, 254
transparency, 135, 137, 156–157, 160, 260, 278, 337, 339–340, 343
twirl, 183, 211, 213–214
Twirl Clockwise tool, 214
type on a path, 287, 289, 303, 306, 310
type options, 44, 304

U

Unsharp Mask, 194, 244, 246

V

Vanishing Point, 182–183, 201–202, 206–207
vector, 35, 184, 187–188, 206, 277, 286–290, 293, 295, 301, 307, 311, 316–317, 319, 338
vector art, 206, 287–288, 317, 338
vector images, 184, 187, 287, 319
vector mask, 277, 295, 301, 311
Vector Tools, 289, 293
Vibrance, 244–245, 262

W

Warp, 33, 51, 53, 57, 210–211, 213, 219–221, 223, 227, 230, 305
Warping type, 305
white balance, 20, 234, 236–238, 240–241, 244–245, 249, 283
White Point, 90–91, 95, 97, 101, 125–126, 233, 242–244, 284
workspace, 3, 6–8, 24, 27, 31, 212, 235, 241, 257, 293

Z

Zoom Tool, 28, 34, 87, 255

CPSIA information can be obtained
at www.ICGtesting.com
Printed in the USA
LVHW07n0036230818
587767LV00012BA/122/P